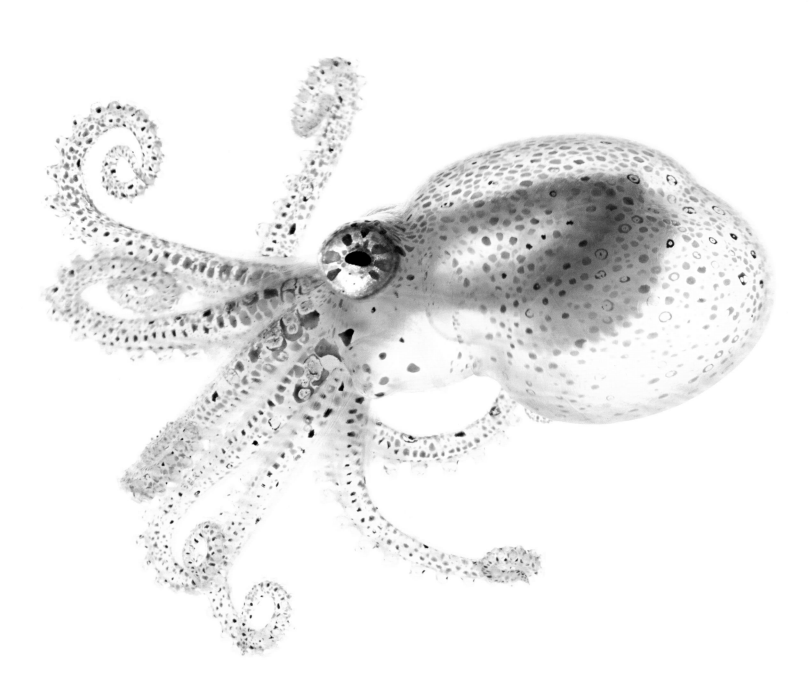

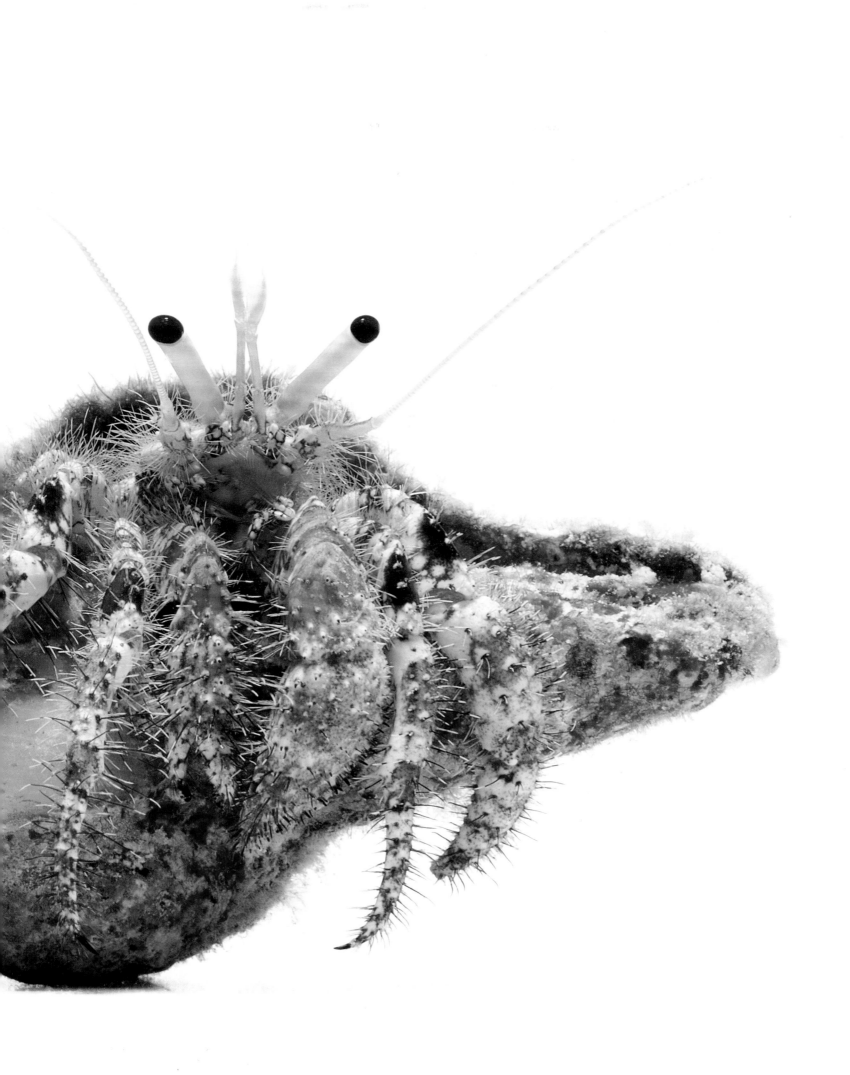

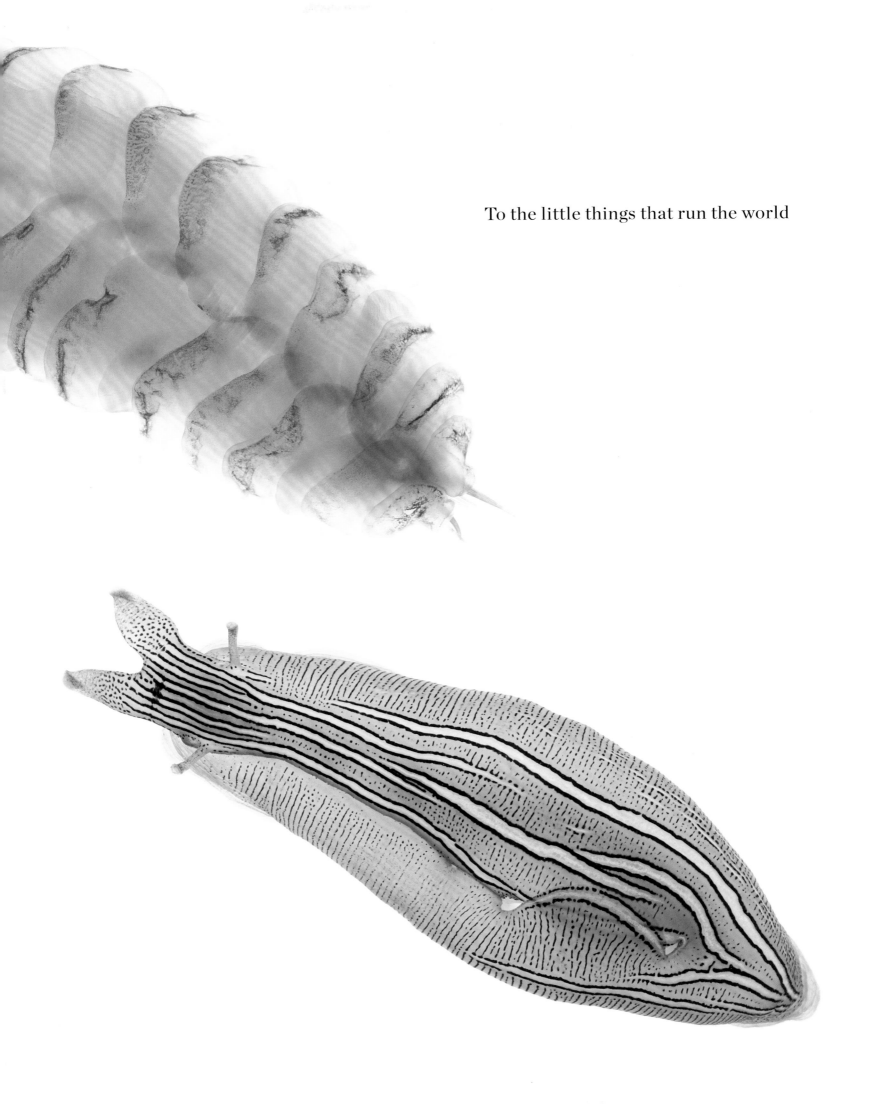

To the little things that run the world

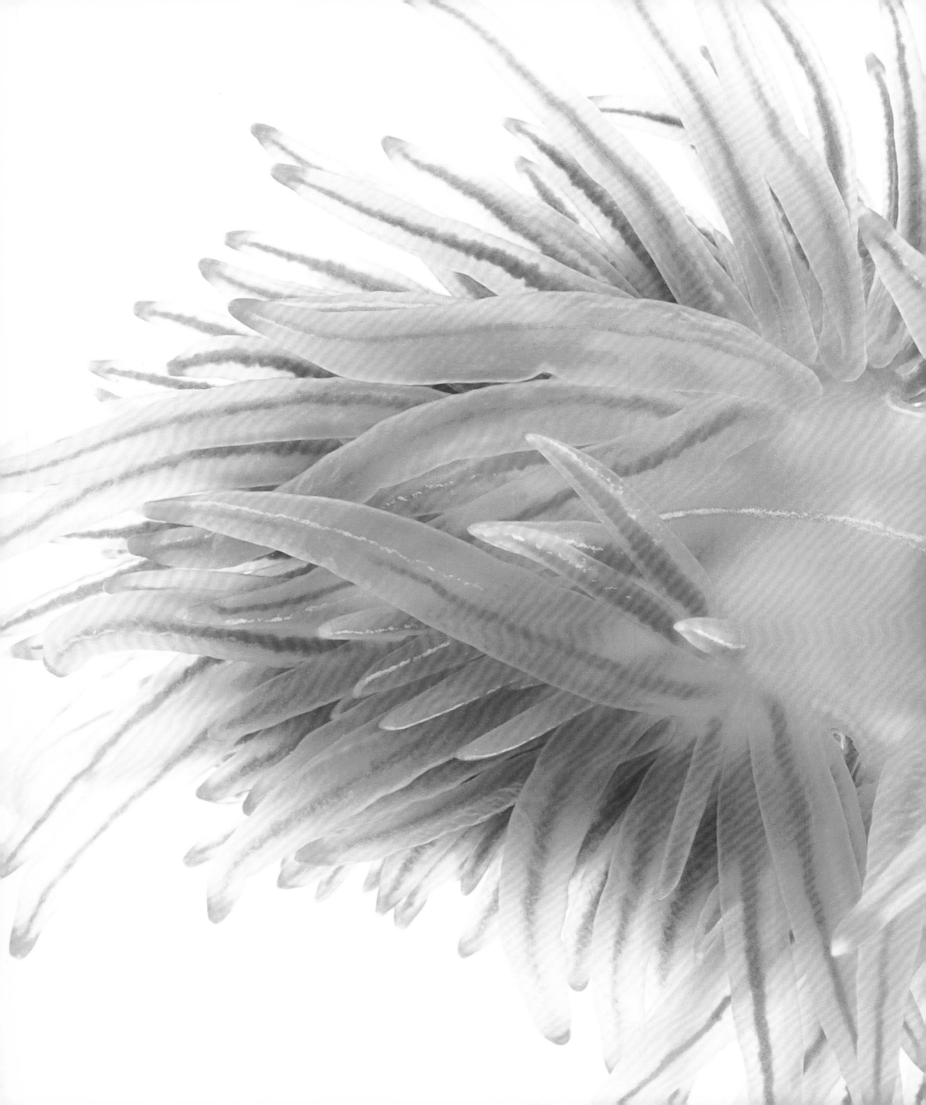

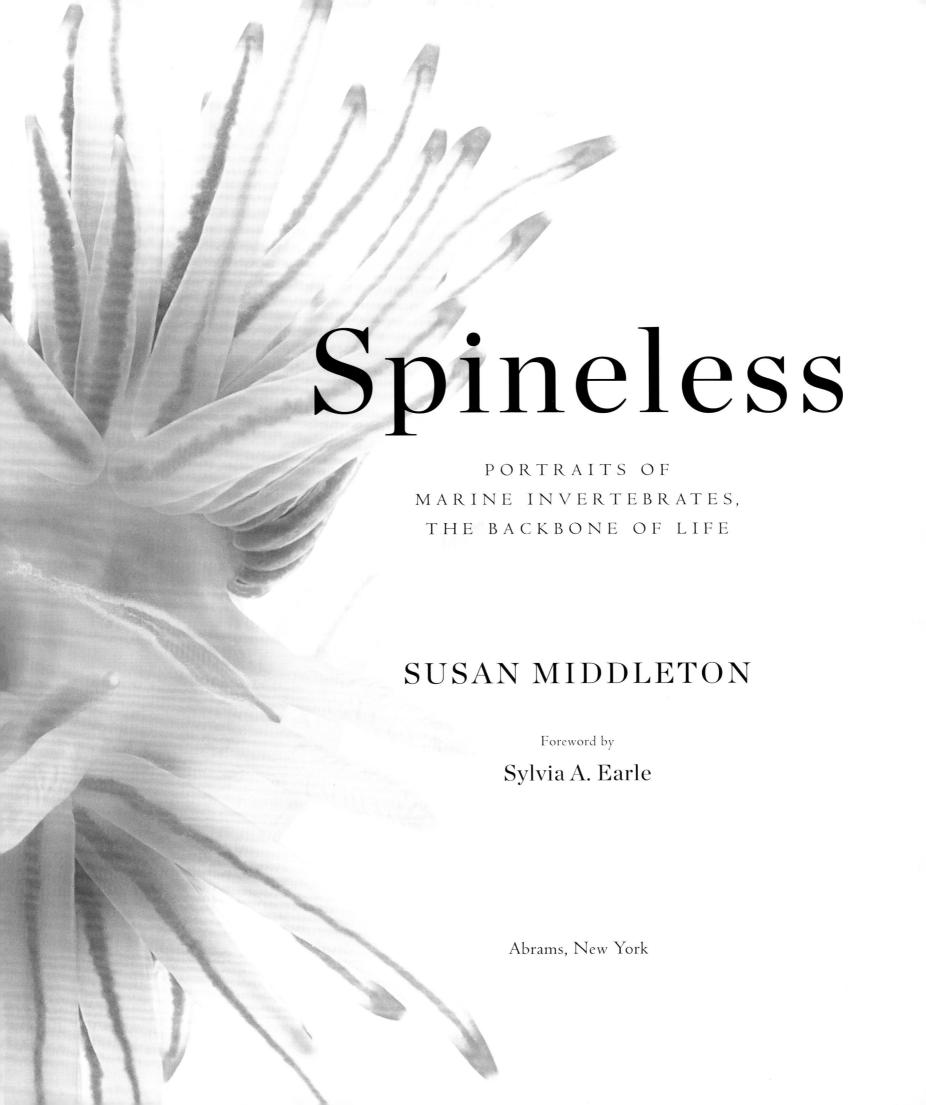

Spineless

PORTRAITS OF
MARINE INVERTEBRATES,
THE BACKBONE OF LIFE

SUSAN MIDDLETON

Foreword by

Sylvia A. Earle

Abrams, New York

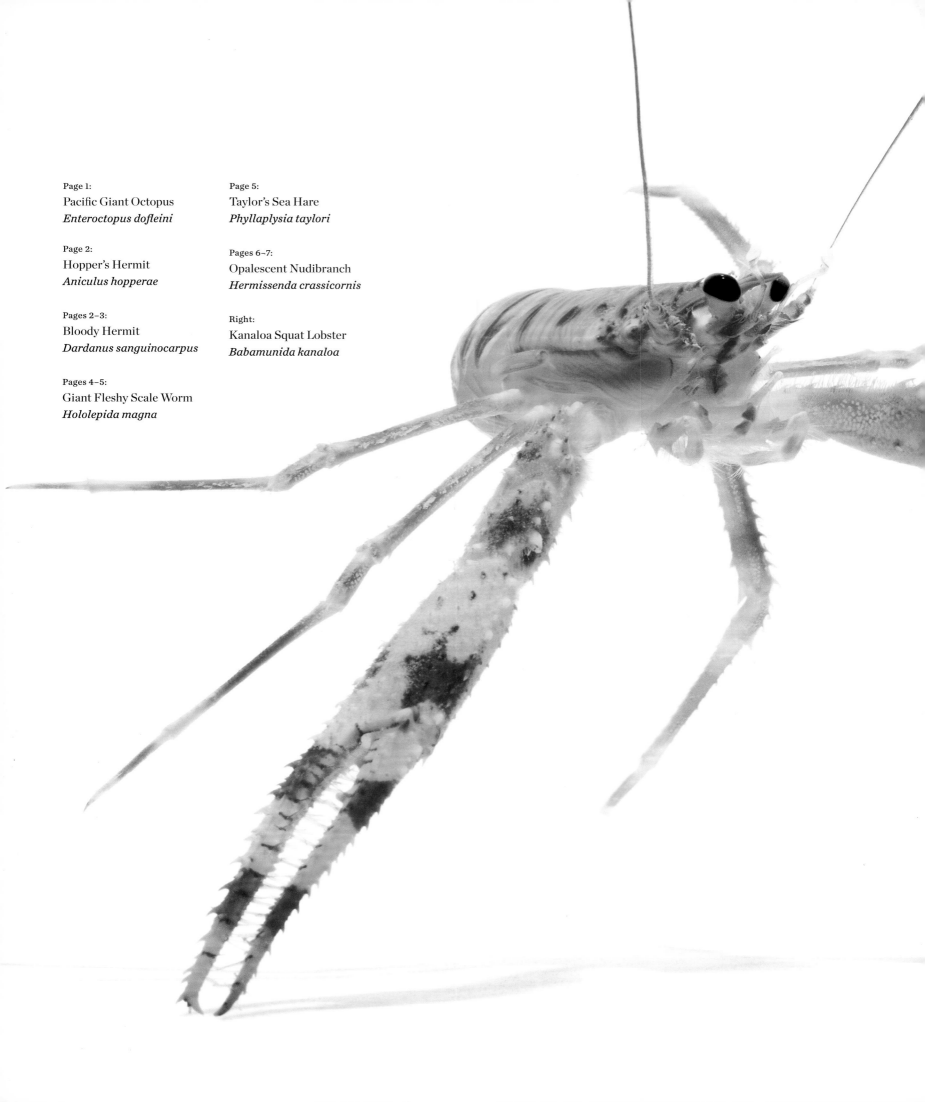

Contents

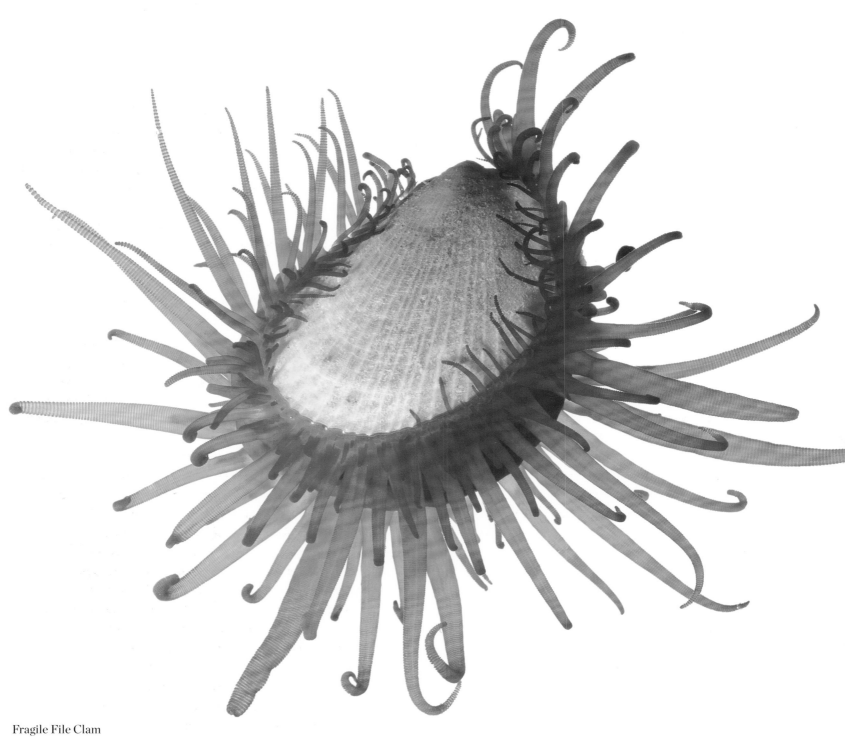

Fragile File Clam
Limaria aff. *fragilis*

Foreword by Sylvia A. Earle

Halfway across the Pacific Ocean, on Midway Island, I sat with Susan Middleton, admiring a very special bird named "Wisdom." Wisdom, a Laysan albatross, got her name from scientists who have been keeping an eye on her for many decades. Banded in the 1950s and reckoned to be sixty-one years old at the time of our meeting in January 2012, she was learning to fly at about the same time that I, as a fledgling marine biologist, was learning to dive.

Since then, Wisdom and I have witnessed a seismic shift in the nature of the ocean—a greater change, perhaps, than in all of human history. Once thought to be too big to fail, the ocean is now clearly being harmed, both by what people have been putting into it and by what we have been taking out, especially since the mid-twentieth century. Trouble for the ocean means trouble for all of life on Earth, birds and humans very much included. And the pace of this trouble is picking up. The human population has more than doubled since the 1950s, and while people are living longer and generally better than ever before, this apparent prosperity has come at a cost. On the land, natural systems and the diverse forms of life they contain have declined precipitously. In the sea, about half of the coral reefs, kelp forests, and sea-grass meadows have disappeared along with 90 percent of many kinds of fish, squid, and other ocean wildlife.

Susan Middleton—creative artist, scientist, author, explorer—has used her considerable talents to make her fellow humans aware of what is being lost, and most importantly, perhaps, why it matters. She has authored and coauthored an impressive number of books and has been behind and in front of many cameras, making portraits and producing films that focus on rare and endangered wildlife. Her distinctive photographic style, portraying animals and plants against a neutral dark or light background, has won well-deserved praise. Its starkly personal intimacy invites viewers to imagine sharing a nest with a wild bird or, as in this volume, to stare into the faces of dime-size hermit crabs, contemplate the elaborate patterns present within translucent pea-size jellyfish, and get nose-to-nose with minute sea slugs that seem to belong on a Cirque du Soleil stage.

Like Middleton, I have spent thousands of hours gazing through various lenses at minute sea creatures and thousands more exploring their aquatic homes. I have imagined strolling through miniature forests of pink, green, and golden-brown seaweeds, greeting animals and wondering at their exquisitely intricate construction: some translucent and yet reflecting rainbows of color; some simple in form but moving with a dancer's grace; and some as resplendent as if dressed in full Mardi Gras attire. And I have longed to share this view with people who know nothing of the existence or importance of the legions of small animals that together shape the nature of the world, making it hospitable for large creatures like us.

This volume invites you to take such a journey, a vicarious expedition into the Lilliputian realm of the small and little-known animals that dominate the world. You will encounter a cross section of most of the major divisions of animal life, all with a history that precedes the advent of humans by hundreds of millions of years.

There are no vertebrate animals here—no mammals, birds, reptiles, amphibians, or fish—but after all, every bilaterally symmetrical creature with a backbone is contained within just one of the thirty-four or so major divisions of animals known to exist. About half of these great categories of life, or phyla, contain creatures that dwell in forests, fields, deserts, and other terrestrial habitats, including mollusks (snails), annelids (think earthworms), nematodes (they are everywhere), and especially arthropods, which comprise about 750,000 kinds of insects and smaller numbers of spiders, scorpions, millipedes, centipedes, and other kinds of joint-legged animals.

The number of distinct species of terrestrial animals, plants, fungi, protists, bacteria, and others accounted for so far is about 1.25 million. According to a recent ten-year survey, the Census of Marine Life, only about 250,000 species of marine organisms have been discovered and named so far, but this is to be expected. The serious exploration of life in the ocean is just getting under way. Nearly every inch of Earth's lands have been mapped, and most have been crisscrossed many times by human observers. Meanwhile, only about 5 percent of the ocean below the surface waters has ever been seen at all, let alone fully explored. The Census of Marine Life predicts the number of species that now live in the sea to exceed 1 million, perhaps 10 million. Others estimate this number at 50 million or more, and that's not counting microbial organisms that would require a new definition of what constitutes a species. It is no surprise, then, that several unnamed creatures make their debut in this book, even before experts have had the opportunity to dignify them with scientifically proper epithets. Rather, it would be astonishing if Middleton had viewed as much of the ocean as she did to prepare for this book and *not* encountered previously unknown animals.

The magnitude of the number of animals in the sea, both known and as yet undiscovered, may seem to suggest that it would not matter if humans caused the decline or loss of a few fish here, a few lobsters there, maybe even some kinds of whales or squid. After all, species have come and gone as long as life has existed on Earth, right? If all the animals illustrated in this book disappeared, who would miss them? Indeed, if you didn't know they existed, how *could* you care?

To consider such questions, imagine flying through the universe on a spacecraft powered by a giant engine. The engine is composed of a mystifying network of brightly colored bits and pieces that have no obvious function. You do not understand how the engine works, but you can see that it is responsible for your safe passage through an otherwise extremely inhospitable environment. Now, imagine that the engine is the ocean. What bits and pieces would you choose to discard? The nearly invisible, tiny bits that are driving photosynthesis? The bits as big as the commas on this page that consume those photosynthesizers?

Would you eliminate the somewhat larger bits that eat the comma-size creatures and return nutrients to the engine that in turn powers the photosynthesizers that generate oxygen and capture carbon? Would you remove those organisms that consume the bits that thrive on those that dine on the smaller elements? Do you like to breathe? If so, be sure to choose wisely when tempted to cut great swaths through the giant blue engine that holds 97 percent of Earth's biosphere and governs the way the world works. Now and always, the most important thing we extract from the ocean is our existence.

Most of the creatures portrayed here live in shallow, coastal waters, but the average depth of the ocean is two and a half miles. At its maximum, the Pacific Ocean stretches seven miles deep, in the waters near the Mariana Islands. First accessed in 1960 by two men who descended in the bathyscaphe *Trieste*, that deepest place was not seen again until 2012, when ocean explorer and filmmaker James Cameron made a solo descent—and return—bringing back news of life throughout the water column, even in the cold, dark recesses of the Mariana Trench. Trails and burrows in the soft sediment on the seafloor wound between a few exotic-looking sea cucumbers and lacy brittle stars. Some scientists have obtained samples of the water that seeps into mile-deep cracks in the ocean's bottom. There, too, life occurs, in microbial forms, prospering in an eternally dark realm that while inhospitable to humans is just right for them.

All forms of life share one thing in common, regardless of where they live, from the deepest sea to the driest desert to the most populous city. That thing is water.

The astrobiologist Chris McKay, who leads the effort to find life elsewhere in the universe, searches first for the presence of water. He notes: "Earth organisms figure out how to make do without almost anything else. The single non-negotiable thing life requires is water."

The poet W. H. Auden puts this reality in human terms: "Many have lived without love; none without water."

The anthropologist-philosopher Loren Eiseley observed: "If there is magic on this planet, it is contained in water."

Magic or not, the novelist D. H. Lawrence suggests: "Water is H_2O, hydrogen two parts, oxygen one, but there is a third thing that makes it water and nobody knows what that is."

Whatever it is, 97 percent of Earth's water is ocean, but unlike the water that has been discovered elsewhere in the universe, here water is literally alive. A single bucketful of apparently clear ocean water taken from any of the areas represented in this book will contain many millions of microbes and may hold as many phyla of animals as there are in all terrestrial systems combined—most of them the microscopic, young stages of larger animals but many full-grown planktonic species as well.

The abundance and diversity of life in the sea seems miraculous enough, but this volume touches on another dimension of diversity: no two animals, of whatever species, are exactly alike. Each has its own distinctive potential for success, each is subject to its own environment, and each develops its own special behavior, within the constraints of its genetic endowment. It seems obvious, when it comes to humans and to animals familiar to us—cats, dogs, horses, cows—that no two are now or ever have been or ever will be exactly alike. Similarly, no two graceful kelp crabs or widehand hermit crabs or red-eye medusae are exactly alike. Every image in these pages is a portrait of a singular being;

together they form a gallery not of spineless animals but of one-of-a-kind individuals, gathered here as ambassadors from their ocean realm to our terrestrial one. Part of the joy of these images is that they offer us a glimpse of some of our rarely seen fellow passengers aboard this water-blessed planet as together we careen through time and space.

Sitting near Wisdom the albatross, Susan Middleton and I talked about what the ocean might be like in both the near and distant futures. We wondered whether the single egg being warmed by Wisdom and her lifelong mate would hatch and, if so, whether he or she would live to bear witness to the world over the next sixty-one years. Never before has a bird or any other earthling faced more uncertain times. After all, the planet is warming, the sea level is rising, the climate is changing, the ocean is acidifying, and individual species and entire ecosystems are disappearing at a faster rate than at any time since the catastrophic events that eliminated the dinosaurs and many other kinds of life 65 million years ago. Albatross and certain other long-lived, intelligent animals may realize that the world is not the same as when they were youngsters, but only humans can know why the changes are happening and only humans have the power to do something to reverse the trends that threaten the underpinnings of all we care about.

The key is *knowing*. As never before, we have the capacity to see ourselves in the context of the natural world that sustains us. As never again, we have the opportunity to protect the ocean systems that will give creatures such as those illustrated in this book a chance at a long and prosperous future and, in so doing, to improve our own chances for an enduring future as well.

And what about Wisdom's egg? Months after our visit, Susan sent me a message that included a photograph of a disheveled-looking hatchling standing next to a serenely watchful parent. Fittingly, the U.S. Fish & Wildlife Service personnel who watch over Midway Island named the youngster "Hope."

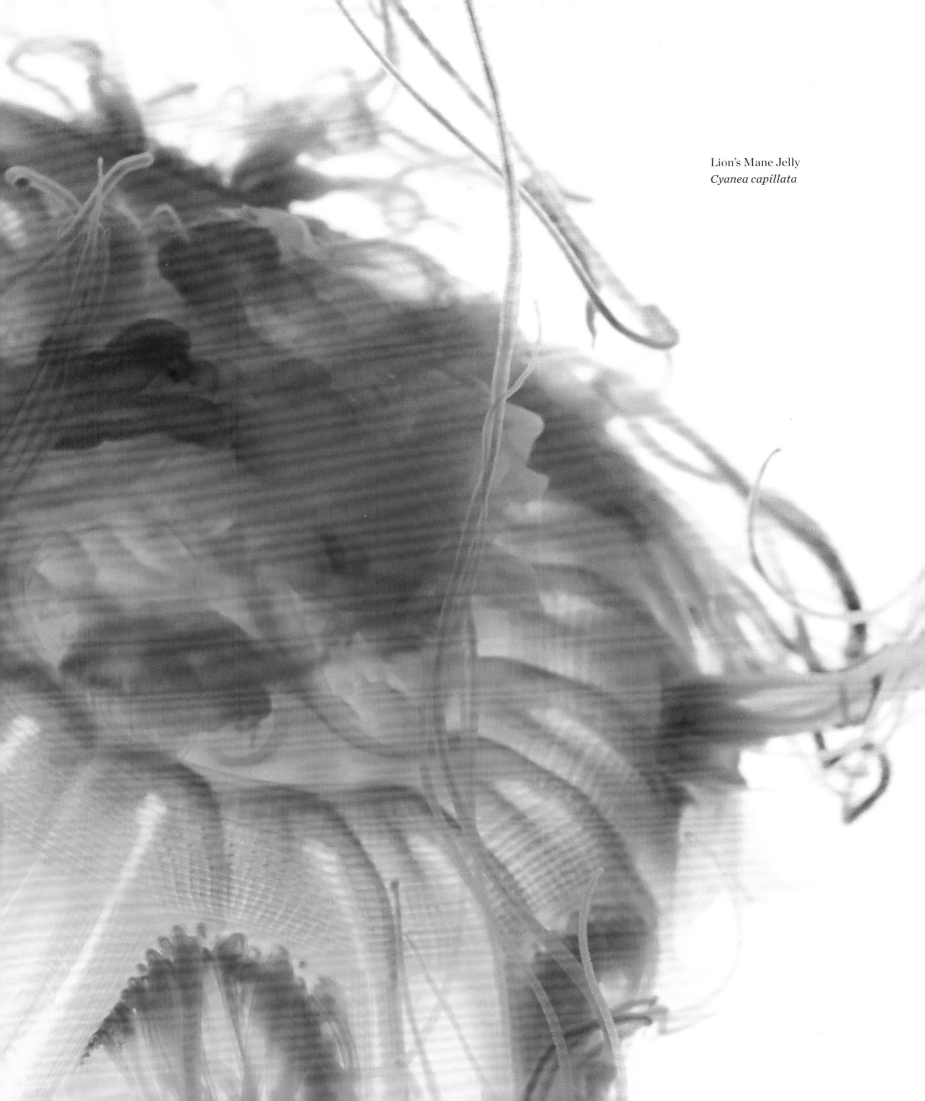

Lion's Mane Jelly
Cyanea capillata

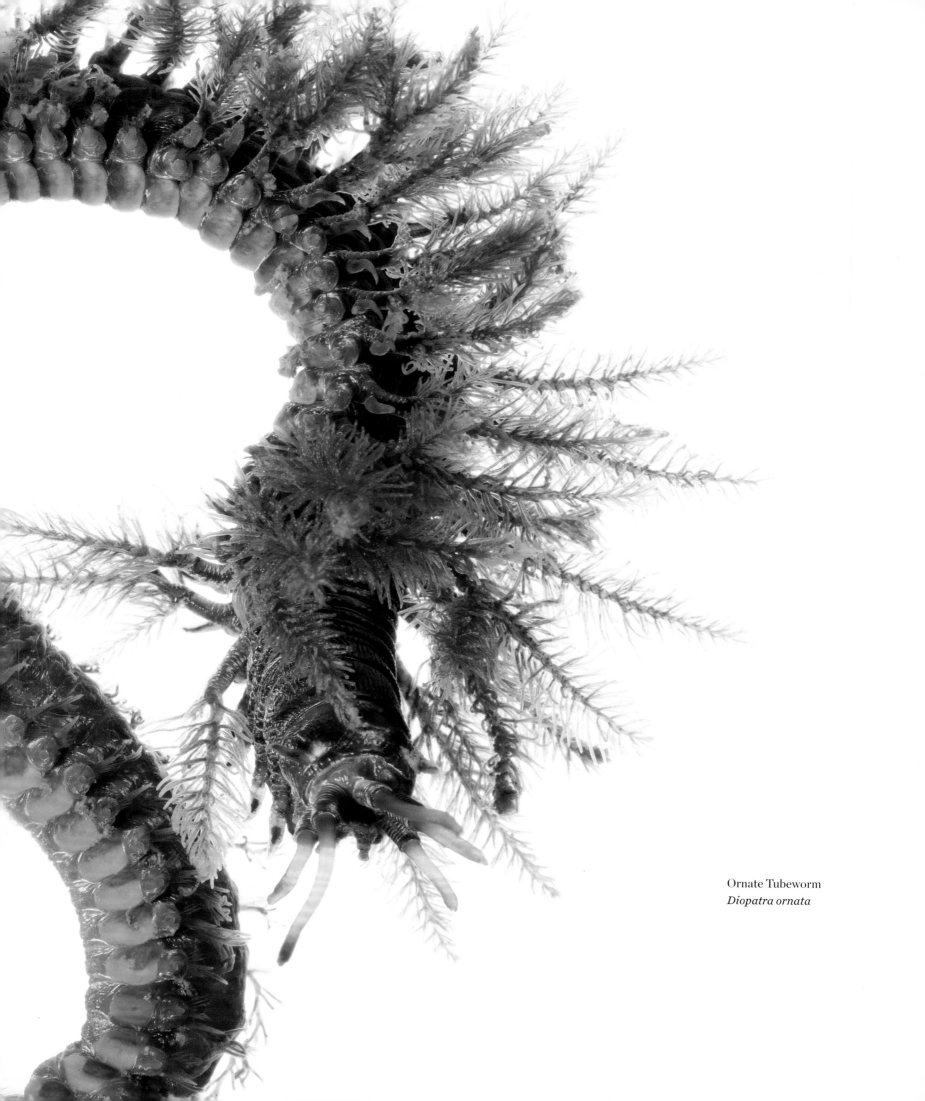

Ornate Tubeworm
Diopatra ornata

Introduction

Beneath the ocean waves, hidden from our view, a spectacular profusion of life flourishes. The vast majority of marine creatures are invertebrates, animals without spines, and they embody some of nature's most exquisite creations. They are nature's fashion show, the haute couture of marine life.

In their sheer number and diversity, invertebrates eclipse all other forms of life on Earth: They comprise more than 98 percent of all animal life, and that proportion is only increasing as more species are described. Their interactions form the biological foundation of all ecosystems. Because life evolved in the oceans, marine invertebrates form the bedrock of all life on Earth. They are, as Dr. Edward O. Wilson puts it, "the little things that run the world."

The first time an invertebrate caught my attention was more than twenty-five years ago when I was photographing a vernal pool tadpole shrimp, an endangered species. I was collaborating with photographer David Liittschwager on a project to photograph one hundred endangered species, including all the wildlife groups represented on the North American endangered species list. The tadpole shrimp was the first invertebrate on our list, following several vertebrates and plants: the controversial northern spotted owl, the charismatic black-footed ferret, the lovely Aleutian Canada goose, the imposing Florida panther, and the extremely rare Presidio manzanita. To photograph the tadpole shrimp, I was escorted by an invertebrate zoologist to a spot northeast of San Francisco. Vernal pools are ephemeral, shallow, freshwater pools that typically dry out during the summer months and are replenished by winter rains and snowmelt. They provide habitat for distinctive plants and animals and are inhospitable to fish, a fortunate circumstance for the ancient tadpole shrimp, which lived on Earth millions of years ago, before fish evolved, and consequently never developed defenses against fish predators. What they did develop was the ability to produce eggs that can withstand many years of desiccation and extreme temperature fluctuations, waiting until conditions are just right to hatch. I was intrigued to learn that this kind of lifestyle was even possible and astonished to be introduced to an animal that was virtually unchanged in 250 million years. Incredible! For me, it was an undreamed-of way of life, an unimagined living shape. Obviously the tadpole shrimp had arrived at a successful strategy in a rarefied home with an ideal body design, appearing simultaneously primitive and modern. That was the beginning of my obsession with the world of invertebrates.

Ever since, I have been fascinated by the bizarre beauty and inherent mystery of this realm of life. The photographs herein are intended to reveal the exceptional shapes, patterns, textures, and colors of these remarkable creatures. Colorful, quirky, quivery, spindly, spiky, sticky, stretchy, squishy, slithery, squirmy, prickly, bumpy, bubbly, and fluttery, the invertebrates appear almost surreal, even alien. These less conspicuous inhabitants of coral reefs and nearshore marine environments are the backbone of life in the sea, yet they receive less attention than the better-known vertebrate realm of marine mammals, fish, and other larger organisms. Consequently there are many new discoveries to be made, both scientifically and photographically. Remarkably, two of the species pictured in this book are new to science and have been formally named and described based on the individuals appearing in the photographs: the Kanaloa squat lobster (pages 8–9) and the Wanawana crab (pages 56–57). The subjects of these photographs are the first specimens ever collected of these species.

The oldest known representations of marine invertebrates date back to around 1500 BCE, when octopuses first appeared on Cretan vases, and cockles and nautiluses decorated frescoes. Aristotle, in his *Historia Animalium*, written in 350 BCE, was the first to describe the distinction between invertebrates and vertebrates. He divided animals into those with blood (the vertebrates) and those without blood (the invertebrates). In fact, this distinction was erroneous, since many invertebrates possess red blood, but it went uncorrected for more than two thousand years. Finally, Jean-Baptiste Lamarck and Georges Cuvier made the correct distinction in the early nineteenth century, focusing instead on the fundamental plan of organization of the animal body.

The animal kingdom is divided into two major groupings: animals with backbones (the vertebrates) and animals without (the invertebrates). Animals in the first group are united by extensive similarities in the arrangement of their organs, bones, and other features. Animals in the second group exhibit a startling variety of design and construction and a seemingly endless array of life designs. The vertebrates hold an exaggerated importance in our minds because they are closely related to us and are relatively large and conspicuous, but life began with invertebrates and remains dominated by them. We evolved from invertebrates and share wide-ranging similarities with them, such as bilateral symmetry, central nervous systems (through which we enjoy a direct relationship with the world), and a myriad of life activities. As Dr. Gustav Paulay, world-renowned marine invertebrate zoologist and my mentor and muse, says, "Humans are invertebrates with spines!"

Life as we know it is broadly divided into three kingdoms: animal, plant, and fungi. The animal kingdom is subdivided into phyla; phyla are subdivided into classes; classes into orders; orders into families; families into genera; and genera into species. Each level in this organizational scheme further differentiates organ-

isms from one another. Phylogenies trace the evolutionary development and diversification of life and are often depicted as trees. Collectively these are often referred to as the Tree of Life. On such a tree, organisms evolve and diverge over time, from the base of the trunk to the tips of the branches: At the base is the group's common ancestor, and at the tips are all its living members. Along some of the tree's branches, we find that very little obvious morphological change has occurred; at these tips, we find so-called living fossils such as the leaf-foot shrimp (page 171). Along other branches, we find that drastic changes have taken place, leading to animals that today look very different from their ancestors. At any point on the tree, animals may evolve from apparently simple organisms to complex ones, and vice versa. In fact, it's a common misconception that evolution is a one-way street from the less to the more complex.

Scientists generally agree that the animal kingdom can be classified into thirty-four groups called phyla. These distinctions are based on body plans. All animals in a particular phylum have the same or similar body plan. Phyla assist in our understanding of life: They are tools we use to recognize patterns that differentiate the animal kingdom, and they change as new discoveries come to light, especially through molecular analysis and gene sequencing. The definition of a phylum is somewhat arbitrary; it depends on the definition of what constitutes a similar body plan. Generally, members of a phylum share consistent traits that create a continuum within the group, and there is a large enough morphological gap between one phylum and another to justify the distinction.

It is remarkable that of these thirty-four phyla, or taxonomic categories, only one, the phylum Chordata, contains all the vertebrates, including us. Almost half of the thirty-three invertebrate phyla are entirely marine, and members of the other phyla are found primarily in marine habitats. We are vastly outnumbered by the invertebrates. We depend on them for the air we breathe, the water we drink, and the soil we need to grow our food. This

realm of life, portrayed in these photographs, contains creatures fantastically endowed with elaborate regalia devised to allure and deceive, protect from predators, attract mates and meals, and express survival strategies that are utterly delightful to the eye and mind. I set out to reveal these spectacular animals that live mostly hidden from our view and are virtually unknown to most people with the hope of encouraging appreciation for the exquisite design and elegance expressed in the natural world.

It is typically more difficult for humans to experience a sense of connection with invertebrates than with vertebrates, but it's the invertebrates' very strangeness that I find so mesmerizing. My greatest concern and fascination lies with the relationship between the human world and the natural world. There is a tendency in our technology-driven era to perceive ourselves as independent of nature and to presume that we can create our own reality, superceding nature, shutting it out, pushing it off to the side. We get carried away with ourselves, using expressions such as "spineless as a jellyfish" to imply weakness and a lack of courage. Invertebrates are not weak! They are tough characters perfectly adapted to their lives on Earth. They embody other realities worthy of our attention and consideration. Try to imagine what a mantis shrimp, whose visual acuity so far exceeds our own, can see. What do nudibranchs experience when they extend their rhinophores, that pair of finely grooved appendages protruding from their heads? We know that rhinophores are "sniffers" and "tasters"; they are chemosensory organs that detect chemicals dissolved in seawater, and in a species of sea hare, the rhinophores can detect pheromones. What, I wonder, is that like? Is it like smelling freshly baked cinnamon rolls? Or a seductive perfume? Or a putrid rotting fish? I never cease to wonder how animals perceive the world, and this curiosity is always with me when I am photographing them.

It is through closely observing animals that I have come to recognize that reality is composed of the perceptions of all creatures. This recognition has opened me to a larger world and to a profound assemblage of energies beyond the human. Of course I cannot know what it is to be an octopus, but after many hours photographing one, I can begin to imagine what it's like. Gazing, for instance, at the Pacific giant octopus pictured on the front of this book, with whom I spent three days, I found myself thinking, "It's a big world out there for you, too, isn't it?" I tried to envision that world from the octopus's perspective. I wondered how I was known by it, since it was clear that I was being perceived, actually looked at. Truthfully, I felt the octopus was engaged with me; I'd go so far as to say we developed a kind of rapport. Some animals really are curious about us. Admittedly this juvenile Pacific giant octopus did not sign up to have its portrait taken by me; it was collected and then cared for during its time in the lab by Elaina Jorgensen, a cephalopod expert. But while I was photographing it in my little octopus tank, it displayed the most astonishing repertoire of gestures and expressions I have ever witnessed from one animal. Just when I thought I'd seen it all, and had made excellent pictures, the octopus would assume a new color pattern in a new position and suddenly morph into another identity. For such a small creature, it had a big attitude, as though it already knew it was a member of the largest octopus species in the world— a force to be reckoned with. It was a joy to photograph an animal that displayed such enchanting gestures, colors, and postures, such extravagant eye makeup, and such various moods; animated, in repose, stubborn, independent, and oddly generous. Truly, it is the most beautiful animal I have ever had the privilege to work with. Elaina offered to let me set the octopus free, and I felt honored by the opportunity. After three days together, I released the octopus off the dock at Friday Harbor Marine Laboratories on San Juan Island in Washington State, so it could return to its ocean home and, with luck, become a full-grown adult.

Overall, the marine environment has afforded its inhabitants a less stressful existence than the terrestrial one has—that is, until recently. If the animals in this book could speak, they would tell us that there is trouble down below. Rising acidity levels worldwide have set the oceans on a dangerous and deadly course. Global climate change is not only warming the oceans but also causing their waters to acidify. Nearly 25 percent of all carbon dioxide emissions are absorbed directly into the oceans, causing the phenomenon known as ocean acidification. As the ocean becomes increasingly acidic, there are harmful consequences for marine life, especially organisms that depend on calcium to live, which are most of the marine invertebrates. We've only begun to study the implications of acidification for marine life, but we already know that it can have (and already has had, in some cases) serious consequences for organisms that have calcareous shells—most notably, mollusks and corals. Acidification makes it both more difficult for these organisms to lay down their shells and more likely that the shells will dissolve after they've been laid down. The negative effects of our reliance on fossil fuels—global warming and ocean acidification—are being felt first by the animals pictured in this book. If they could speak, they would cry out for help.

I am reminded of the words of the great Gerald Durrell, from his book *Encounters with Animals*: "Man, for all his genius, cannot create a species, nor can he recreate one he has destroyed. There would be a dreadful outcry if anyone suggested obliterating, say, the Tower of London, and quite rightly so; yet a unique and wonderful species of animal which has taken hundreds of thousands of years to develop to the stage we see today, can be snuffed out like a candle without more than a handful of people raising a finger or a voice in protest."

We will need countless handfuls of people to raise their voices in protest if we are to meet the challenge. To secure our own survival, we need thriving marine invertebrates in healthy oceans, but now we are threatening their survival, and thus our own. They need us to save them—from us.

I hope these photographs serve to bring people closer to these precious lives and to provide a unique opportunity to relate to these creatures in a personal way. I realize it's a lot to ask, especially when it comes to an animal like the broadbase tunicate, which looks more like a vegetable. Nevertheless, gazing at these creatures, I find there is much to enjoy. Each person will respond to these images differently: Some will be amused, others startled; some will be stunned by the exquisite design and beauty; some may find them sensual or feel their imaginations stretched; some will be curious about the animals and will, hopefully, be moved to help protect these creatures and their ocean home; some will recognize that we depend on the ocean as much as the subjects of these photographs do, that we are all connected, and that life on planet Earth is one enormous web. If seeing is believing, I hope these photographs are evidence that these creatures are worthy of both contemplation and of serious consideration.

My photographs are not about conveying information; they are not intended to serve as scientific evidence (though sometimes they do). They are meant to be felt. They are about seeing and imagination. I am striving to capture the dignity and mystery of these animals, and I hope my photographs transmit that. I can say that devoting considerable time over the last seven years to seeking out, watching, and photographing these beautiful spineless oddities has produced not only thousands of images but also a change within me. I have a deeper awareness of my connection to all of life and a strange feeling of companionship, even kinship, with these animals.

I wrote the following entry in my journal on my last day at Friday Harbor Marine Laboratories, a week after I completed the final fieldwork for this book:

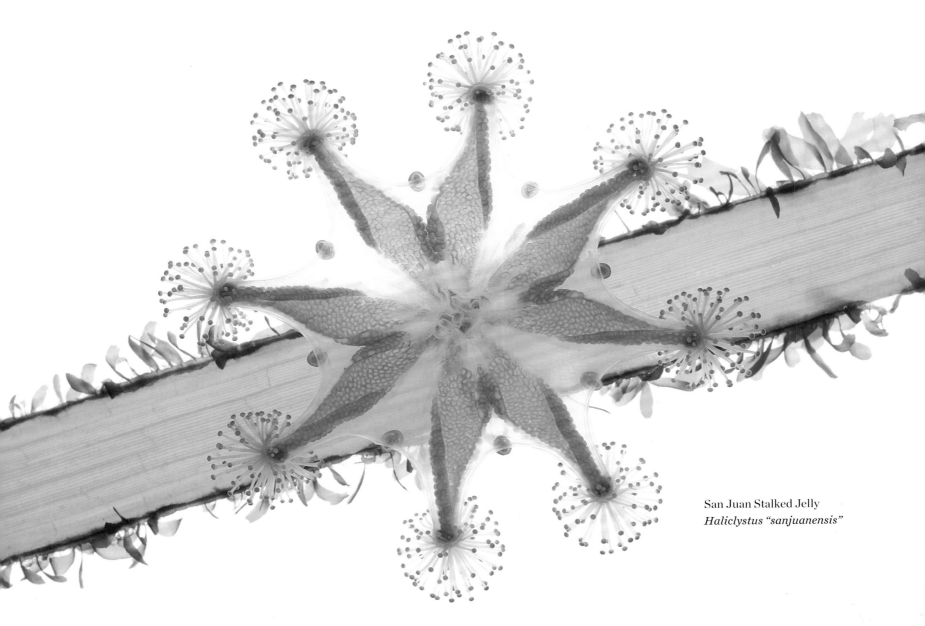

San Juan Stalked Jelly
Haliclystus "sanjuanensis"

"I miss the animals—it's been over a week since I packed up my equipment, and the sea tables were emptied, and animals returned to their habitats or relocated to other labs for study or as pets. I miss watching them, the sound of the water, the calmness, the chance to eavesdrop on their world. They inspire me, amaze me, surprise me—I can almost lose myself and experience the distinction between us dissolving. Immersed and enraptured. My task is to select my next subject for portrait making, prepare the tank, test the equipment, and then introduce my subject to the filtered water, observe how it responds, and begin the photography. Learn how to light it, what angle of view is best. What is the repertoire of behavior? Endless with an octopus, limited with a chiton. The two ends of the spectrum! Always revelations, never predictable—sensing that I am often witnessing something never seen before, at least by a human. A scientist might look at it differently, seeking characteristics that offer clues about where it fits into the taxonomic and phylogenetic puzzle. Looking for particular features, for information. I'm looking for visual character, gesture, line, form, texture, color, opaqueness, translucency, transparency, iridescence, striking behaviors, shape shifting, sheer beauty: how each animal expresses itself visually. The animals are my source of inspiration and strength to carry this through. So, on this last day, I want to breathe in their energy and fix it in my psyche. I can do this, but I can't speak of it. It is sacred."

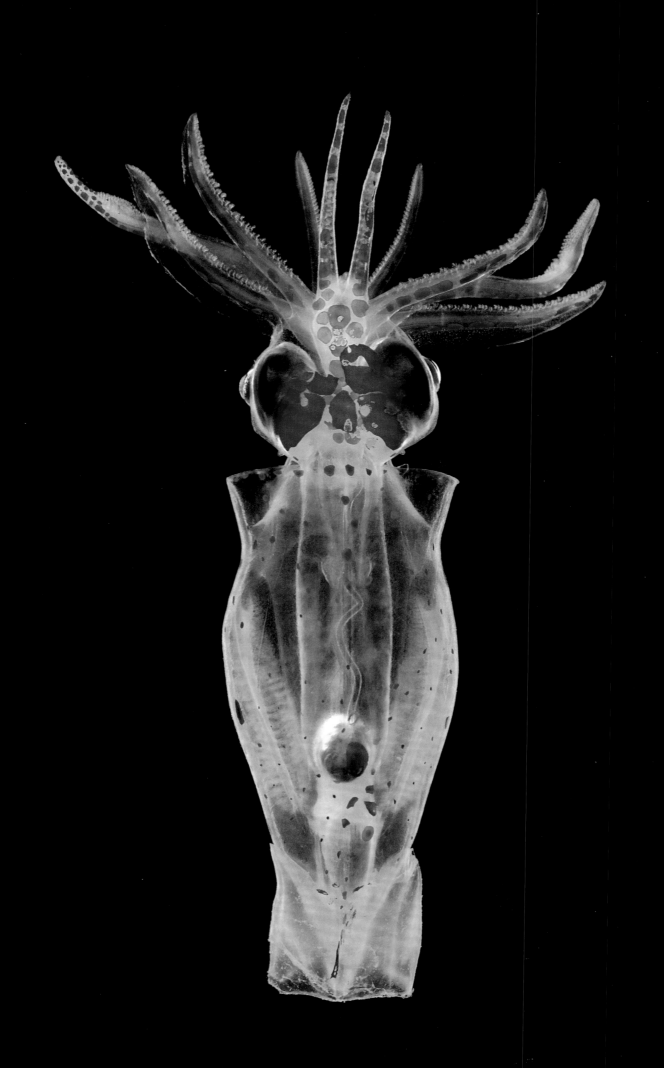

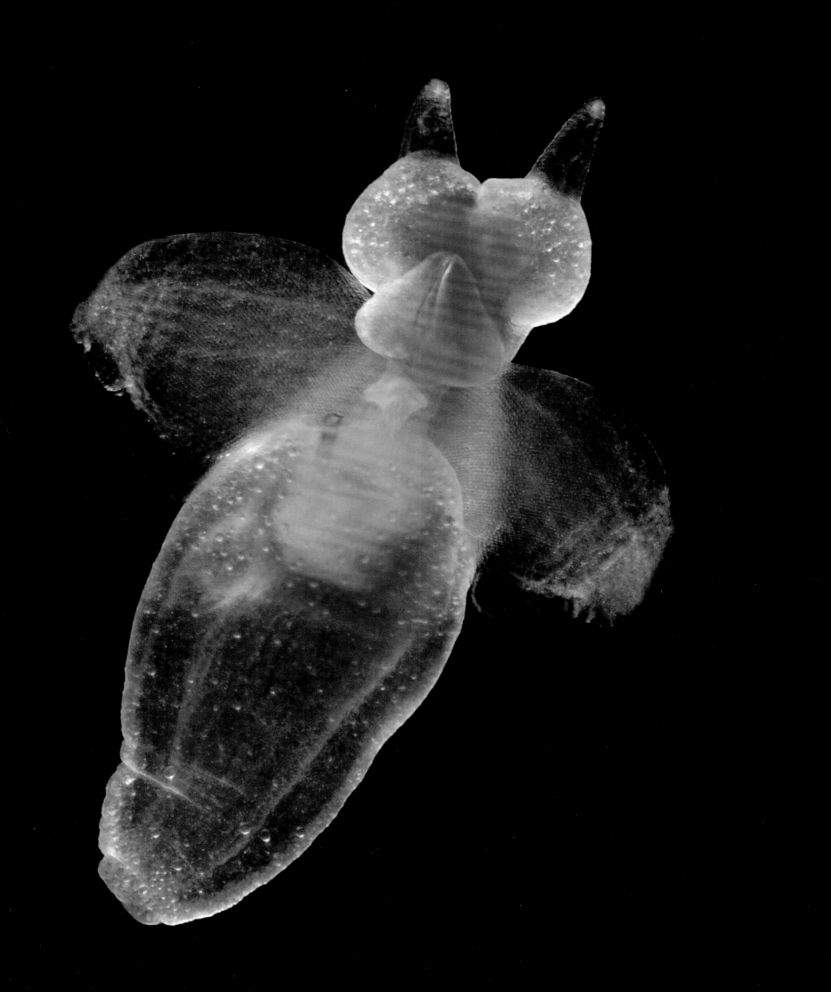

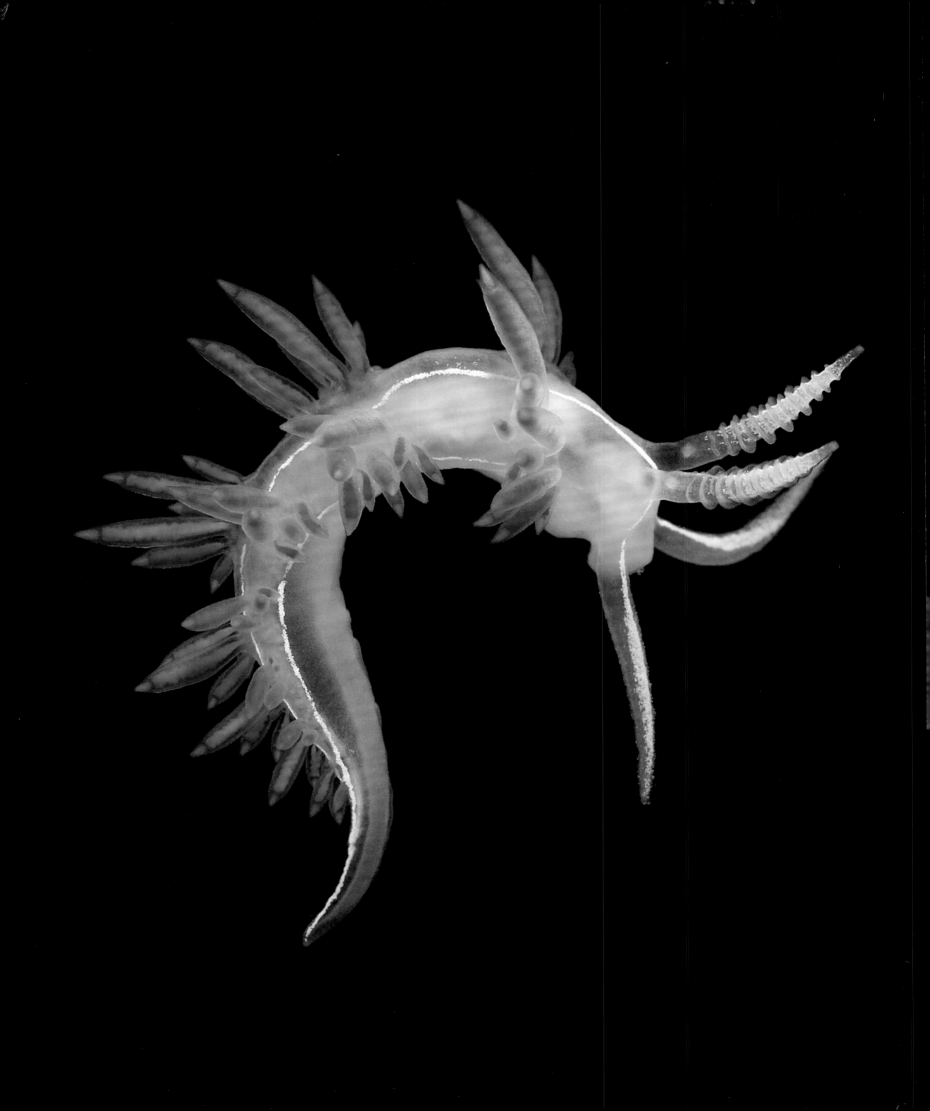

Previous page left:
Black-Eyed Squid
Gonatus onyx

Previous page right:
Sea Angel
Clione limacina

Opposite:
Three-Lined Nudibranch
Flabellina trilineata

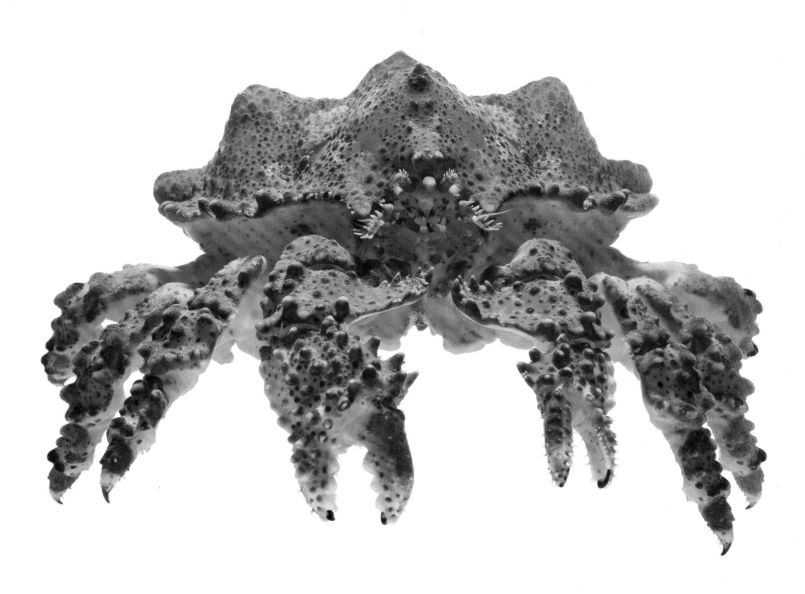

Above and overleaf:
Puget Sound King Crab
Lopholithodes mandtii

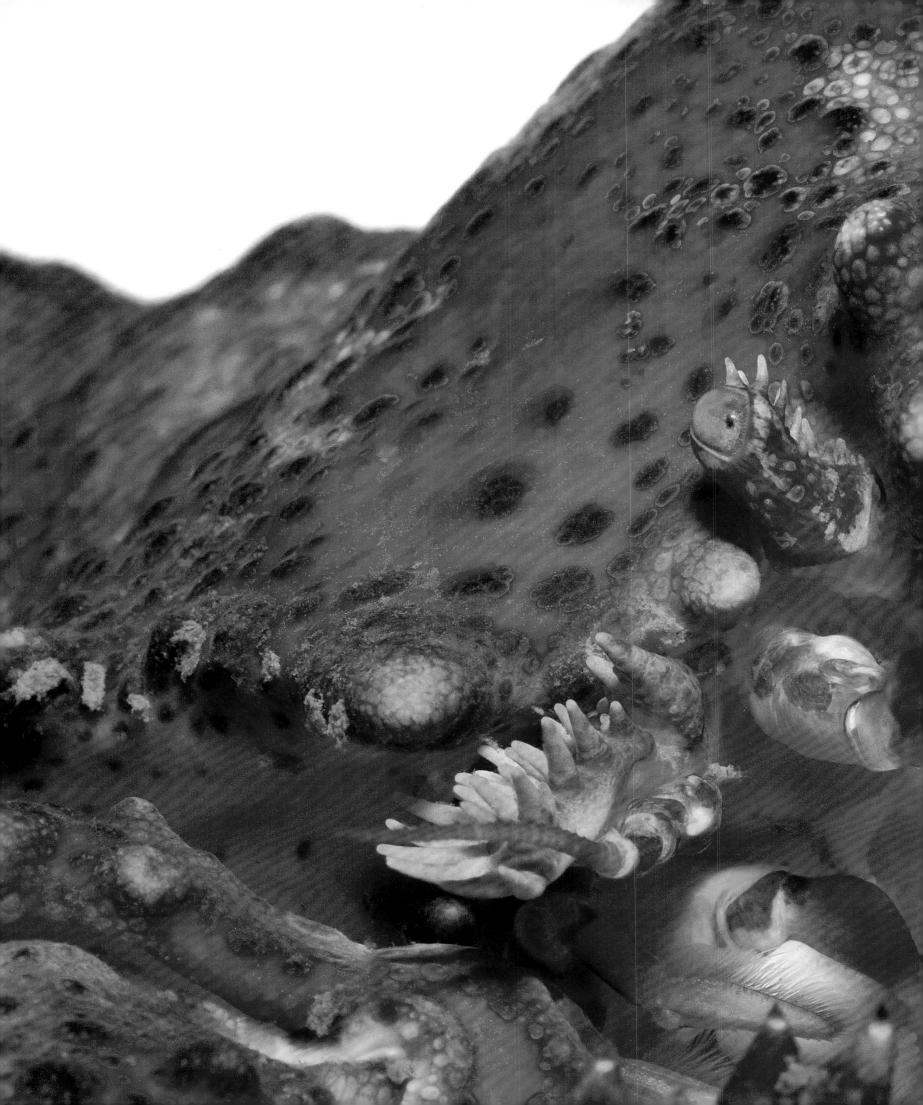

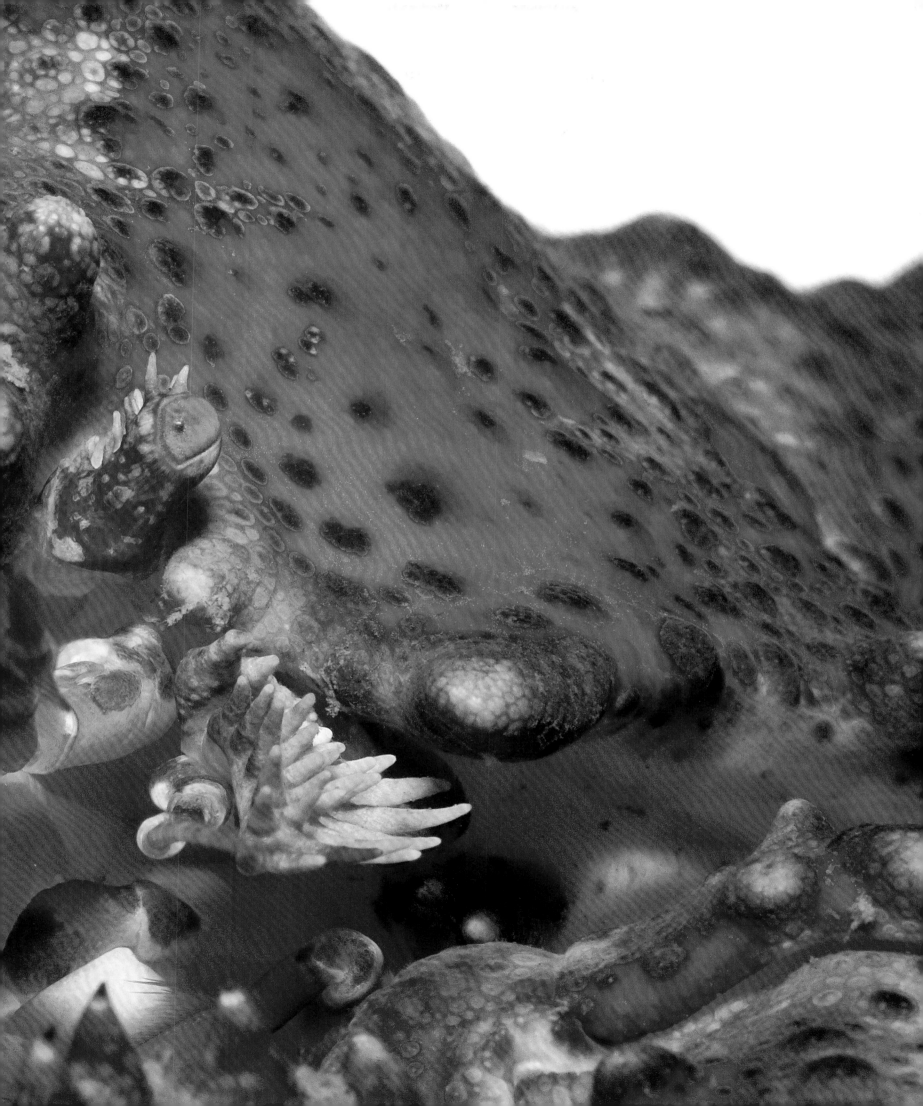

The Tree of Life

Ancestral Relationships

"We are all cousins back in the darkness of time."

—Craig Staude

What are the origins of animal life? What was the first animal? And how did we humans evolve from this complex tapestry? Planet Earth is more than 4.5 billion years old. About 3 billion years ago the first life emerged, in the ocean, most likely as cyanobacteria, or blue-green algae, performing photosynthesis and producing oxygen. Deep-sea hydrothermal vents may have provided the necessary conditions for these complex organic molecules to transition into living cells. Around 2.5 billion years ago, single-celled beings called protists, which lacked cellular organization or differentiation, came on the scene. Many of us will recall being introduced to primitive protists like amoebas and paramecium in our high school biology class. Despite their simple design, these protozoa performed all the functions necessary for life. Multicellular organisms appear to have taken a very long time to evolve from their single-celled ancestral forms; the oldest known fossils of more complex animals, called metazoans, are about 600 million years old.

Somehow, cells developed a language that allowed them to work together for the good of the animal, all in the absence of internal organs, a head, muscles, limbs, a brain, a nervous system, a heart, or blood. What kind of alien was this? The ancient sponge, an animal that links us to deep time. If we humans could trace our origins back far enough, we might come face-to-face with a sponge! Sponges transformed the nature of life. They became the basic blueprint for all multicellular life, for living large—all animals are derived from that blueprint. There are many advantages to multicellularity, as we ourselves can attest, and as the animals pictured in this book illustrate. Although primitive and seemingly lifeless, sponges are far more than blobs in the sea. Firmly attached to the bottom, they do not swim or crawl. Composed of a loose assemblage of cells without a definitive shape, sponges are capable of elaborate behavior, including filtering enormous amounts of water while feeding on the tiniest marine organisms. They were the first animals to reproduce sexually and to develop cell-to-cell communication. The division of labor at the cellular level is accomplished via the specialization of cells for different functions. Because it lacks a nervous system, a sponge does not respond to stimuli as a unified whole; rather, every sponge cell reacts individually and uniquely to stimuli. Sponges have the remarkable ability to regenerate themselves: Certain cells in a sponge, can, if separated from the body, build a new sponge. Sponges can live for hundreds of years. Collagen, a protein that provides the sponge body with its structural support, is ubiquitous throughout the animal kingdom. Over the centuries, sponges have been variously described as animals, plants, animal/plant, and even as a nonliving substance. Sponges were not accepted as animals until about 150 years ago.

Knowledge about life, and about animals in particular, has been, throughout most of history, disorganized and anecdotal. Only a few hundred years ago, the study of animals was crudely descriptive: an assemblage of many facts with no coherent organization. Eventually, biological science arrived at a method of classification, grouping animals according to their fundamental structural similarities. Taxonomy is the branch of science devoted to organizing and classifying the diversity of life. While Aristotle was the first to codify organisms according to their internal and external similarities, it wasn't until the eighteenth century that Carolus Linnaeus developed a standard method for naming organisms (including genus and species) in the belief that species were "perfect and unchangeable creations."

The most familiar classification scheme in use today is the taxonomic framework Linnaeus established in 1758. The animal kingdom is first divided into large groups, called phyla, which are based on radically different plans of organization; members of a phylum share a common basic structure. One hundred years later, Darwin challenged the Linnaean assumption that animals are immutable and posited instead that all animals have descended from some primordial form through a process he called natural selection; that is, descent with favorable modifications preserved over time. Since then, observations about the relationships between species, and specifically about ancestry, have provided mounting evidence in support of Darwin's evolutionary theory. After the theory of evolution took hold, classifications became genealogies, in which ancestral relationships were depicted in a so-called phylogenetic tree, or tree of life, revealing the order of evolution and relationships between the phyla. The tree of life is a human construct to help us understand patterns in the evolutionary process. It is not a fixed entity or dead structure upon which we plot the diversity of life; it is a growing, evolving concept that changes in light of new evidence. Our powers of perception are limited only by our tools to perceive, including at the genetic and molecular level, so undoubtedly our understanding of the complex relationships among the creatures on the tree will grow and evolve, and with that, the tree of life will change to reflect new revelations.

All classification schemes are imperfect mirrors: They are in part our artificial attempts to impose order. A variety of phylogenetic trees have been proposed over the years. In the earliest schematics of evolution, animals were usually pictured ascending in increasing complexity, straight up a vertical ladder, from amoeba to human. Now we know that animals do not evolve in a series of consecutive steps and that their relationships to one another are more correctly represented by a branching tree.

The animal kingdom comprises about thirty-four phyla, or major distinct groups, each based on a common underlying design or body plan that distinguishes it from all other phyla. It's worth noting that invertebrates constitute thirty-three of these phyla and are even represented in the thirty-fourth, Chordata, along with the vertebrates. All members of a particular phylum are presumed to have evolved from a common ancestor. Based on the fossil record, most animal phyla have been represented on Earth for at least 500 million years. Since that time, no new body plan worthy of its own phylum has emerged; this, in spite of five major extinction events, including the most devastating, 250 million years ago, when 95 percent of existing species diversity on the planet was lost. Many new species evolved after that catastrophe, but all conformed to preexisting body plans. Clues to the origins of various phyla involve events that happened long ago and their exact history may never be known, but the clues are numerous and diverse and, though fragmented, they can be used to create a phylogenetic tree that reflects how the thirty-four phyla are related to one another and across time. All evidence pertaining to how different phyla are related goes so far back in time that direct observation and experimentation isn't possible. This evidence is primarily comparative, based on similarities and differences in structure, development, physiology, biochemistry, and genetics. Probably the best, most objective evidence comes from the fossil record and from genetic analysis.

Genes tell us a great deal about evolution. Deoxyribonucleic acid (DNA) is extracted from the nucleus of a cell, and the living code is then reduced to data that scientists can analyze. Gene sequences are like blueprints for constructing an organism, and they can reveal how closely animals are related. The gene-sequencing process has become faster and the techniques for comparing genetic information more advanced, which facilitates analysis and allows us to more accurately group animals and see

how they're related. These powerful tools provide insights into the evolution of animal life, offering proof of our kinship with all living things and of our common origins.

The invertebrate past is beautifully traced in the fossil record, with fossils of marine invertebrates being particularly abundant. Shallow water, with its constant shifting of mud and sand, facilitates the rapid burial of organisms. Later, these sea sediments, when uplifted, present a legible record, with the earliest animals preserved in the lowest layers and the most recent in the highest. The earliest period for which good fossils exist is the Cambrian, which reigned more than 500 million years ago.

An eruption of life took place between 500 and 600 million years ago, and this surge is referred to as the Cambrian explosion. This extraordinary burst of animal life led to a huge influx of animal diversity and the appearance of almost all of the phyla we have today. Ample evidence for this phenomenon is found in the fossil record at the Burgess Shale Formation, discovered in 1909 in the Canadian Rocky Mountains. Before the Cambrian explosion, only simple creatures existed and the course of life was relatively slow. But suddenly evolution took a sharp turn and fantastic creatures sprang into being.

The cause of the Cambrian explosion remains one of the great puzzles of the planet's history, and the theories are numerous and varied. It's possible that climatic conditions became more favorable to multicellular life. Oxygen, which had been accumulating in the atmosphere for close to 2 billion years, reached about 20 percent of its present levels during the Cambrian period, so perhaps this rise in oxygen levels is the key. Perhaps there was a genetic revolution. Before the Cambrian, sponges had cell differentiation and cell-to-cell communication; cnidarians (including anemones, corals, and jellyfish) had tissues and the ability to move; flatworm-type animals had a brain and sensory organs and were the first hunters. These inventions may have produced a critical threshold of genetic complexity in the Cambrian that supported the profusion of different life-forms with the ability to adapt their habits throughout a myriad of habitats. They had time on their side.

After the explosion, wondrous new and increasingly complex life-forms flourished in the marine world. The sea became the realm of the hunter and the hunted, and survival became the name of the game. Survival demands innovation, and competition forced animals to find new ways to defend themselves. The dynamic between predator and prey, where the point is to avoid being eaten and to develop predatory skills, pushes the evolutionary process along. The quest to stay safe is a principle driver of animal diversity. In habitats where competition is more intense, such as tropical coral reefs, animals must be smaller and more cryptic to survive.

The ancestry of almost every creature on Earth can be traced back to the Cambrian explosion, as fossils from the period indicate. If all living animals evolved from a single ancestral form many millions of years ago, then all animals are related. No matter how distant, there must be some genealogical connection among sponges, flatworms, anemones, sea stars, nudibranchs, octopuses, crabs, whales, and dolphins. Trace your ancestry back far enough, and you will find an invertebrate in your family tree.

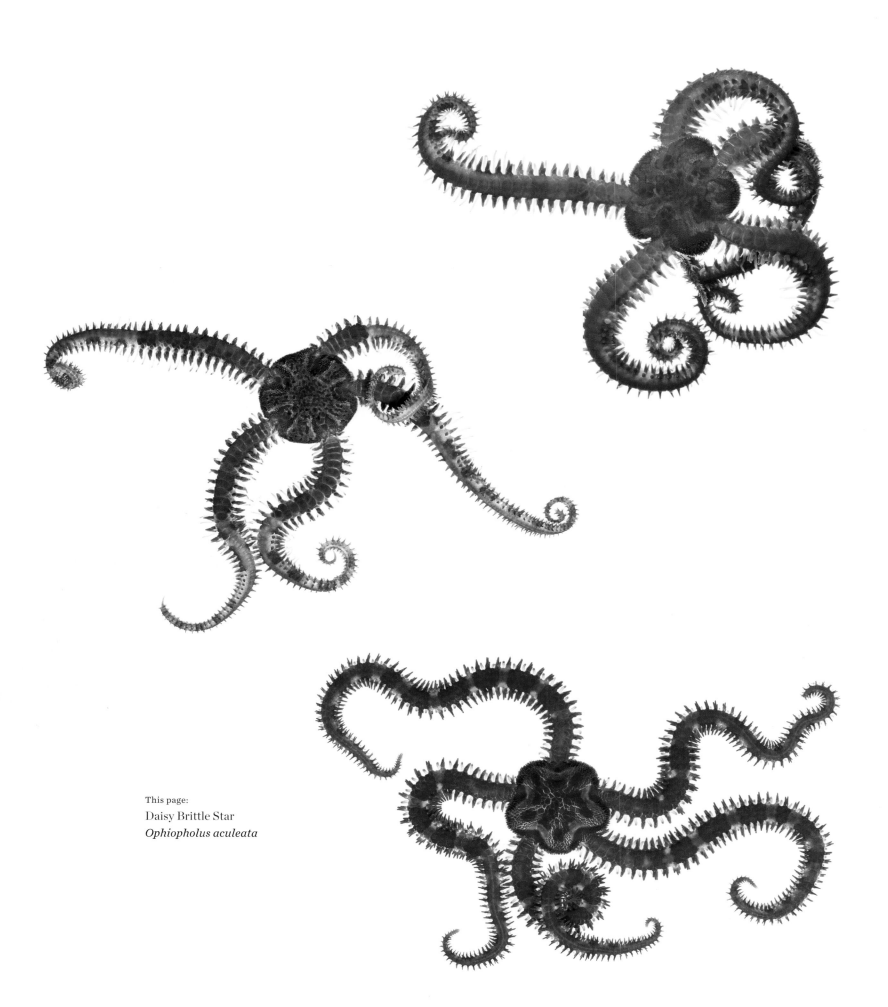

This page:
Daisy Brittle Star
Ophiopholus aculeata

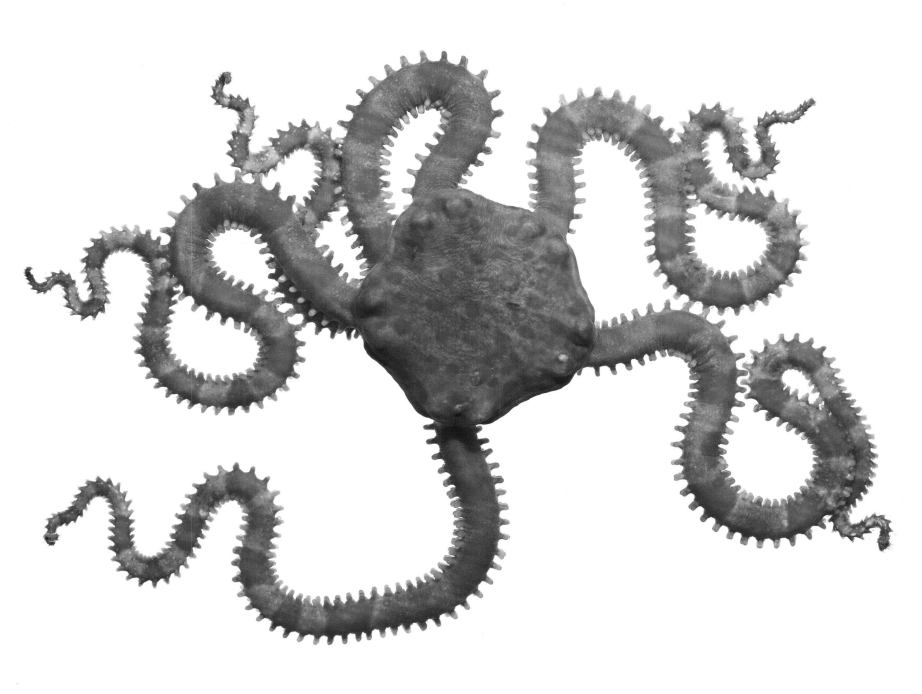

Pink Brittle Star
Ophiomyxa australis

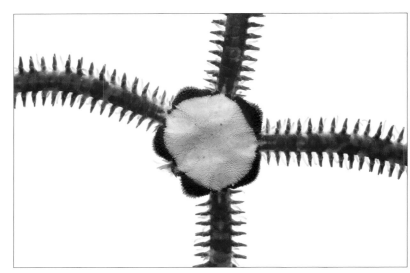

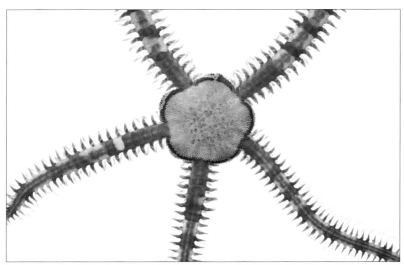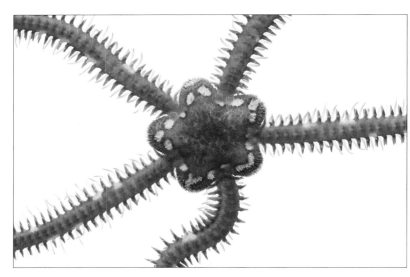

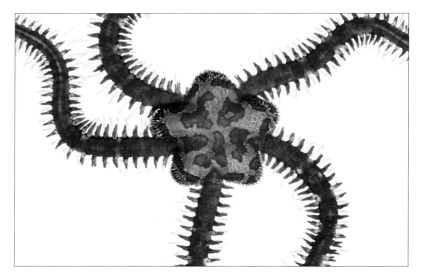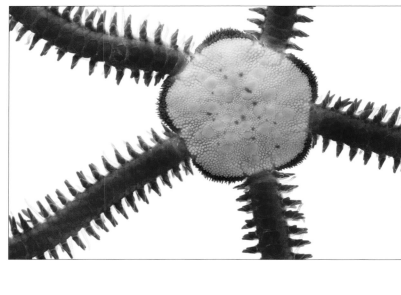

Top left:
Elegant Red-Banded Brittle Star
Ophiarthrum elegans

Rest of page:
Daisy Brittle Star
Ophiopholus aculeata

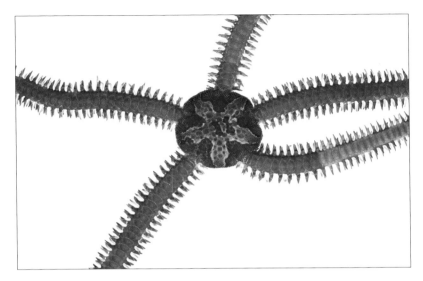
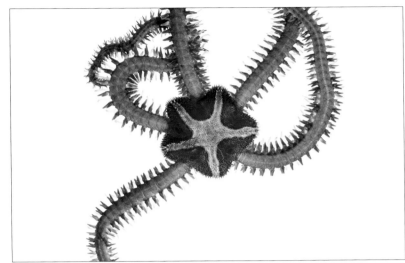
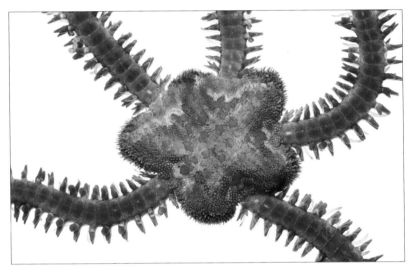
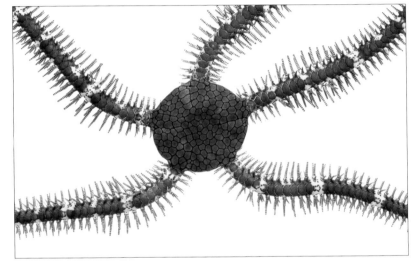

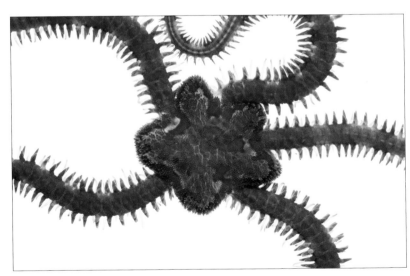

Top left and right, center left, and bottom right:
Daisy Brittle Star
Ophiopholus aculeata

Center right:
Honeycomb Brittle Star
Ophiocoma doederleini

Bottom left:
Spot Brittle Star
Family Ophiodermatidae sp.

Candy Corn Nudibranch and Finger Copepod
Janolus fuscus and *Ismaila belciki*

Opposite:
Candy Corn Nudibranch (eggs)
Janolus fuscus

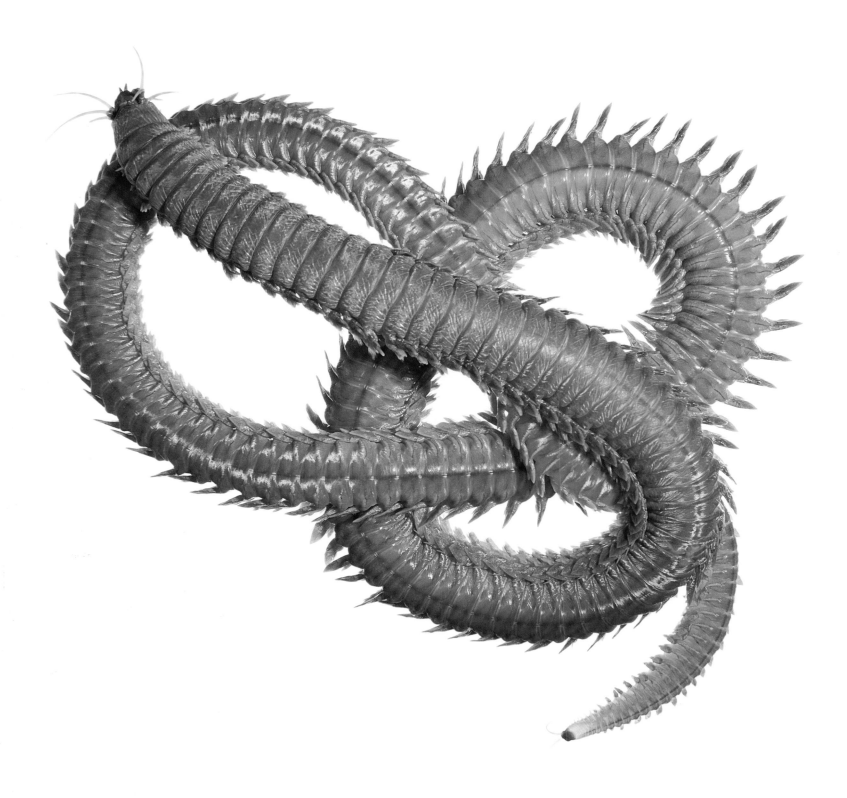

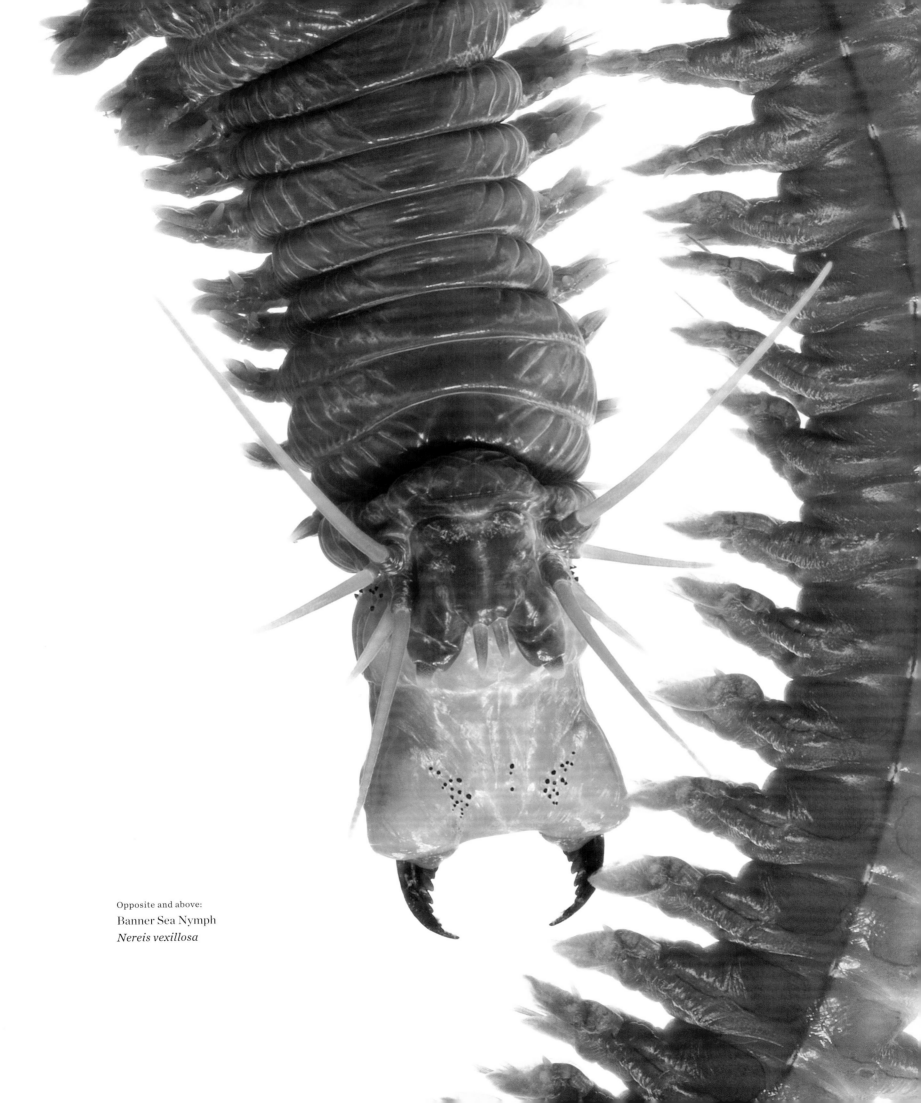

Opposite and above:
Banner Sea Nymph
Nereis vexillosa

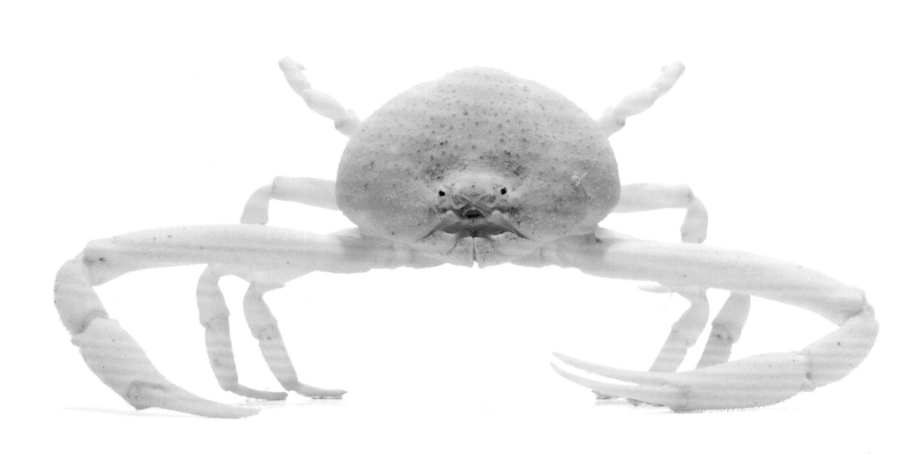

Graceful Kelp Crab
Pugettia gracilis

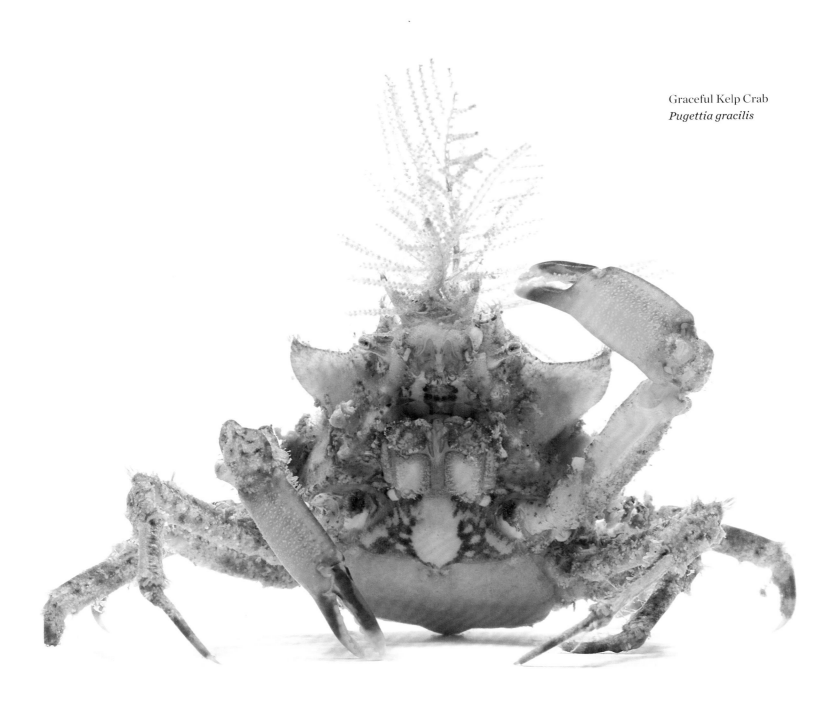

Opposite:
White Phantom Crab
Tanaoa distinctus

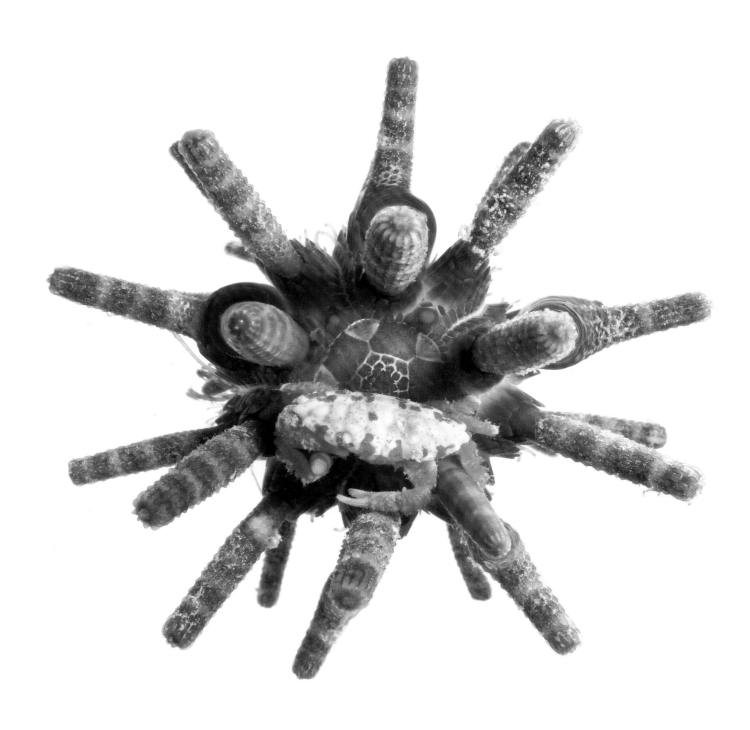

Ten-Lined Sea Urchin and Knobby Liomera
Eucidaris metularia and *Liomera monticulosa*

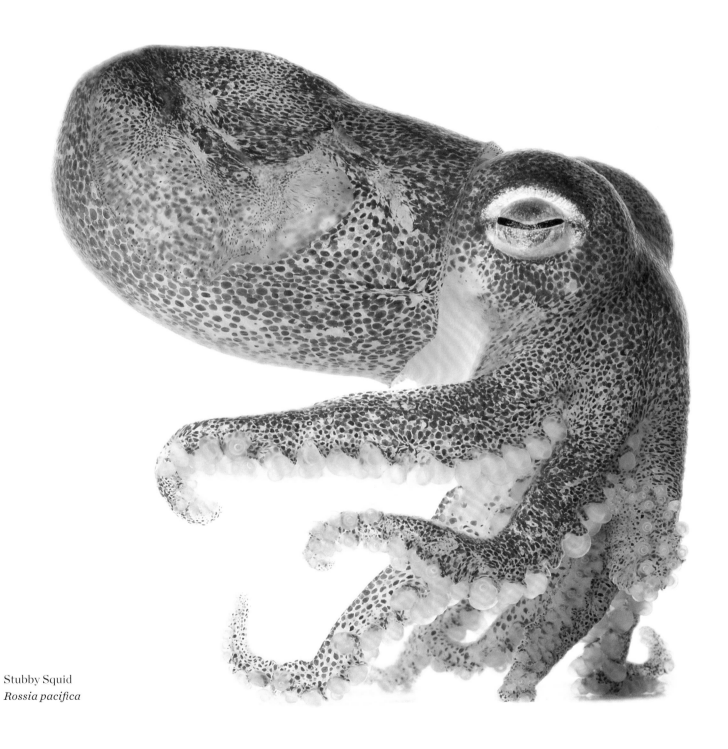

Stubby Squid
Rossia pacifica

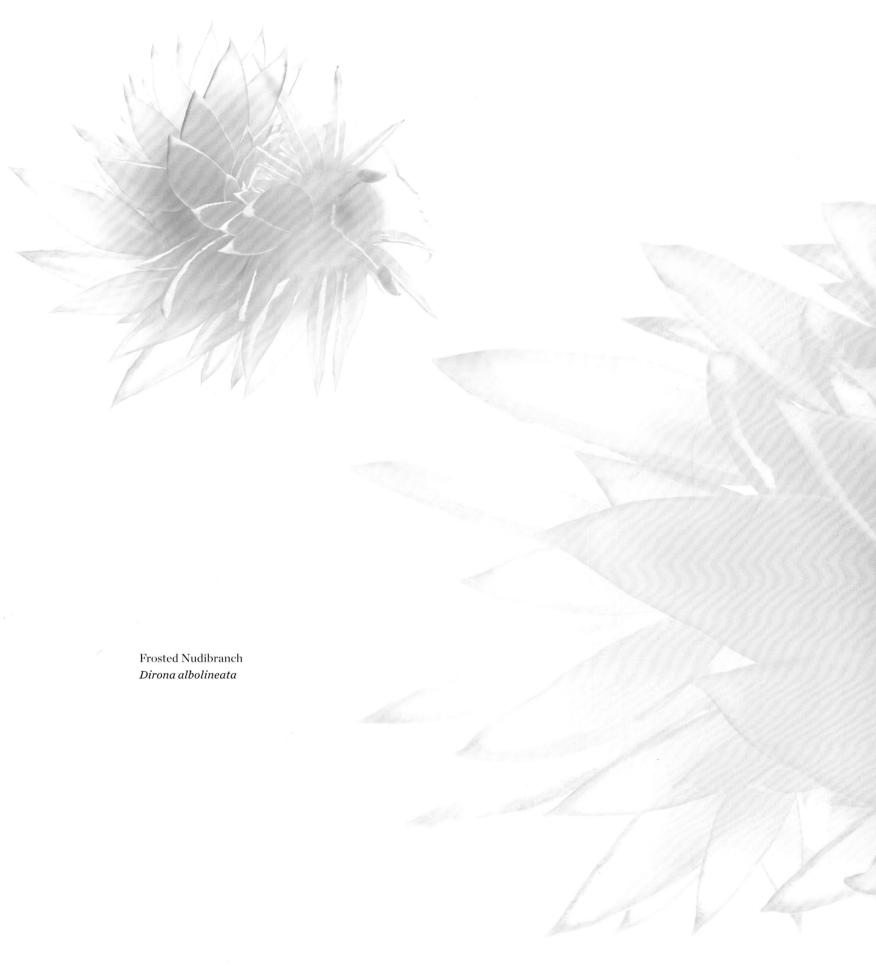

Frosted Nudibranch
Dirona albolineata

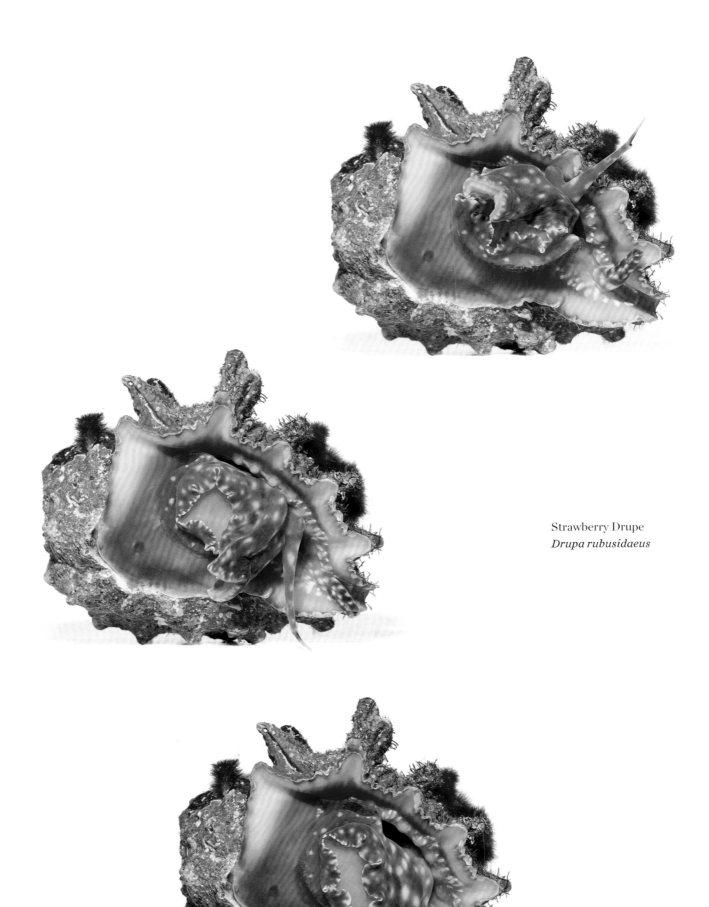

Strawberry Drupe
Drupa rubusidaeus

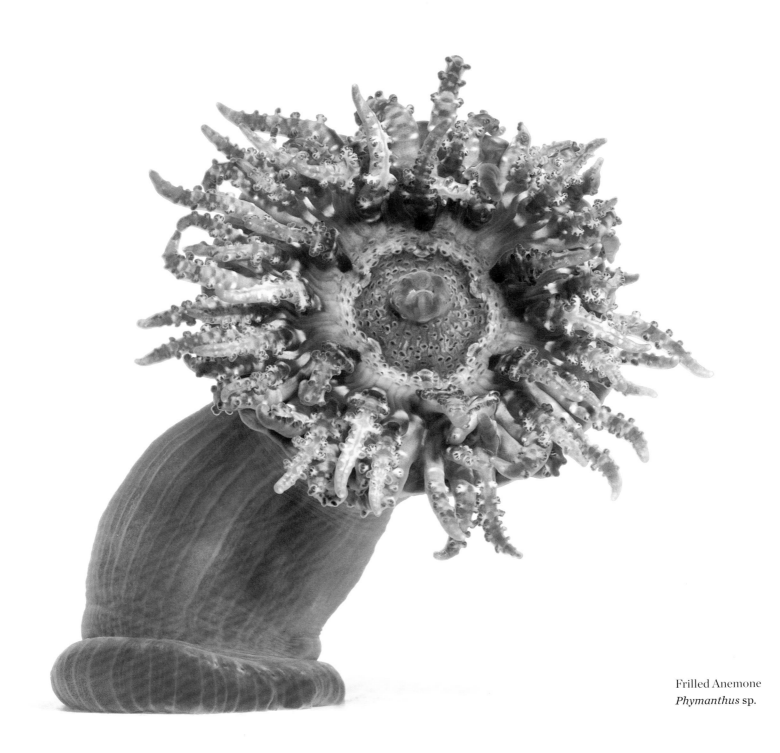

Frilled Anemone
Phymanthus sp.

Above:
Pacific Leopard Flatworm
Pseudobiceros sp.

Below:
Orange-Rimmed Flatworm
cf. *Maiazoon orsaki*

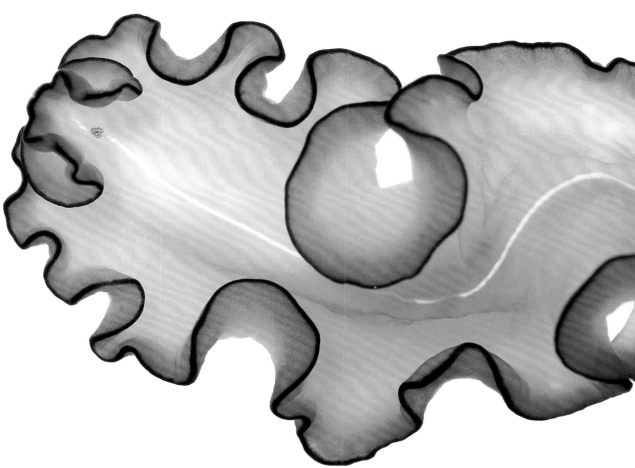

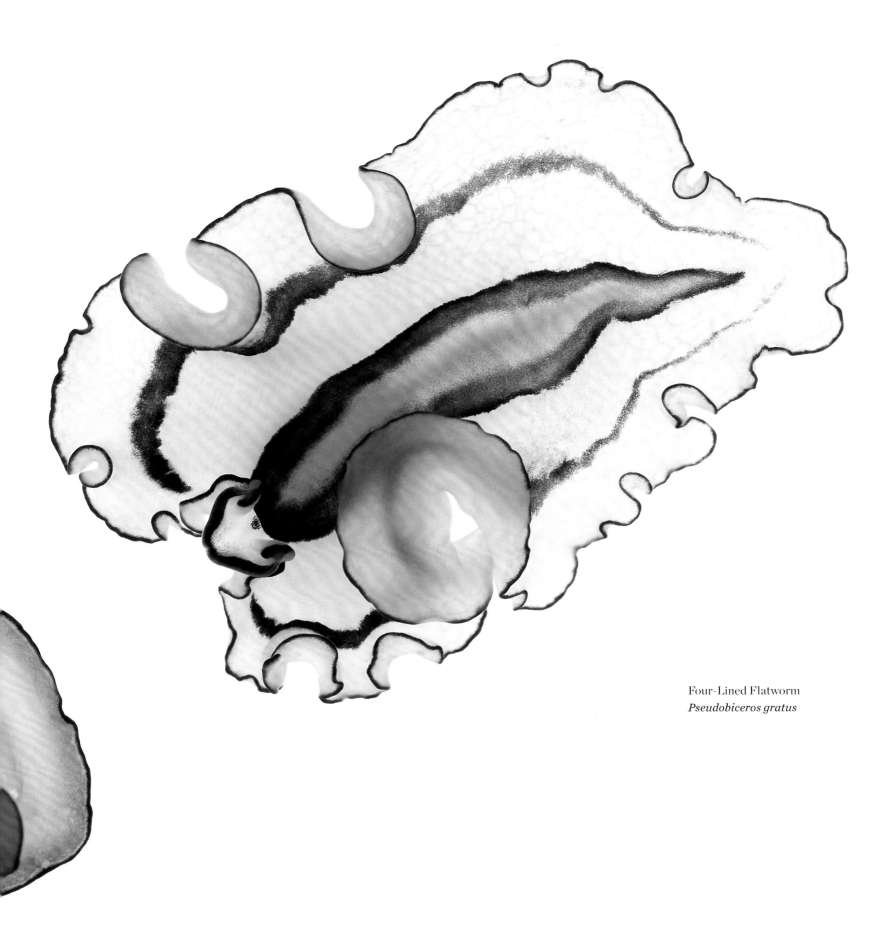

Four-Lined Flatworm
Pseudobiceros gratus

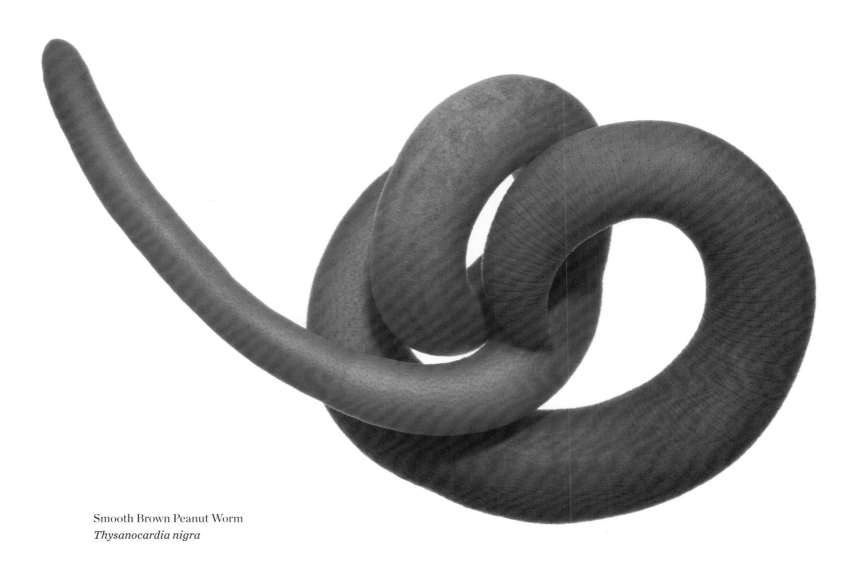

Smooth Brown Peanut Worm
Thysanocardia nigra

Suborbicular Kelly Clam
Kellia suborbicularis

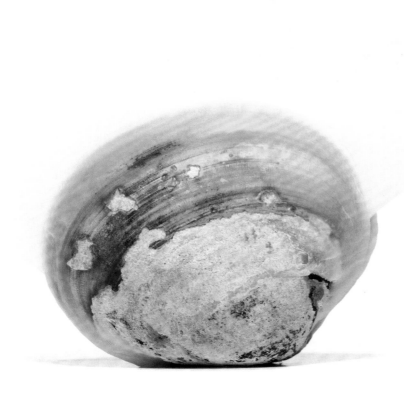

Opposite:
Columbia Doto
Doto columbiana

Above:
Hooded Nudibranch
Melibe leonina

Opposite:
Twice-Branched Hydroid
Macrorhynchia phoenicea

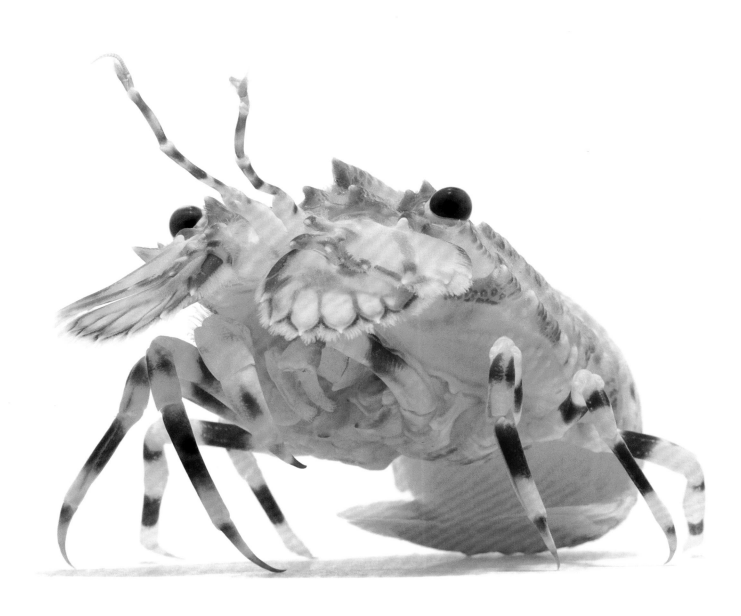

Aurora Slipper Lobster
Galearctus aurora

Previous spread:
Wanawana Crab
Sakaila wanawana

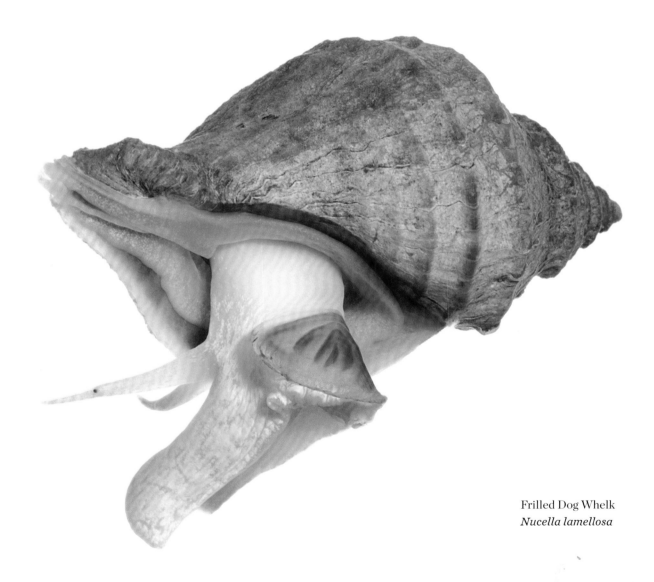

Frilled Dog Whelk
Nucella lamellosa

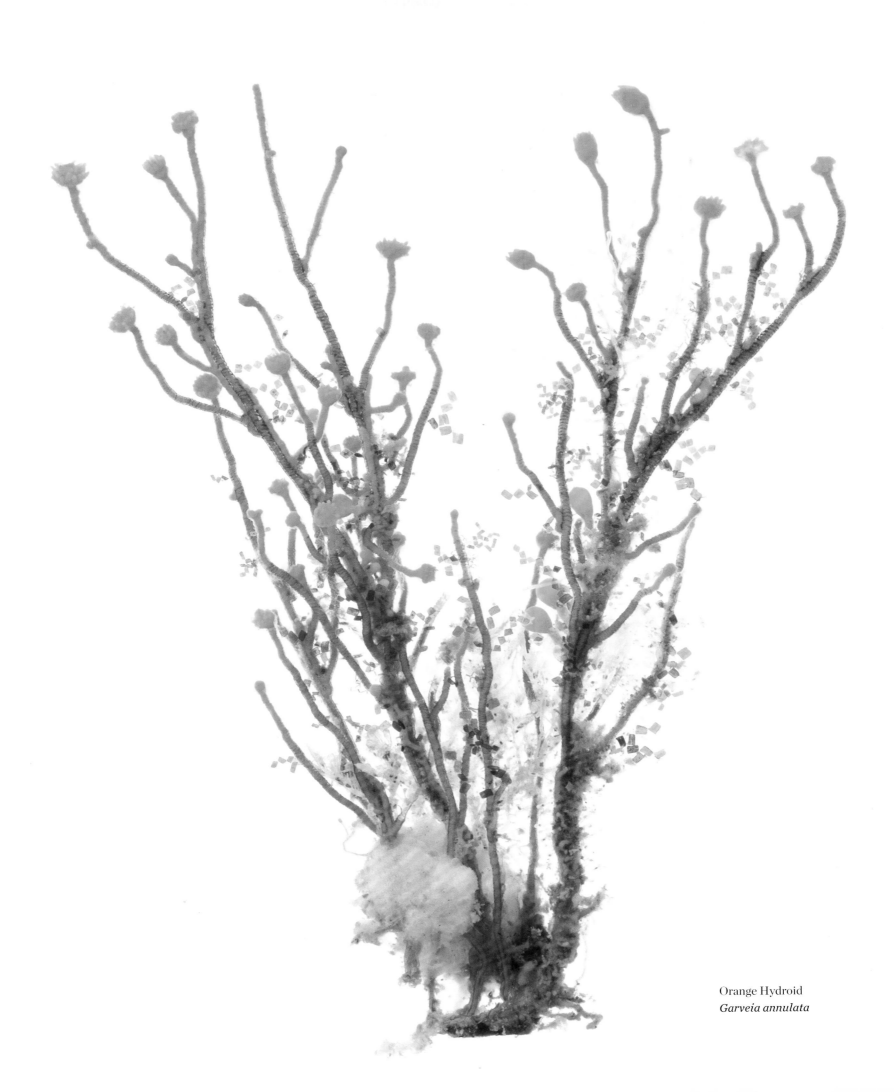

Orange Hydroid
Garveia annulata

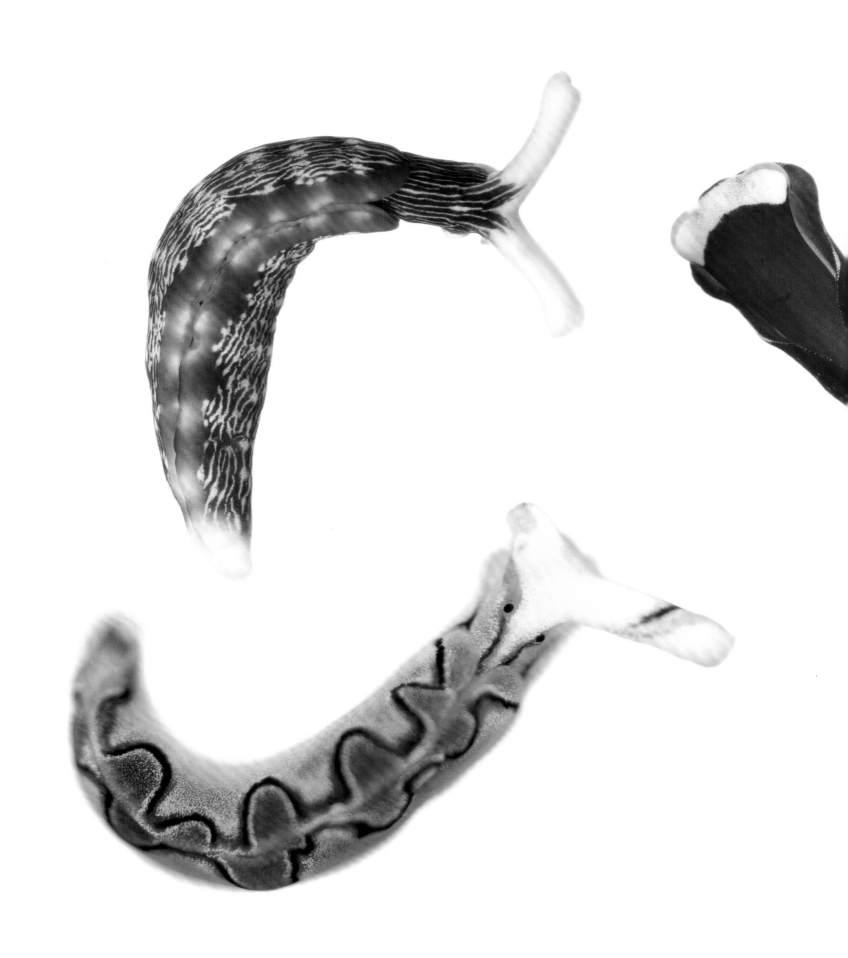

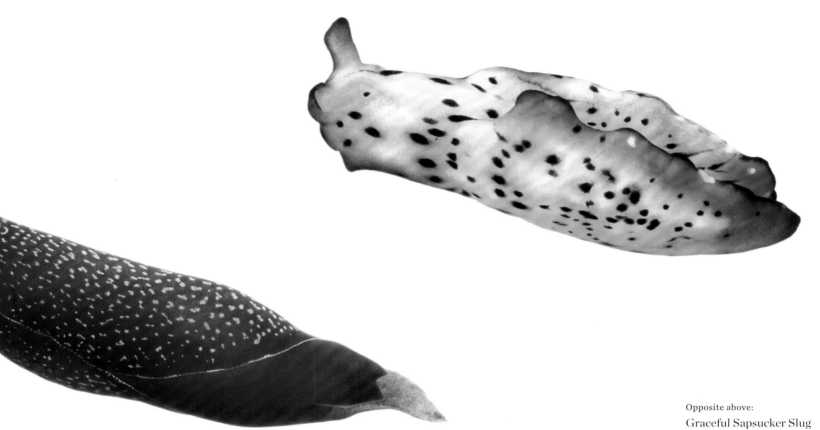

Opposite above:
Graceful Sapsucker Slug
Thuridilla gracilis

Opposite below:
Neon Sapsucker Slug
Thuridilla neona

Center:
White-Faced Swallowtail Slug
Chelidonura inornata

Above:
Sapsucker Slug
Elysia sp.

Below:
Electric Swallowtail Slug
Chelidonura hirundinina

Below:
Green-Eyed, Red-Spotted Guard Crab
Trapezia rufopunctata

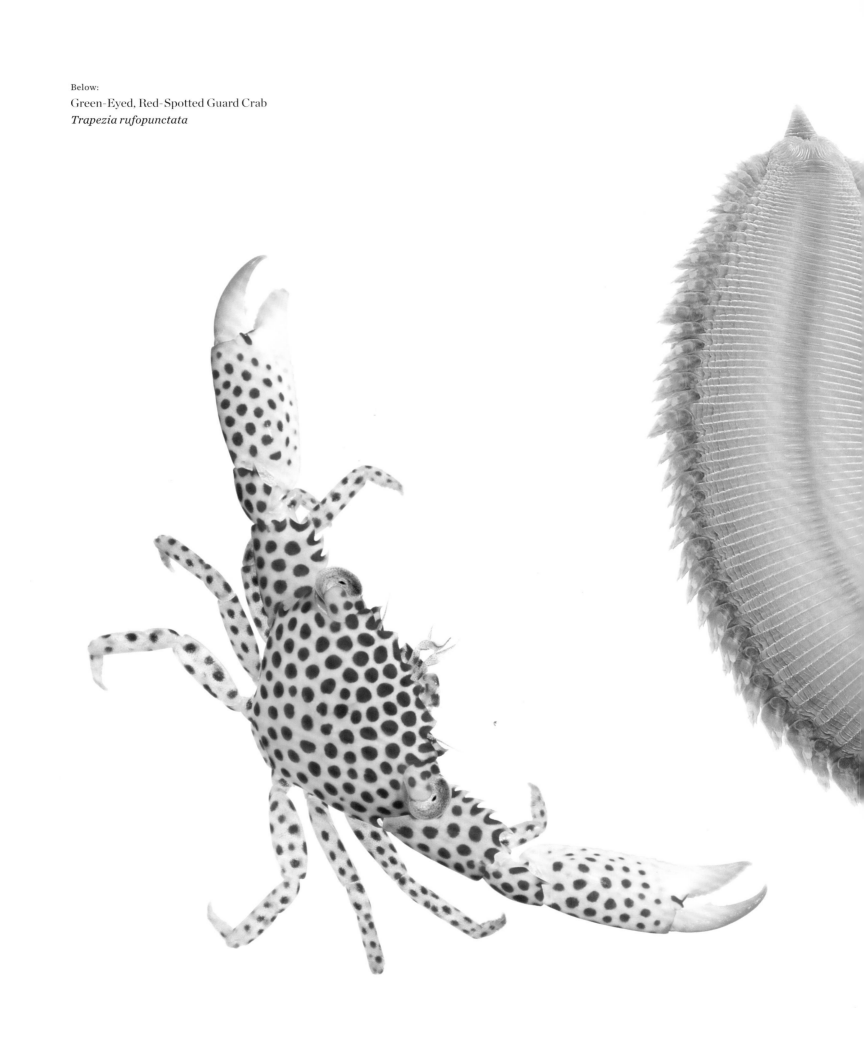

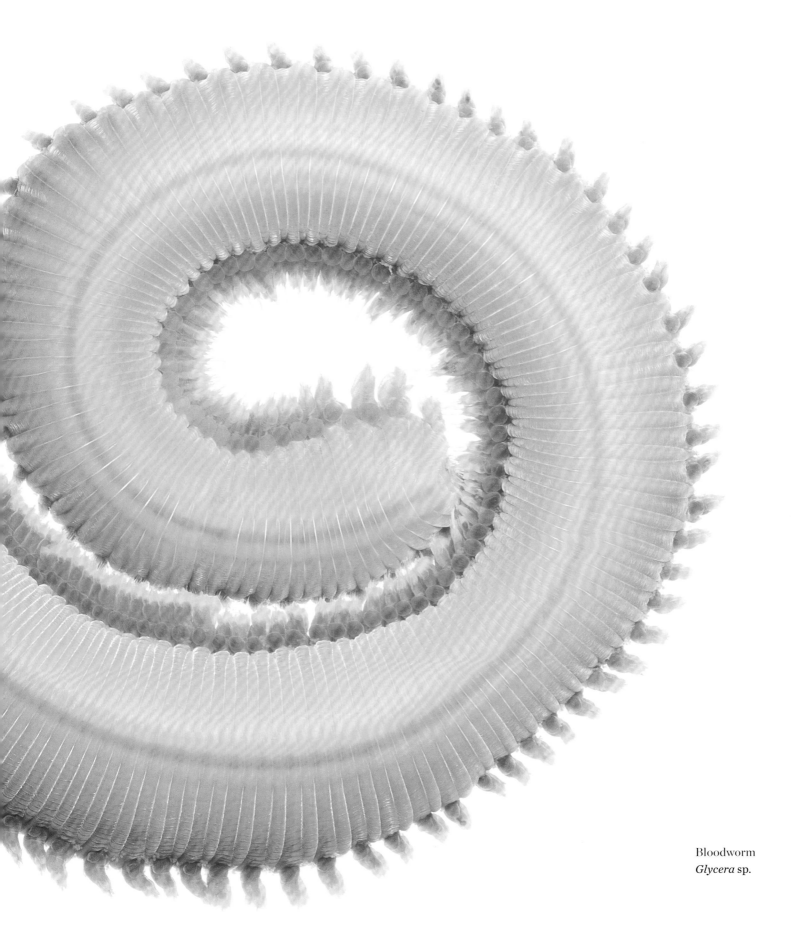

Bloodworm
Glycera sp.

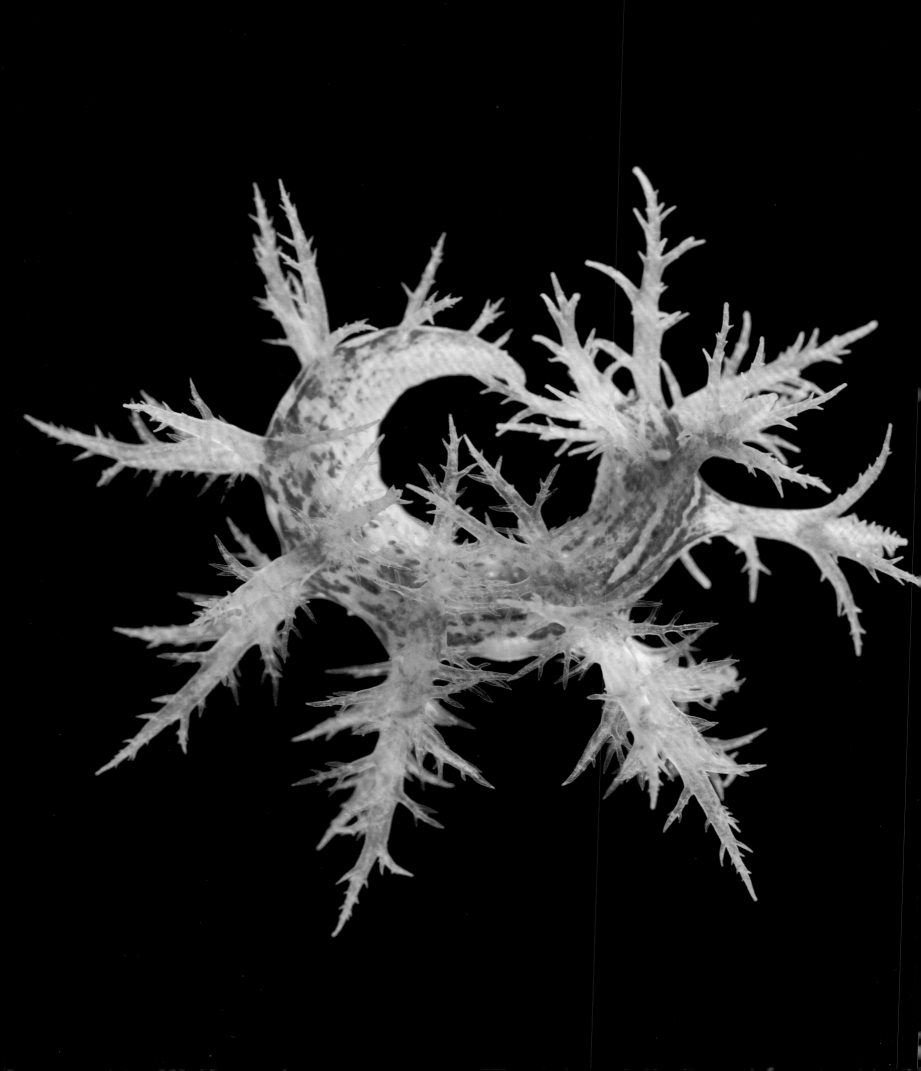

Opposite:
Tree-Top Nudibranch
Dendronotus venustus

Below:
Ground-Digger Dumbbell Worm
Sternaspis fossor

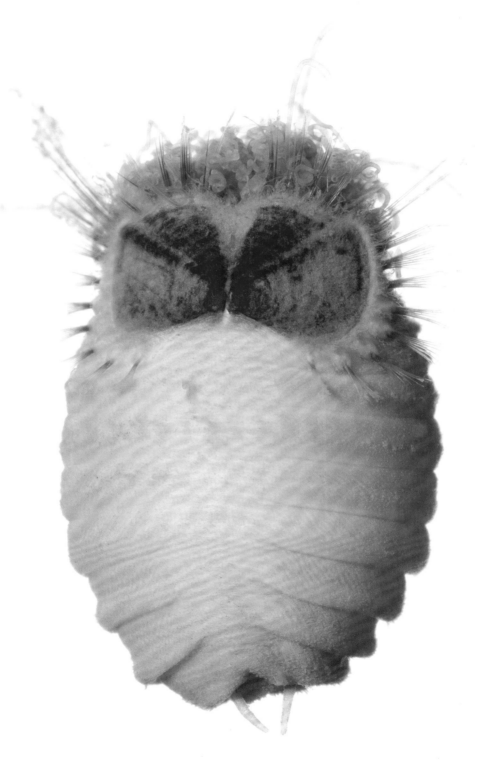

Overleaf left:
Hanging Stomach Jelly
Stomotoca atra

Overleaf right:
Sea Gooseberry
Pleurobrachia bachei

Second overleaf left:
Rainbow Comb Jelly
Beroe abyssicola

Second overleaf right:
Red-Eye Medusa
Polyorchis penicillatus

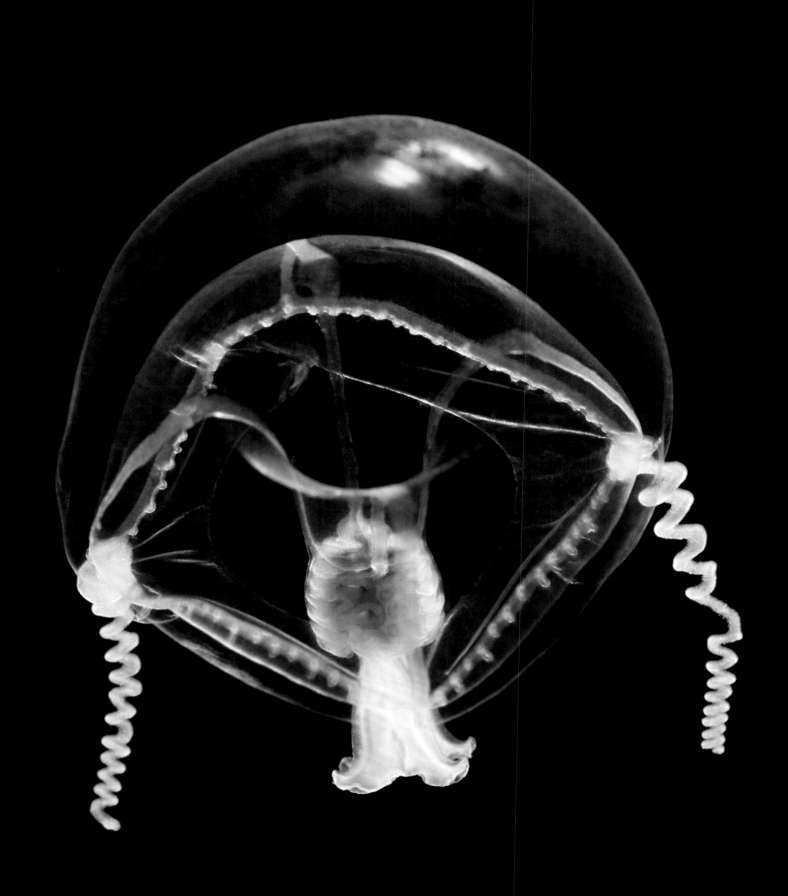

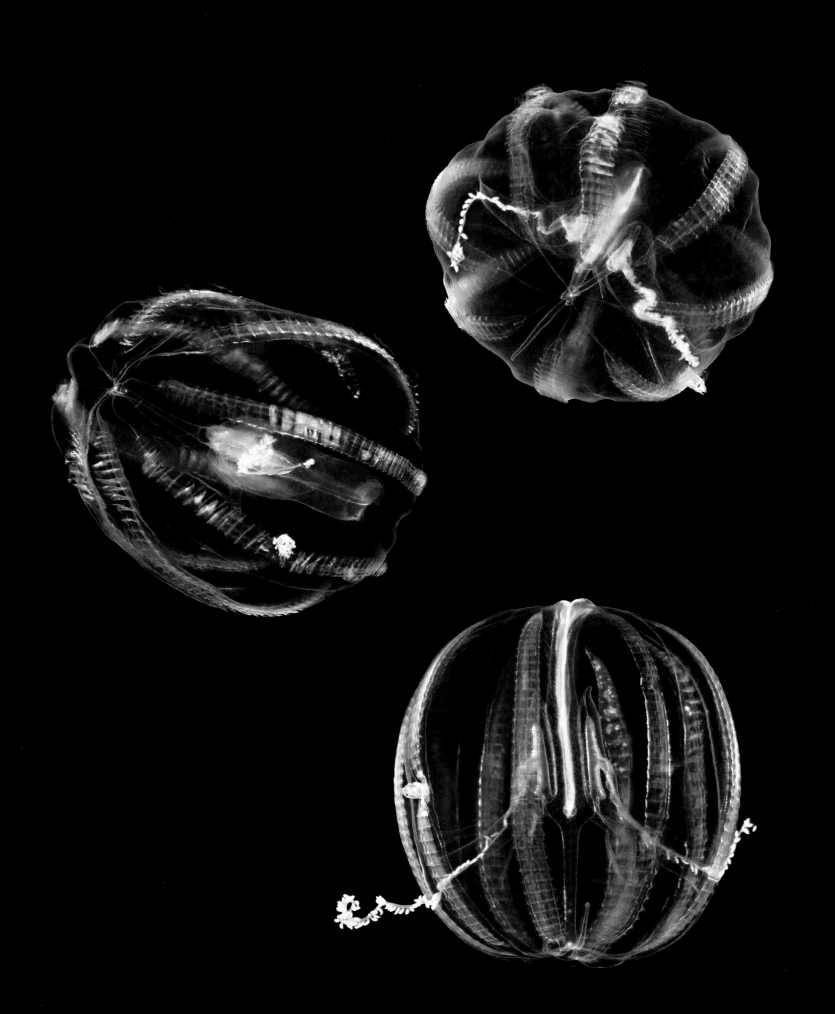

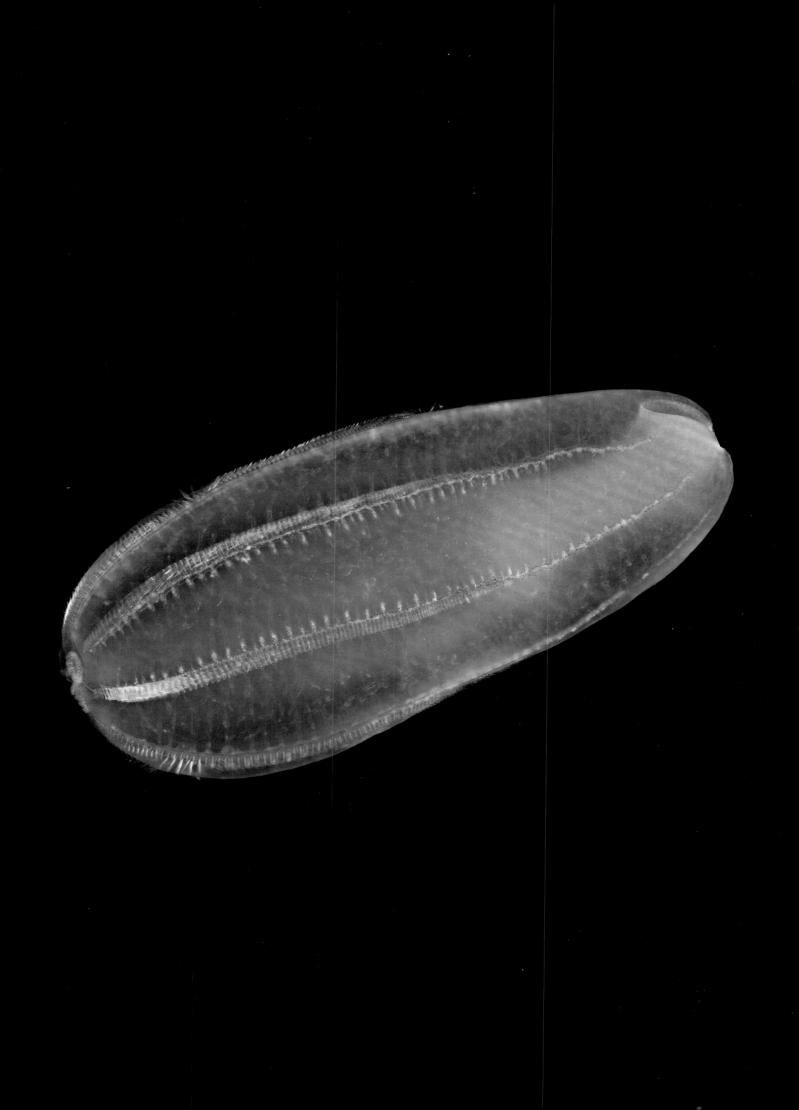

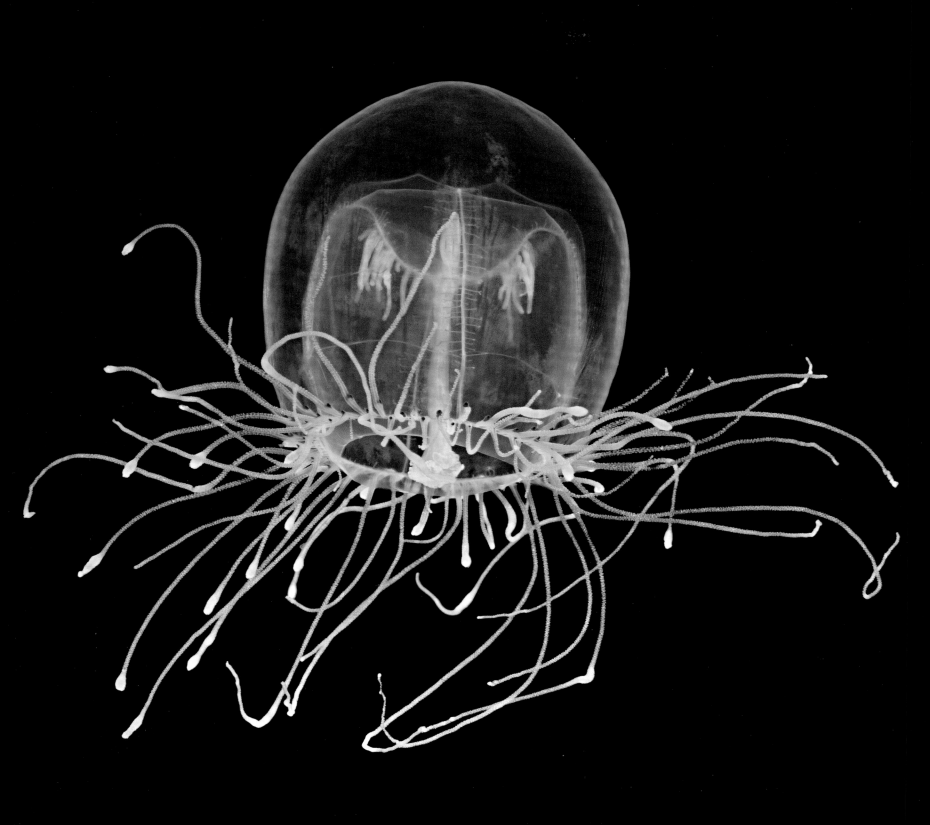

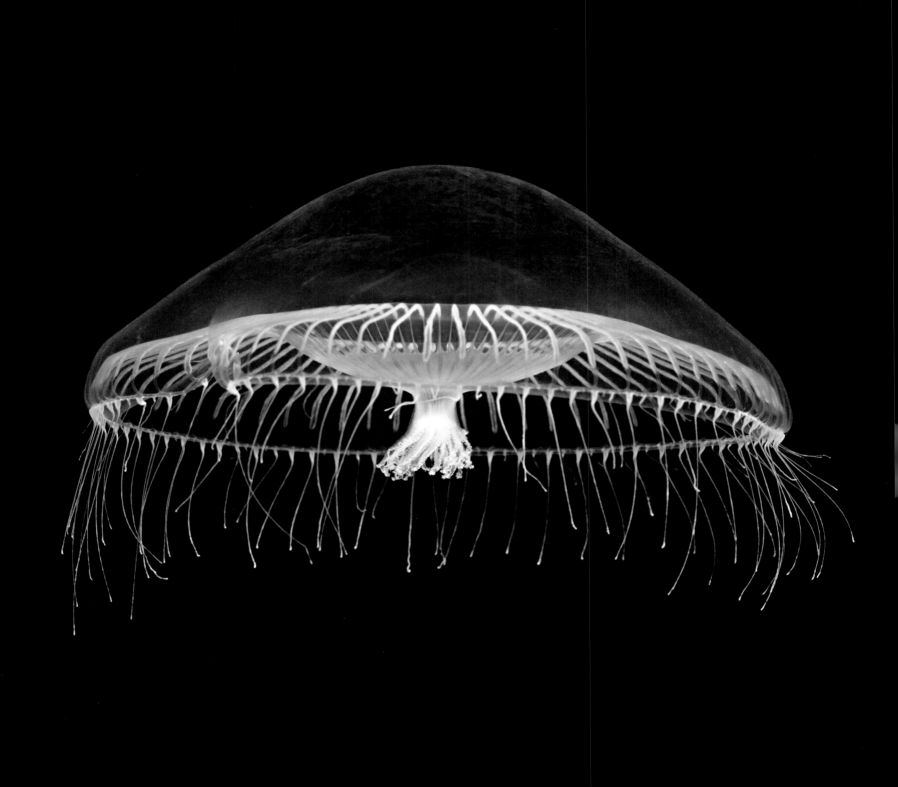

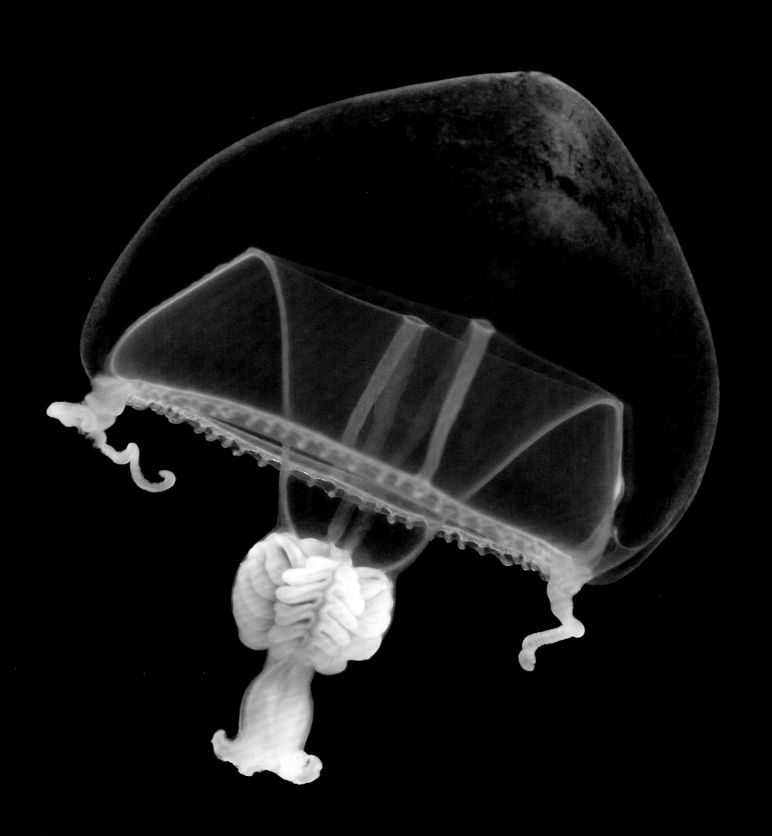

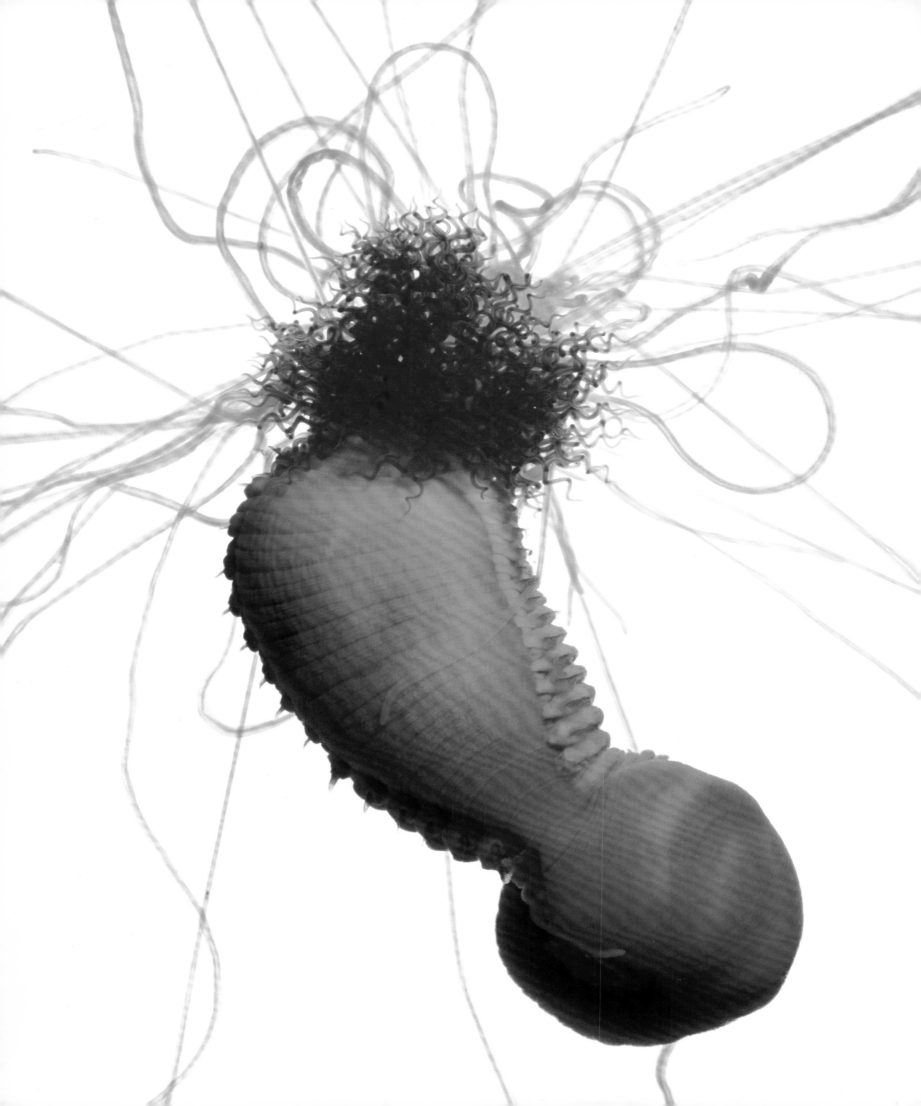

Broadbase Tunicate
Cnemidocarpa finmarkiensis

This spread:
Painted Anemone
Urticina crassicornis

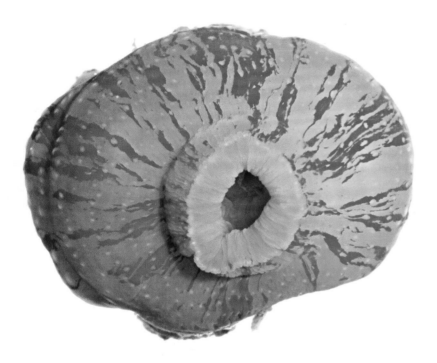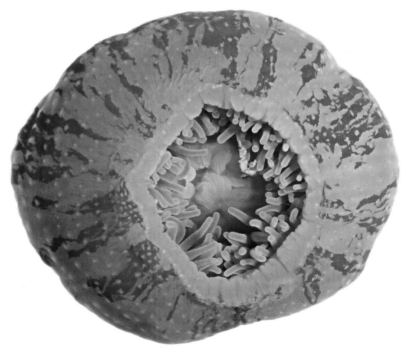

Overleaf left top:
Porites Nudibranch
Phestilla lugubris

Overleaf left center:
Cockerell's Nudibranch
Limacia cockerelli

Overleaf center top:
Leopard Dorid
Diaulula sandiengensis

Overleaf right top:
Lemon Drop Slug
Berthellina delicata

Overleaf right center:
Pustulose Nudibranch
Phyllidiella pustulosa

Overleaf left bottom:
Seaweed Nudibranch
Melibe pilosa

Overleaf center bottom:
Imperial Nudibranch
Hypselodoris imperialis

Overleaf right botom:
Yellow-Rimmed Nudibranch
Cadlina luteomarginata

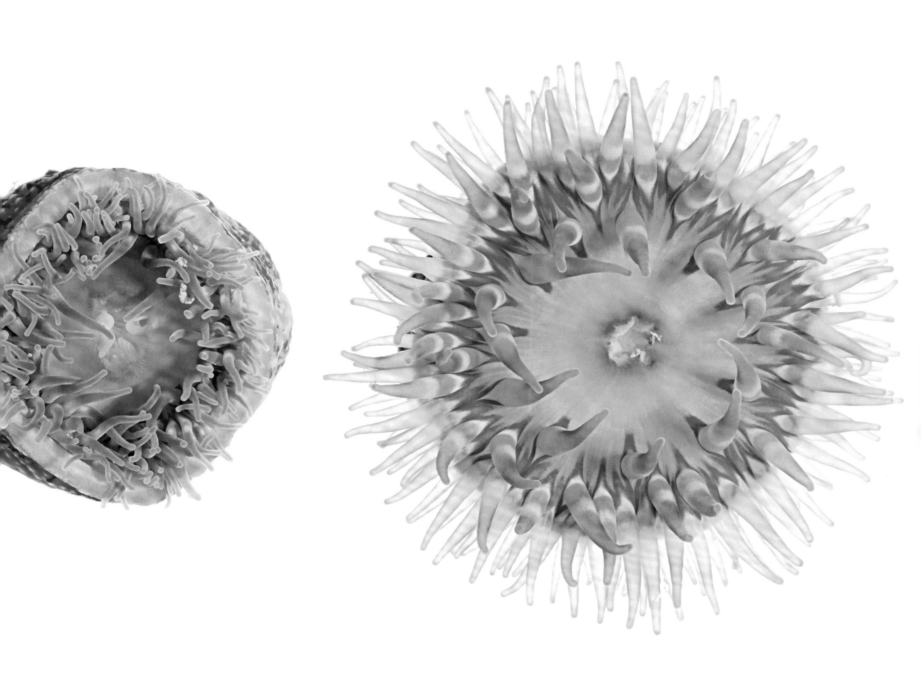

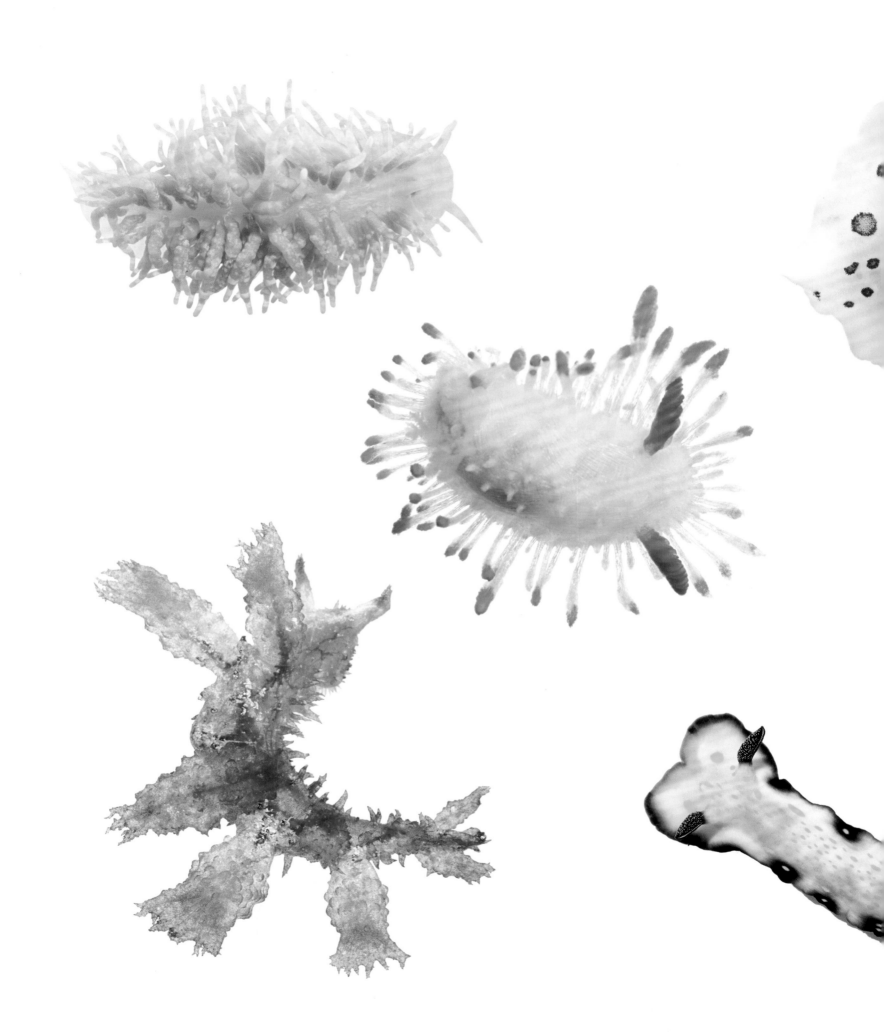

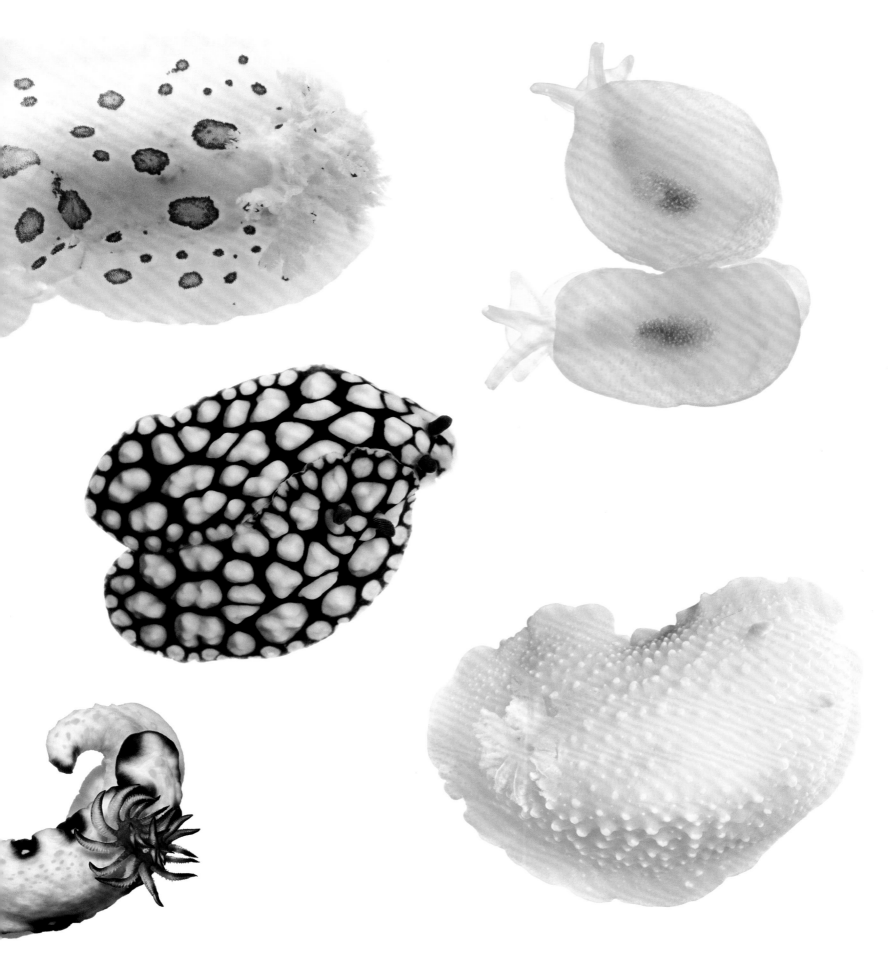

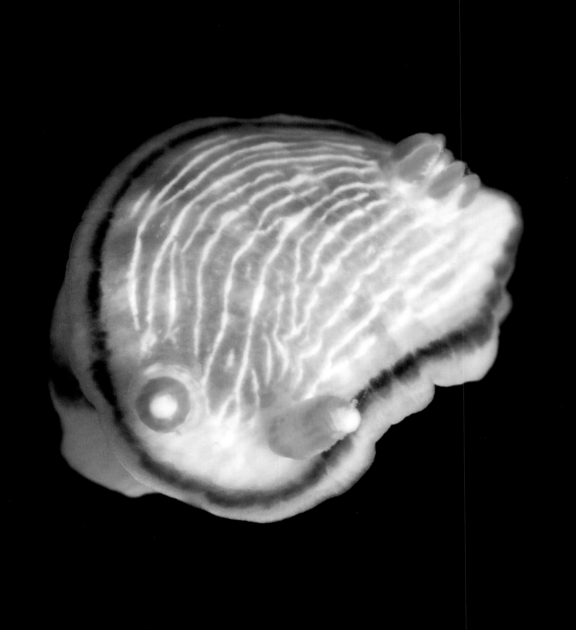

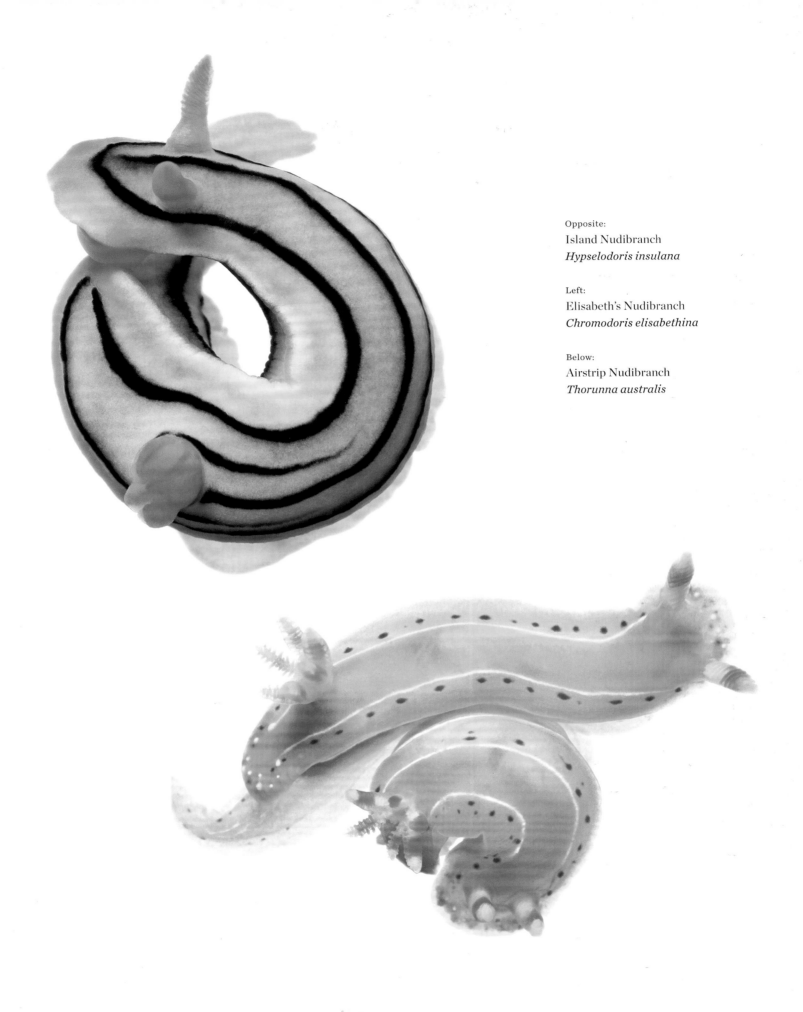

Opposite:
Island Nudibranch
Hypselodoris insulana

Left:
Elisabeth's Nudibranch
Chromodoris elisabethina

Below:
Airstrip Nudibranch
Thorunna australis

79

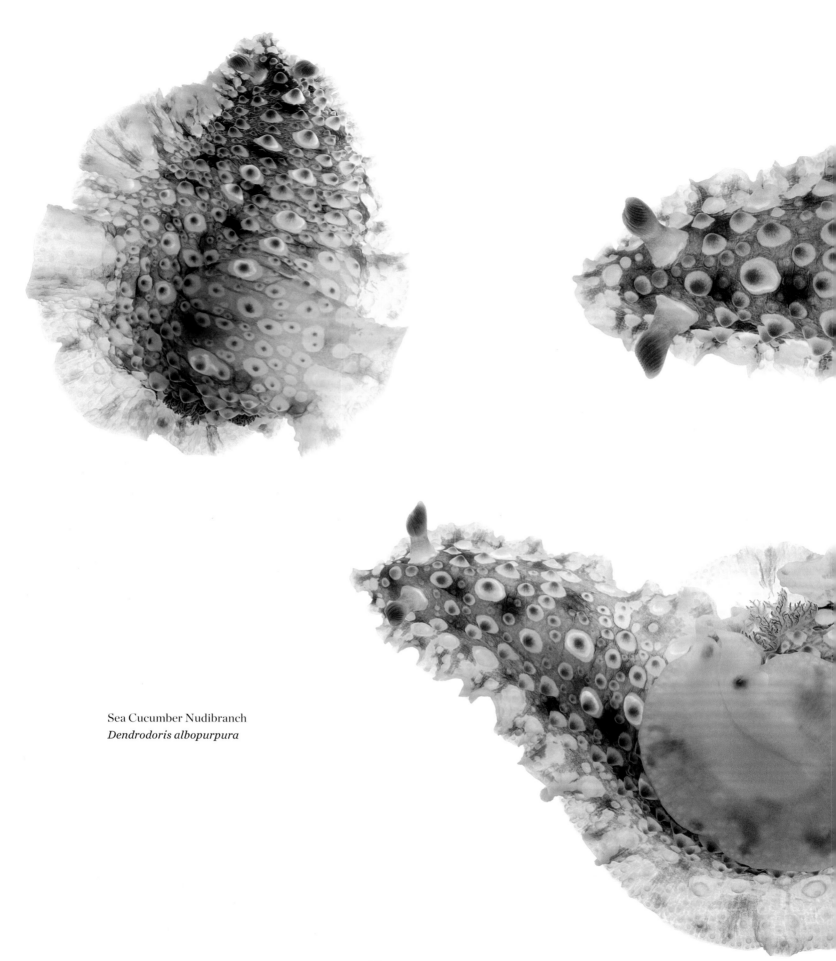

Sea Cucumber Nudibranch
Dendrodoris albopurpura

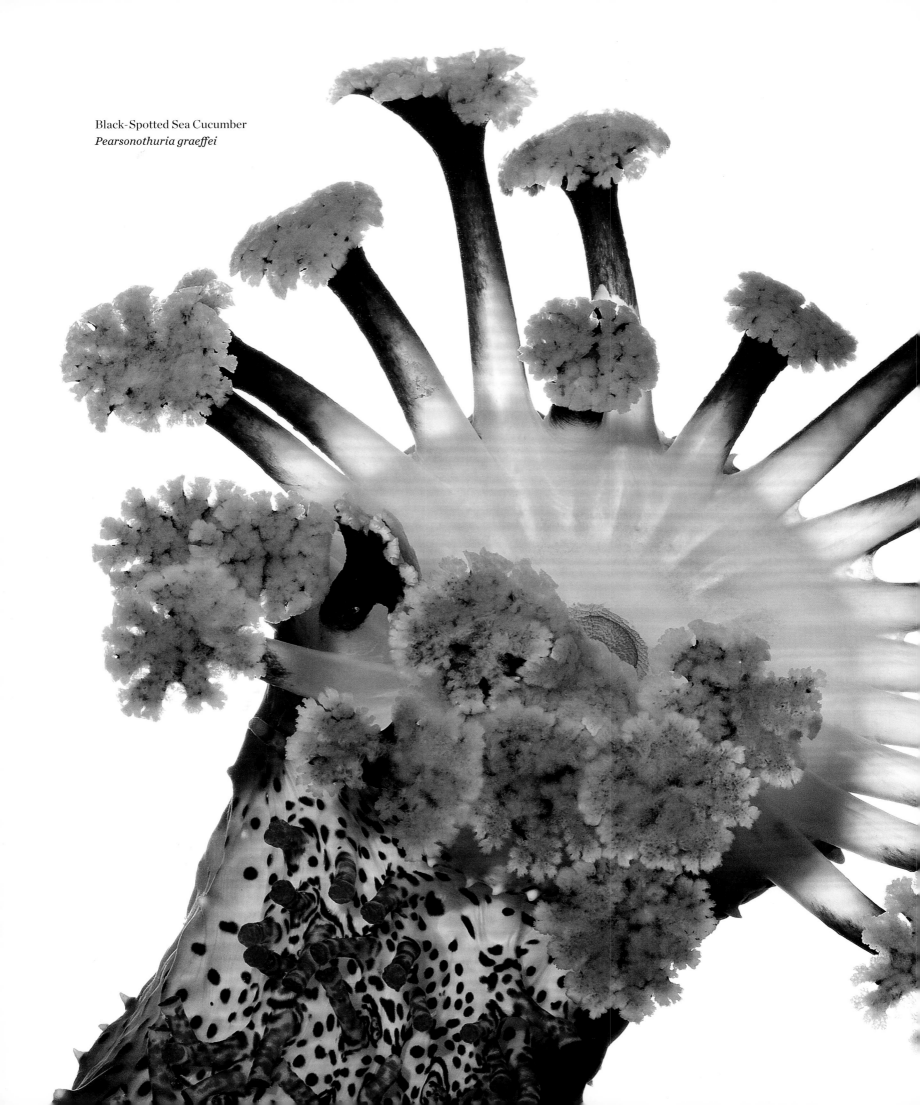

Black-Spotted Sea Cucumber
Pearsonothuria graeffei

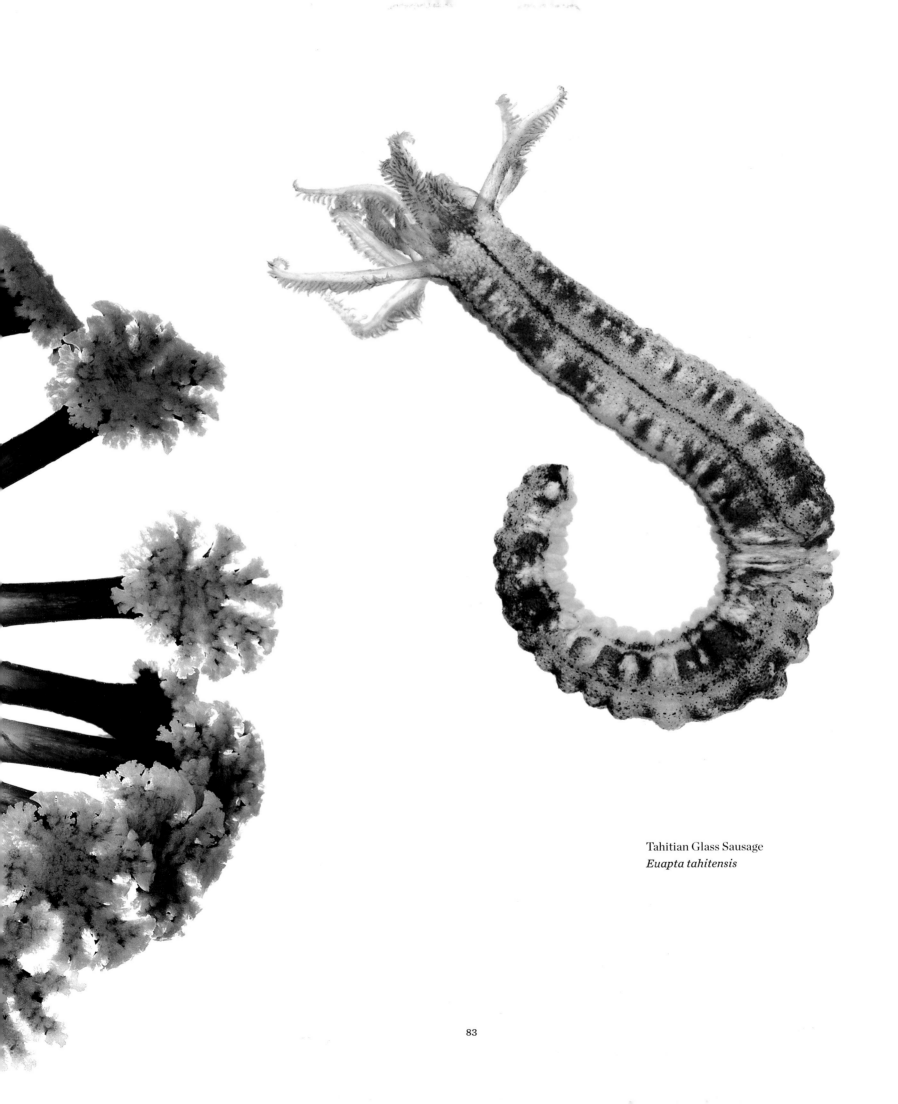

Tahitian Glass Sausage
Euapta tahitensis

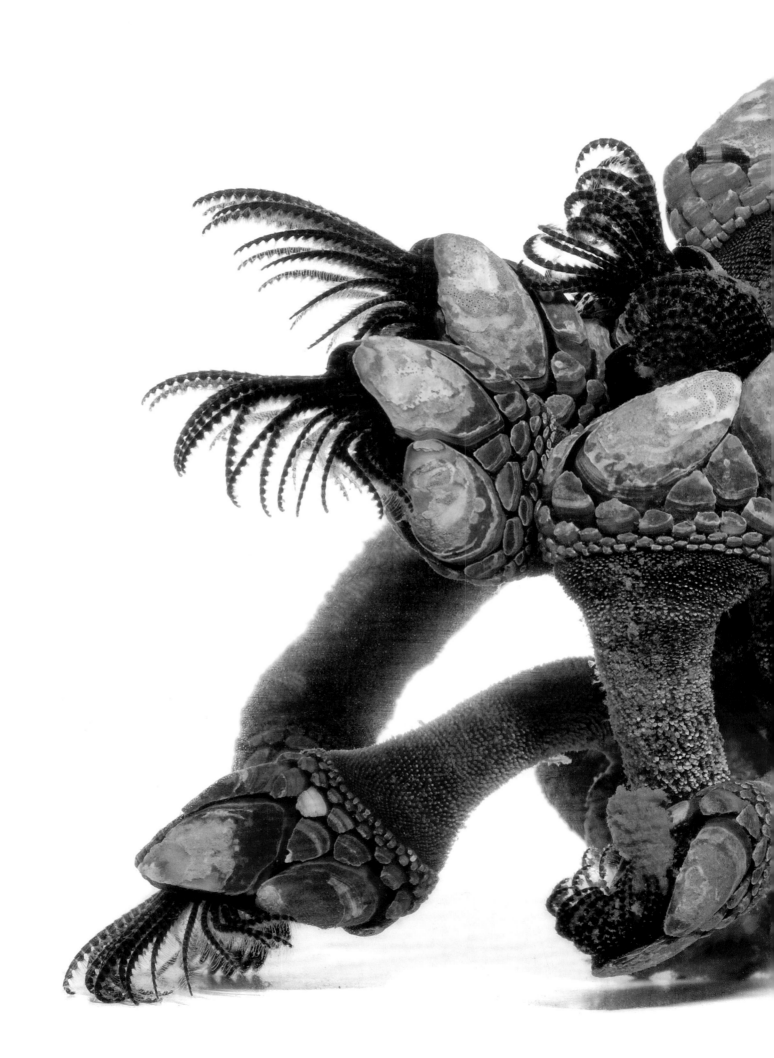

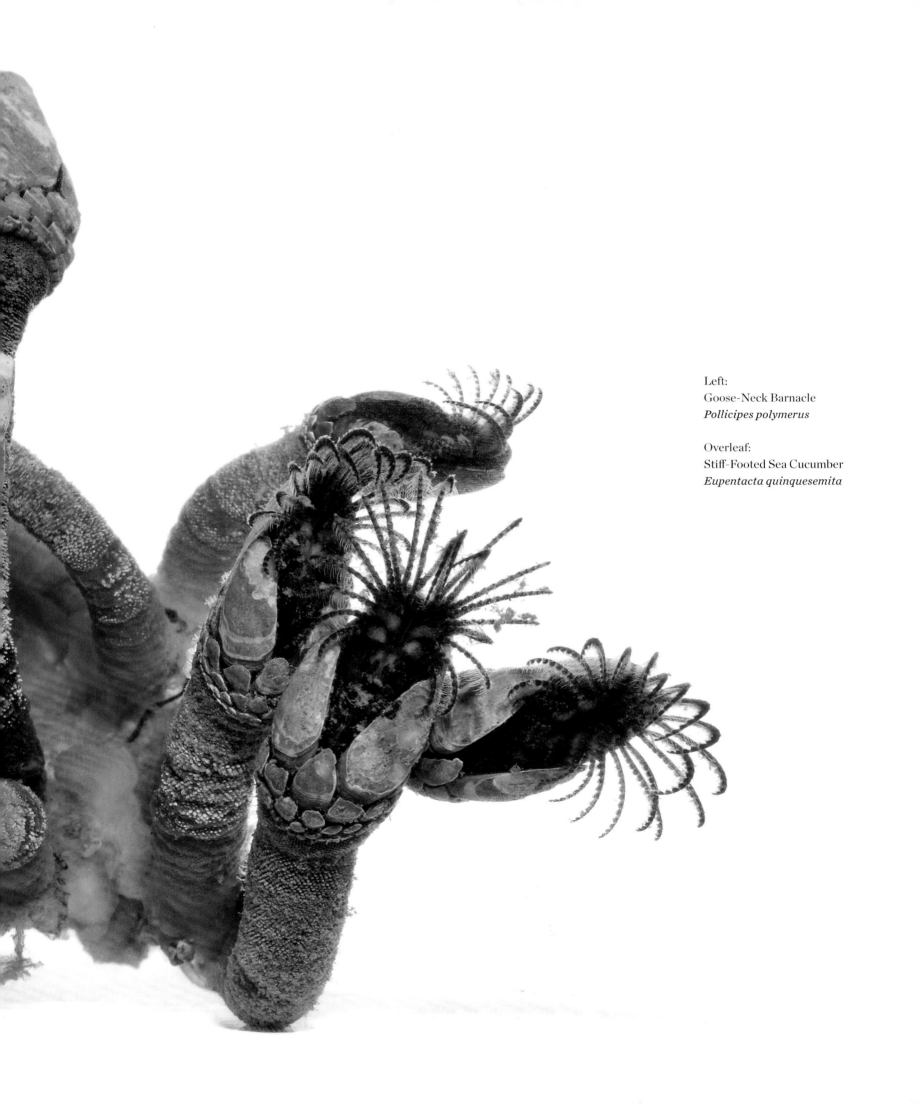

Left:
Goose-Neck Barnacle
Pollicipes polymerus

Overleaf:
Stiff-Footed Sea Cucumber
Eupentacta quinquesemita

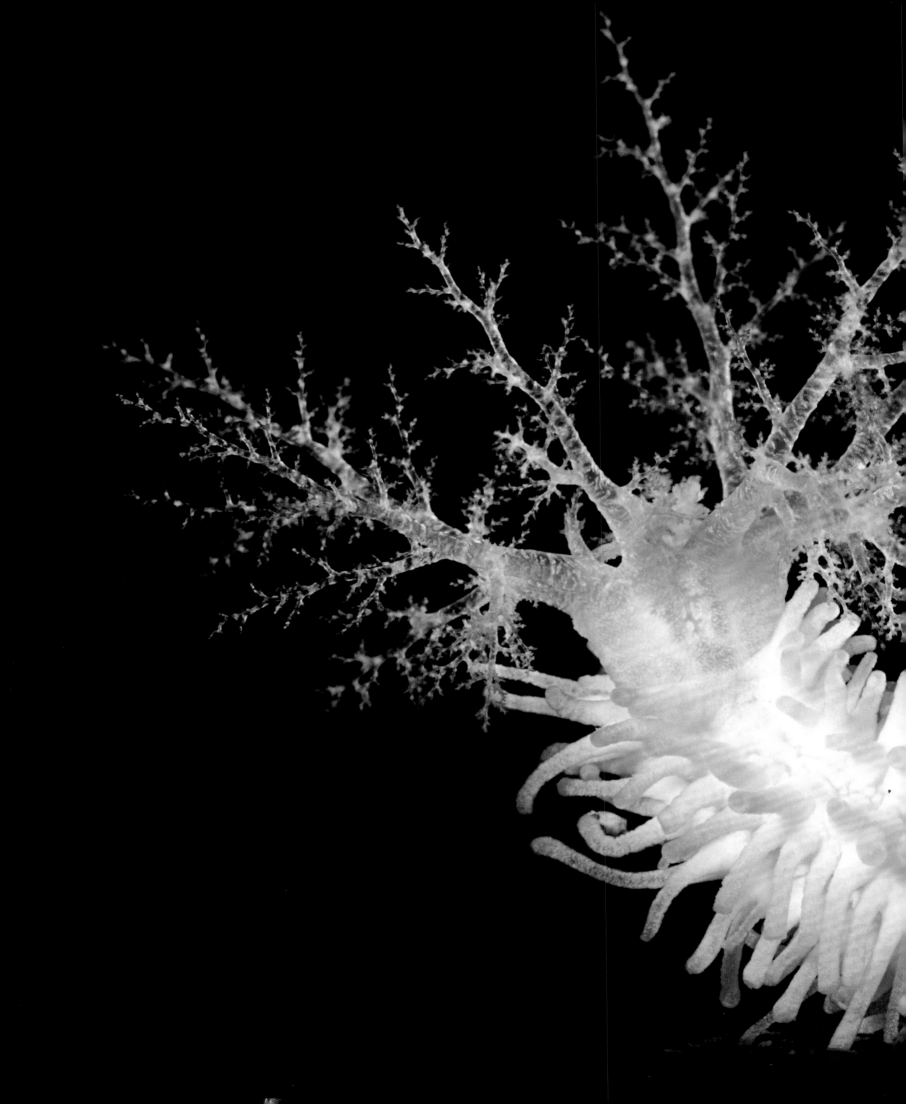

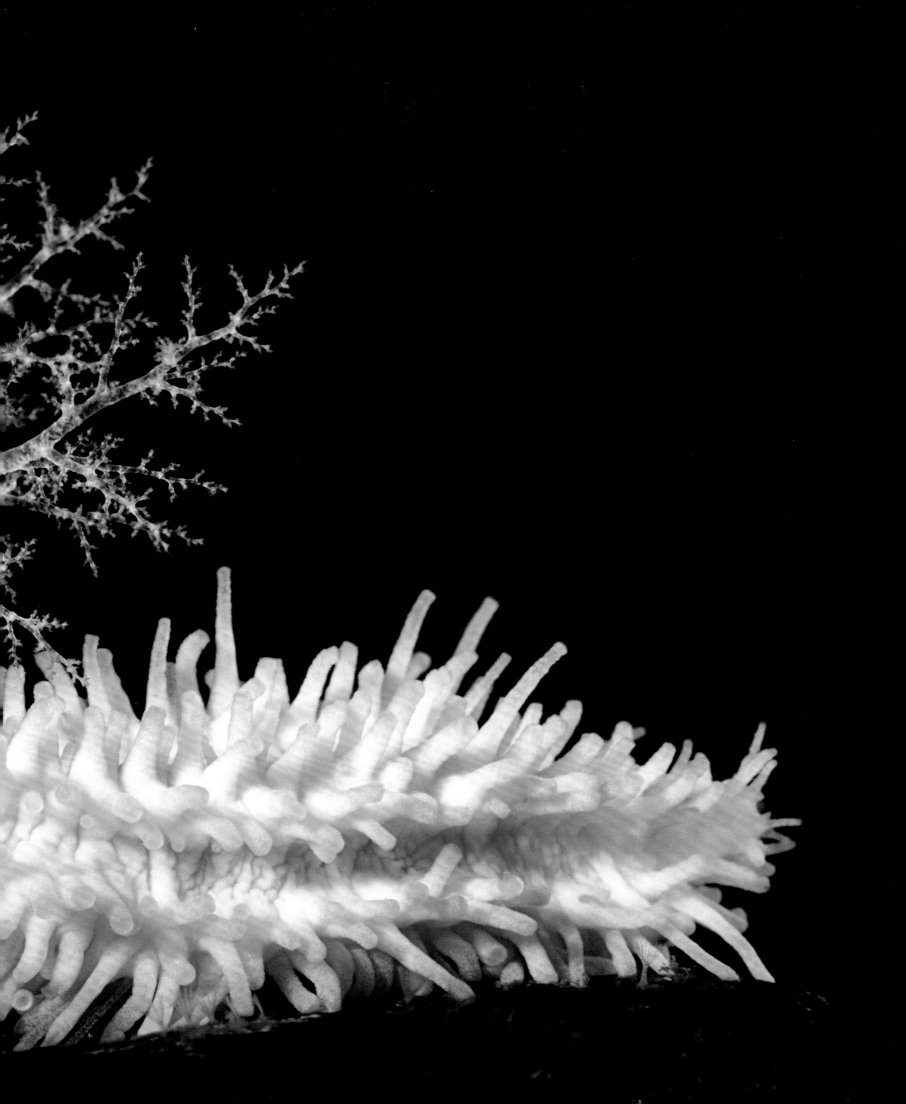

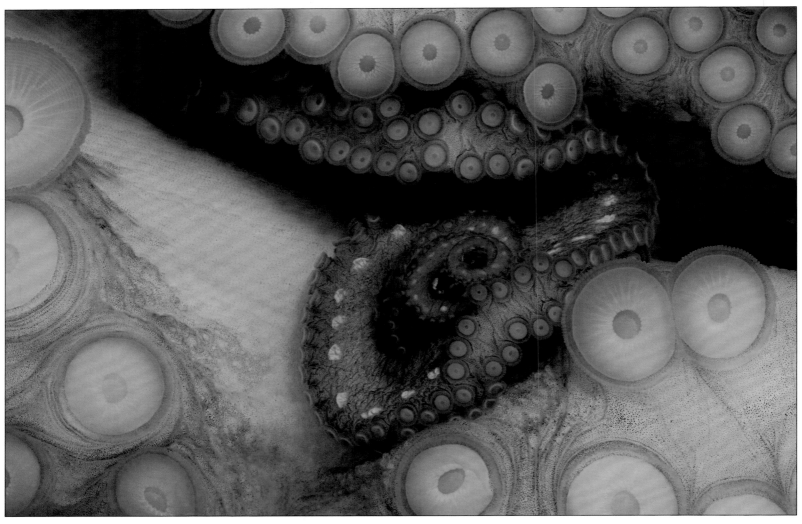
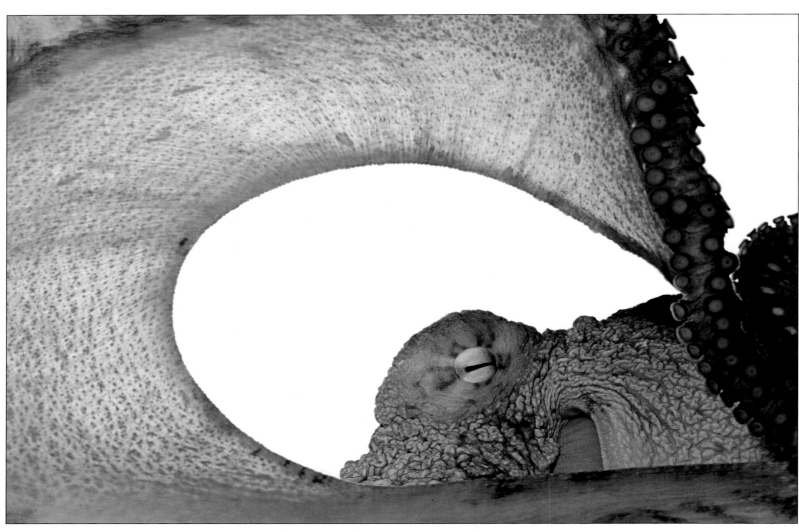

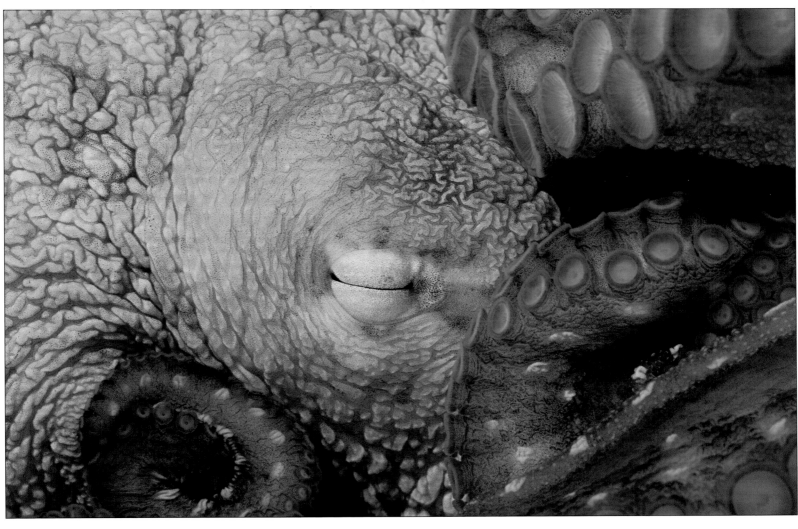

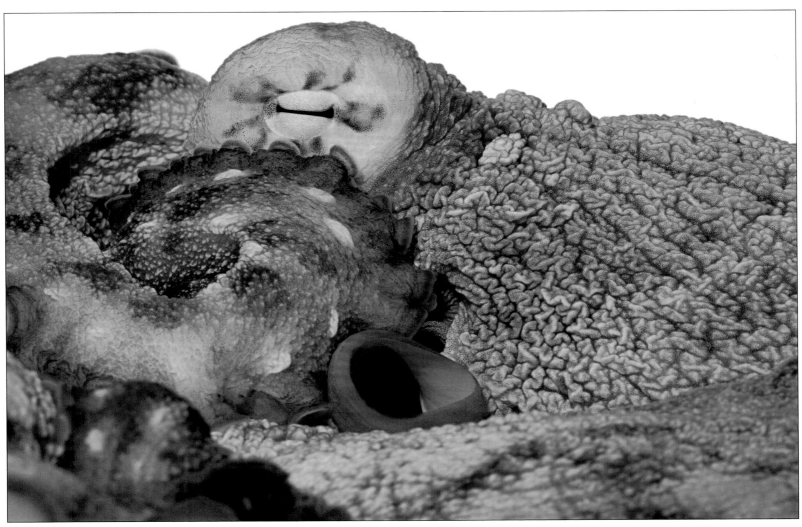

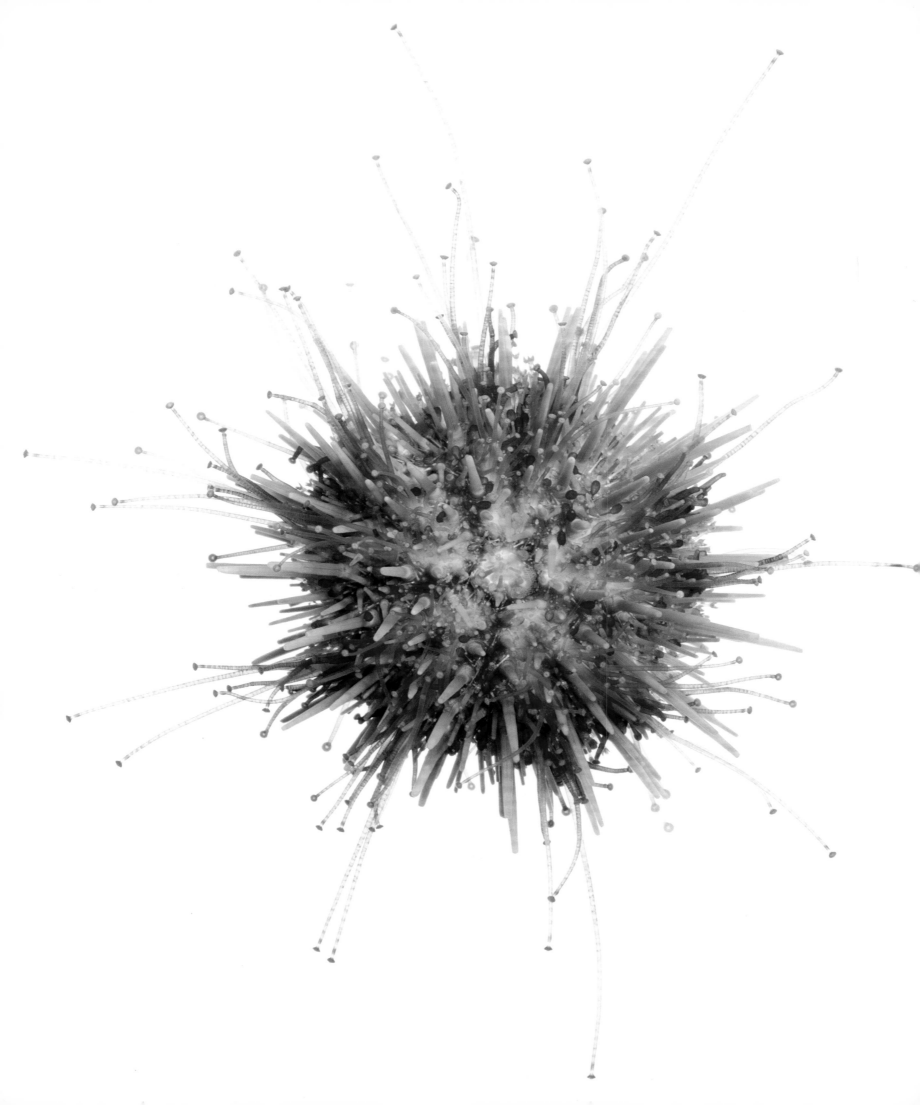

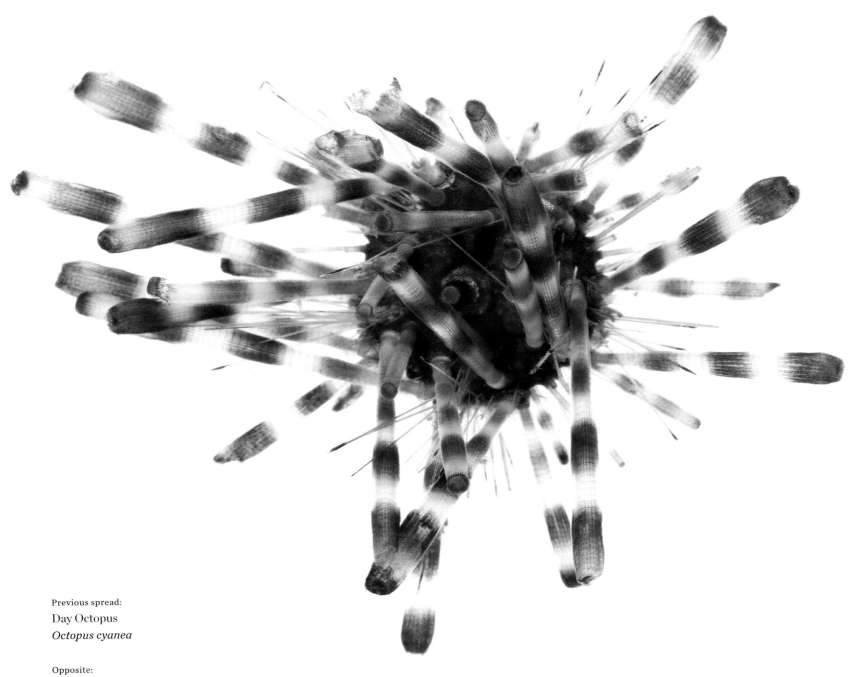

Previous spread:
Day Octopus
Octopus cyanea

Opposite:
Green Sea Urchin
Strongylocentrotus droebachiensis

Above:
Banded Sea Urchin
Echinothrix calamaris

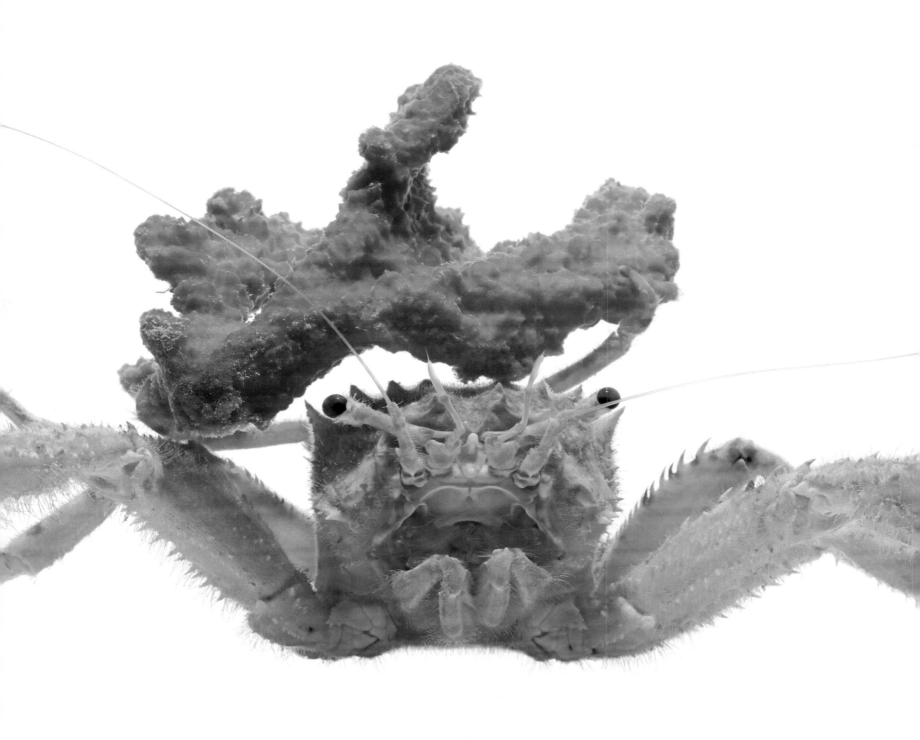

Oriental Sponge Crab and Sponge
Homola orientalis and Phylum Porifera

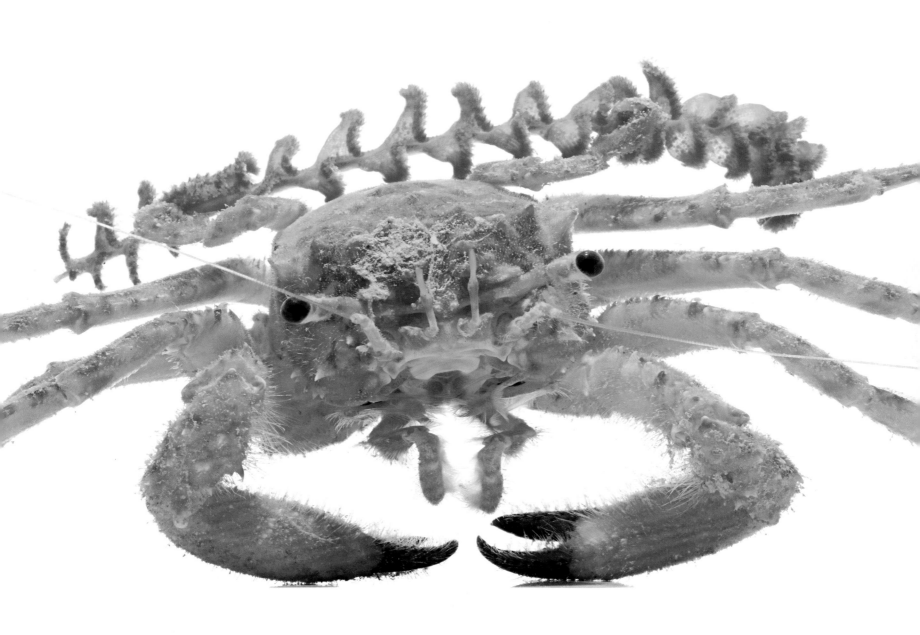

Oriental Sponge Crab and Flame Sea Pen
Homola orientalis and *Pennatula* sp.

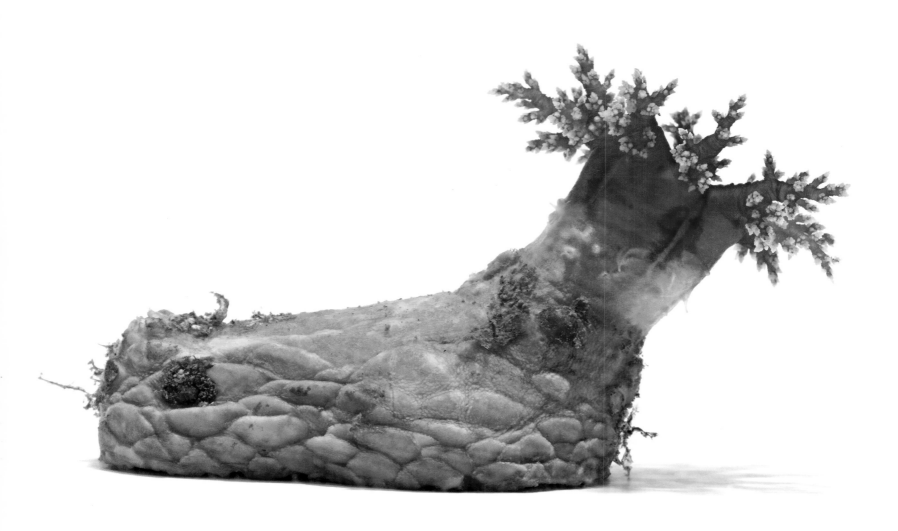

Creeping Pedal Sea Cucumber
Psolus chitonoides

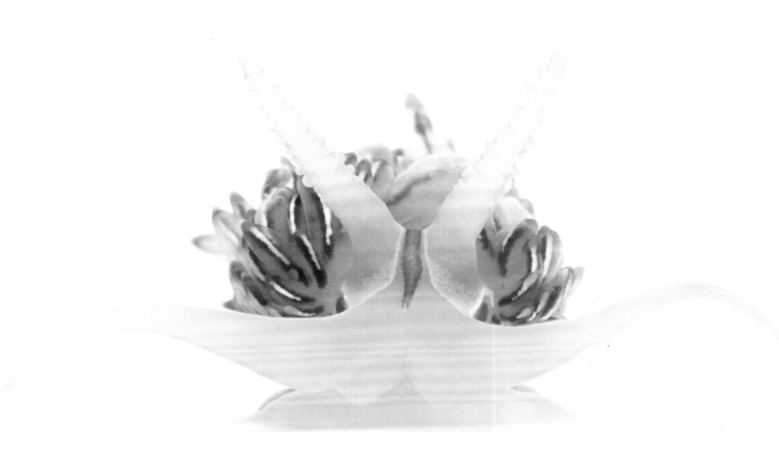

Opalescent Nudibranch
Hermissenda crassicornis

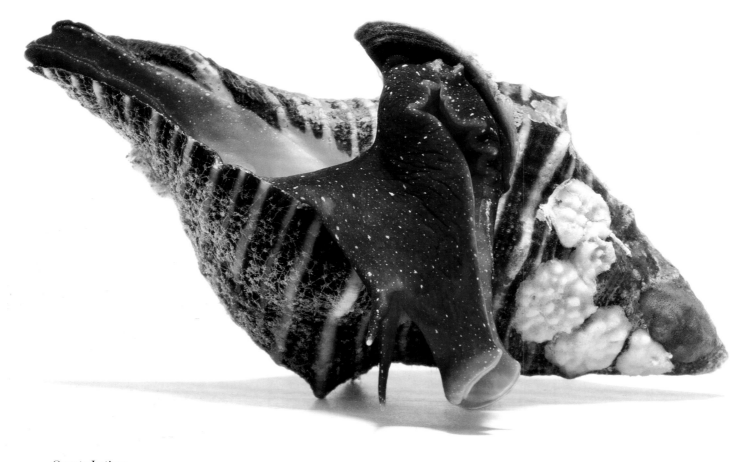

Ornate Latirus
Latirus amplustre

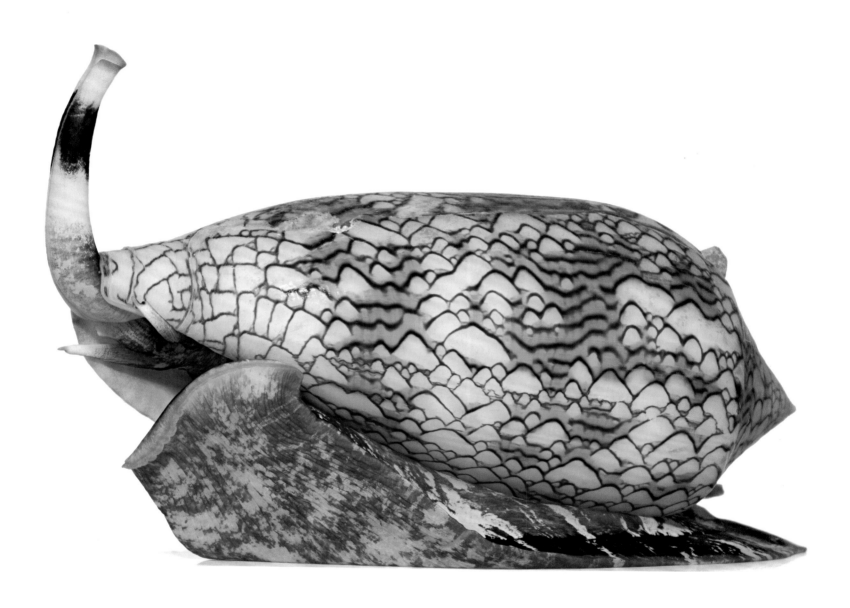

Textile Cone
Conus textile

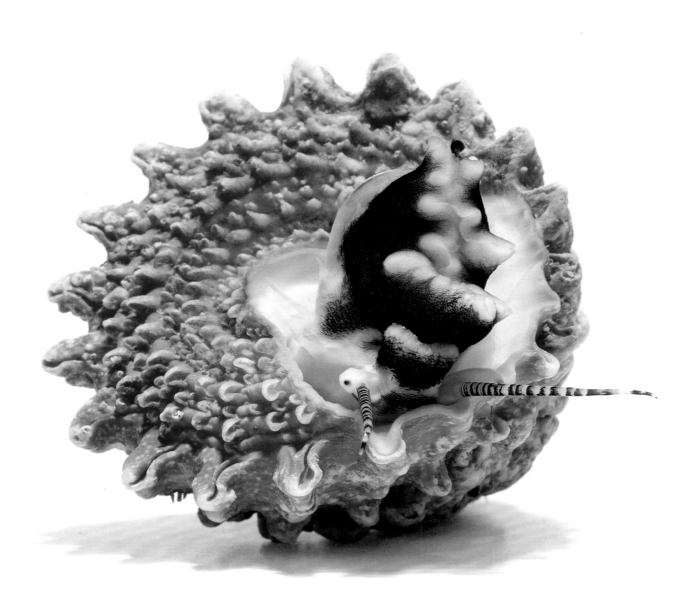

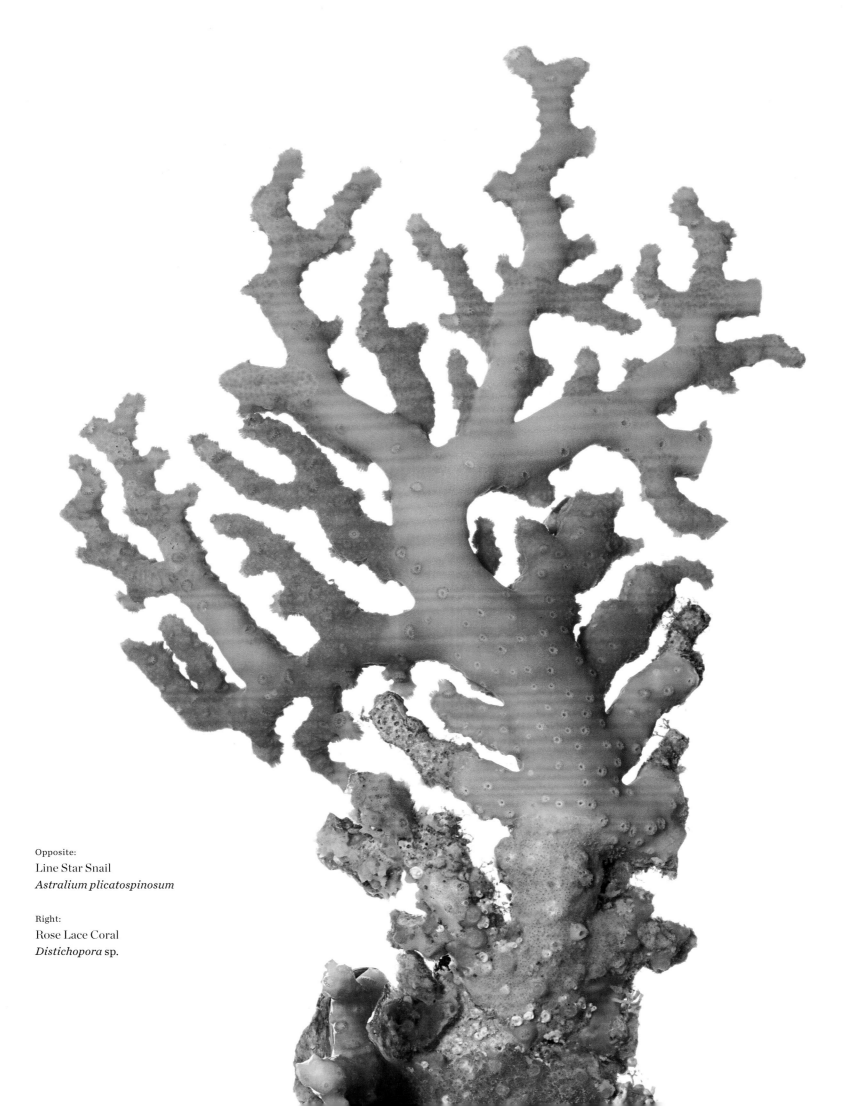

Opposite:
Line Star Snail
Astralium plicatospinosum

Right:
Rose Lace Coral
Distichopora sp.

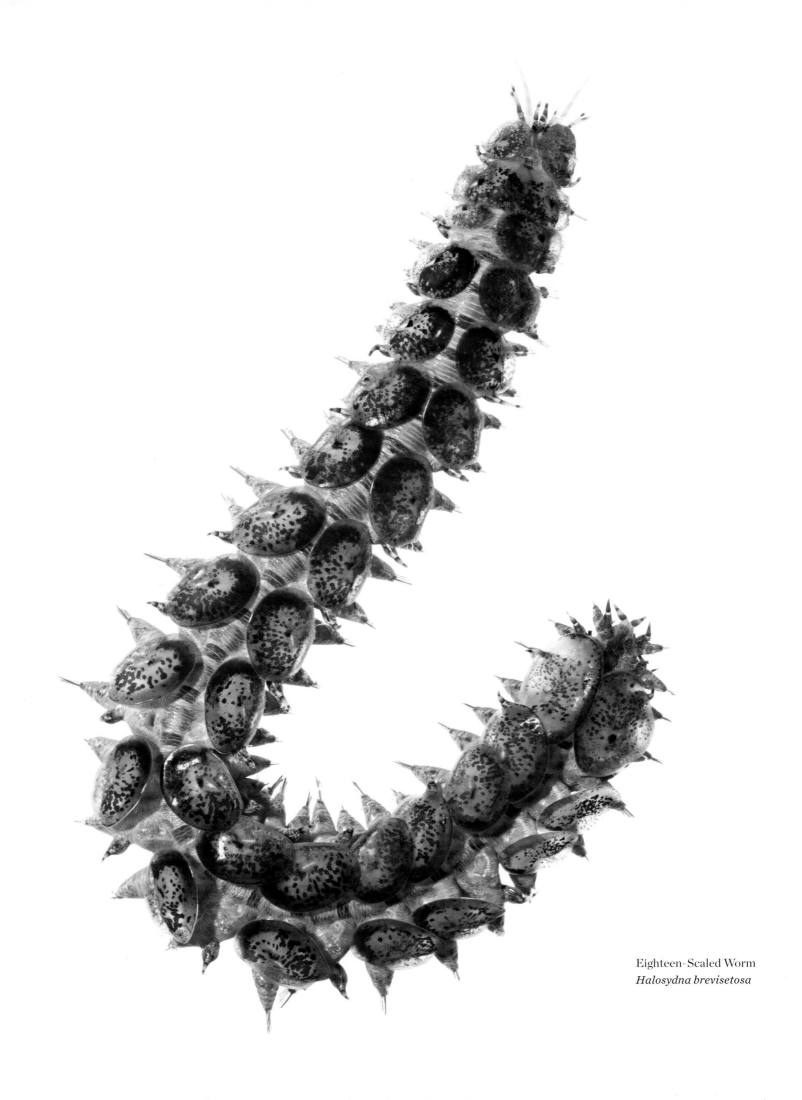

Eighteen-Scaled Worm
Halosydna brevisetosa

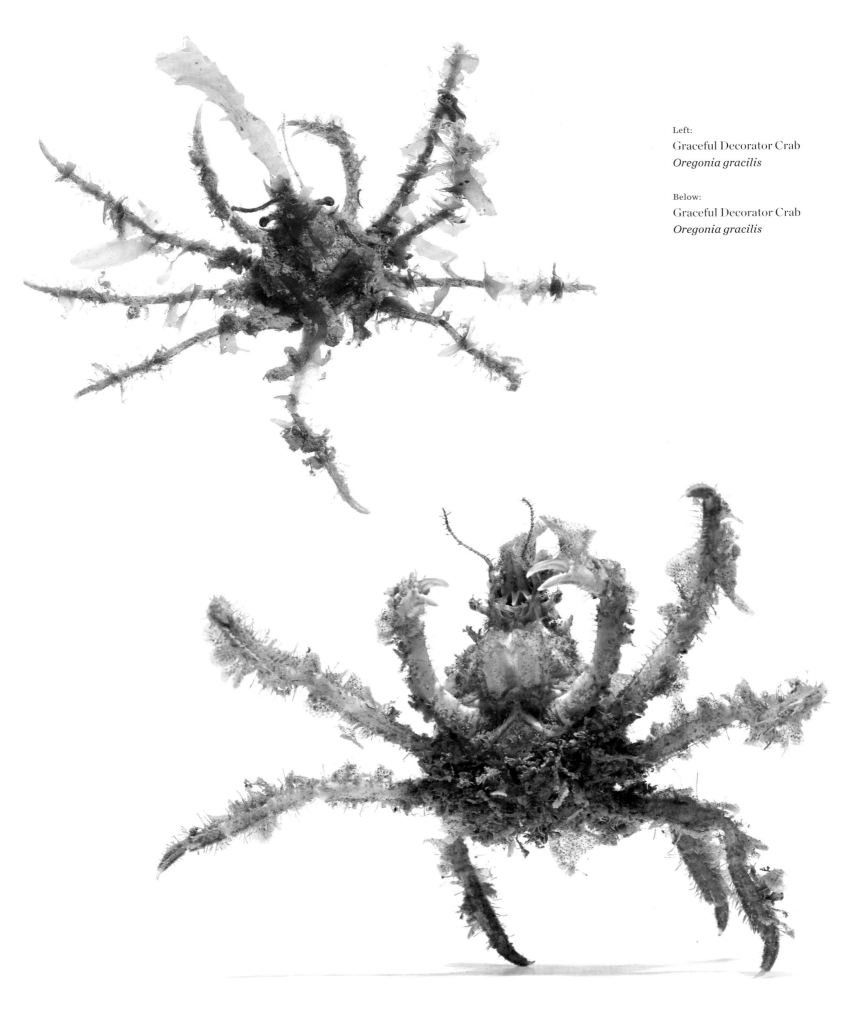

Left:
Graceful Decorator Crab
Oregonia gracilis

Below:
Graceful Decorator Crab
Oregonia gracilis

Basic Designs for Living

Body Plans

"Nature has created an inexhaustible wealth of wondrous forms whose beauty and diversity way exceed anything that has been created by man."

—Ernst Haeckel, 1899

How have animals acquired their shapes and designs? Every animal on Earth has a colorful history that illuminates how it has survived and kept its genetic information alive. Each animal is uniquely designed to win at the game of life. The vast majority of basic body plans in the animal kingdom came into being during the Cambrian period more than 500 million years ago. The species on the planet today follow those body designs. In fact, the Cambrian explosion produced the first representatives of most of the major phyla. There are millions of species on Earth, yet all the basic designs in the animal kingdom are represented in the thirty-four phyla, which encompass everything from shrimps to whales, from those that burrow underground to those that swim, live on coral reefs, walk the earth, fly the skies. All life's essential designs arose in a single evolutionary leap. Every new shape that followed is a variation on one of those themes. All but one of the thirty-four phyla are invertebrates, animals without backbones, and the phylum containing vertebrates, Chordata, where humans fit in, also contains invertebrates.

An animal's body plan enables it to live and reproduce within a particular environment, and an organism's early developmental stages are just as important as its adult features. How it develops from one stage to the next is part of its body plan. Often it is easier to determine similarities and differences in an organism's fundamental body plan in the embryonic stage, before modifications in response to environmental conditions take place. A body plan incorporates all the changes that take place during the life of an individual.

Animals have always been in continuous conversation with their environments, which shape and transform their body plans through evolutionary history. This conversation affects the genes of the species, which in turn mold future evolution. Clearly, some lively conversations were taking place during the Cambrian when a convergence of conditions set the stage for the emergence of an astonishing array of life-forms. An ancient body plan was passed down to fish, amphibians, reptiles, mammals, birds, and humans, all of which are within the phylum Chordata and possess a spinal cord, muscles, and a brain.

Each phylum has a characteristic body plan. The details of an animal's internal anatomy and embryology are important to its classification. Genetic analysis has opened the door to more clearly ascertaining the relationships between the phyla and their underlying body plans. Often the species within a particular phylum are found in a wide variety of habitats and display a great diversity of form, yet each retains some or all of its phylum's distinctive features. Basic body structure is laid down during early developmental stages and is thus more impervious to modification than the more superficial structures that appear at later stages. Sometimes adult structures are so highly adapted to different ways of life that related groups in the same phylum bear few similarities. Yet their embryonic stages are nearly identical.

I witnessed something akin to this phenomenon when I was on a magazine assignment to photograph several breeds of dogs. For each breed, I photographed an adult and a newborn puppy. The objective was to illustrate how different the mature dogs looked from one another and yet how strangely alike the newborn puppies looked. Of course dogs are all members of the same species, but even within a species, differentiation is less obvious in the early developmental stages.

All organisms carry in their genes clues to their evolutionary history, and genetic sequences are blueprints for carrying out body plans. Almost all the cells in our bodies have a complete set

of genes, and in those genes are the instructions for building an organism. Scientists have identified a group of genes that regulate the complex process of development; they masterfully conduct an orchestra of thousands of other genes. Known as Hox genes, they are turned on early in development and, when activated, they tell other genes what patterns to form in order to turn an embryo into a hermit crab, an octopus, or a human being.

Considering the seemingly endless variety of bizarre forms animals can achieve, it may be surprising that there are only three basic styles of symmetry in animal design: spherical, radial, and bilateral. Sponges are the exception because they have an asymmetrical body plan.

Spherical symmetry is found only in adult unicellular protozoan organisms, the best example of which are radiolarians, free-swimming, shelled protozoa that occur in all the world's oceans. The zoologist and artist Ernst Haeckel, a contemporary of Darwin and a popularizer of his evolutionary theory, made exquisite renderings of the microscopic radiolarians, some of which became the inspiration for the furniture designs and architecture of the day. The gateway to the Paris World's Fair in 1900 was inspired by Haeckel's drawings of radiolarians.

All radial animals, such as anemones, jellyfish, corals, sea stars, sea urchins, and sand dollars, are essentially pie-shaped; a lengthwise cut will yield two identical pieces, while a crosswise cut in any direction will yield two differently shaped pieces. They have a top and a bottom but no right or left sides. They have no head and no tail, and no side that leads first, rendering locomotion relatively ineffective. Radial animals either drift or live a sessile life. Those that are sessile have nothing to fear from below since their bottoms are specialized only for attachment. The circle of tentacles around an exposed mouth is prepared to meet the environment from above and all sides.

To achieve efficient locomotion, one end of an animal must go first. The specialization of a leading end, accompanied by a differentiation of the upper and lower surfaces of the body, is called bilateral symmetry. Bilateral design lends itself to streamlining and, with a head to direct movements, gives rise to a fast-moving and extremely successful organism. The first bilateral animal was something like a modern flatworm, and it was the precursor to all bilaterally symmetrical creatures.

Bilateral animals may appear to be more vulnerable to attack than radial animals, which can detect and ward off predators from all sides. However, the intense concentration of sense organs in the front end of a bilateral animal enables these animals to detect danger ahead, and their more efficient locomotion—that is, their speed—allows them to escape from enemies more successfully than radial animals can. It's better to know where you're going than where you've been!

A ROMP THROUGH THE PHYLA

Now we'll consider eight of the major phyla and their defining body designs: Porifera, Cnidaria, Platyhelminthes, Arthropoda, Mollusca, Echinodermata, Annelida, and Chordata.

The ancient sponges, members of the phylum Porifera, are at the base of the phylogenetic tree and predate all other animal phyla that emerged during the Cambrian explosion. At the cellular level of organization, they have no definitive shape; they are asymmetrical and amorphous. Sponges invented collagen, a protein found in all animals that provides the body with the rigidity required to grow large. Sponges are active and powerful pumping organisms, filtering a ton of water for every ounce of food they consume. Deceptively simple, they can resurrect themselves from a single cell. Nervous systems—the centralization of cells into nerve cords—developed after sponges.

Members of the phylum Cnidaria, such as anemones, jelly-

fish, and coral, invented the ability to move, an important evolutionary breakthrough. Cnidarians developed tissues made up of two layers of cells and had two sets of muscles that could bend in any direction. Built on a radially symmetrical body plan, they were the first animals to have nerves with electronic impulses. Muscles and nerves! They also wielded toxins, making them the first predators on the planet. All cnidarians have tentacles surrounding a mouth, which is the only opening to the digestive system. There is no anus. Cnidarians must eat and pass undigested food through their mouths. Early naturalists understandably wondered whether cnidarians were plants or animals or something in between.

Coral polyps, another cnidarian, instead of competing with one another, cooperated and built collective homes so massive they are visible from outer space. Here is an interesting question: What is the largest biogenic structure on Earth? A coral reef! (The human-built Panama Canal is the second largest.) Corals are living proof of the power of cooperation. Most cnidarians were originally bound to the seafloor, but then jellyfish released themselves and began to swim the oceans in search of prey. A new variation on the body plan was created. The flattened radial shape was not designed for forward motion, but the high drag of the body form creates a flow that allows jellyfish to capture prey. Every jellyfish shape creates a unique flow for capturing different prey.

A revolutionary body plan emerged about 565 million years ago in the form of an animal much like the modern flatworm, a member of the phylum Platyhelminthes. The fossil tracks sketch a portrait of an animal that had a sense of direction—it had a head! It was the first animal with bilateral symmetry, having a head and a tail and sophisticated stereo senses directed by a primitive brain. It was also the first to assemble genetic instructions for building this new kind of body, which is the same basic design humans have. This was the first animal to move with intent, the first to pursue food and sex. It was the first active predator, having a direct relationship with the world through sense organs that could locate prey and the locomotory ability to pursue it. It was also the first animal with a central nervous system. These animals could search out whatever they needed to survive.

More than 80 percent of all described living animal species—including crabs, lobsters, shrimp, copepods, barnacles, insects, and spiders—belong to the phylum Arthropoda, making the arthropod body plan the best represented in the animal kingdom. They are characterized by an exoskeleton—a hard, external, protective covering, which, in addition to protection, facilitates locomotion. The exoskeleton is made of chitin, an organic protein, and is biomineralized with calcium carbonate for added strength. Equipped with jointed legs, which provide flexibility, stability, and shock absorption, they have the ideal features of an all-terrain vehicle. Tendons attach to powerful muscles to produce a range of motion. They developed sensors (antennae) to help guide them, and they were the first animals with complex eyes capable of perceiving sharp images. Their legs and body segments could adapt to almost any opportunity, and arthropods took full advantage of their infinitely modifiable design. They ruled the ancient seas and were the first to venture onto land and to take flight. They conquered sea, land, and air and are the only group of animals to have accomplished all three.

There are more arthropods in the ocean than any other group. Those that left the sea eventually developed a tool kit with which to master their environment on land. In a sense, arthropods were preadapted to colonize land. Their jointed exoskeleton provided protection against drying out, support against gravity, and a means of locomotion that was not dependent on water. Fossil evidence traces the first footprints on land, called track ways, more than 400 million years ago, and this pioneering animal walked out of the sea and onto land on legs with hinged joints. Arthropods landed with a winning design! The field of robotics

has drawn inspiration from the arthropod body plan and used it as a model. This versatile body plan never stopped adapting—the arthropods revolutionized life.

The body plan of the phylum Mollusca, whose members include snails, slugs, clams, oysters, octopuses, and squids, is the most malleable in the animal kingdom. There are so many variations on this plan, from slow tank-like snails to jet-propelled squids, that commonalities are often difficult to detect. The basic body plan includes some kind of foot for mobility, a rasping tongue called a radula, and a mantle that secretes body armor. The basic features are highly modified in a specialized creature such as the octopus and are relatively unchanged in the more primitive forms such as chitons, which have evolved very little in 500 million years. Mollusks are an enormously successful group, morphing their body parts to adapt to new conditions and lifestyles. They have been unquestionable winners in the biological arms race, managing, through endless innovation, to eat and to avoid being eaten. More than any other invertebrates, mollusks and their shells have played significant roles in human culture as food, ornamentation, a form of monetary exchange, symbolic imagery, and in ceremonial rituals. People have long been fascinated by seashells; their spiral beauty is an inspiration in form and design. And of course people relish the soft and succulent flesh of clams, oysters, calamari, and escargots!

Because the basic blueprint of the molluscan body plan lends itself to extreme modification, mollusks have survived and thrived, as exemplified by the wildly dissimilar animals living in a wide range of habitats. "Adapt or die!" would be an appropriate motto for members of the phylum Mollusca. No other phylum has produced such ingenious plasticity of form. Consider that one of the basic characteristics of the molluscan body plan, a muscular foot used for clinging and locomotion, has in the octopus evolved into a mouth!

The chambered nautilus is a member of the phylum Mollusca, an impressive example of a lineage that managed to break free of the seafloor and achieve buoyancy, rising at night to seek food and swimming by jet propulsion. Sometimes called a "living fossil," it is a descendent of the long-extinct ammonites, which are beautifully represented in the fossil record. They were well armed against predators, with their thick spiral shells sometimes reaching several feet in diameter. Ammonites dominated the sea until they were outgunned by swift, shell-cracking predators. When their armor was no longer sufficient protection, they had to retool and develop other defenses to survive; this led to the remarkable trajectory of cephalopod evolution. Over time, cephalopods jettisoned their external shells and internalized them, as exemplified by cuttlefish, squid, and the greatest achievement in marine invertebrate evolution—the octopus. Their skill set expanded to include camouflage, speed, curiosity, excellent vision, and, above all, intelligence. Octopuses are the most intelligent of all marine invertebrates. They are capable of memory and learning but unfortunately have life spans of only a few years. Imagine what they could achieve if they were long-lived! I have seen them in the wild and photographed them many times, and when they look back at me, I cannot help recalling Sylvia Earle's comment, "You know someone is home there." They wear their hearts on their sleeves, expressing themselves instantaneously on the surface of their skin by changing colors, patterns, and textures in relation to matters of defense, disguise, and courtship, as well as in response to various stimuli such as light, temperature, humidity, hormonal rhythms, and psychological challenges. This astounding ability to change color and pattern is accomplished via several layers of special pigment cells in their skin called chromatophores, which expand and contract according to nervous control from the brain. Octopuses also possess reflecting cells, which act like mirrors creating iridescence. Plus, they have eight muscular arms festooned with

suckers and an ink sac that discharges a dark cloud of ink to confuse predators. They are adapted to an active lifestyle and complex behavior and are truly the crowning achievement of the marine invertebrate world.

Members of the phylum Echinodermata, such as sea stars, sea cucumbers, brittle stars, sand dollars, sea biscuits, sea urchins, sea lilies, and feather stars, demonstrate that there are ways of being successful that do not depend on brainpower, strength, and speed. In fact echinoderms do not have heads, faces, or eyes and are barely recognizable as animals. One of the students I met during my fieldwork remarked that "echinoderms are the punk rockers of the marine invertebrate world." They are indeed bizarre and seemingly alien creatures, and they stretch our imaginations. Yet they are evolutionary success stories. Their body plan is based on five-part radial symmetry, and all echinoderms—from urchins, which are five-part spheres, to sea cucumbers, which are five-part tubes—are variations on that plan. Their mobile, sensory tube feet are unique in the animal world. Some species manage to coordinate the movements of thousands of these tiny, hydraulic feet, which can also "taste" water. Most echinoderms have a well-developed internal skeleton with protruding calcareous skeletal structures. The echinoderm design would not seem to be a blueprint for success, but in fact it exemplifies a distinctly different way of succeeding in the world.

When I worked at Friday Harbor Marine Laboratories, I was continually amazed by the echinoderms. At any given time there were many species of invertebrates from different phyla living together in the lab's sea tables, with fresh seawater pumped in from the harbor just outside the lab to create a hospitable environment for the animals. While in the sea tables, the animals were observed by students and researchers and photographed by me. Who were all the animals in the sea tables afraid of? The sea stars! They all avoided them. Sea stars are lovely to look at but are fear-

some predators. They also lay eggs from their "armpits," defying human expectations of how animals should operate.

No discussion of the major phyla would be complete without the worms. More than half of the thirty-four phyla have wormish shapes, and the very first bilateral animal was an ancestor of the modern flatworm. Worms, which excel at the art of digging and pushing their way underground, have adapted to almost every habitat on Earth, and their collective impact on the planet is significant. It is thought that burrowing worms play a key role in sustaining life on Earth by recycling plant and animal matter into carbon dioxide gas and thereby helping to stabilize the atmosphere. Marine worms help shape their environment by stabilizing the mud bottom.

I have been enthralled with some of the tube-building marine worms. They are architectural artisans, carefully selecting individual sand grains and assembling them into tubular homes by secreting a substance that works like mortar. These constructions are exquisitely beautiful and serve their makers well. Some marine worms secrete a substance that they fashion into delicate tubes resembling fine parchment.

The members of the phylum Annelida represent what Dr. Alan Kohn, one of my marine invertebrate mentors, calls "advanced wormishness." Basic worm design begins with a pointed cylinder, sometimes flattened, that is well suited to many lifestyles. Annelids are segmented, which facilitates flexibility and controlled movement, and possess semi-independent compartments, which allows for regional specialization, along with powerful muscles and a sophisticated nervous system.

I have learned not to underestimate marine worms. Their diversity, as reflected in their structures, colors, iridescence, and various ways of making their living, is impressive and fascinating. Admittedly I avoided them at first but was won over after several guided expeditions to the mudflats. They are not easy to get to

know. You have to be willing to get down and dirty, shoveling and digging in the mud, but you must also know how to extract them without harming them. You have to exercise a lot of patience while waiting and watching over them as they adjust to their temporary homes in the sea tables and eventually reveal themselves. I've witnessed some dazzling revelations in the marine worm realm and have attempted to capture them in my photographs.

Now for the phylum Chordata, which includes the vertebrates and humankind. I will not elaborate too much on the chordates since 97 percent of them are vertebrates, but it is worth noting that we share this phylum with some unlikely invertebrate relatives: tunicates, sometimes called sea squirts (broadbase tunicate, page 73); and lancelets, nearly transparent flattened spear-shaped animals. What possibly could be the inconspicuous body plan unifying the chordates? The three defining chordate creature features are a notochord, which is a cartilage-like stiffening rod supporting the body that in vertebrates has been replaced by a bony spinal column; a dorsal nerve, which is a hollow nerve structure that in most chordates becomes the upper part of the spinal cord and brain; and pharyngeal gill slits. These shared features are often present only in extremely early developmental stages. All three features are present in the larval stage of tunicates but not in the adults; our own pharyngeal gill slits close up when we're still in the womb. Nevertheless these shared traits make us evolutionary cousins. The phylum Chordata is a prime example of animal relationships established exclusively through the embryonic stages, since similarities between member species are difficult, or impossible, to detect in the adults.

The acorn worms are not chordates; however, they were introduced to me by enthusiastic scientists who emphasized an affinity between these animals and our own phylum, Chordata. They have soft, long bodies that burrow in the sand and mud of seashores. In fact, they are their own phylum, the hemichordates,

members of the phylum Hemichordata; and in the big picture of all animal life, they are relatively closely related to chordates. They share early developmental similarities, particularly gill slits. Some scientists think that primitive ancestral forms of the phyla Chordata, Echinodermata, and Hemichordata may have looked like acorn worms. I have attempted more than once to make a successful portrait of an acorn worm and have accepted the fact that although these animals hold extreme fascination for scientists, they just don't qualify as good portrait subjects for me. But you be the judge—here it is!

Above:
Acorn Worm
Glossobalanus berkeleyi

Opposite:
Purple-Ringed Topsnail
Calliostoma annulatum

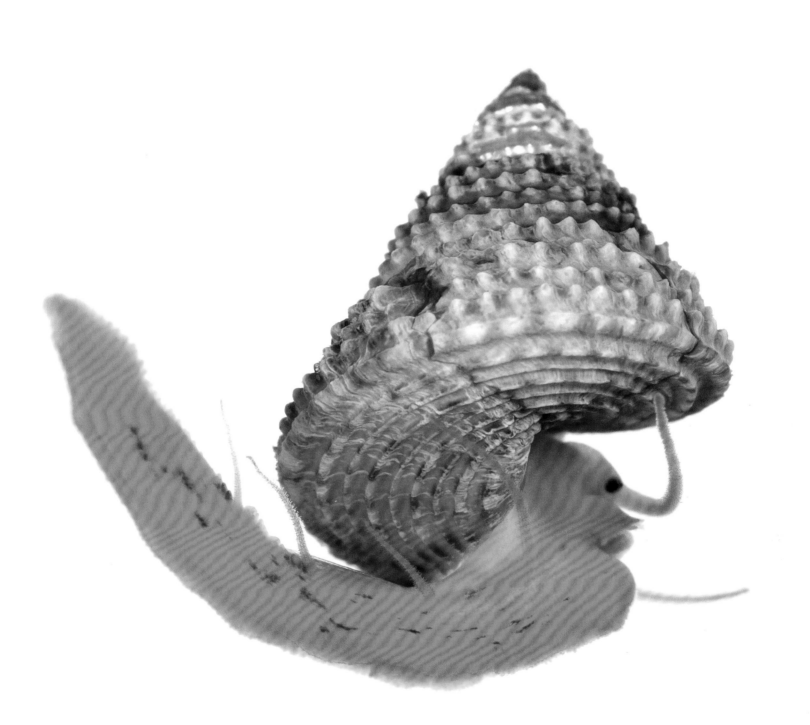

Mosaic Pom-Pom Crab and Anemone
Lybia tessellata and *Triactis* or *Bunodeopsis* sp.

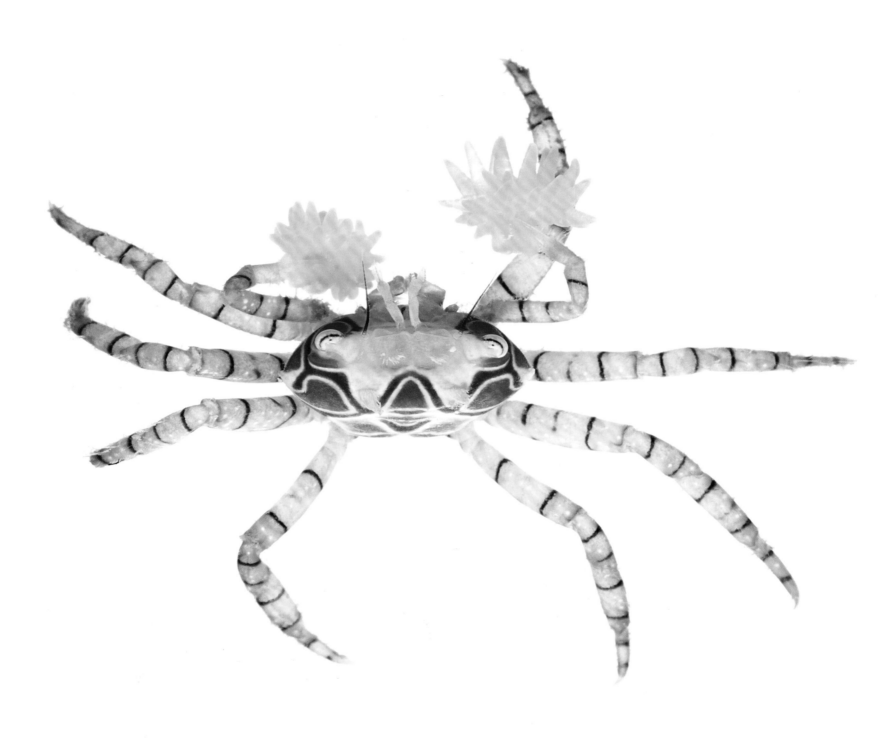

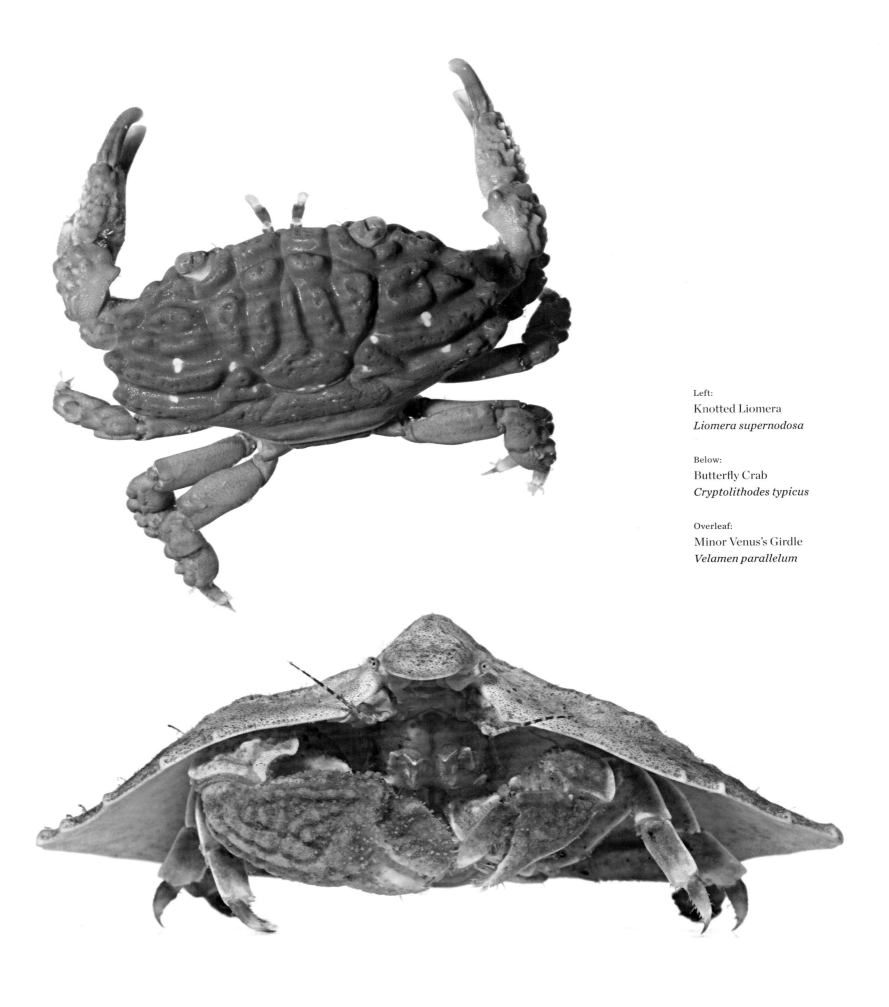

Left:
Knotted Liomera
Liomera supernodosa

Below:
Butterfly Crab
Cryptolithodes typicus

Overleaf:
Minor Venus's Girdle
Velamen parallelum

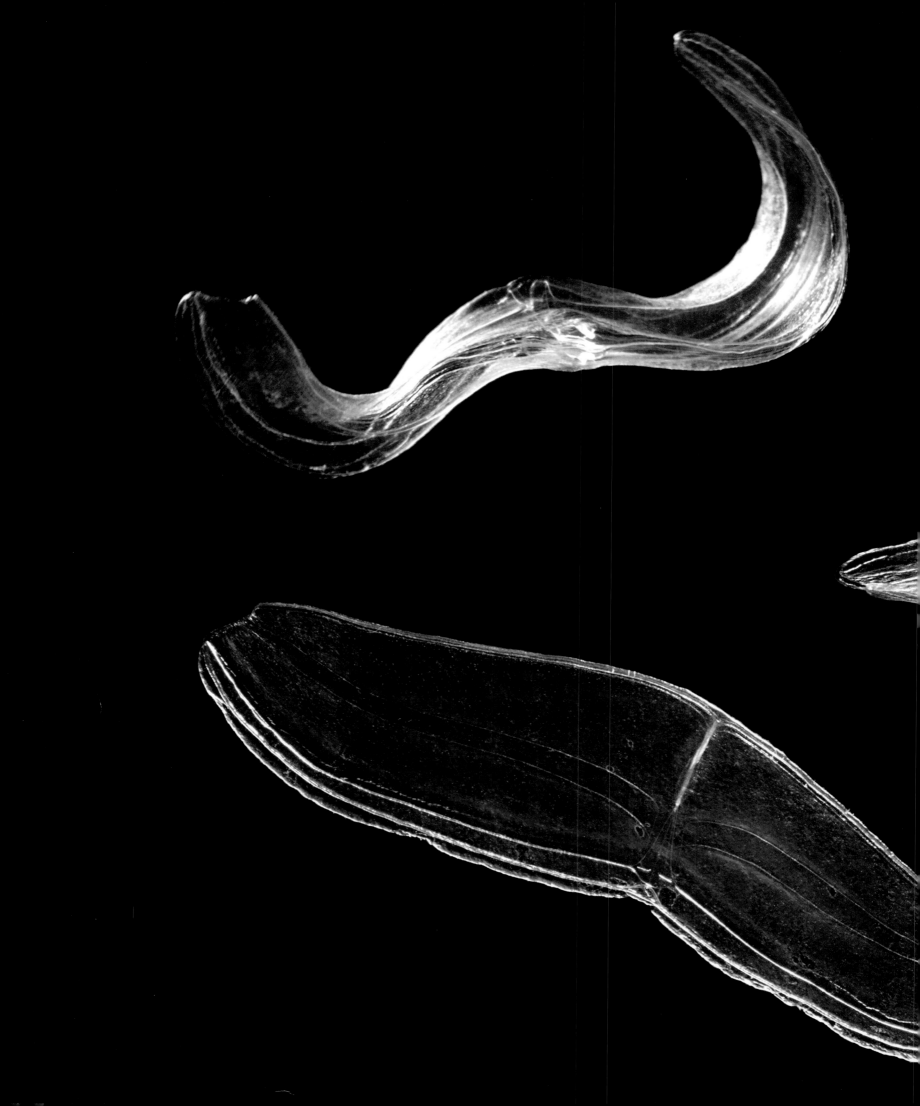

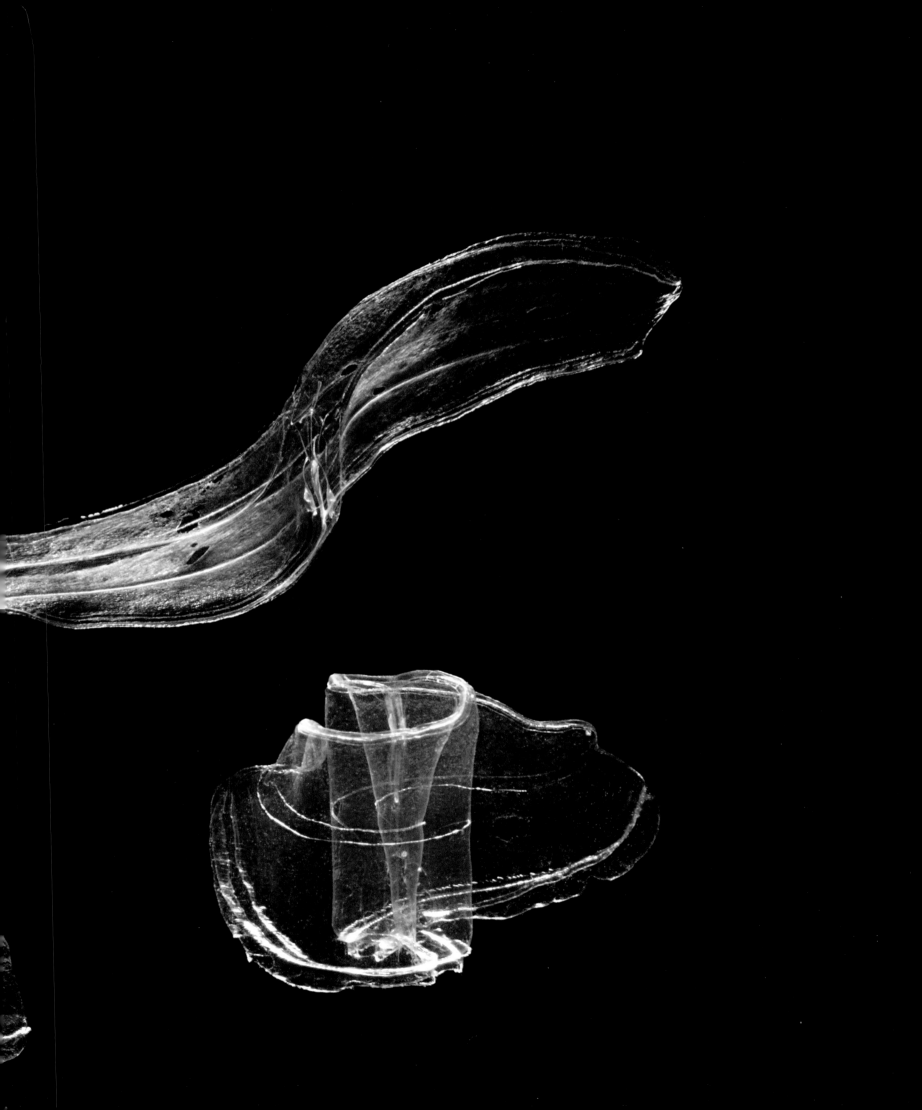

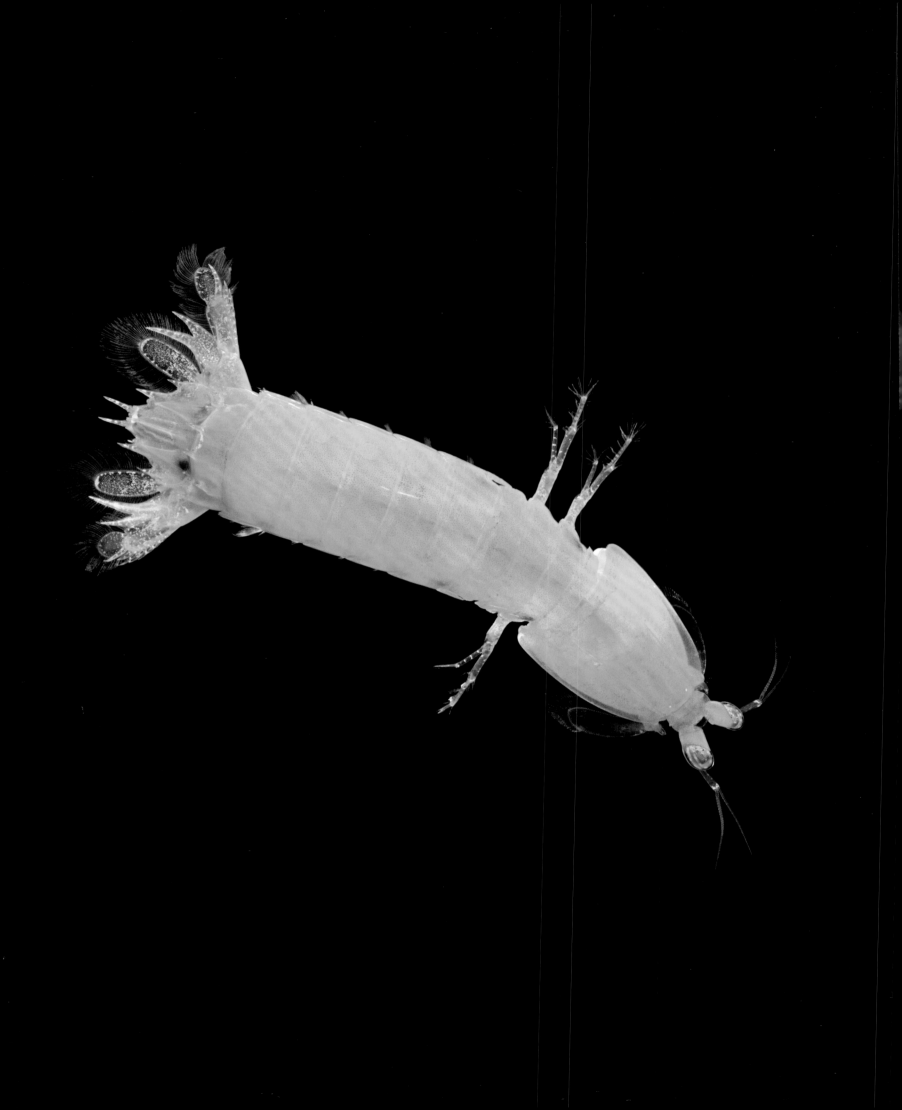

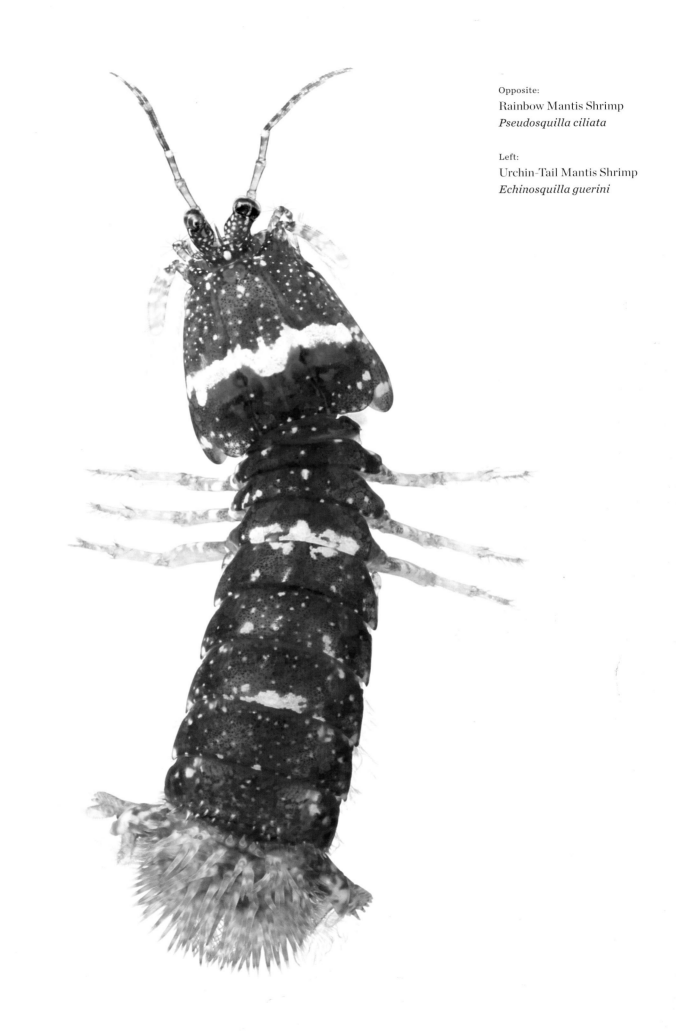

Opposite:
Rainbow Mantis Shrimp
Pseudosquilla ciliata

Left:
Urchin-Tail Mantis Shrimp
Echinosquilla guerini

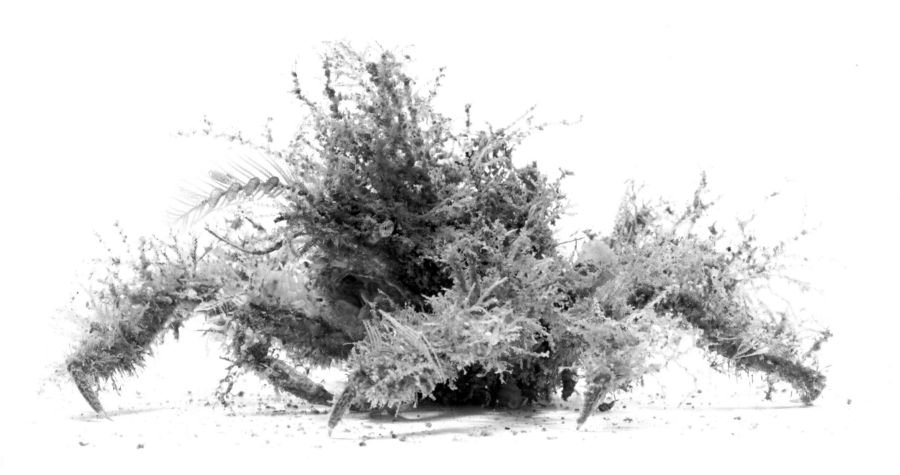

Overleaf left:
Snake-Arm Brittle Star
Ophionereis porrecta

Overleaf right:
Black Coral and Stalked Barnacle
Order Antipatharia and
Family Oxynaspididae

117

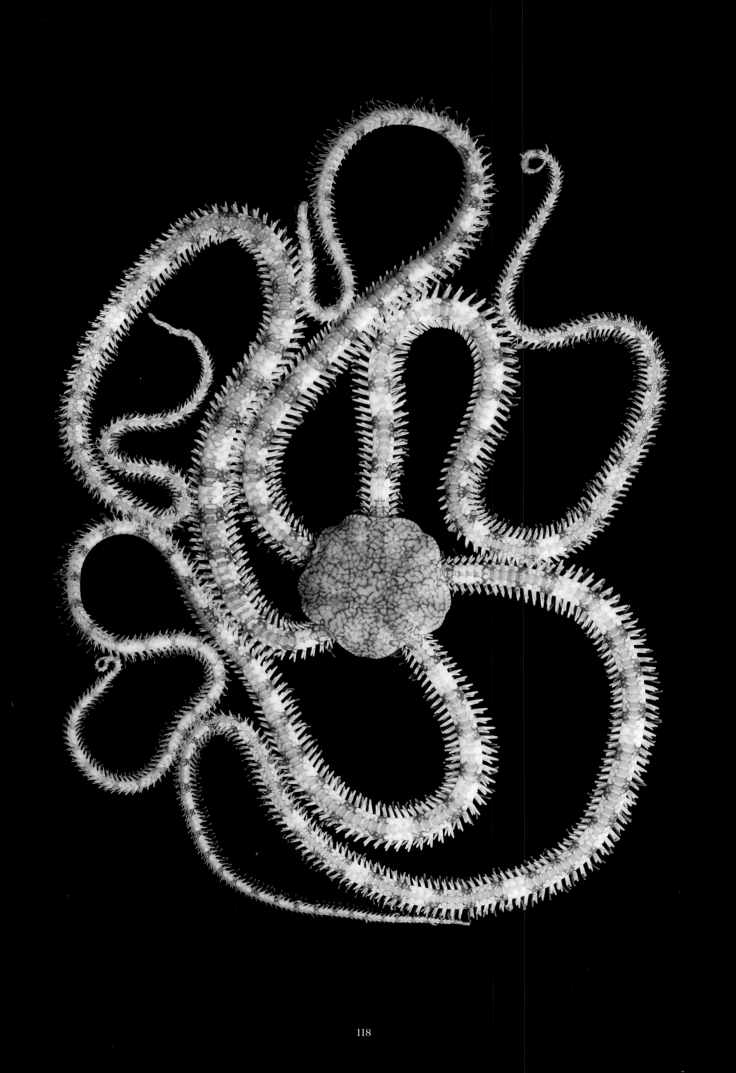

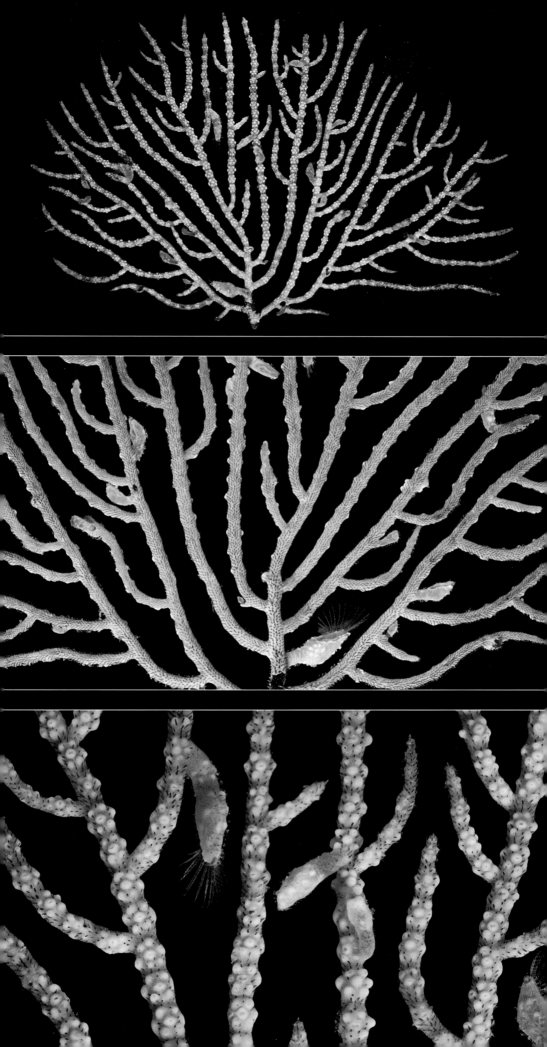

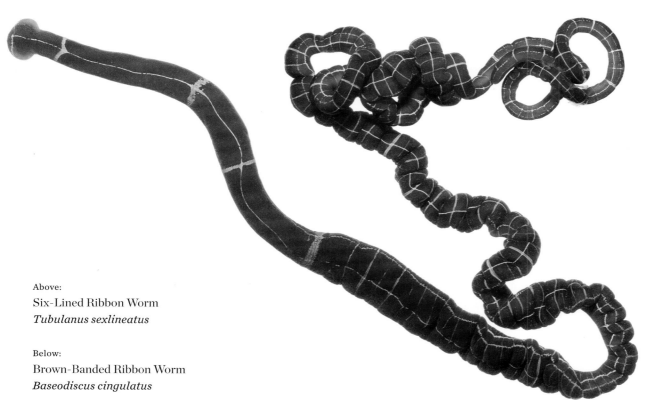

Above:
Six-Lined Ribbon Worm
Tubulanus sexlineatus

Below:
Brown-Banded Ribbon Worm
Baseodiscus cingulatus

Opposite:
Orange Ribbon Worm
Tubulanus polymorphus

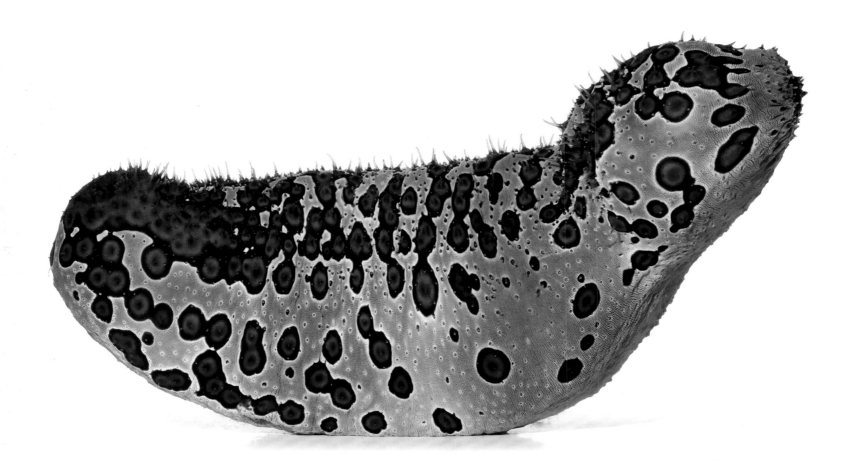

Leopard Sea Cucumber
Bohadschia argus

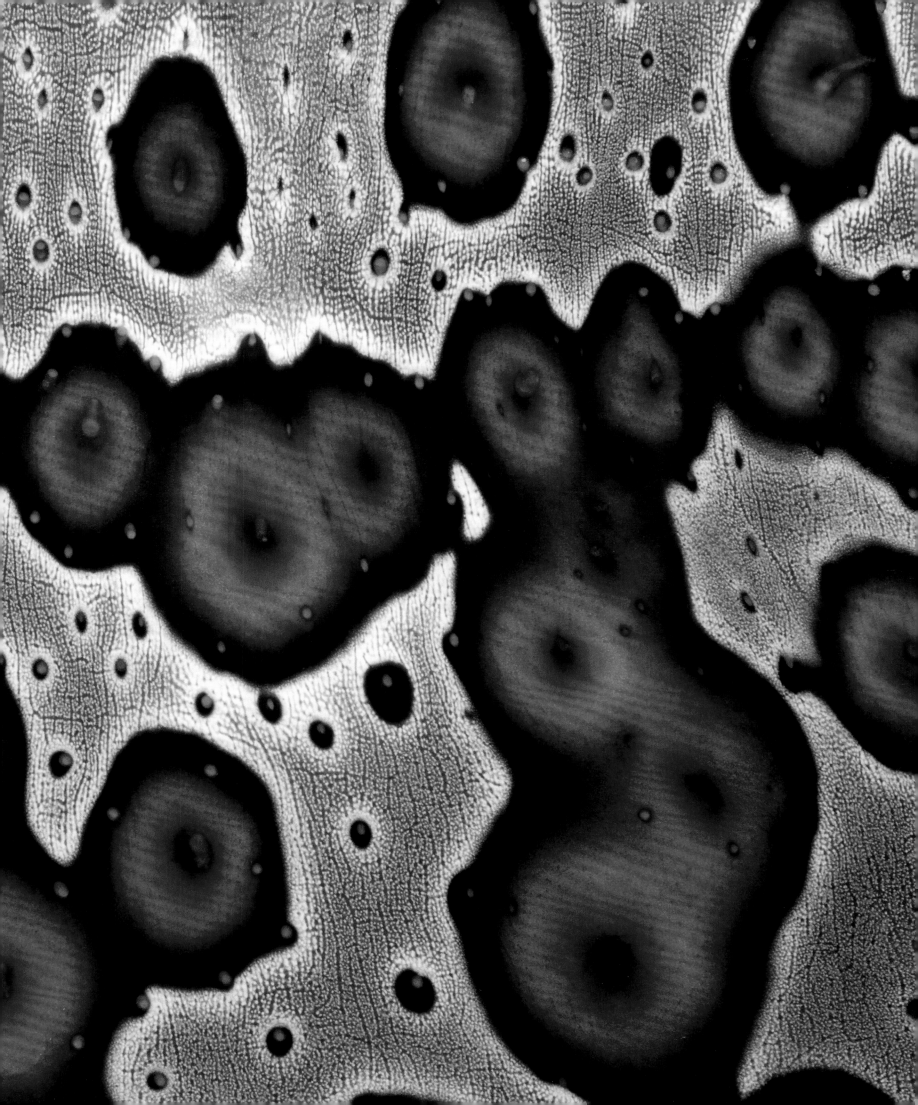

Opposite and below:
Sea Spider
cf. *Phoxichilidium*
quadradentatum

Overleaf:
Large Green Phoronid
Phoronopsis harmeri

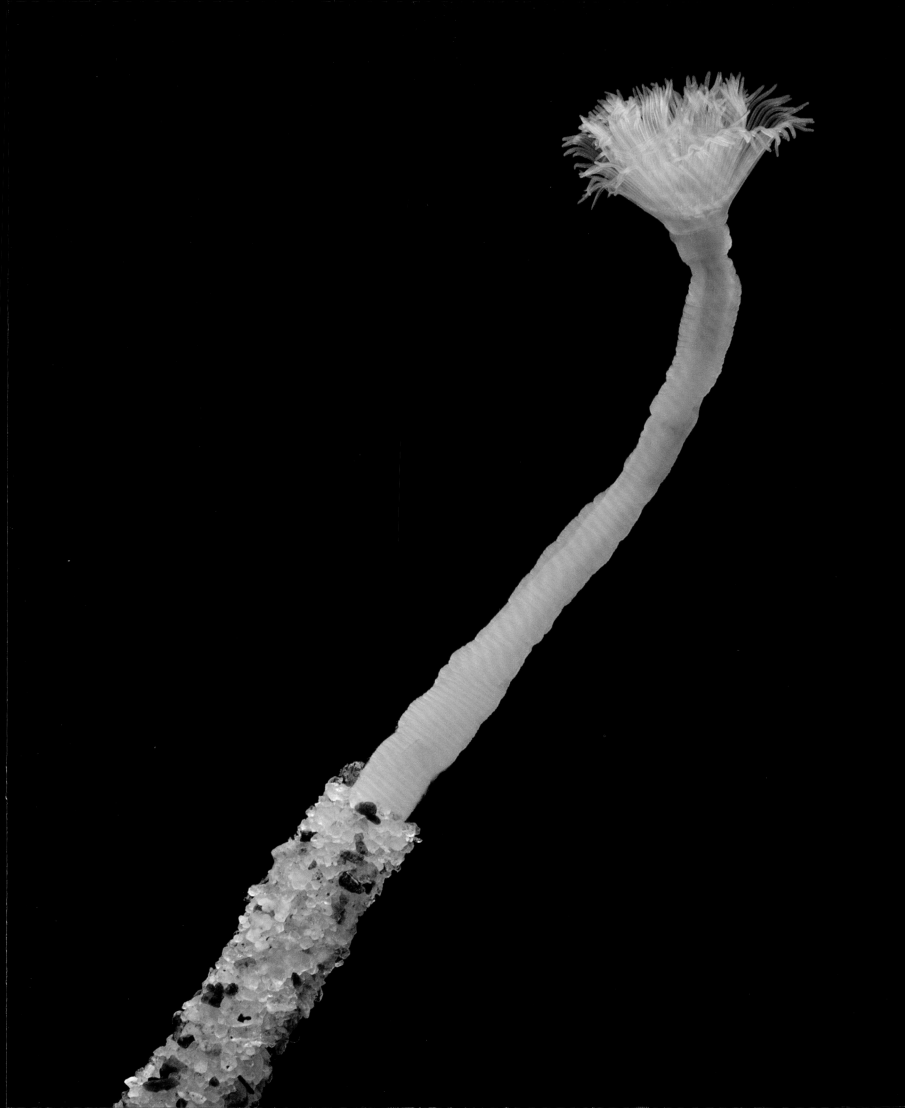

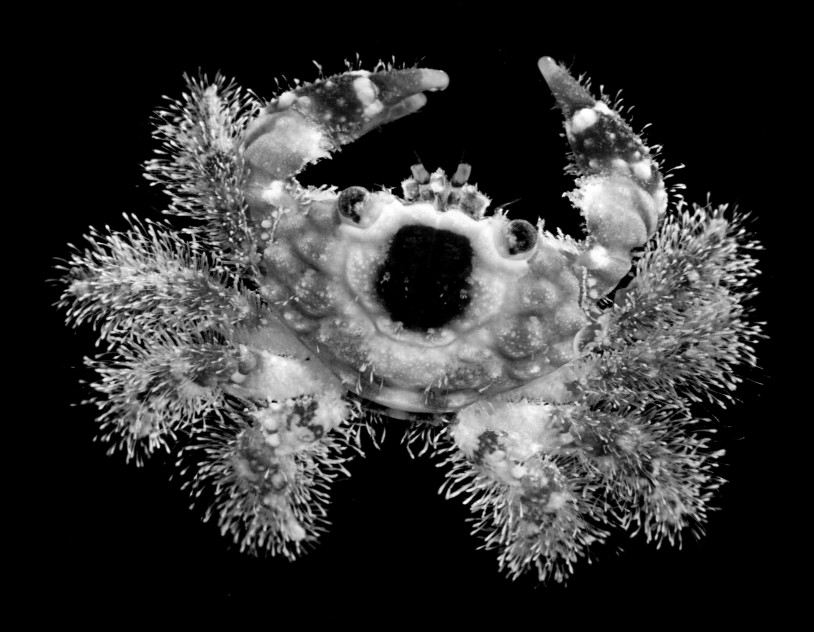

Previous page left:
Ice Cream Cone Worm
Pectinaria sp.

Previous page right:
Fuzzy Island Crab
Tweedieia laysani

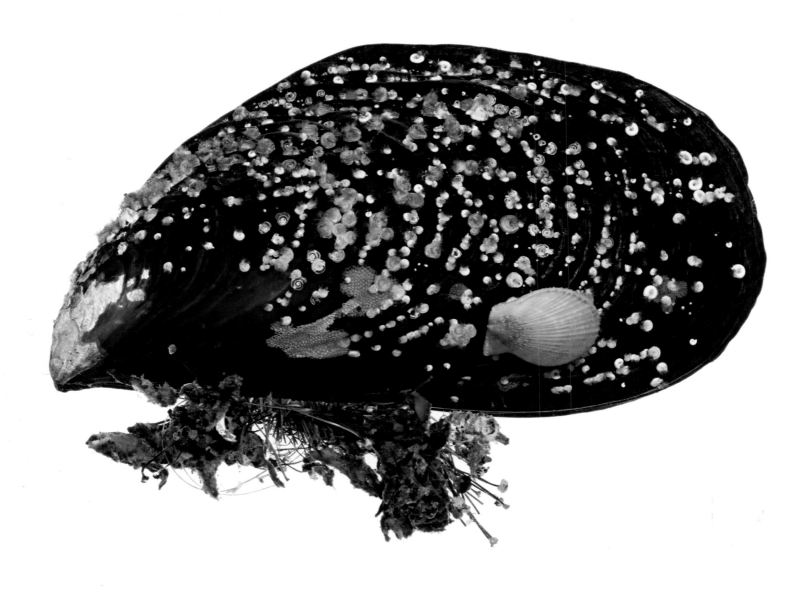

On this spread:
Bay Mussel, Scallop, Dwarf Calcareous
Tubeworm, and Moss Animal
Mytilus trossulus, Chlamys sp., Subfamily
Spirobinae, and Phylum Bryozoa

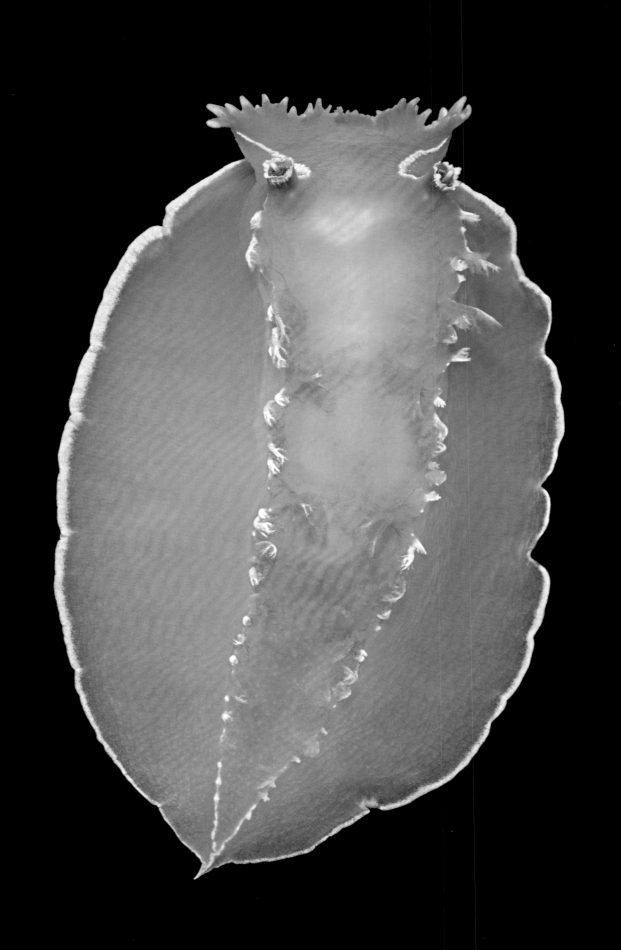

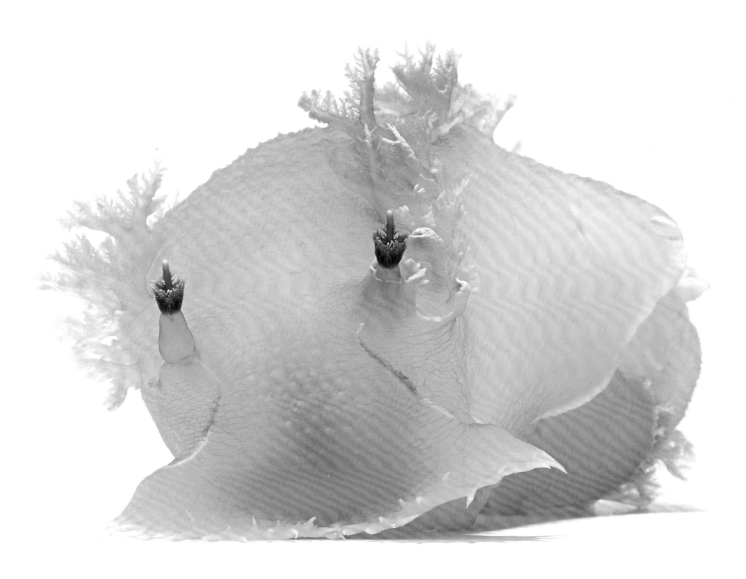

Pink Tritonia
Tritonia diomedea

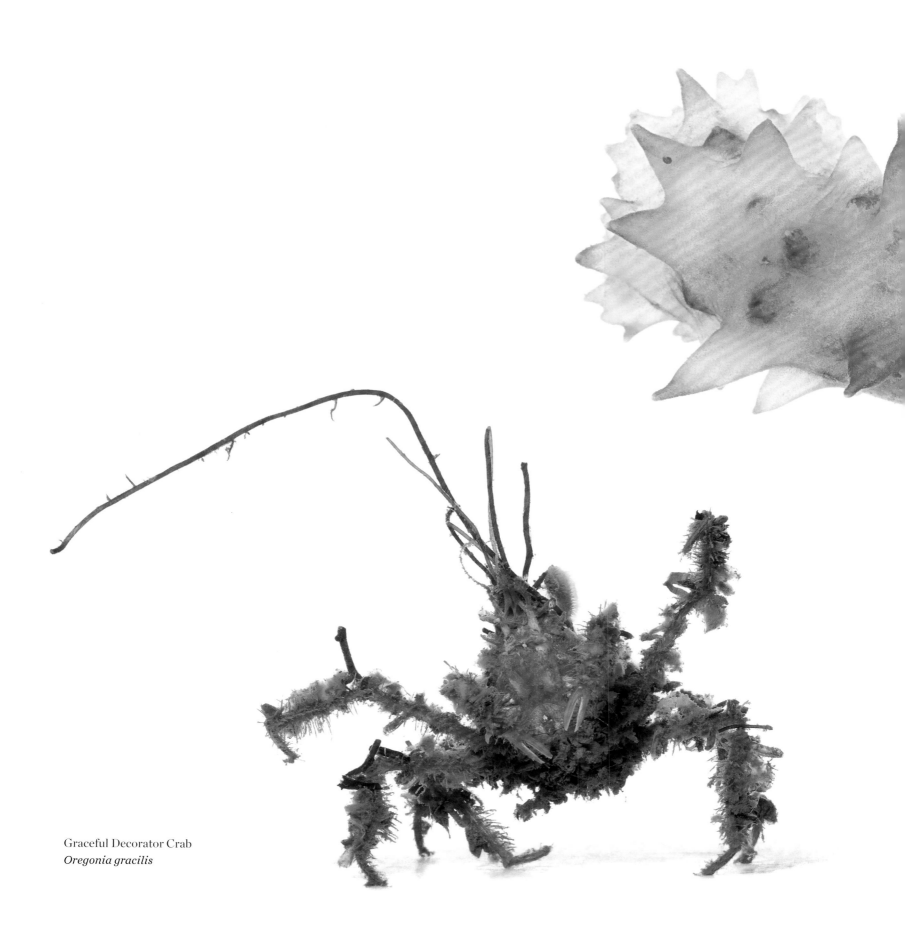

Graceful Decorator Crab
Oregonia gracilis

California Sea Cucumber
Apostichopus californicus

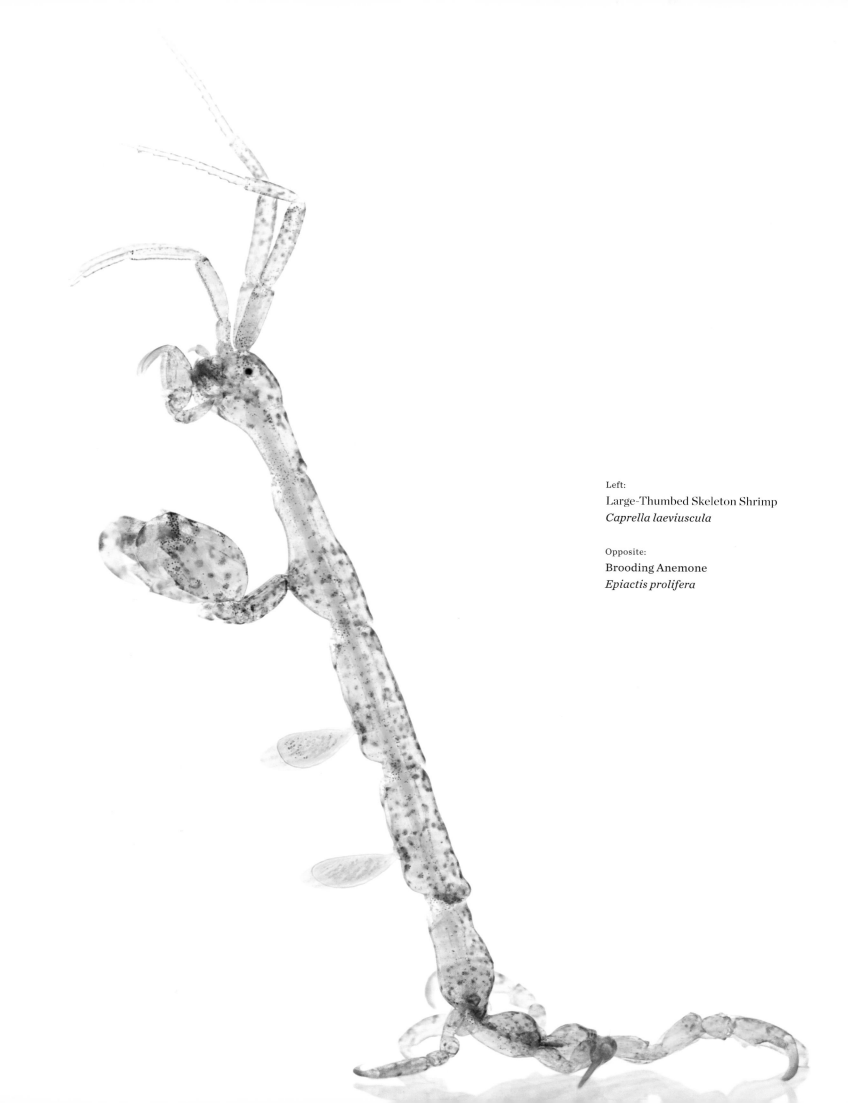

Left:
Large-Thumbed Skeleton Shrimp
Caprella laeviuscula

Opposite:
Brooding Anemone
Epiactis prolifera

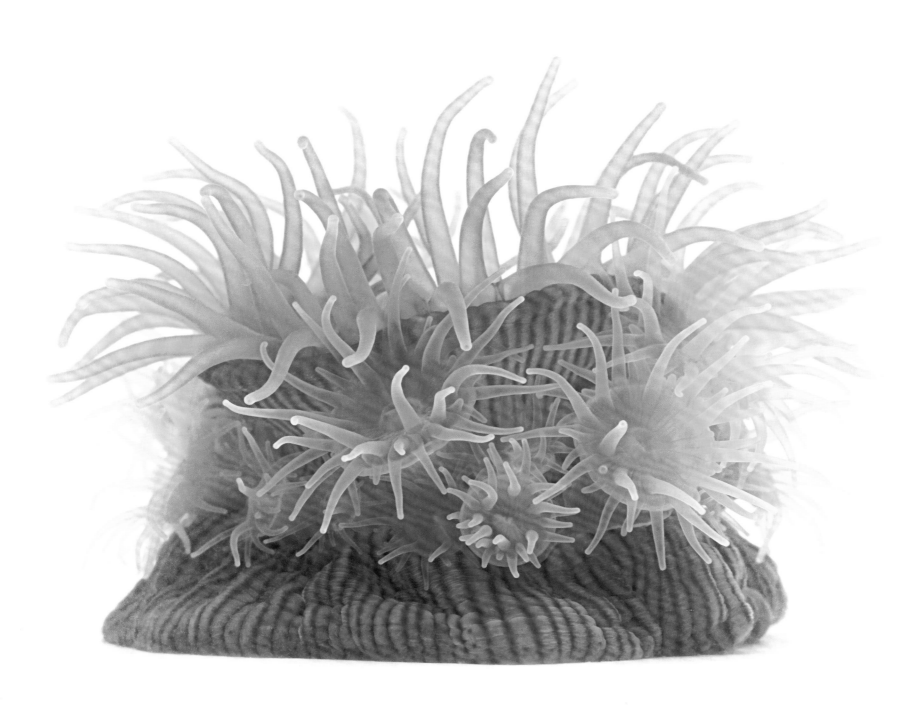

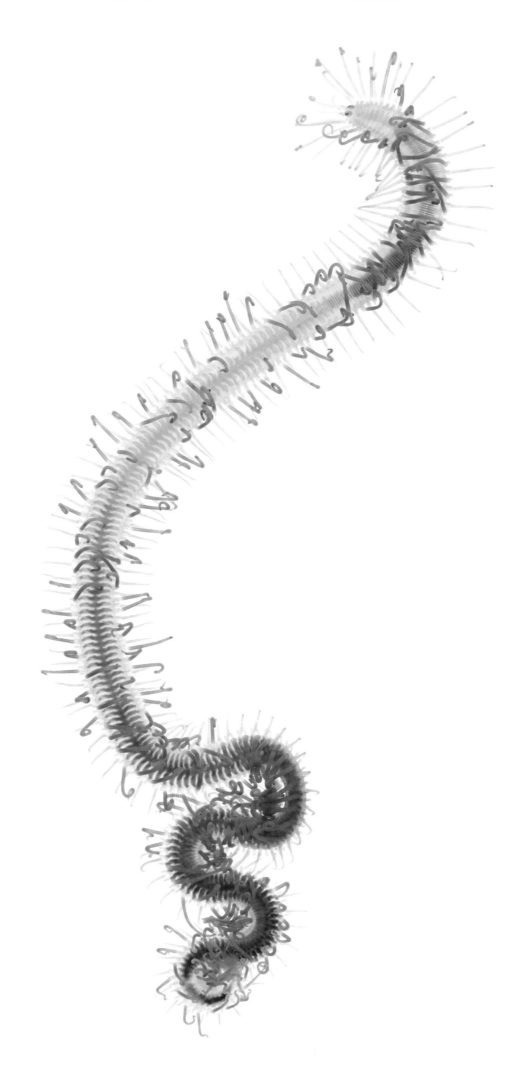

Right:

Necklace Worm

Trypanosyllis sp.

Opposite:

Frosted Nudibranch

Dirona albolineata

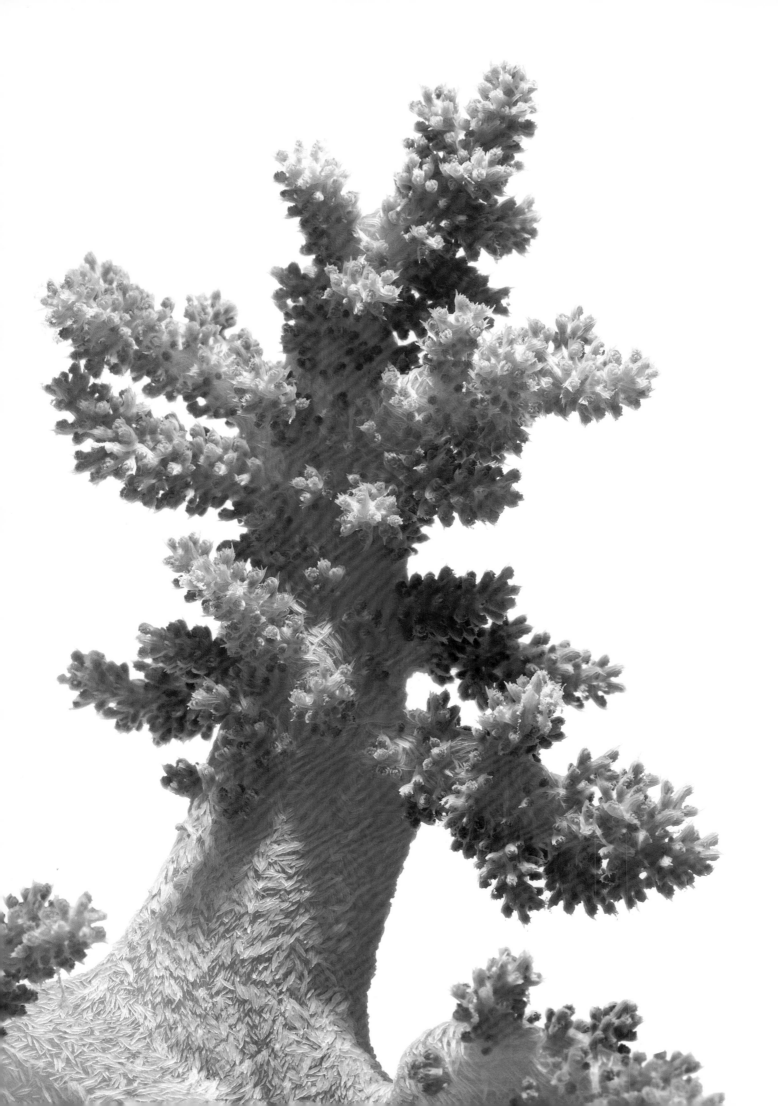

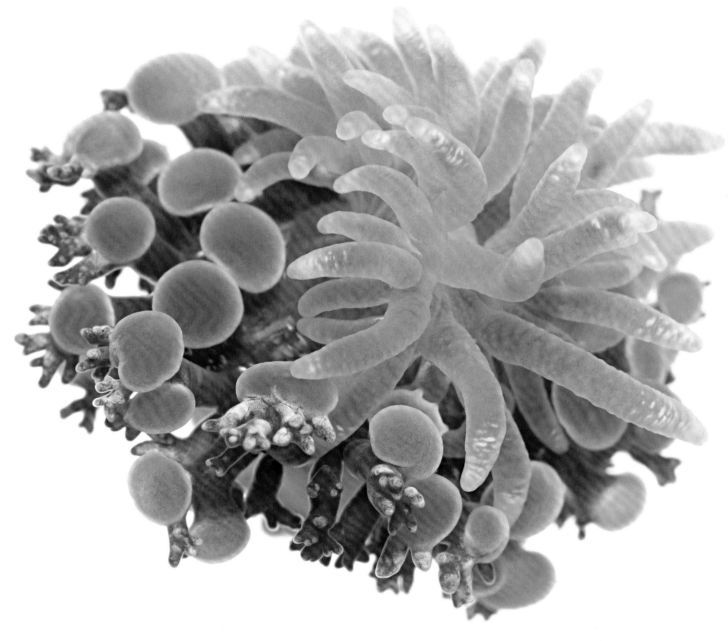

Opposite:
Soft Coral
Family Nephtheidae

Above:
Prolific Anemone
Triactis producta

141

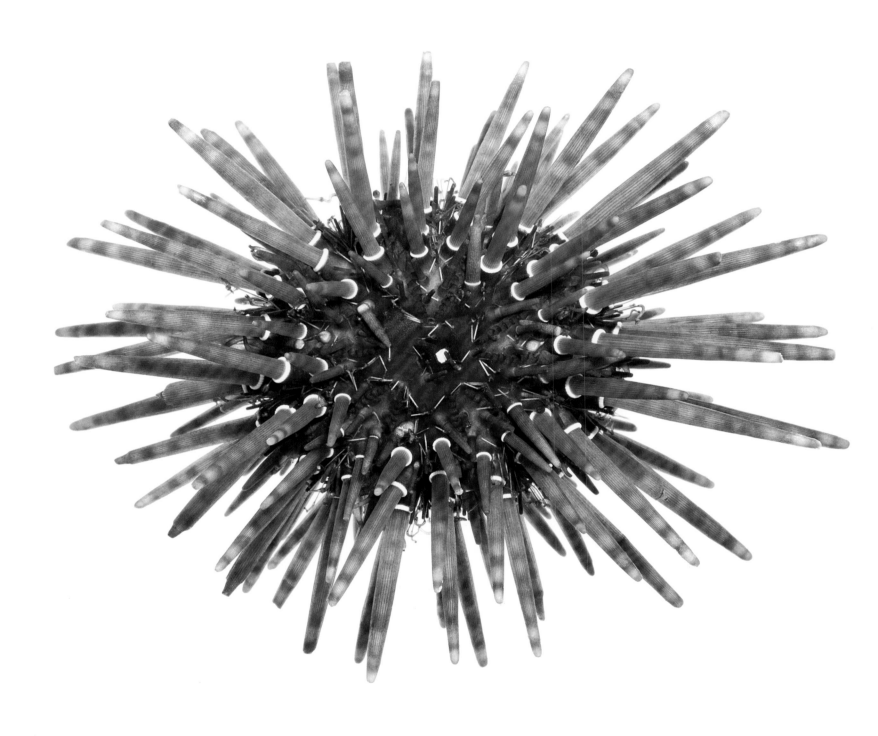

Opposite:
White-Circled Urchin
Parasalenia poehlii

Left:
Carpenter's Melanella
Melanella micans

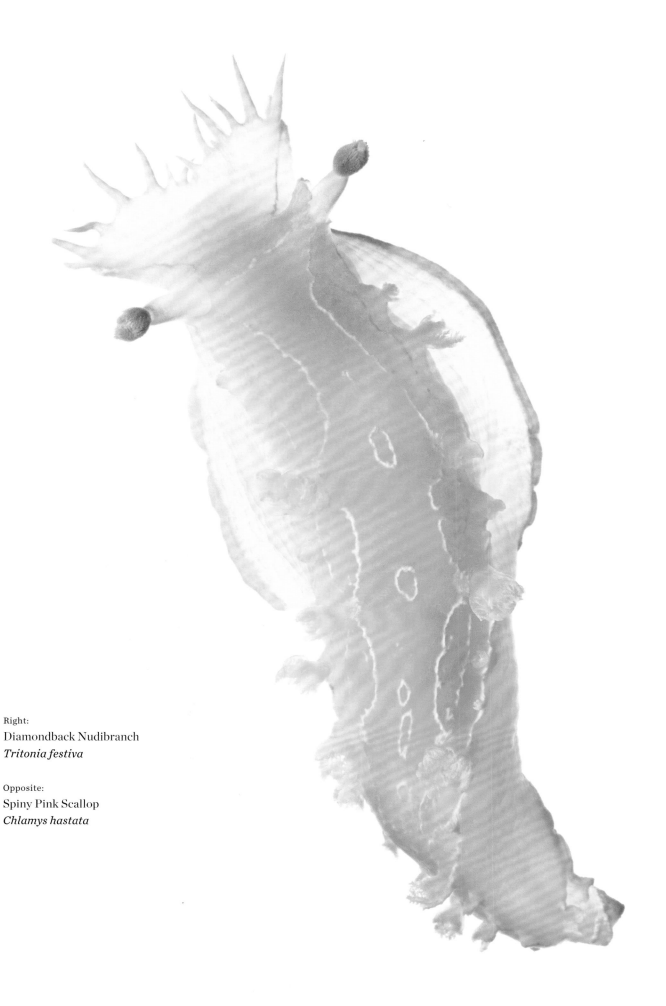

Right:
Diamondback Nudibranch
Tritonia festiva

Opposite:
Spiny Pink Scallop
Chlamys hastata

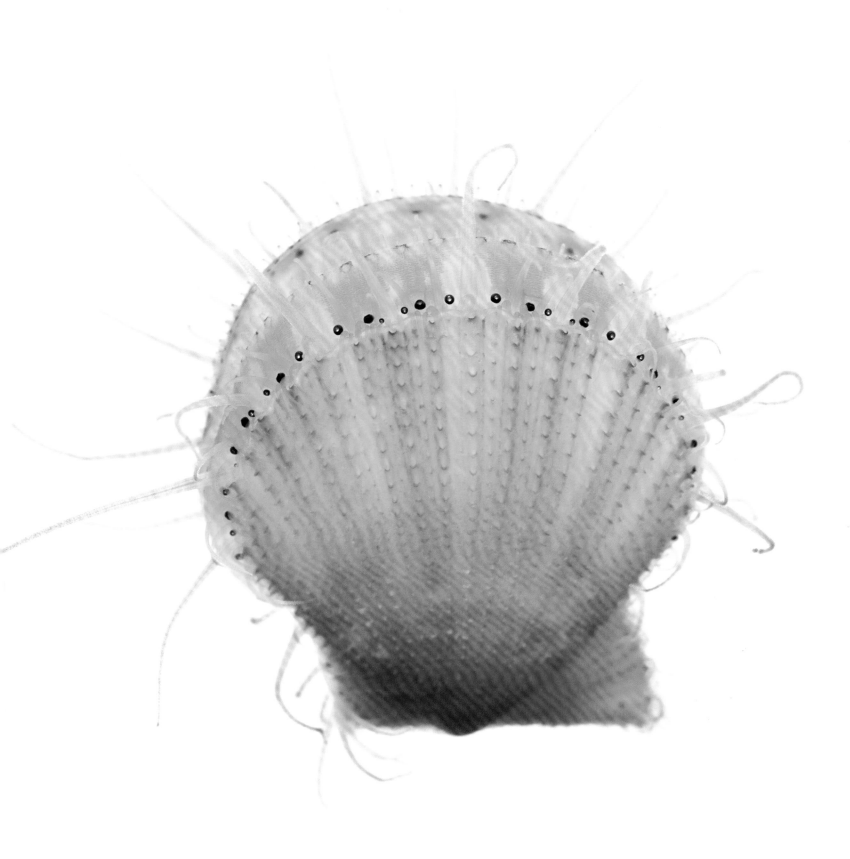

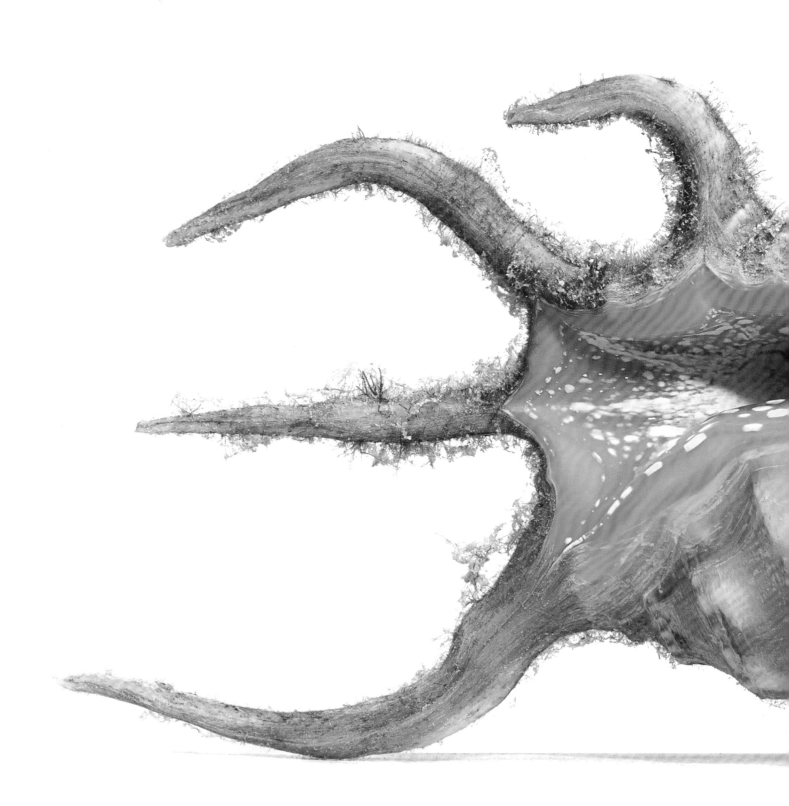

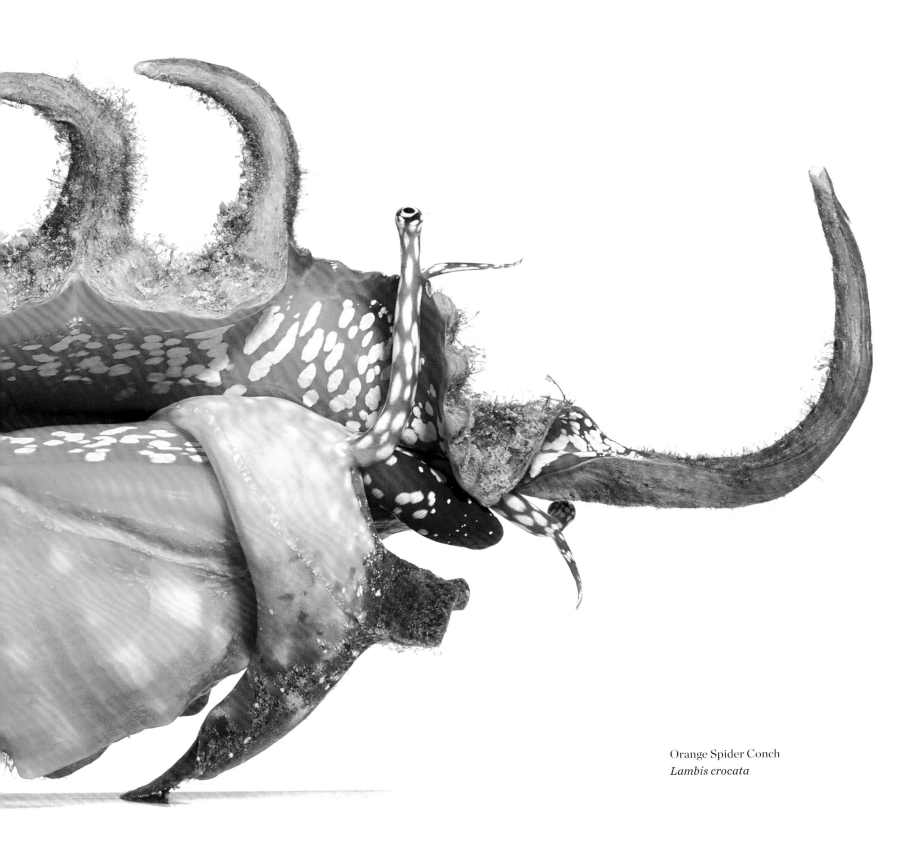

Orange Spider Conch
Lambis crocata

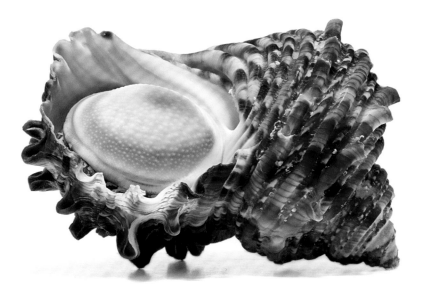

Silver-Mouthed Turban
Turbo argyrostomus

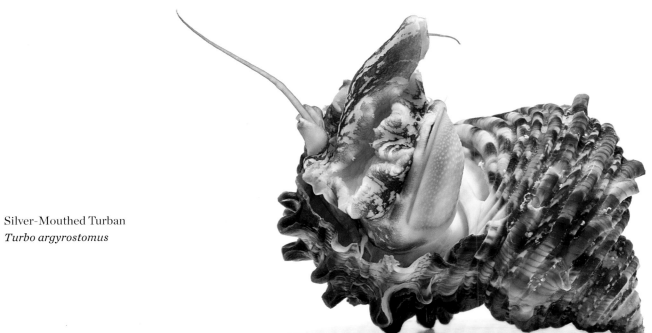

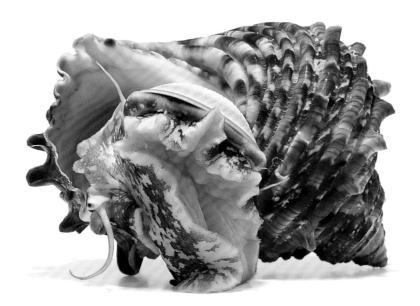

Common Distorsio
Distorsio anus

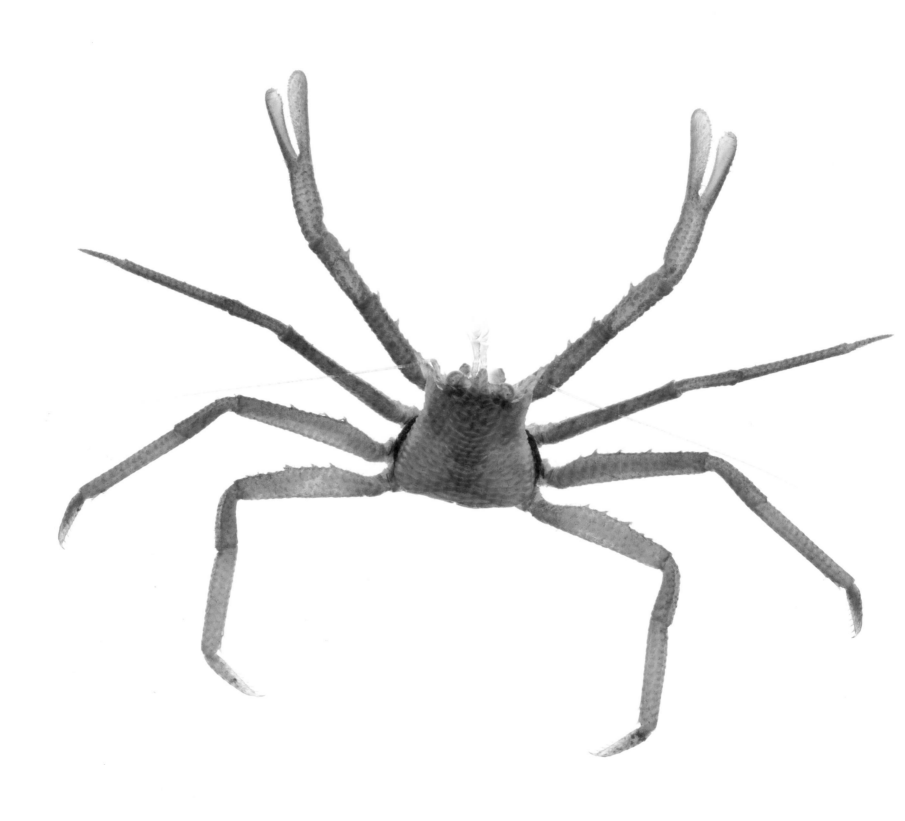

Graceful Decorator Crab
Oregonia gracilis

Giant Spider Conch
Lambis truncata

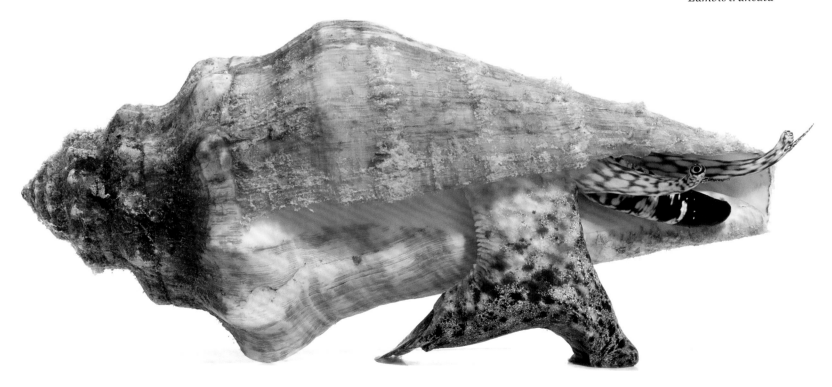

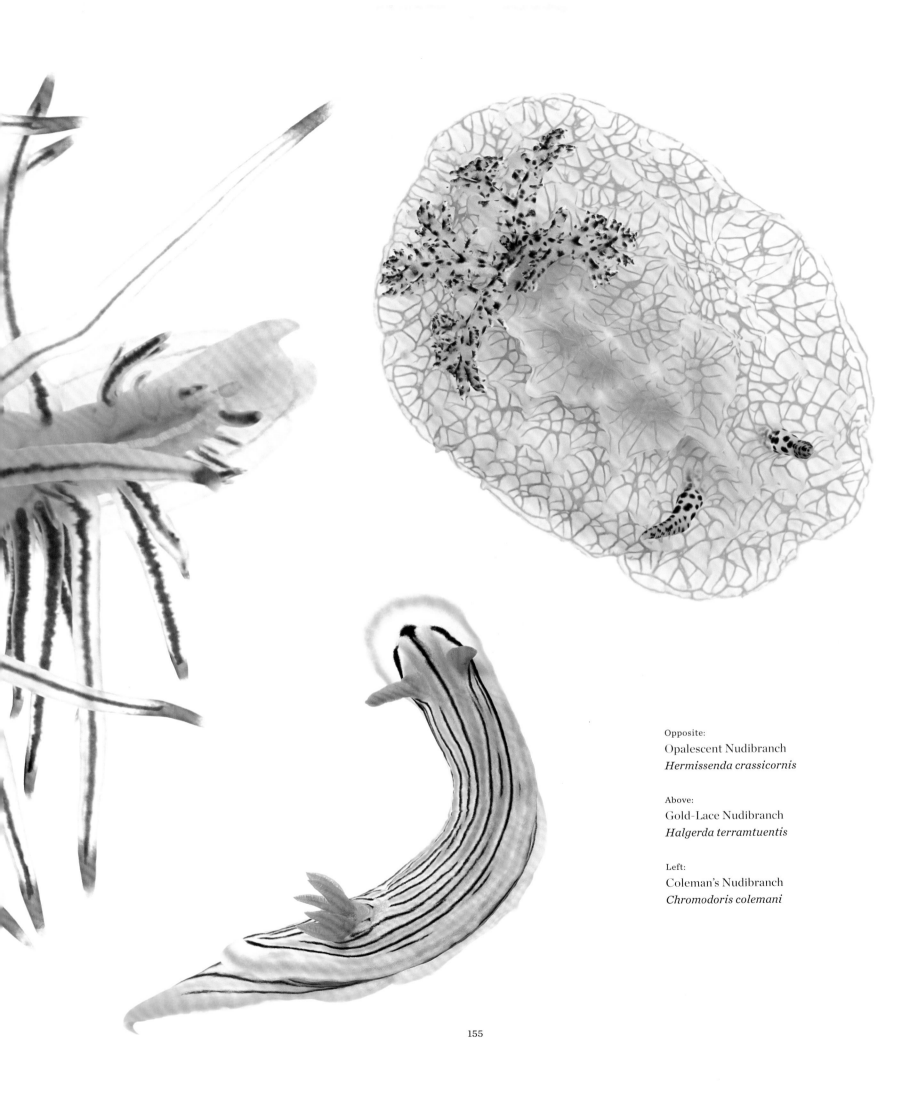

Opposite:
Opalescent Nudibranch
Hermissenda crassicornis

Above:
Gold-Lace Nudibranch
Halgerda terramtuentis

Left:
Coleman's Nudibranch
Chromodoris colemani

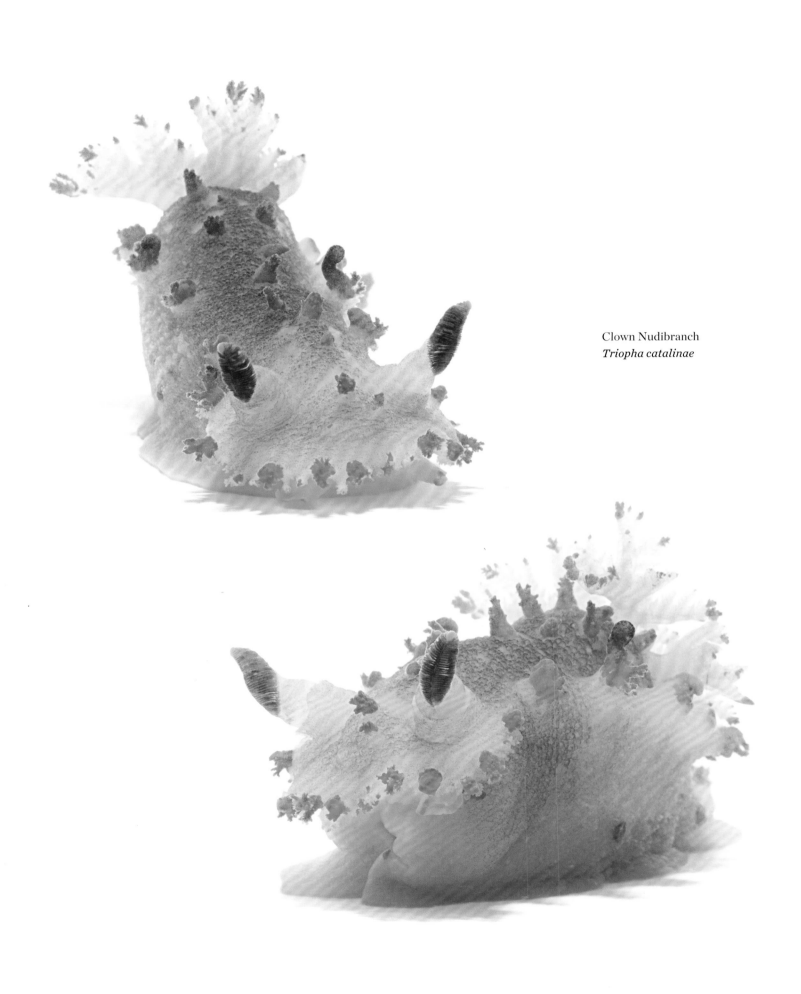

Clown Nudibranch
Triopha catalinae

Clownfish Nudibranch
Thecacera pacifica

This page:
Egg Cowry
Ovula ovum

Opposite:
Tiger Cowry
Cypraea tigris

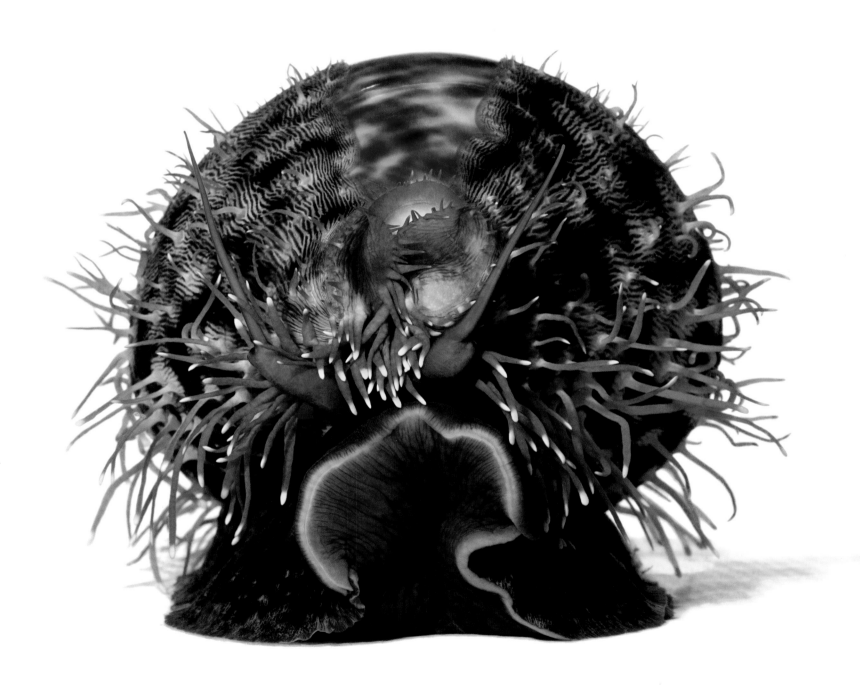

This page:

Opalescent Inshore Squid
Doryteuthis opalescens

Opposite:

Christmas Tree Hydroid
Pennaria disticha

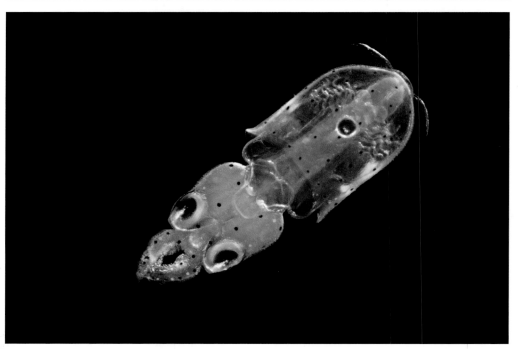

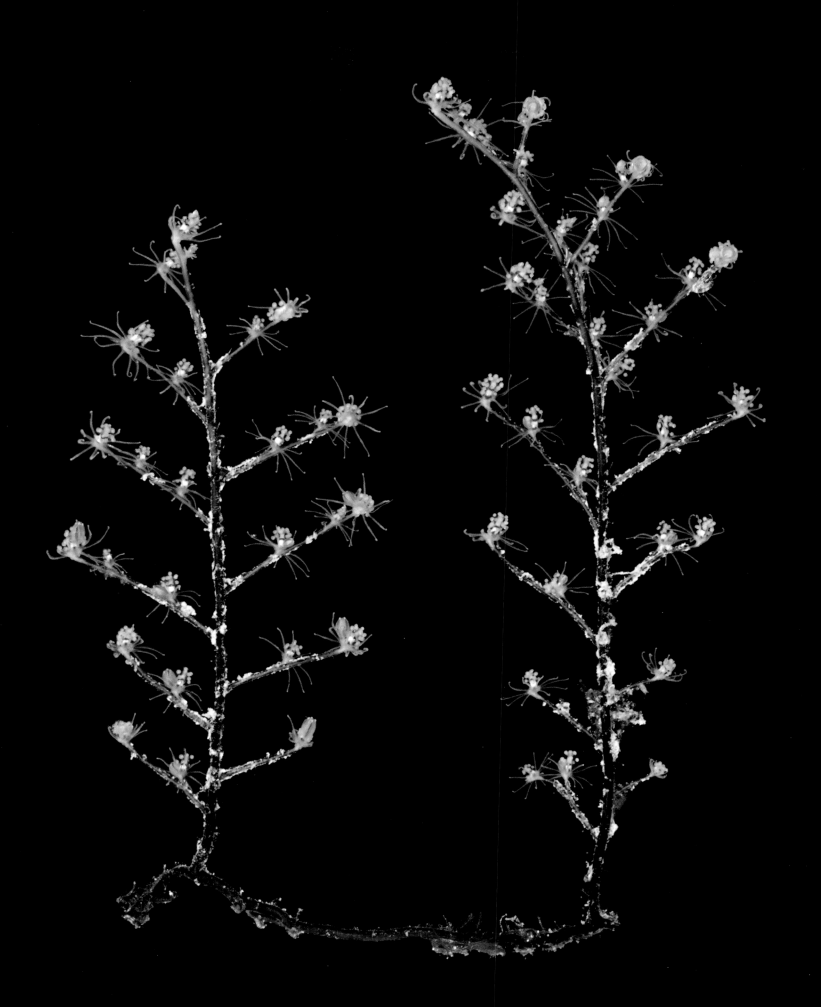

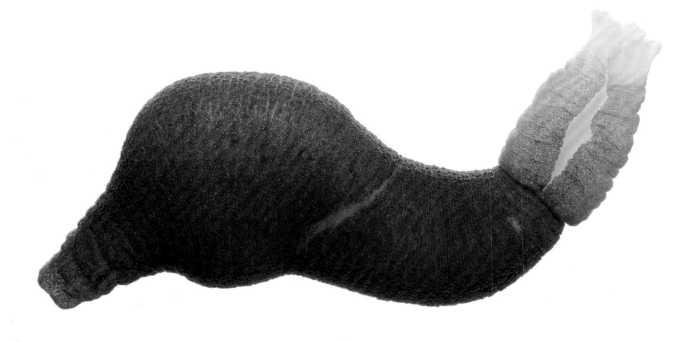

Spoon Worm
Anelassorhynchus or *Thalassema* sp.

Opposite:
Kelp-Encrusting Bryozoan
Membranipora villosa

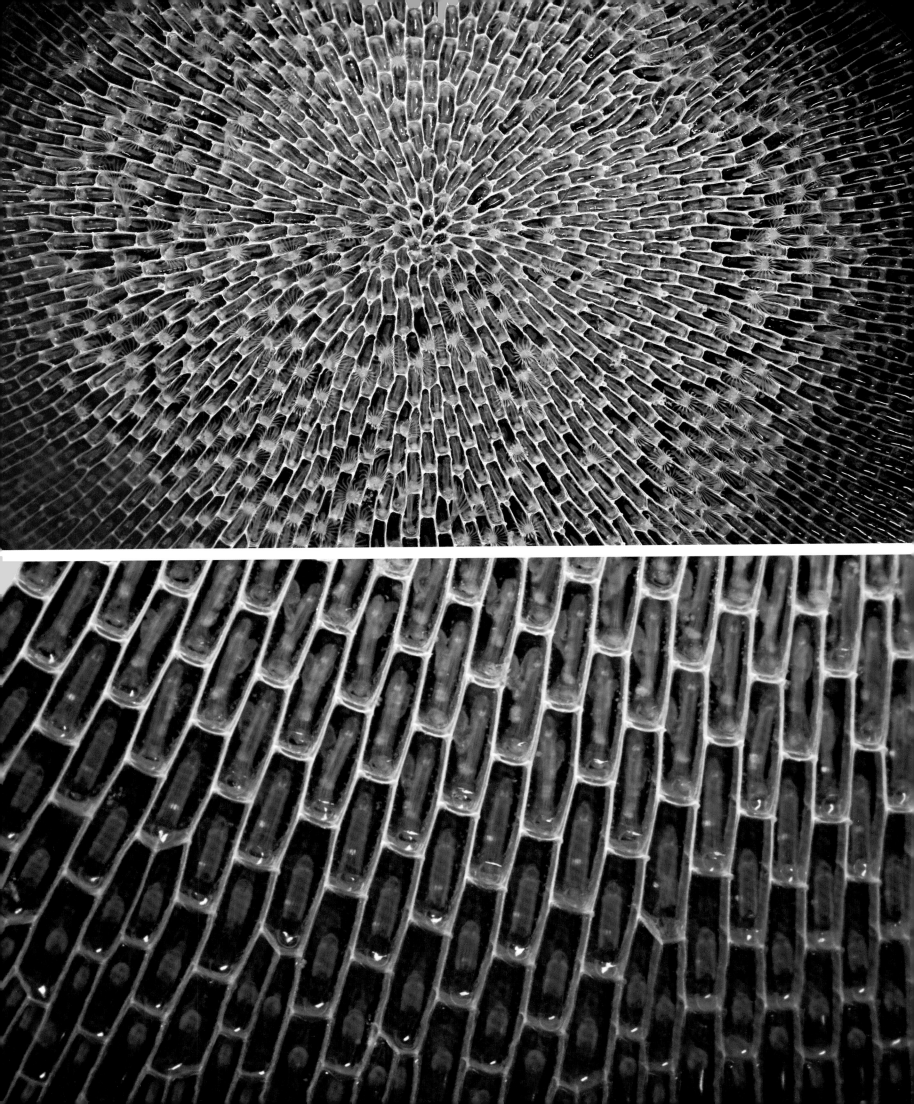

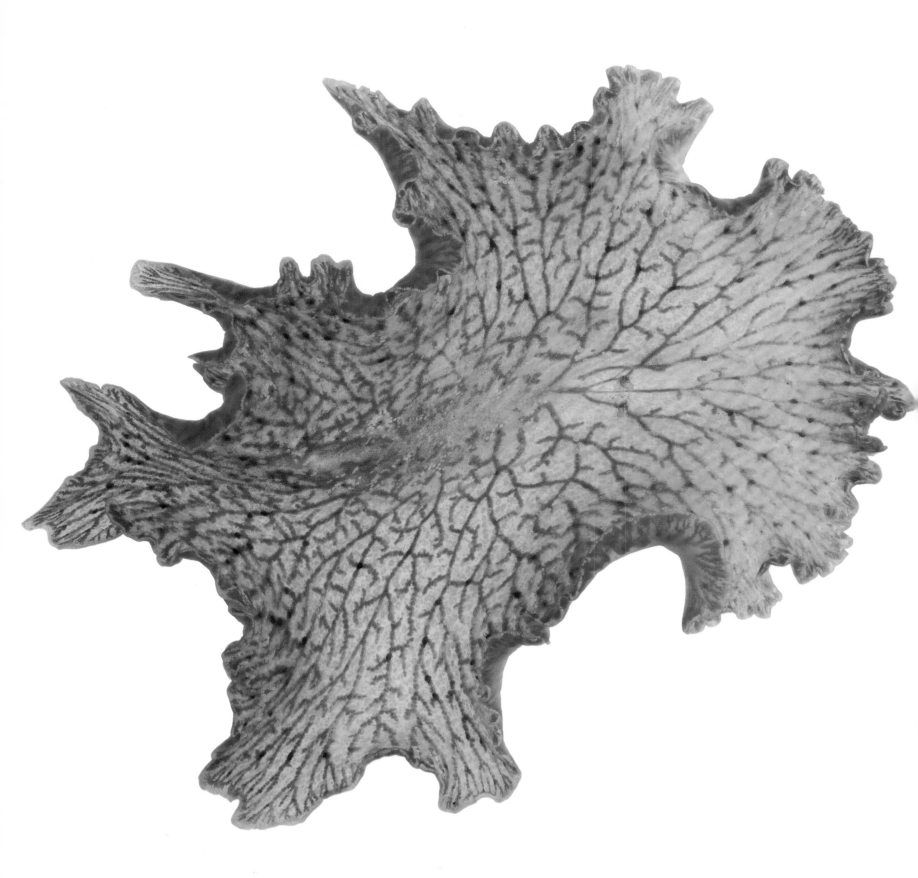

Opposite:
Leaf Flatworm
Paraplanocera oligoglena

Above:
Black Dendrodoris
Dendrodoris nigra

Right:
Leaf Flatworm (eating black dendrodoris)
Paraplanocera oligoglena (*Dendrodoris nigra*)

Unity and Diversity

Life Activities

"All life is one and yet every single life is unique."

—William S. Merwin

Much has surfaced in the human collective consciousness over the last twenty-five years about the diversity of life and its importance to the overall health of the planet. The term "biodiversity" has become a catchphrase, popularized in the writing of Dr. Edward O. Wilson and others, particularly in relation to conservation. Taxonomy—the classification and description of species—has revealed the extreme variety of life, and evolutionary theory has exposed ancestral relationships between species. Similarities and differences are understood as evidence of genealogies, elucidating where animals and plants fit into the tree of life. The study of phylogeny examines the evolutionary development and diversification of life. The concept of evolution provided the crack in the door that would illuminate the inherent connection of all living things.

The extravagant variety of life-forms on Earth is as unified as it is diverse. All life-forms have shared histories, if we look far enough back in time. The study of embryology helps us to see connections evident in the early stages of animal lives that are not necessarily obvious later on. Genetic research has shown that all of life arose from common origins. Our genetic codes have been cracked and the resulting DNA sequences—the blueprints for building every organism on Earth—are strikingly similar.

We tend to think of ourselves and our closest relatives—the mammals, birds, fish, amphibians, and reptiles—as the most representative members of the animal kingdom, but in fact we live in a world dominated by invertebrates. And marine invertebrates are the real treasure trove of nature's most exquisite and varied creations. The living conditions in the ocean are distinctly different from those on land, and the ocean supports a broader spectrum of animal designs. Water offers more physical support than does air or land. While drying out is not a problem in the ocean, there is less oxygen available than on land. Marine invertebrates have adapted to these conditions in marvelous ways, developing hydrostatic skeletons, elaborate external gill structures for breathing, and ingenious methods of movement, including cilia, tentacles, jet propulsion, buoyancy, a muscular foot that can cling and glide, and multifarious mechanisms for swimming. Yet, though astonishing and endlessly intriguing, marine invertebrates remain relatively unknown compared to the vertebrate world.

There is both diversity and commonality among animals. In a basic sense, animals are machines that feed, reproduce, exchange gases, and engage in various life activities. They are functional systems with structures and principles; the variations are limited, the number of solutions finite. Of course, a critical distinction between animals and machines is that animals cannot be turned off and on like a motor; their life activities are ongoing and must be operating at all times if the animal is to survive.

Locomotion is one of several life activities that most animals share. Almost all multicellular animals, including invertebrates, require a skeleton in order to move. A skeleton is usually thought of as a set of articulated bones, but this is only one kind of skeleton. A spine, which only vertebrates have, defines a particular kind of skeleton. A skeleton can be a solid or fluid system that permits muscles to be stretched back to their original length after a contraction. It may or may not have additional supportive and protective functions.

Water is inherently supportive, and marine invertebrates have taken full advantage of this in their various physical adaptations to their environment. Many marine invertebrates have hydrostatic skeletons that, like water balloons, are supported by the water in which they live. Fluid can serve as the vehicle through which sets of muscles interact. Even for spined animals such as

ourselves, being in water, especially saltwater, provides a kind of support that we don't experience on land, facilitating physical exercise while minimizing stress and strain on our joints. Jellyfish, soft corals, and anemones go limp when taken out of water, and even octopus and squid, which are muscular animals, don't fare well on dry land. They need the support of the water to maintain their shape and protect them against desiccation. The arthropods fare better on land because their jointed, protective exoskeletons hold them together. All the better for transitioning to a terrestrial existence.

All multicellular animals engage in essential life activities, including obtaining, digesting, and assimilating food; circulating nutrients and gases within the body; disposing of metabolic wastes; coordinating activities; avoiding predators and other threats; growing; and reproducing. Marine invertebrates have manifested many ways of accomplishing these activities and have invented novel body equipment suited to a given task. Although the mechanisms employed by animals for carrying on life activities vary, all animals consist of basic units, living cells, and the cell is the smallest unit of an animal that can carry out its basic life activities.

Ingestion, or the taking in of food, is an essential life activity. All animals need to eat. To feed, an animal must possess some type of sensory receptor for picking up information about the surrounding environment, as well as mechanisms for locomotion and ingestion. These mechanisms are made possible by just the right physical design, which in each case is the result of an evolutionary process of trial and error and the implementation of favorable modifications over time. Once food is ingested it must be digested, which involves the chemical alteration of raw food into smaller units and a usable form of energy to fuel life activities, including growth and the replacement of worn-out or damaged body parts. Once food has been digested, it is assimilated, another chemical process that integrates digested food material

into living substance. Not everything that enters a body can be digested. Indigestible solid wastes must be removed from the body (as feces) through a process of elimination so that the digestive system can continue to run smoothly. The excretory system takes care of removing the nongaseous waste material of assimilation. In humans, kidneys filter out other wastes as urine.

Animals produce special chemical substances—secretions—such as calcareous shells, sponge fibers, silk, and mucus. Some secretions are enzymes that speed up chemical reactions. Life depends upon enzymes, and only living organisms manufacture them.

The circulatory system carries nutrients, wastes, and gases through the body. The blood vessels of vertebrates are lined to support faster metabolic rates and to avoid rupture due to increased blood pressure. Ninety-five percent of animals do not have lined blood vessels. In the marine invertebrate realm, cephalopods (including octopus) have lined vessels to support their rapid metabolism.

Respiration, or gas exchange, is a key life activity, and organisms have arrived at various ways of accomplishing it. It requires an adequate surface area without a protective cuticle to allow for gas exchange. Larger animals require a greater surface area; thus gills and lungs evolved into frilly, complex structures, maximizing the surface area available for respiration. In the ocean, external gills are efficient, but on land respiration must occur inside the body to prevent desiccation.

Life's one imperative is to persist, and the only way to persist is to reproduce. Although reproduction is not necessary to maintain the life of a single individual, it is required for the continued existence of the group. Evolution is predicated on reproduction, not just replication; it requires descent with modification, allowing improvements to be added along the way. Hence the value of sexual reproduction and genetic variation. Almost all adaptations that characterize a species enhance that species' reproductive

success. Invertebrates show a far greater diversity of reproductive and developmental strategies than do the members of the vertebrate world.

Every animal has a metabolism, the sum total of chemical processes that occur in the body to sustain life. There are two phases of metabolism: a constructive phase, in which the proteins, carbohydrates, and fats that build tissue and store energy are synthesized; and a destructive phase, in which substances are broken down and energy and waste are produced. In young healthy animals, the constructive phase dominates over the destructive phase and creates growth, or an increase in the amount of living matter. In mature individuals, the two phases are more or less balanced, and in old or sickly individuals, the balance tips toward the destructive phase.

The ability to repair damage to the body is ubiquitous among animals and is greater among invertebrates than vertebrates. Generally, the lower the degree of cellular organization in an animal, the easier it is to replace lost parts. The more complex animals are more limited in their capacity for regeneration. Sponges can and do regenerate themselves from a single cell. Humans can't do this! We can heal from wounds and mend broken bones, but we can't replace a worn-out hip joint.

Seeing is not an essential life activity, but photoreceptors are found in many phyla, including flatworms, annelid worms, mollusks, and arthropods. These light receptors do not generally take the form of image-making eyes, but they can detect light and shadow, which can be useful in the game of survival. Compound eyes can form images, and they are common among crustaceans. Some polychaete worms and bivalve mollusks have compound eyes. Scallops have dozens of eyes lining the rims of their shells. When asked why scallops have so many eyes, Dr. Alan Kohn, one of my mentors, answered, "Because they don't have necks!" I have often pondered what a mantis shrimp can see. They are known to have the best eyes in the world, and they can see much

that we cannot. They are equipped with sixteen photoreceptors, as opposed to our three, and they can also see ultraviolet light and polarized light, perceive depth with one eye, and move each eye independently. The perceptions of marine invertebrates are very different from ours, and learning about them can stretch our imaginations. They perceive the world in their own ways that are no less real or valid than our own.

Evolution has produced ever more complex and efficient machinery to carry out essential life activities. Marine invertebrates have a knack for innovation and, in particular, for doing more with less. Sponges are a rudimentary life-form, yet without organs or a nervous system they have become large living structures capable of feeding themselves by actively pumping massive amounts of water through their bodies. Flatworms, anemones, and urchins manage to live quite nicely without an anus, using their mouths for ingestion and excretion. An anus is a relatively new invention in the animal kingdom. Barnacles have the longest penises, relative to their body size, of any animal, a useful adaptation for a creature cemented in one spot while searching and probing for a mate.

Every species makes a living in a different way, but all face the same challenges. Over hundreds of millions of years, genetic instructions have taken us down different paths but there are features common to all organisms. A small worm-like creature similar to the modern flatworm was the first to have a head and a brain and to move with direction and intent; we have inherited those abilities from that distant relative. Cnidarians invented muscles and nerves, and all subsequent life featuring muscles and nerves shares that common ancestor. The most primitive animal, the sponge, invented the protein collagen as a supportive system for its body; collagen now exists in all animals. Collagen is the primary structural protein in our connective tissue; it's what breaks down as we age, causing our skin to wrinkle. The same genes that direct development in lancelets, our closest

invertebrate relatives, direct development in all animals with backbones, including us!

All vertebrates stand on the shoulders, as it were, of countless invertebrates that have preceded us. We carry their inventions in our own bodies. Likewise, marine invertebrates carry innovations and chemical languages that benefit us, especially in medical applications. One of the first HIV drugs, AZT, was based on a sponge, and the antiviral drug acyclovir is synthesized from nucleosides isolated from a Caribbean sponge. Since sponges are glued to the seafloor they had to invent novel ways to defend themselves, and because they are ancient creatures they had a lot of time to develop defensive strategies. What did they come up with? Biochemical protection. Sponges are storehouses rich in bioactive compounds. We are only beginning to understand and mine for our own use the chemical defenses that invertebrates employ to defend and protect themselves.

We share our origins with every animal. Scientists have uncovered evidence linking us to the simplest of creatures, confirming age-old beliefs in the unity of all life. Many indigenous peoples have understood this intuitively; a deep and inextricable connection to nature is part of their cultural identities. When there is no separation between nature and self, the natural world is respected and even revered. In contrast, modern Western cultures view nature as distinct and separate from humankind, as "other," and accordingly assign it an inferior status, which ultimately leads to a great loneliness of spirit. When we become too self-focused as a species, we miss out on the spectacular diversity of the animal kingdom. Recognizing this profusion of life as our own ancestral lineage, as truly part of us, can be thrilling! Photographing marine invertebrates over the last several years has introduced me to all of these cousins I didn't know I had. The fact that the simple flatworm invented the architecture to support motion directed by a central nervous system stirs and delights my imagination!

"Let it be borne in mind how infinitely complex and close-fitting are the mutual relations of all organic beings to each other and to their physical conditions of life."

—Charles Darwin

Opposite:
Leaf-Foot Shrimp
Nebalia sp.

Overleaf left:
Galeo Clam
Family Galeommatidae

Overleaf right:
Marbled Shrimp
Saron marmoratus

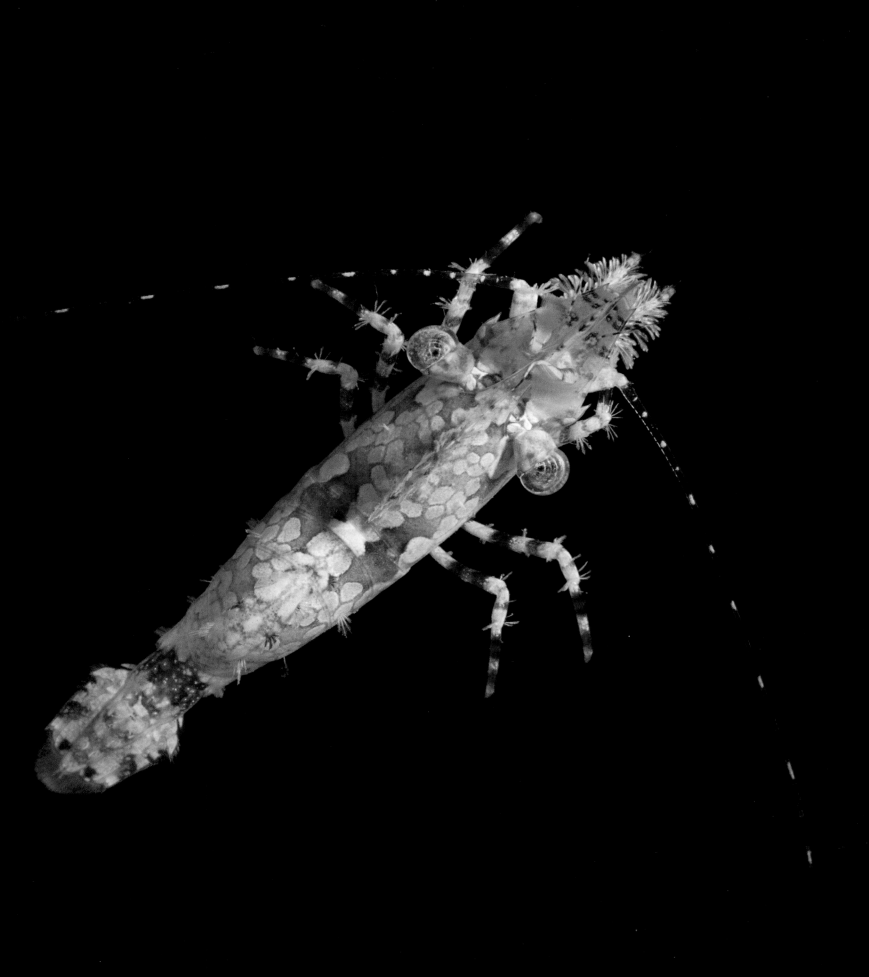

Previous spread:
Plankton Sample

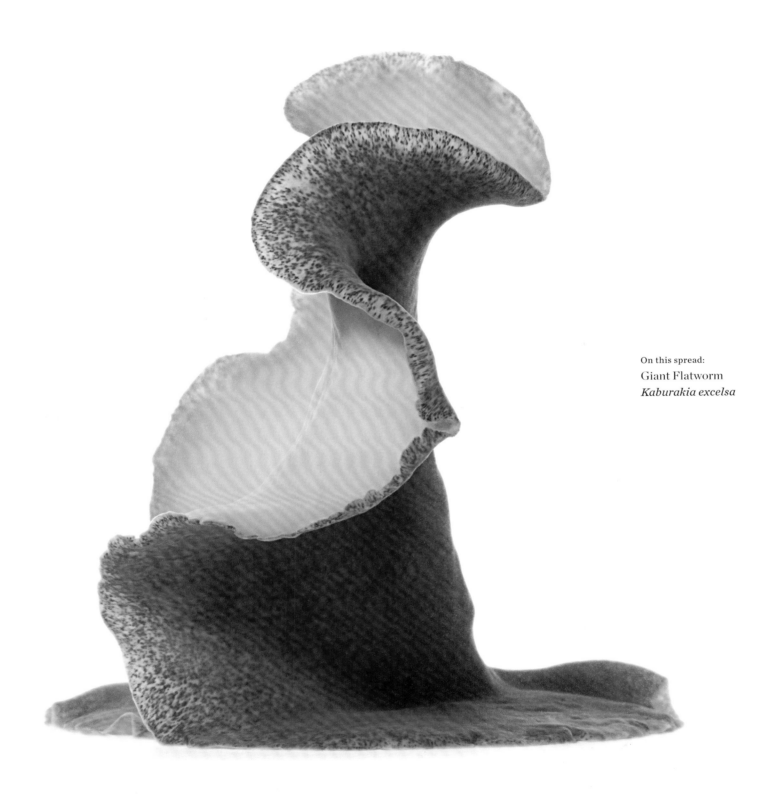

On this spread:
Giant Flatworm
Kaburakia excelsa

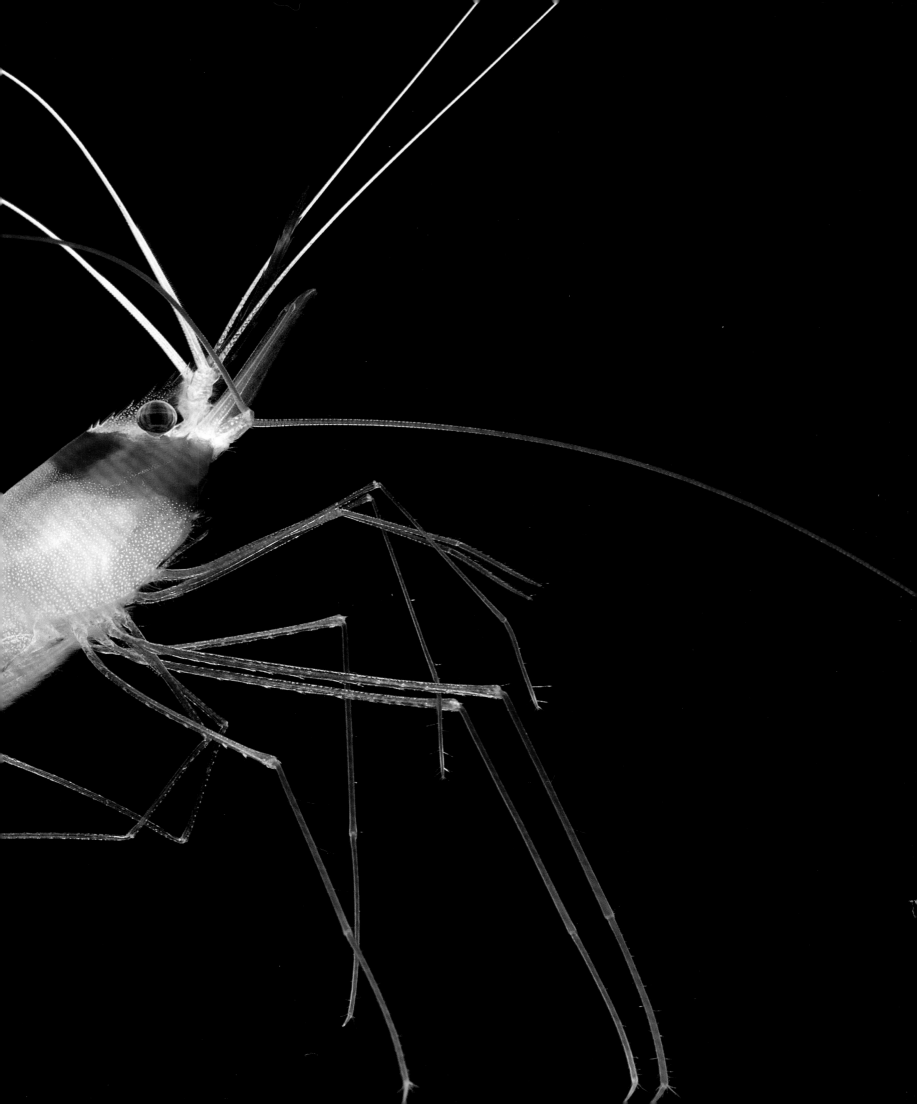

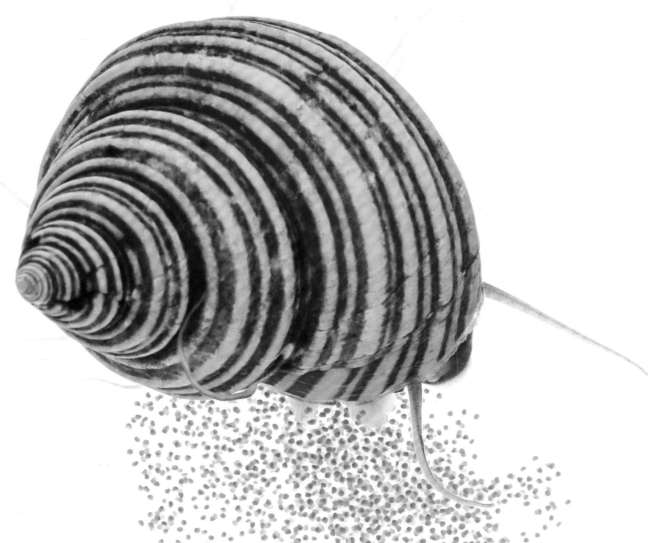

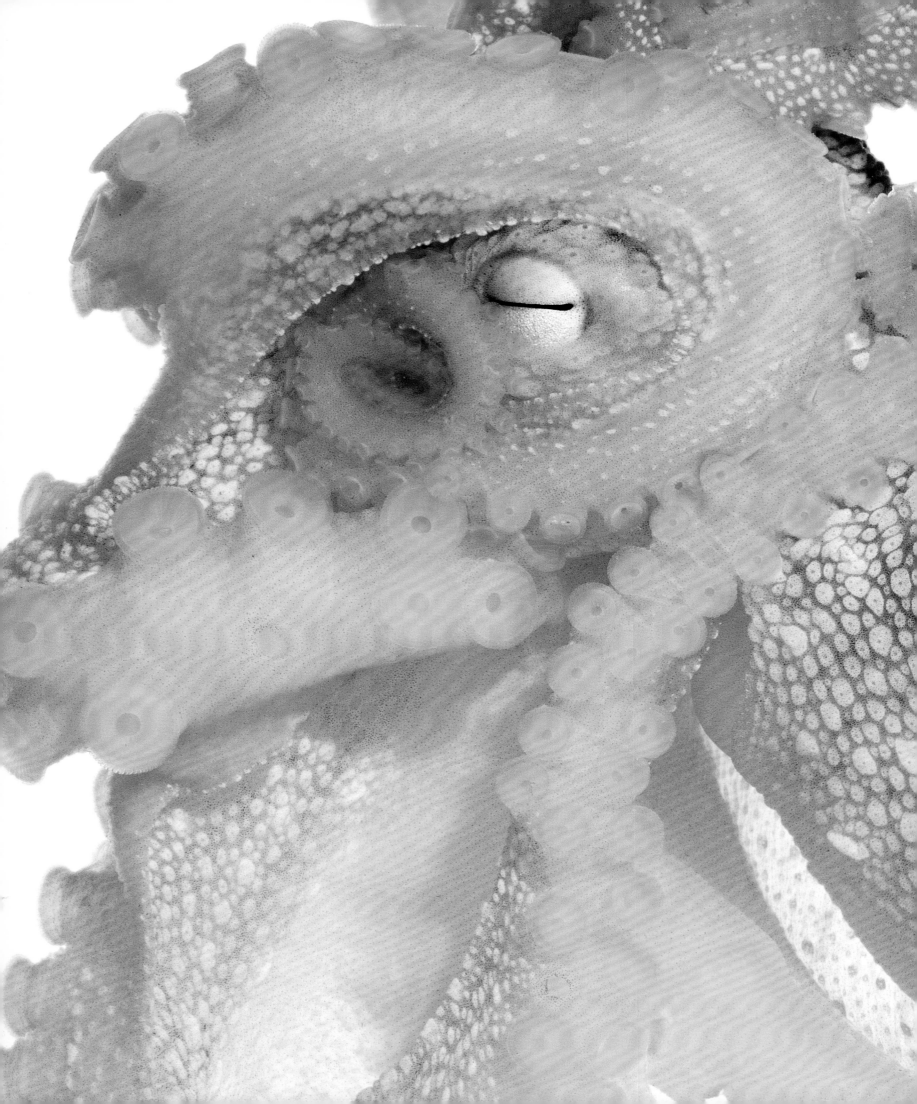

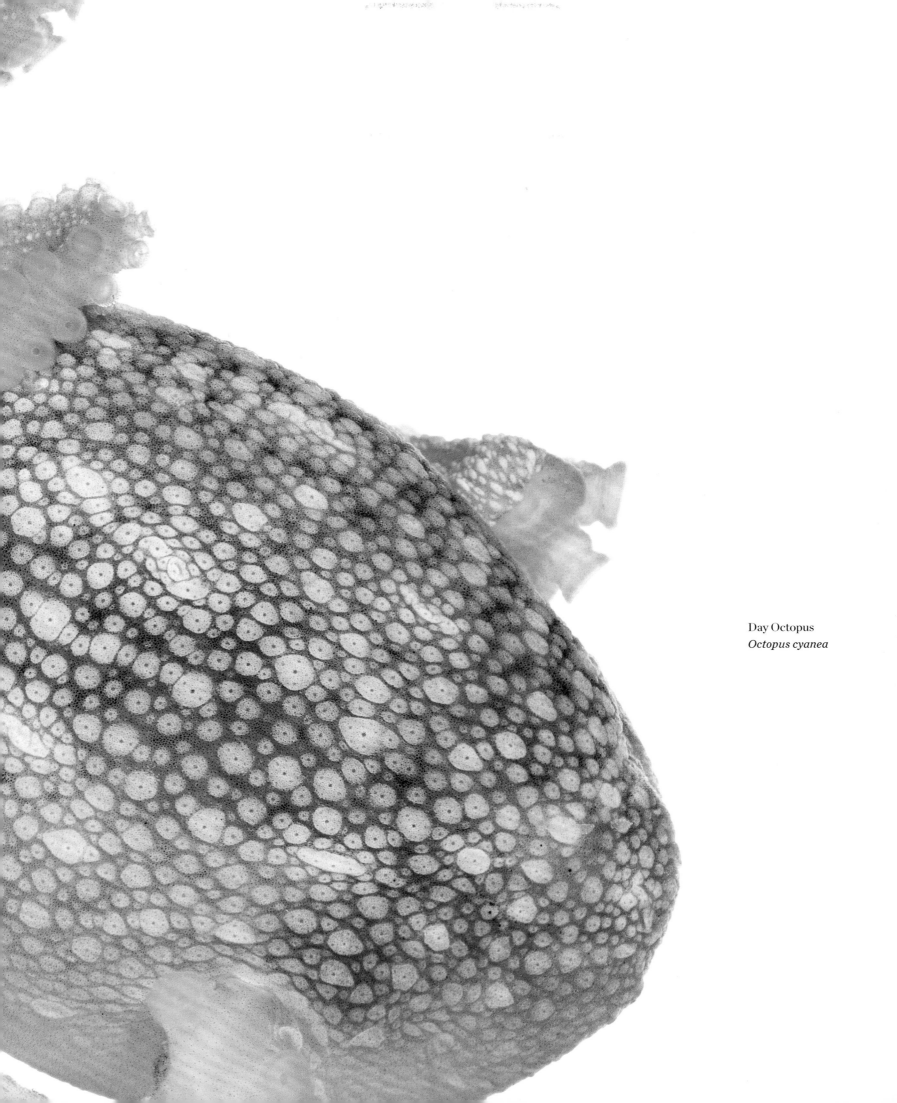

Day Octopus
Octopus cyanea

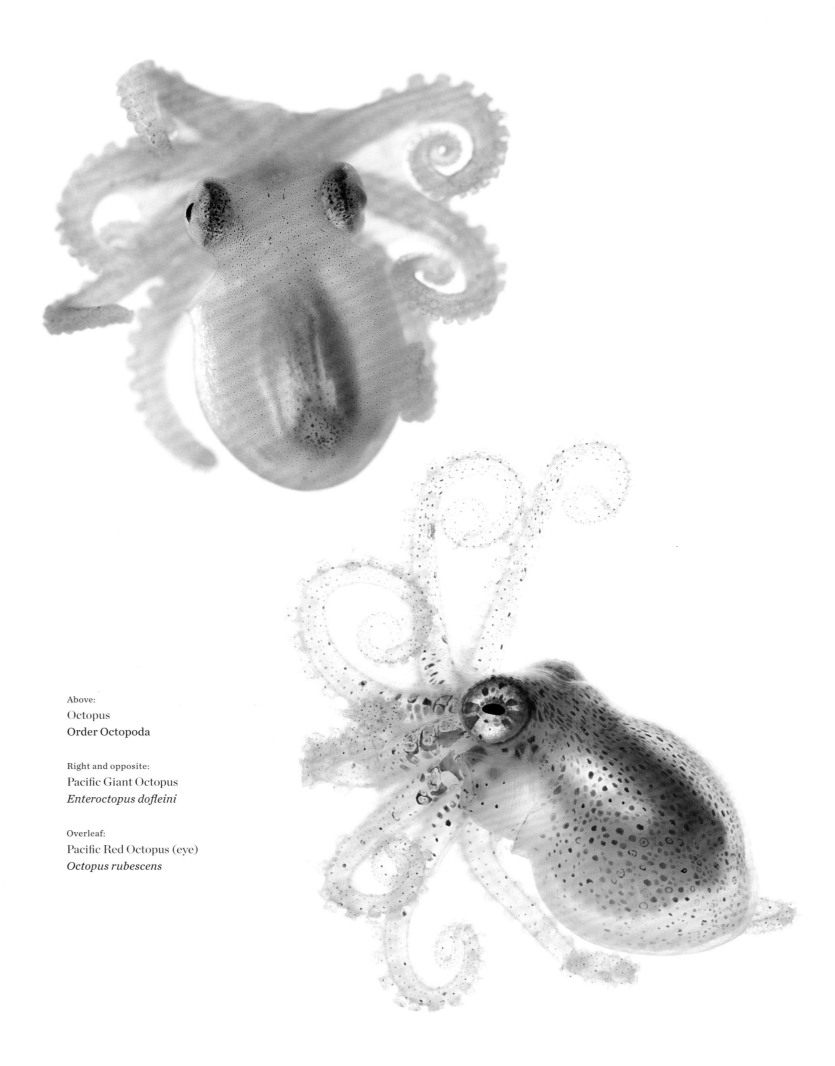

Above:
Octopus
Order Octopoda

Right and opposite:
Pacific Giant Octopus
Enteroctopus dofleini

Overleaf:
Pacific Red Octopus (eye)
Octopus rubescens

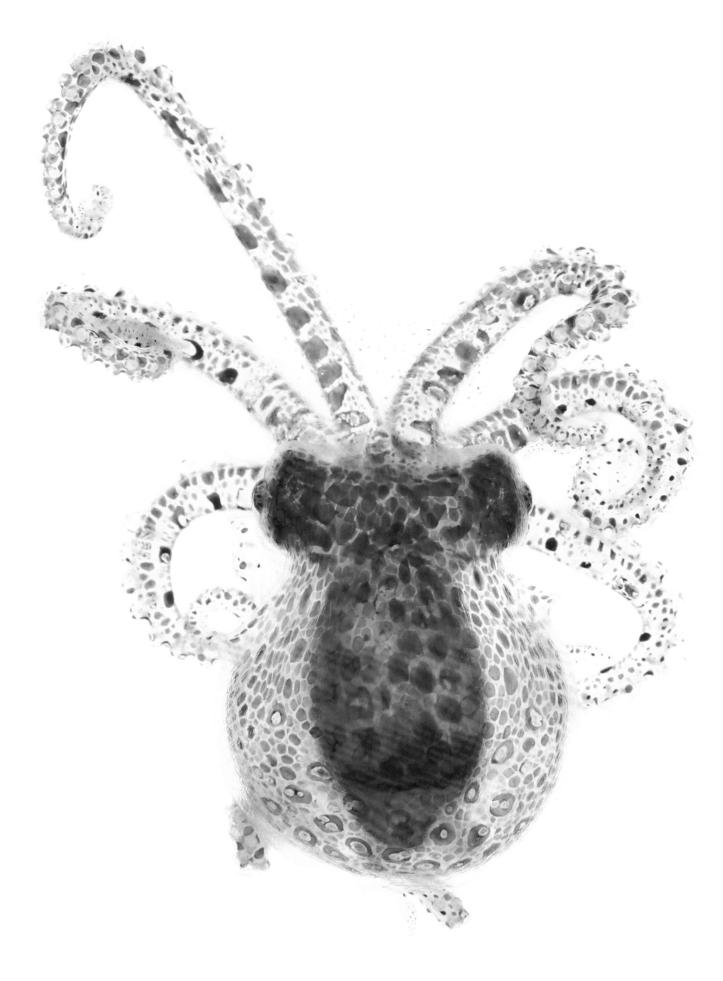

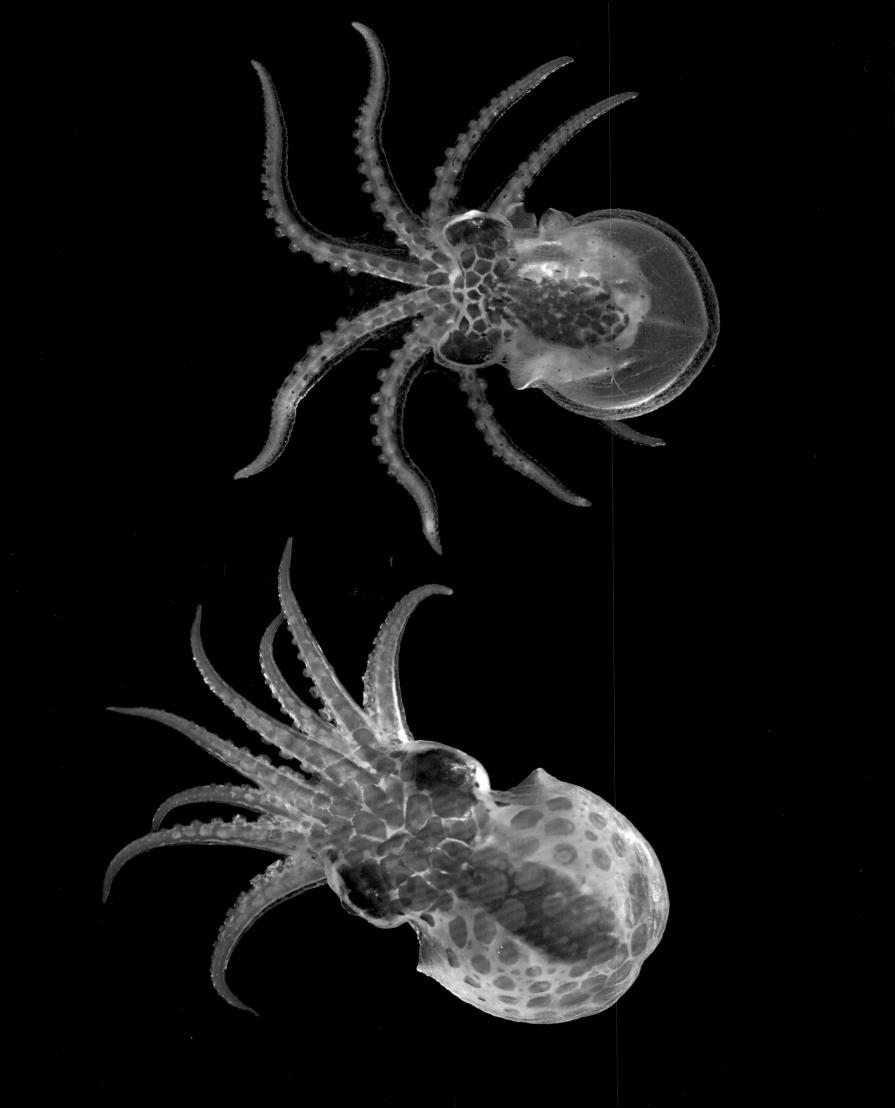

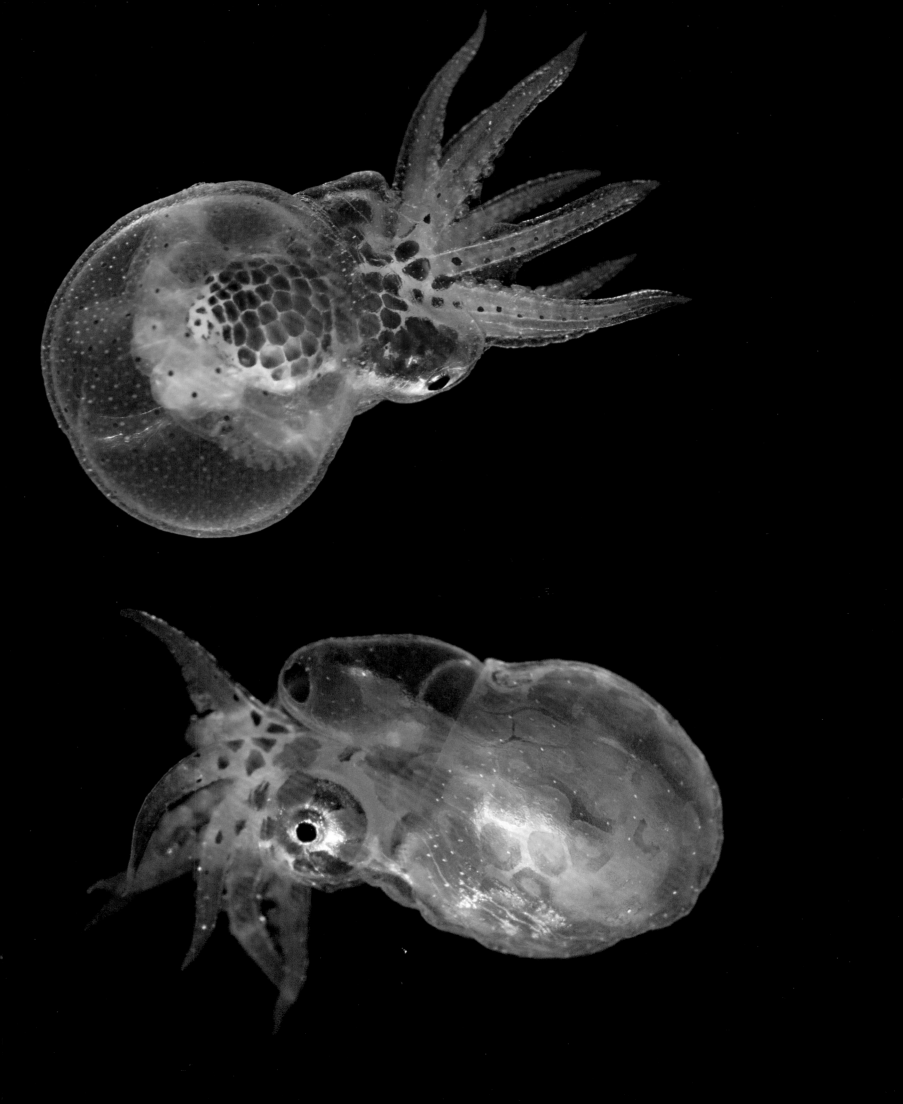

Previous spread, top left and right:
Pacific Giant Octopus
Enteroctopus dofleini

Previous spread, bottom left and right:
Pacific Red Octopus
Octopus rubescens

On this spread:
San Juan Stalked Jelly
Haliclystus "sanjuanensis"

Top left:
Hemprich's Sea Star
Ophidiaster hemprichii

Top right and center left and bottom right:
Sea Star
Class Asteroidea

Center right:
Egyptian Sea Star
Gomophia egyptiaca

Bottom left:
Multicolored Linckia
Linckia multifora

Opposite top left:
Dwarf Mottled Henricia
Henricia pumila

Opposite top right:
Pacific Blood Star
Henricia leviuscula

Opposite center left:
Rose Sea Star
Crossaster papposus

Opposite center right:
Dwarf Mottled Henricia and
Six-Rayed Sea Star
Henricia pumila and
Leptasterias hexactis

Opposite right:
Red Fromia Star
Fromia milleporella

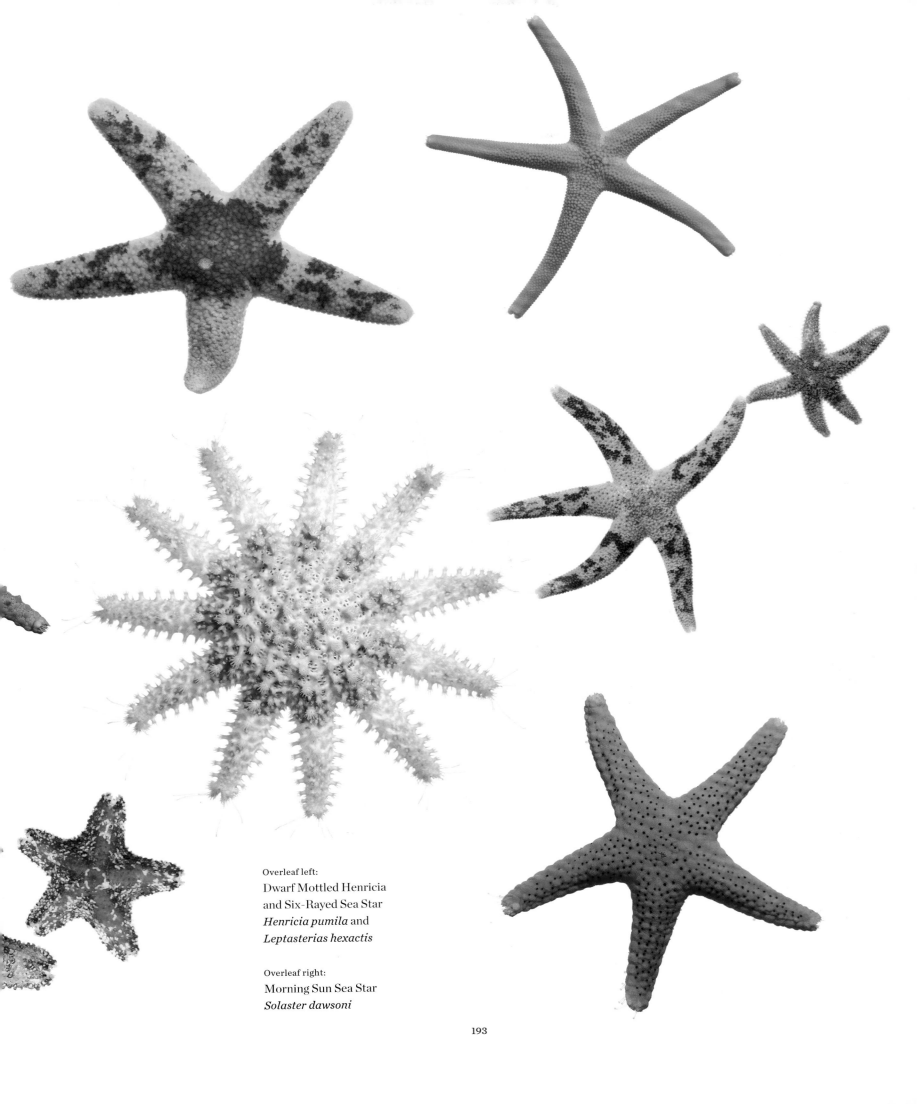

Overleaf left:
Dwarf Mottled Henricia
and Six-Rayed Sea Star
Henricia pumila and
Leptasterias hexactis

Overleaf right:
Morning Sun Sea Star
Solaster dawsoni

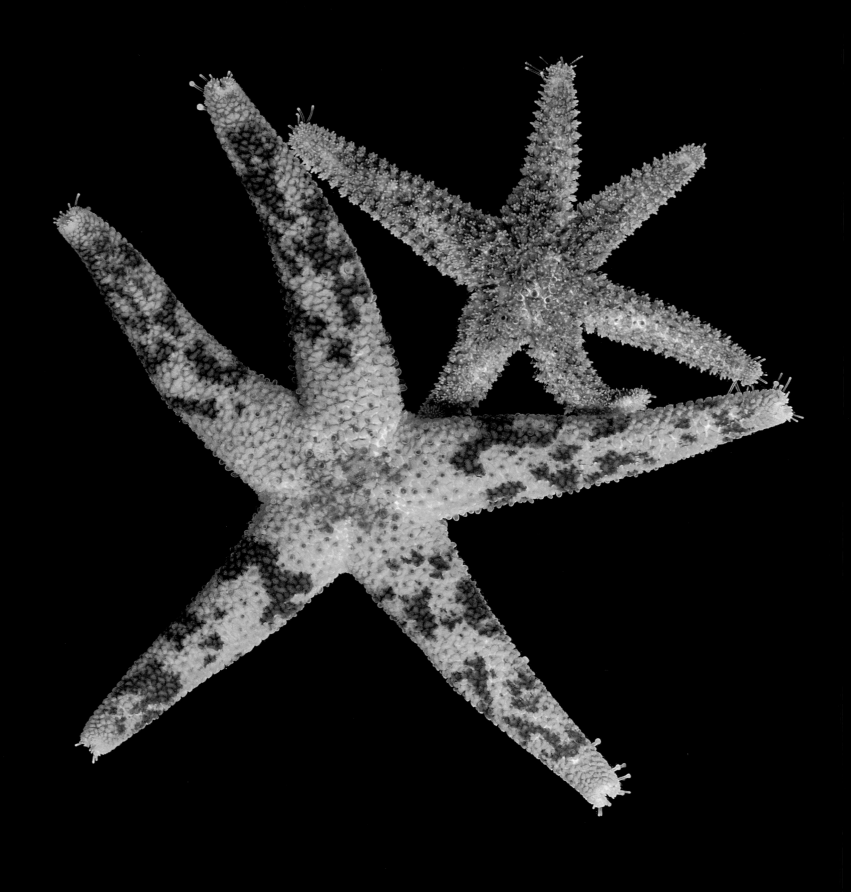

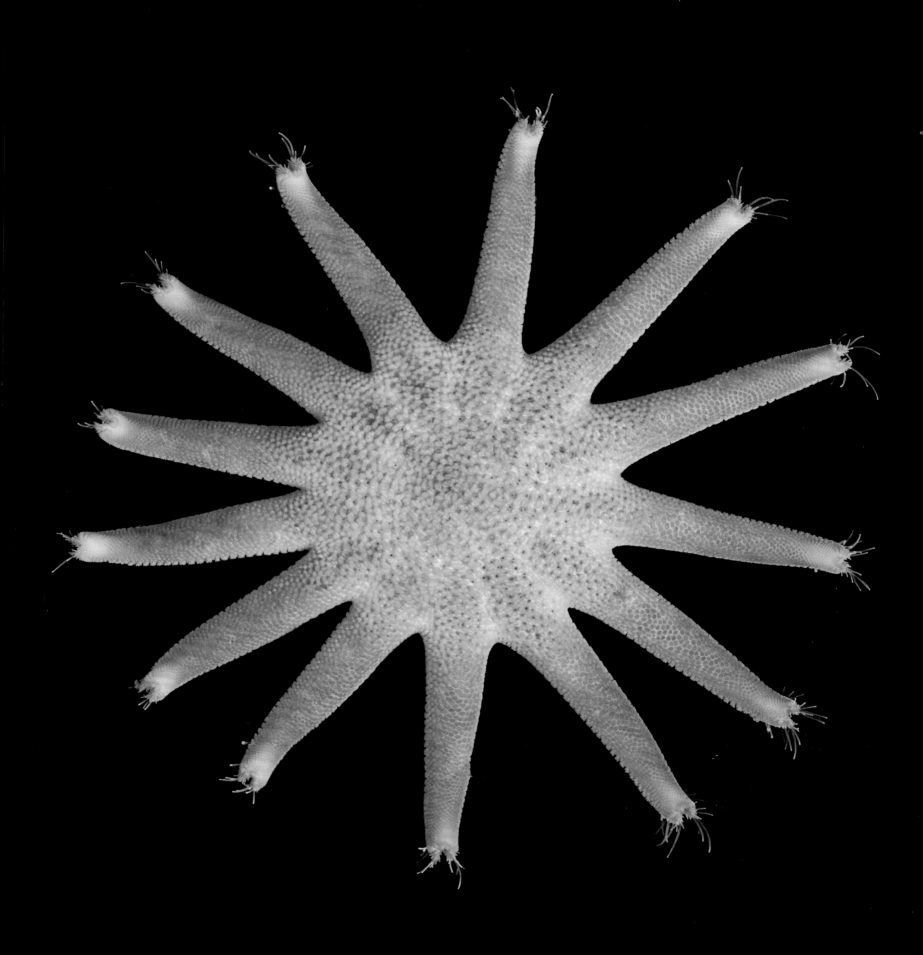

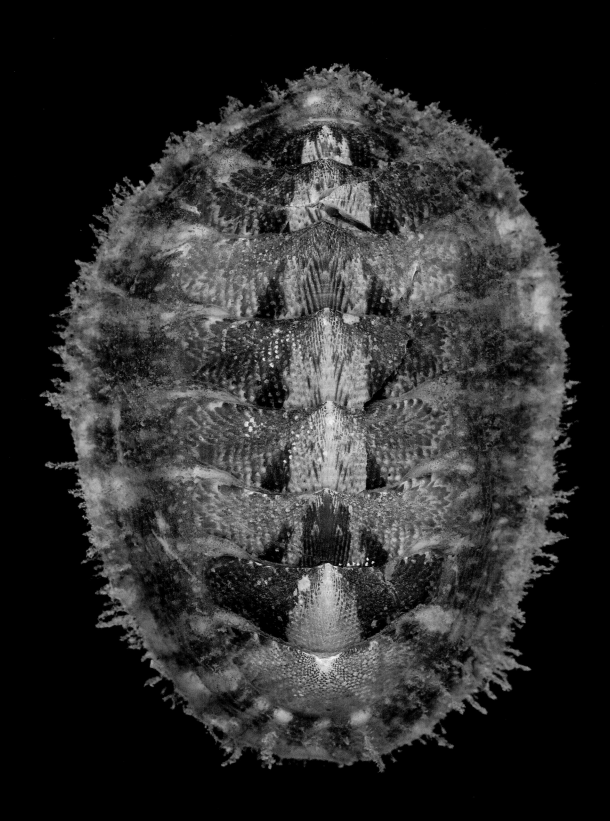

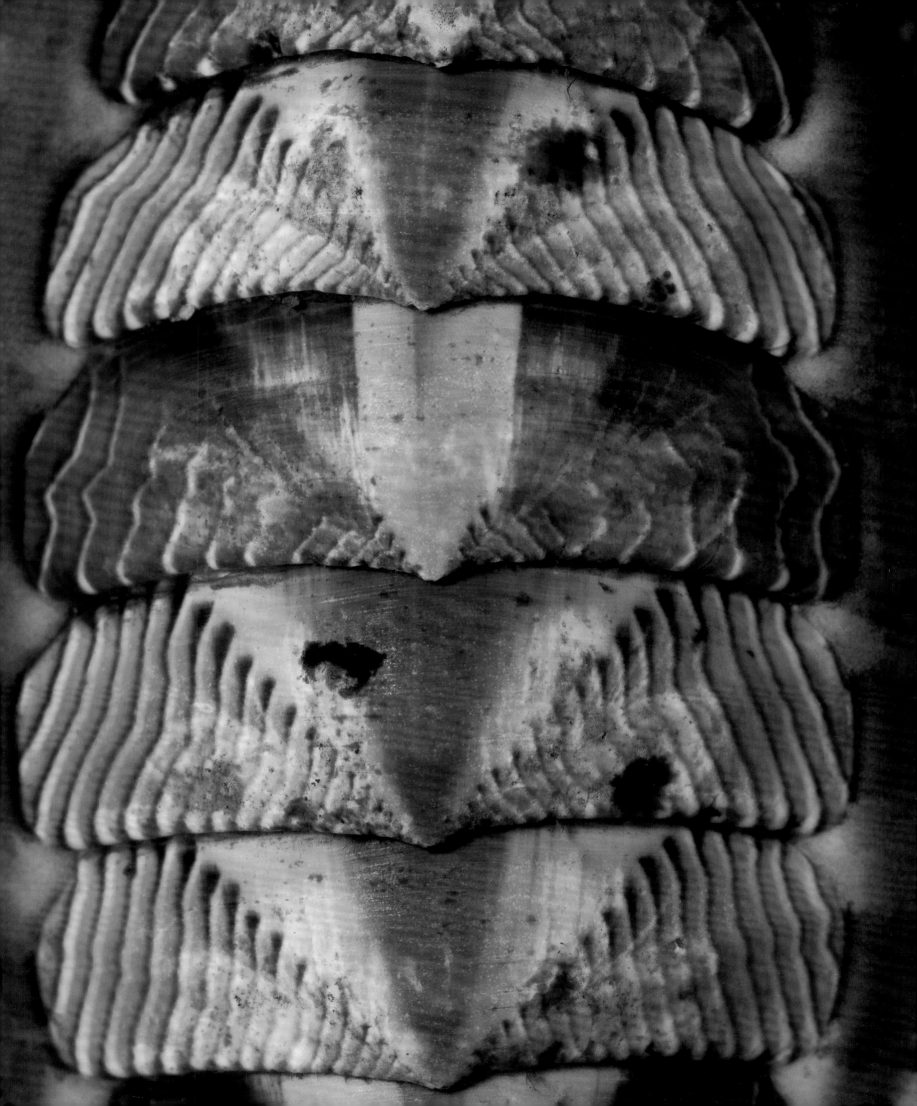

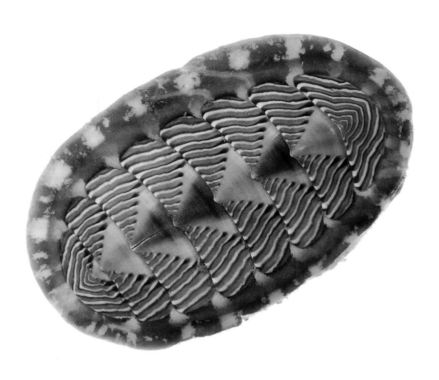

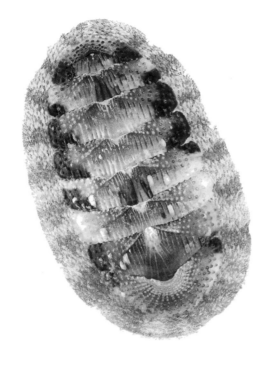

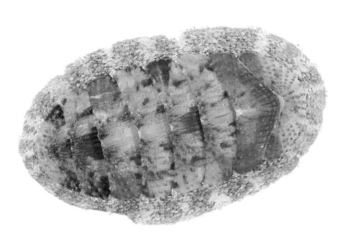

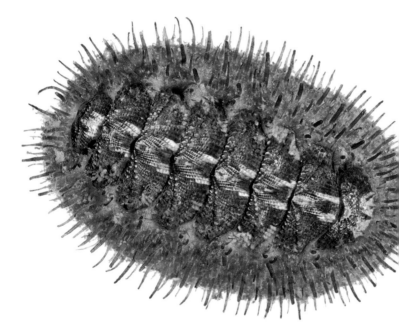

Previous page left:
Northern Hairy Chiton
Mopalia kennerleyi

Previous page right; this page top left and bottom;
opposite top left, top right, and center left:
Lined Chiton
Tonicella lineata

Top right, center left, opposite center right, and
opposite bottom right:
Merten's Chiton
Lepidozona mertensii

Center right and opposite bottom left:
Mossy Chiton
Mopalia muscosa

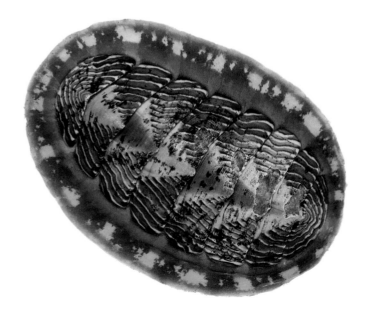

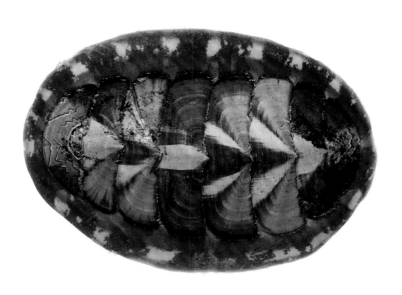

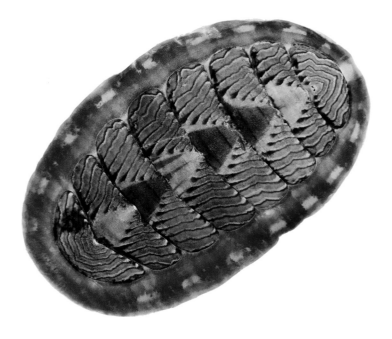

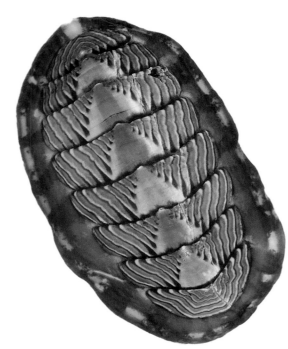

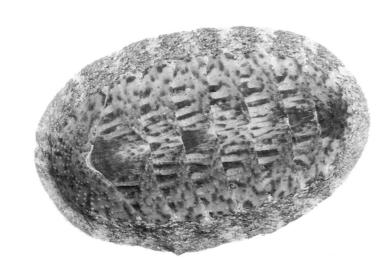

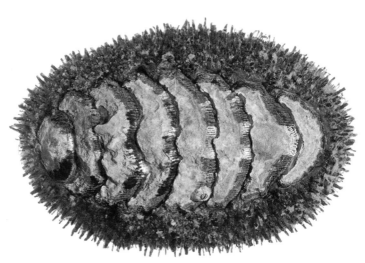

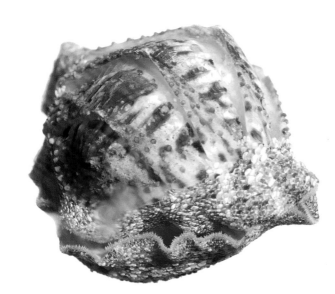

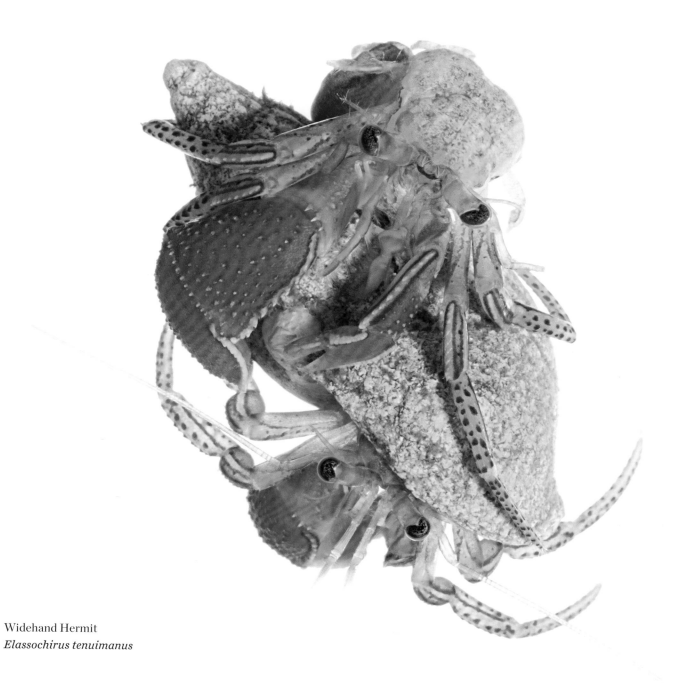

Widehand Hermit
Elassochirus tenuimanus

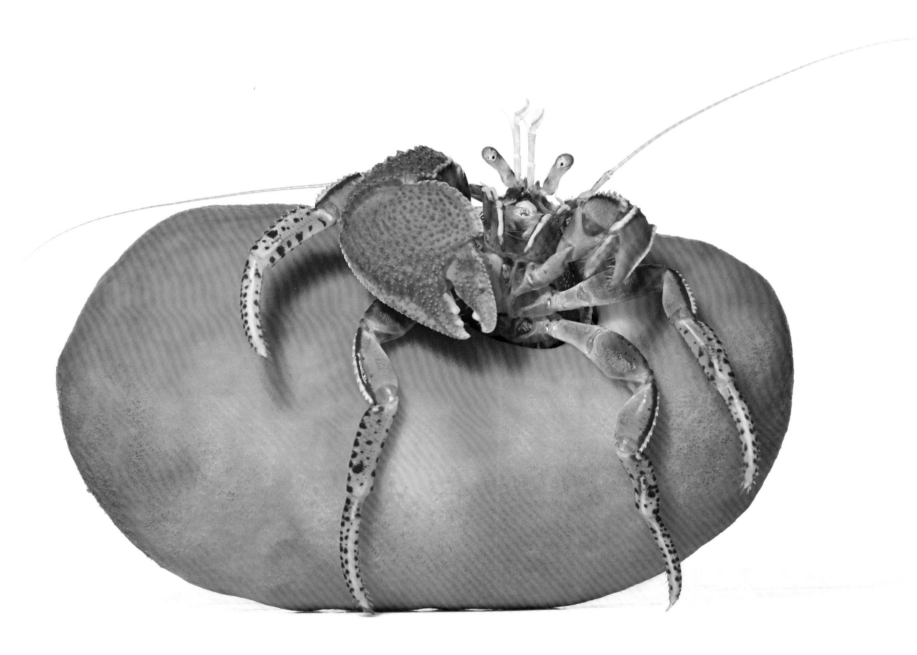

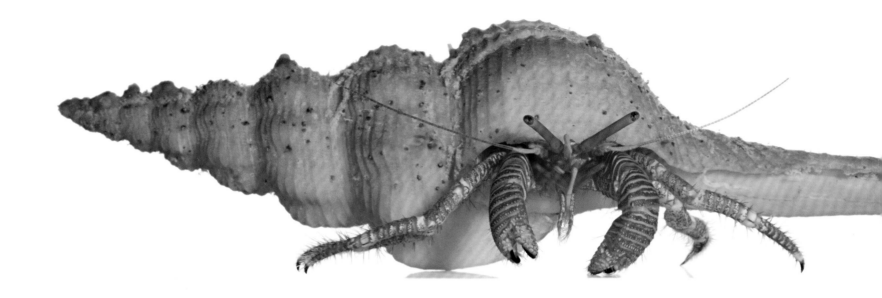

Above and opposite above right:
Hawaiian Hermit
Ciliopagurus hawaiiensis

Right:
Carnival Hermit
Ciliopagurus strigatus

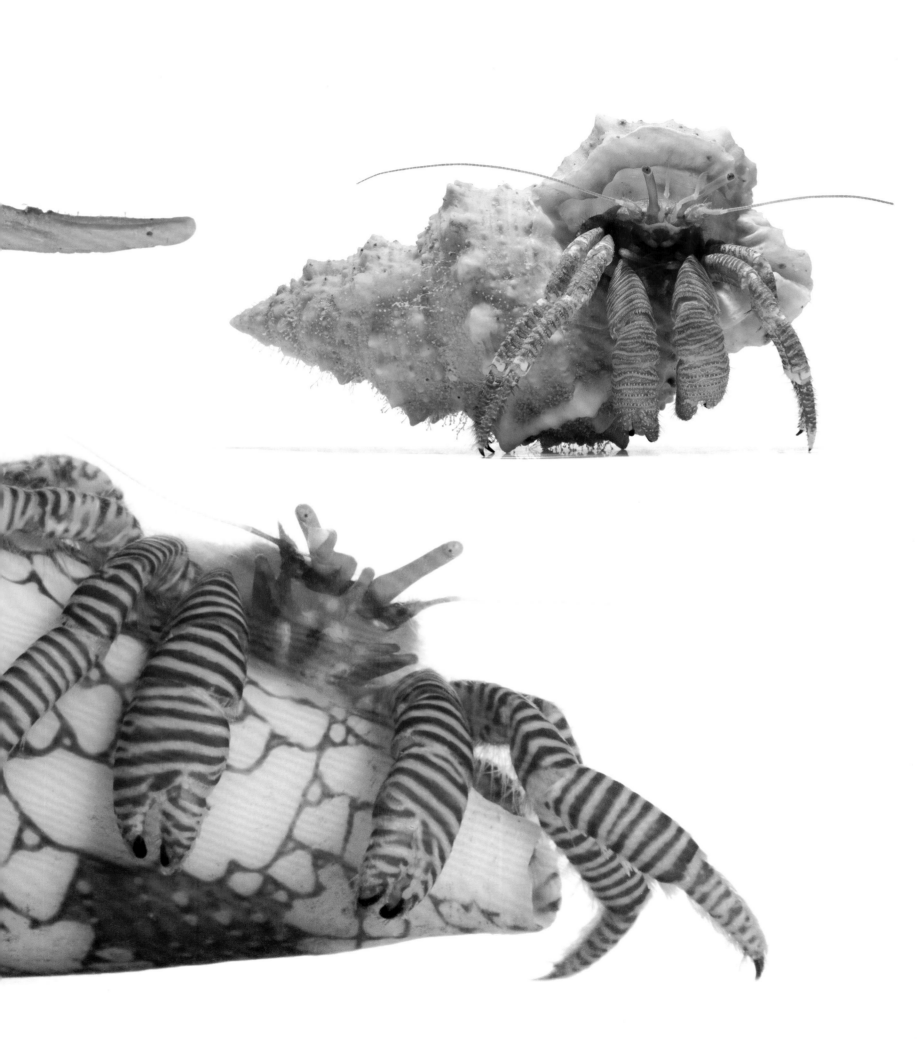

Jeweled Anemone Hermit and Hermit Crab Anemone
Dardanus gemmatus and *Calliactis polypus*

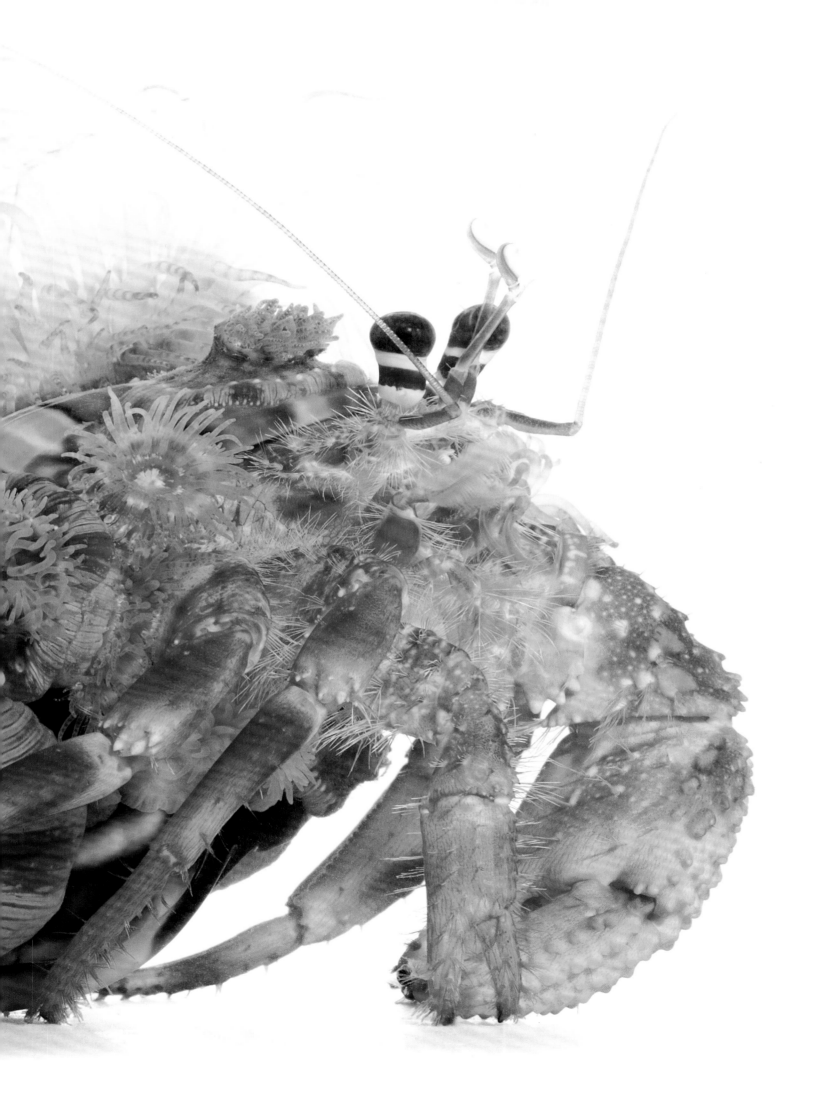

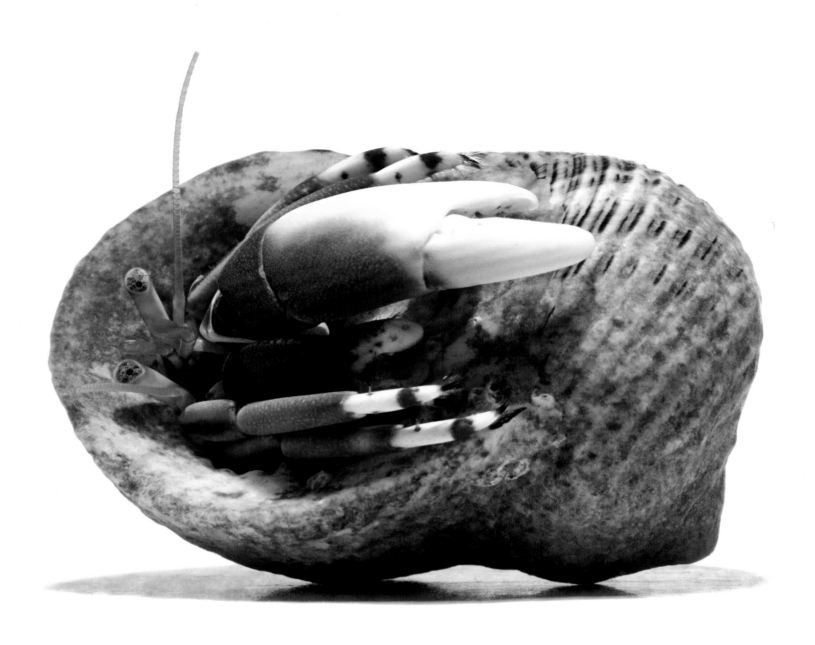

Above and opposite:
Dwarf Zebra Hermit
Calcinus laevimanus

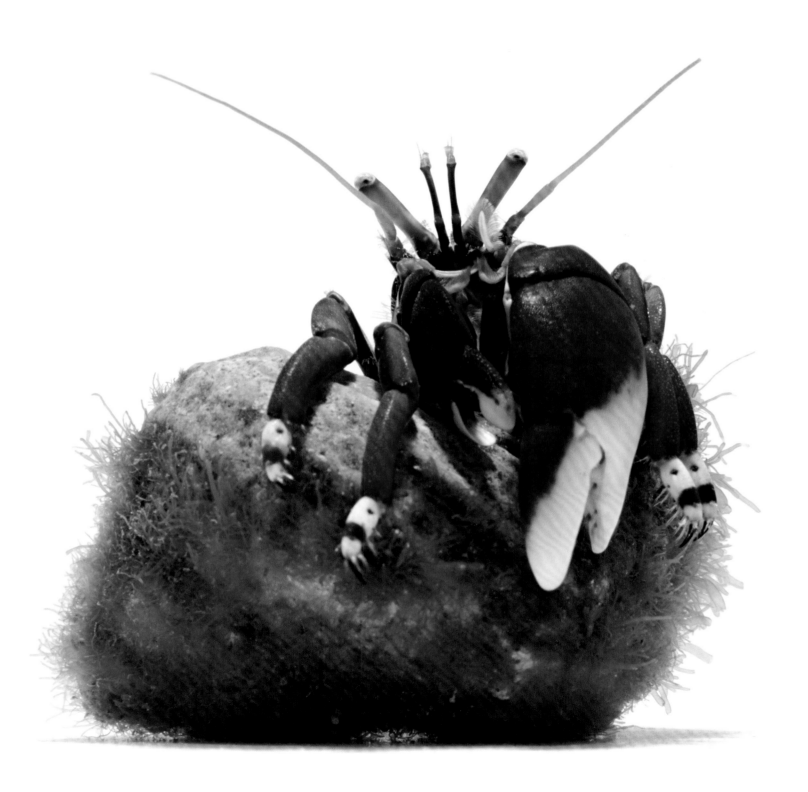

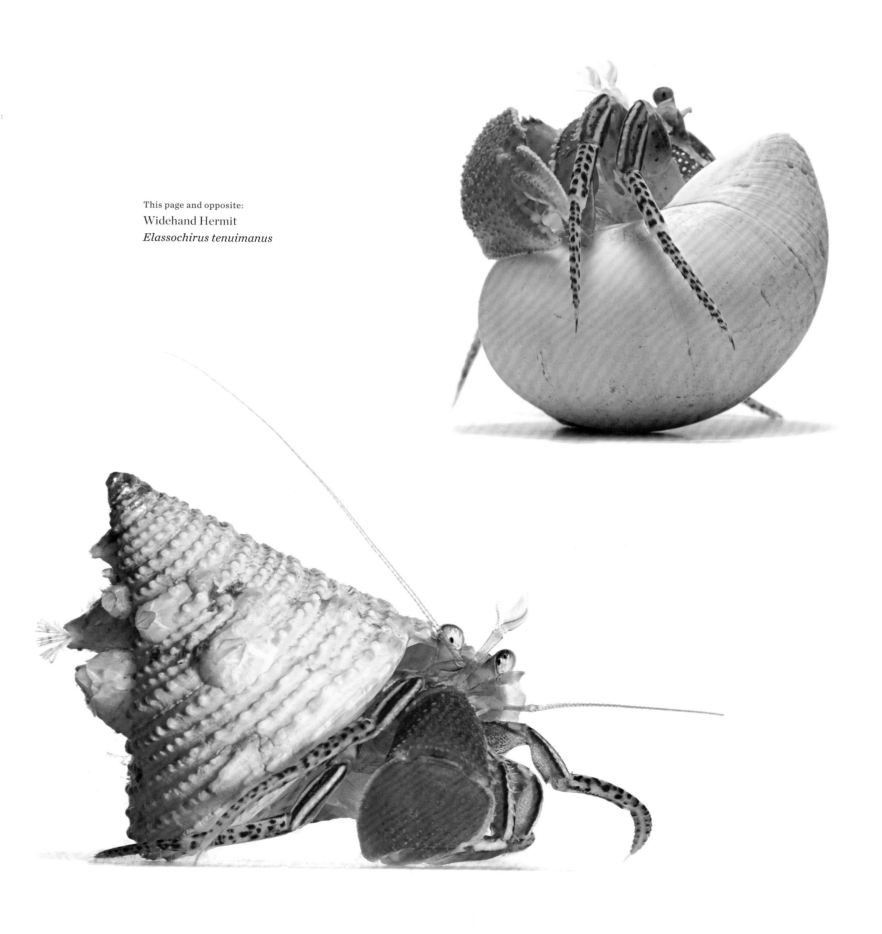

This page and opposite:
Widehand Hermit
Elassochirus tenuimanus

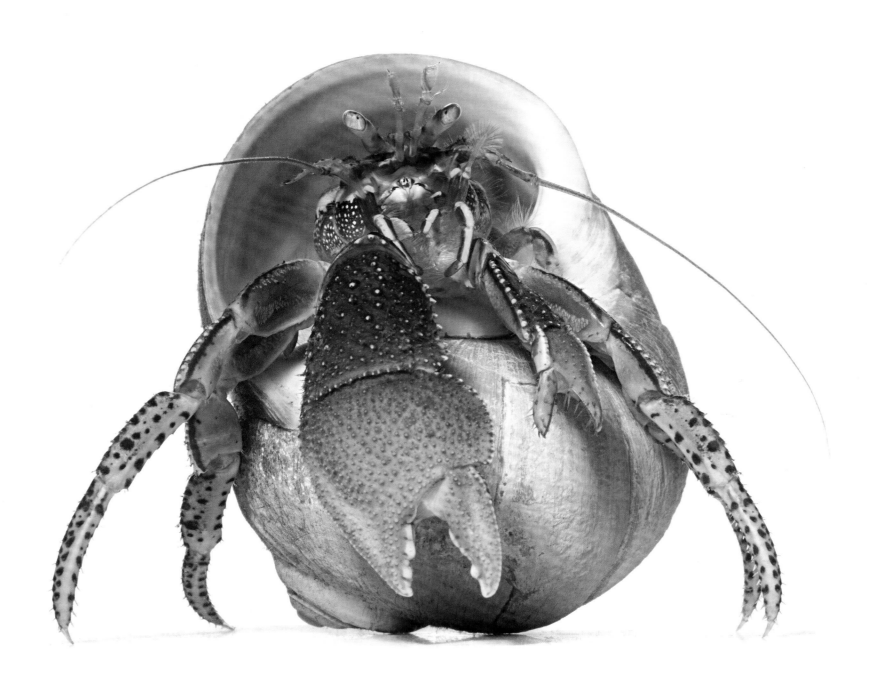

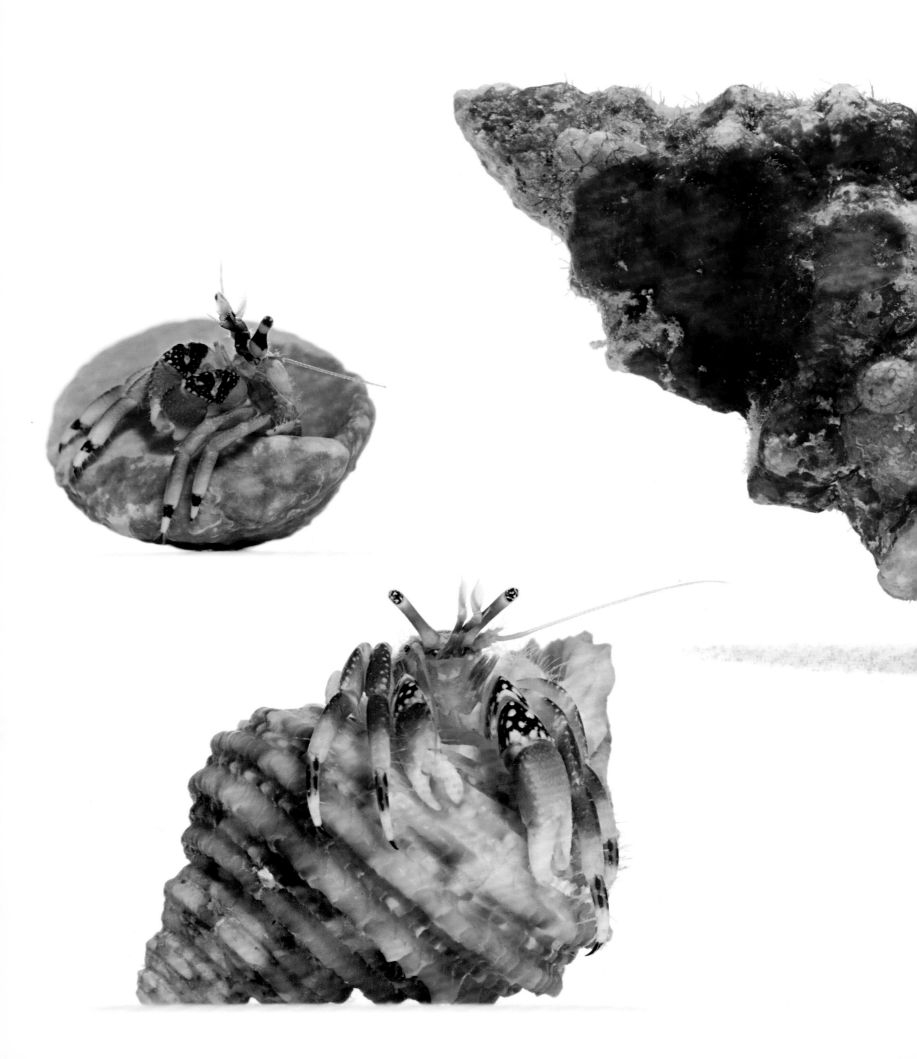

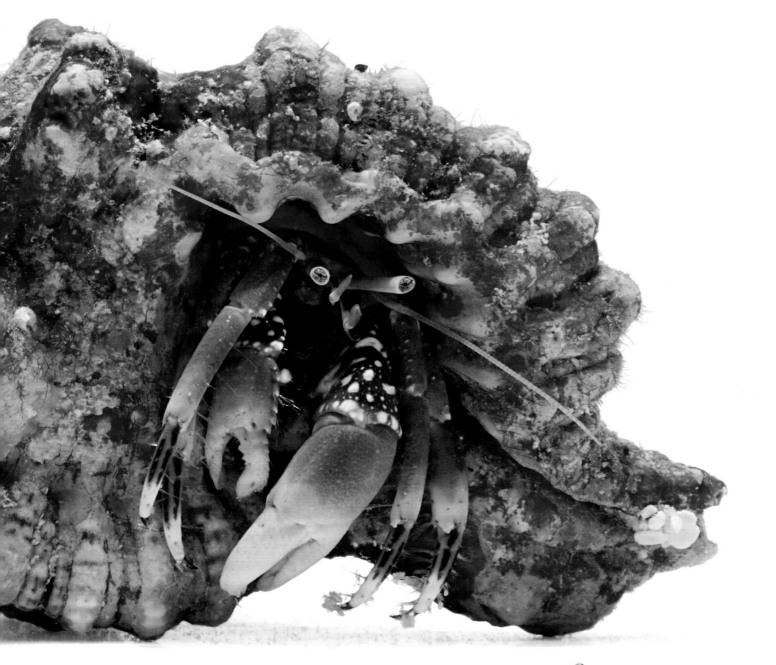

Opposite top left:
Guam Hermit
Calcinus guamensis

Opposite below, above, and right:
Hidden Hermit
Calcinus latens

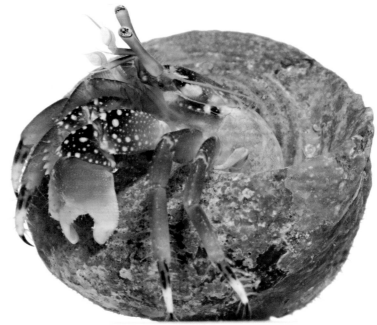

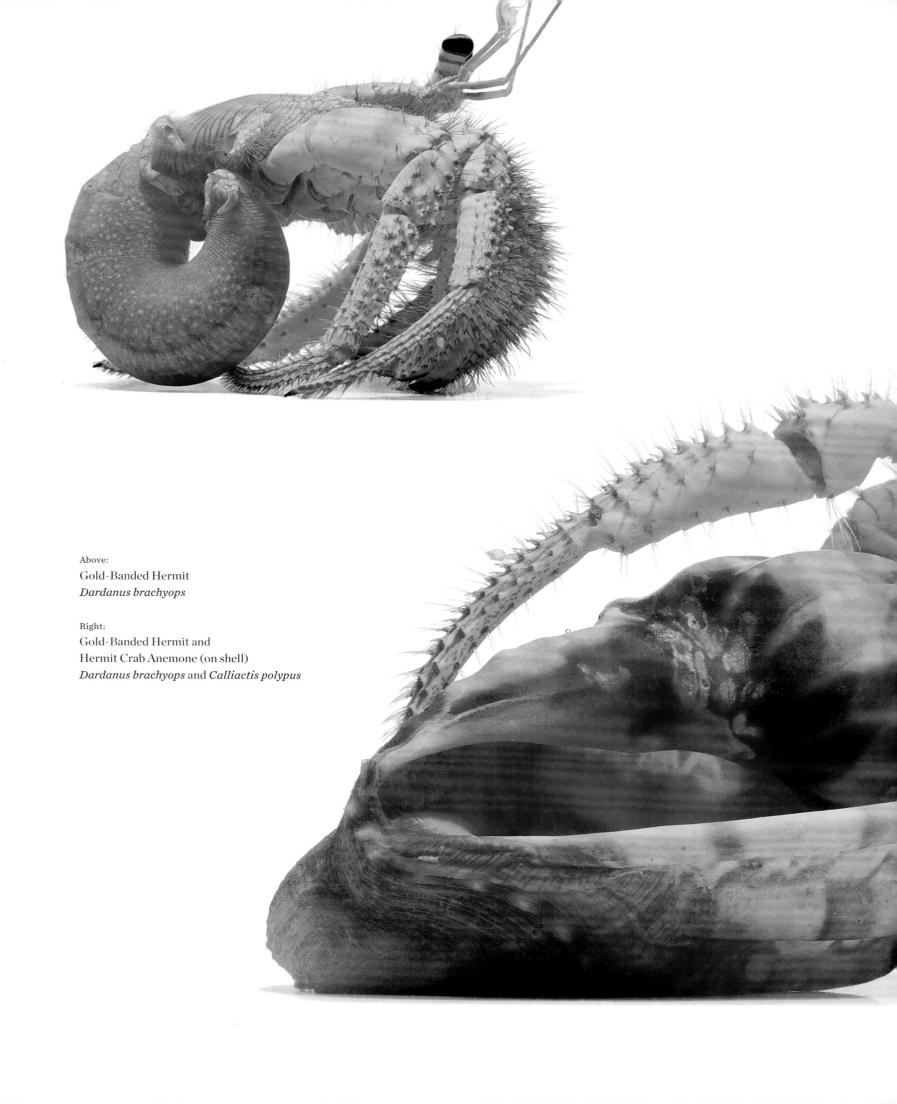

Above:
Gold-Banded Hermit
Dardanus brachyops

Right:
Gold-Banded Hermit and
Hermit Crab Anemone (on shell)
Dardanus brachyops and *Calliactis polypus*

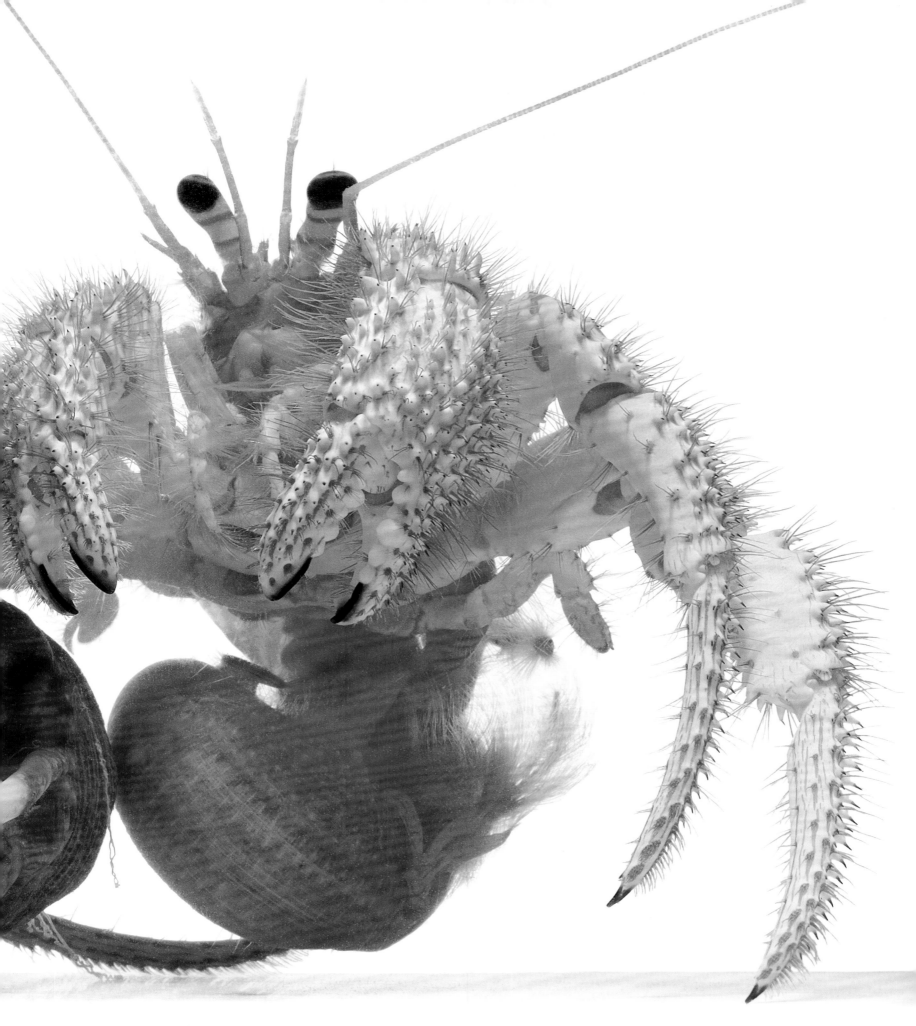

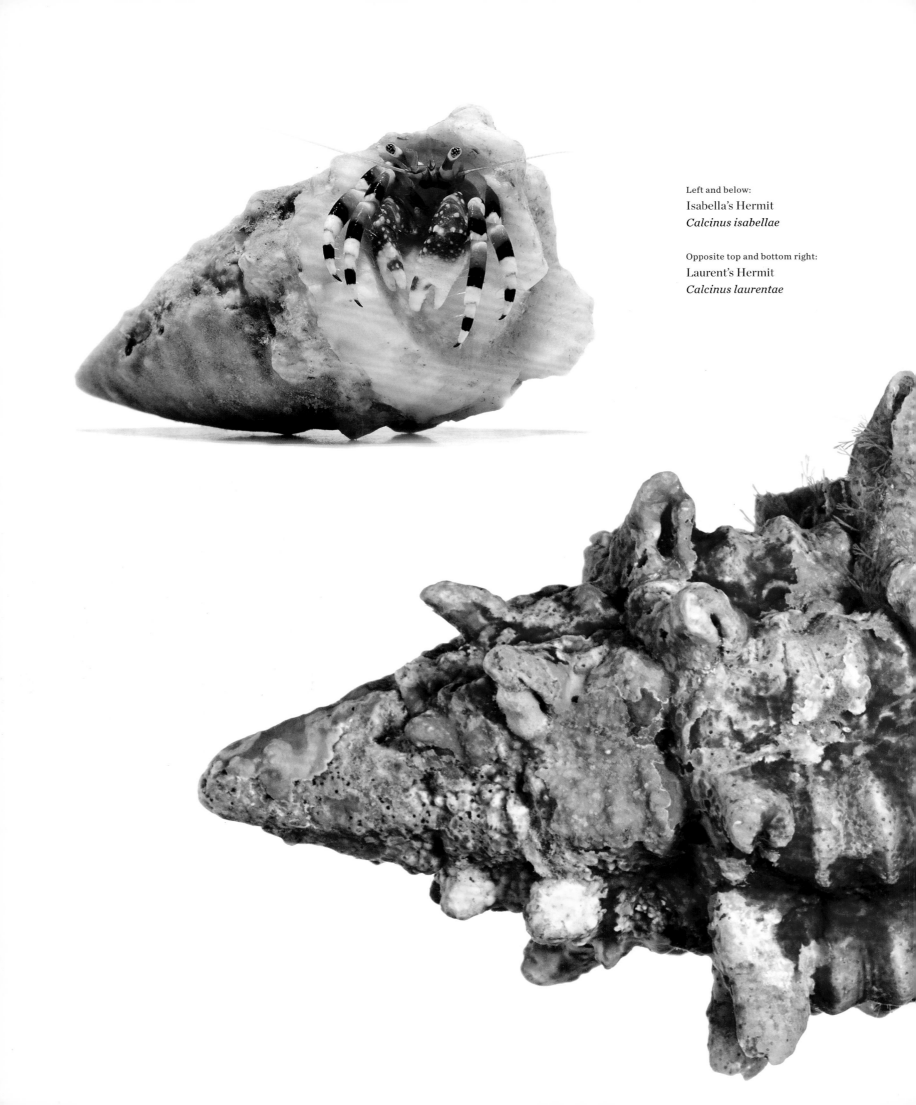

Left and below:
Isabella's Hermit
Calcinus isabellae

Opposite top and bottom right:
Laurent's Hermit
Calcinus laurentae

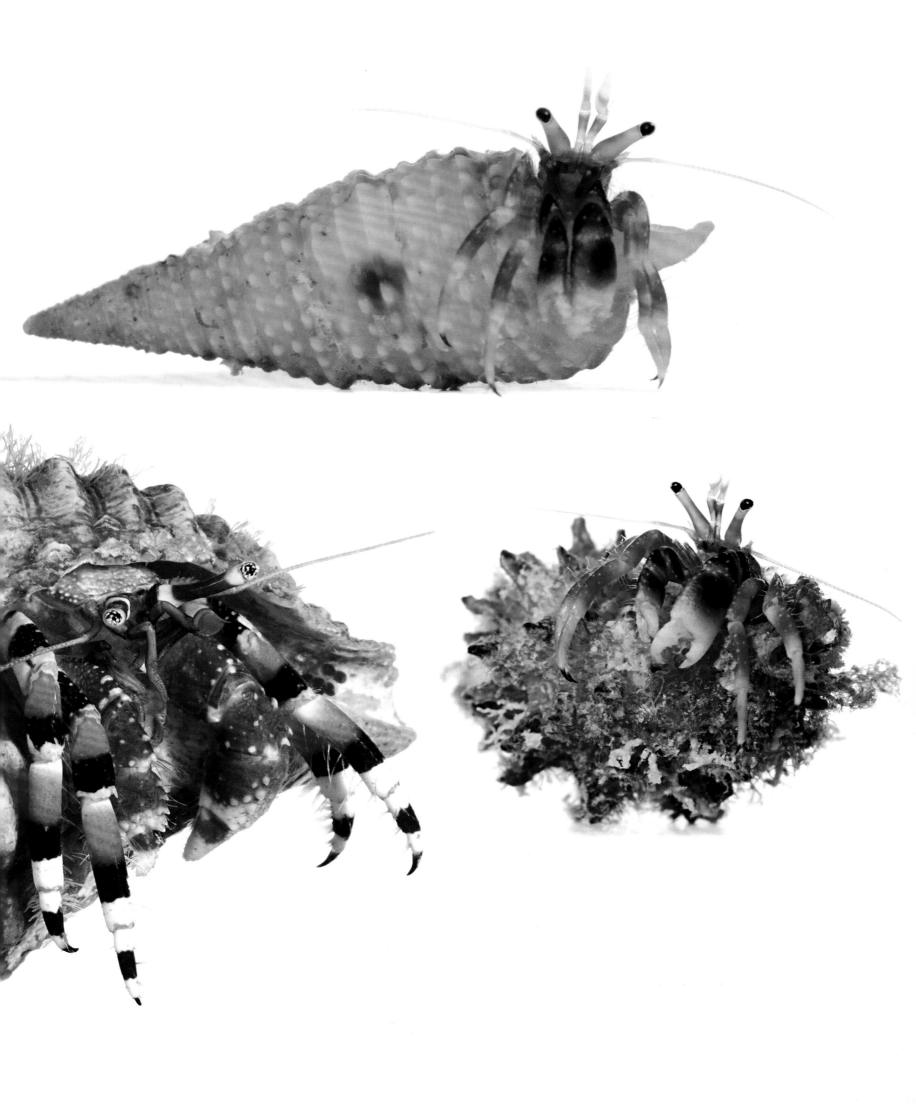

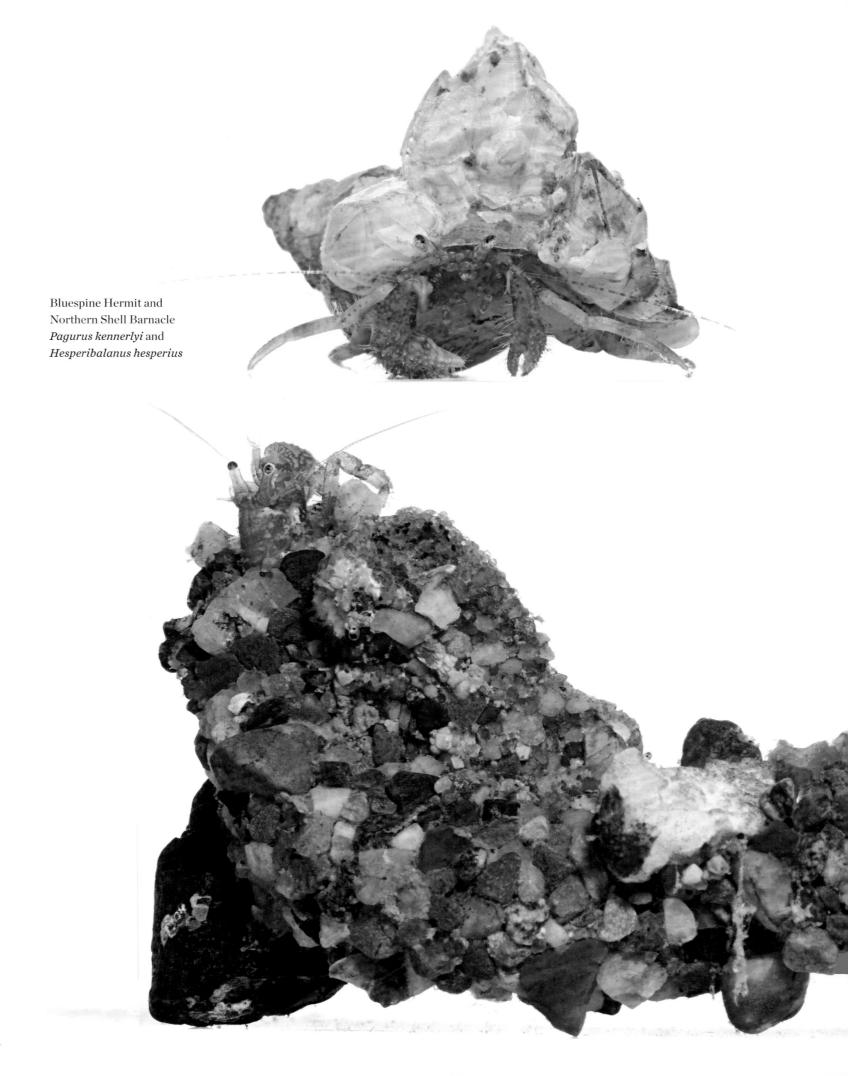

Bluespine Hermit and
Northern Shell Barnacle
Pagurus kennerlyi and
Hesperibalanus hesperius

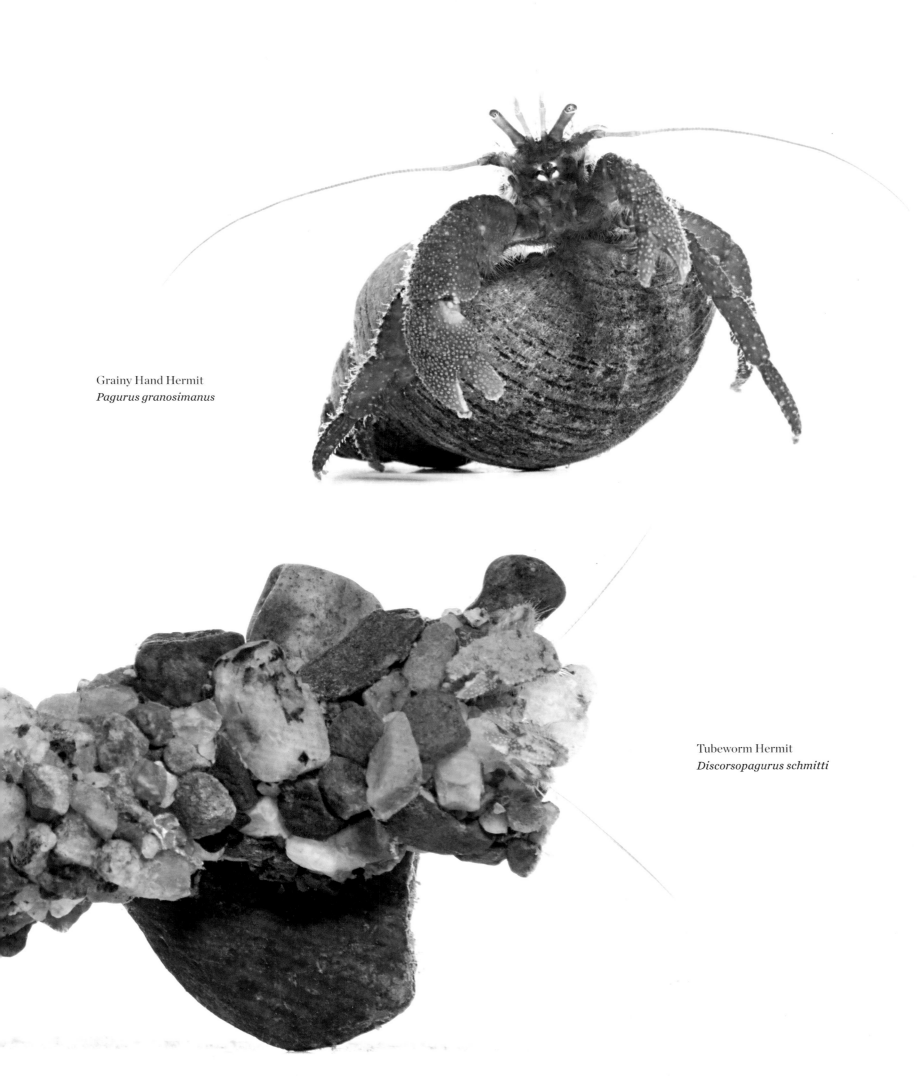

Grainy Hand Hermit
Pagurus granosimanus

Tubeworm Hermit
Discorsopagurus schmitti

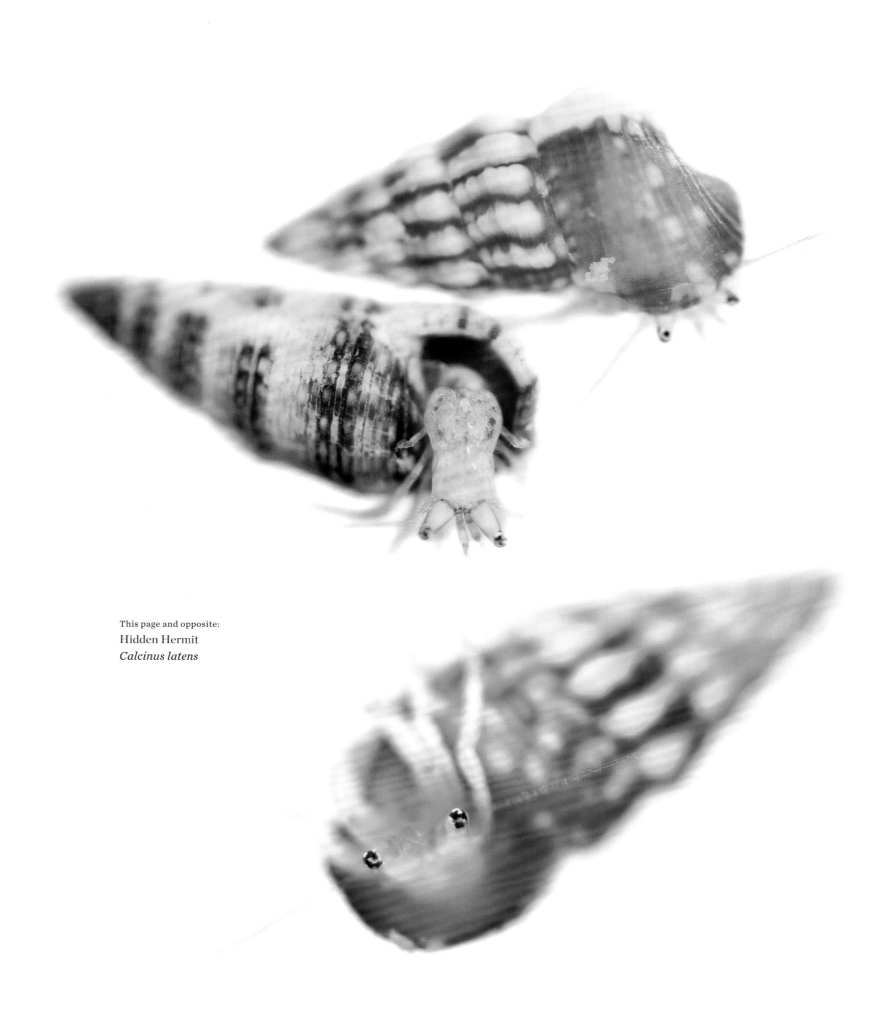

This page and opposite:
Hidden Hermit
Calcinus latens

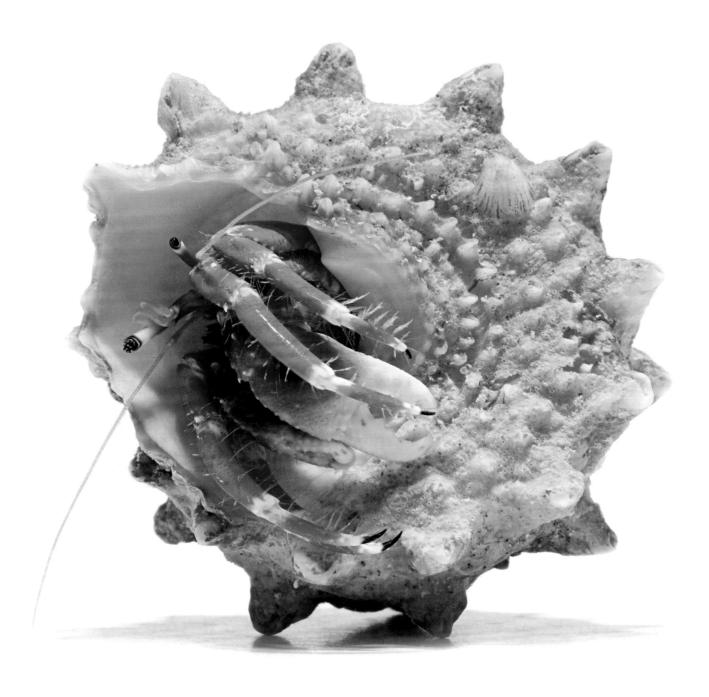

Candy Stripe Hermit
Calcinus gouti

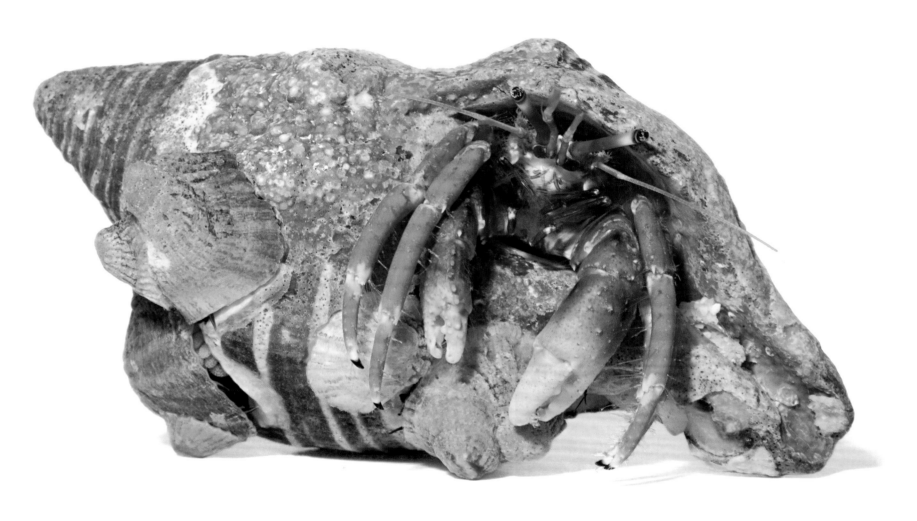

Candy Stripe Hermit and Bonnet Limpet
Calcinus gouti and *Sabia conica*

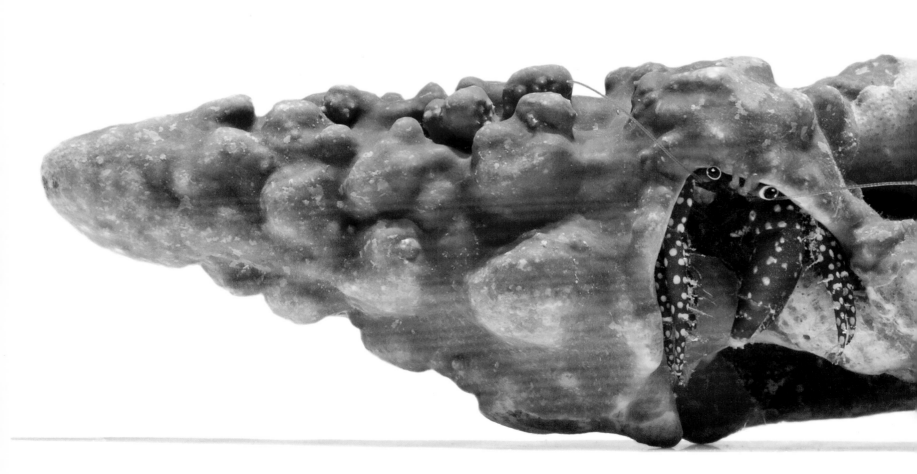

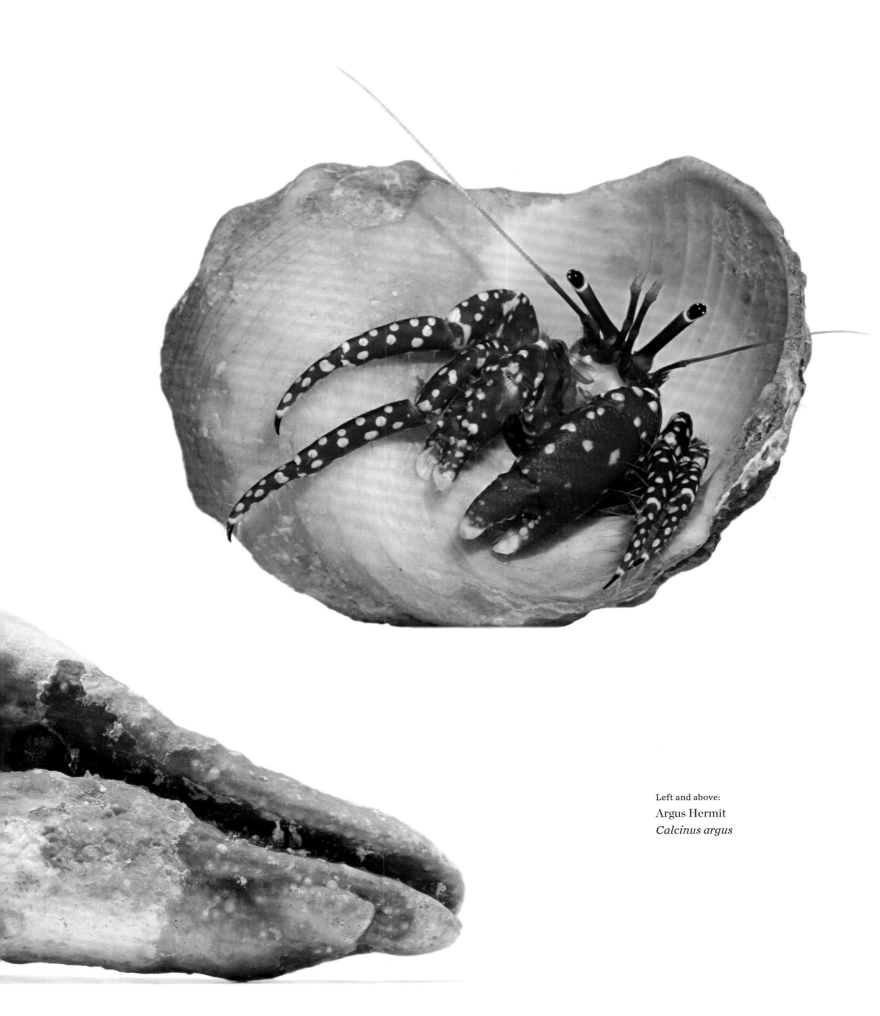

Left and above:
Argus Hermit
Calcinus argus

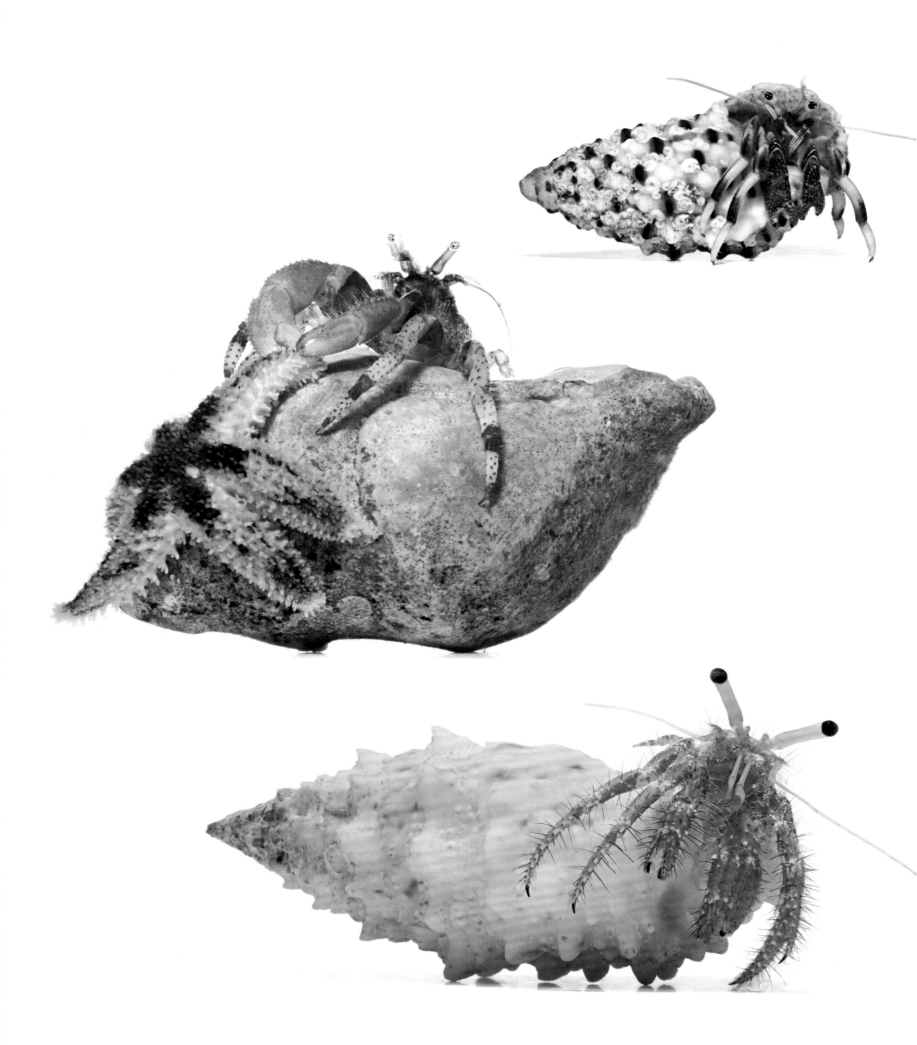

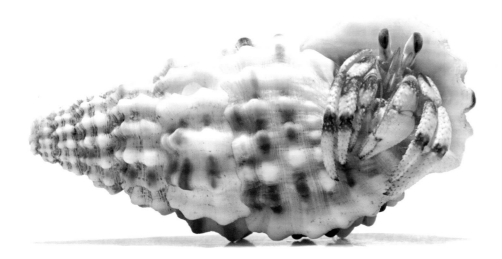

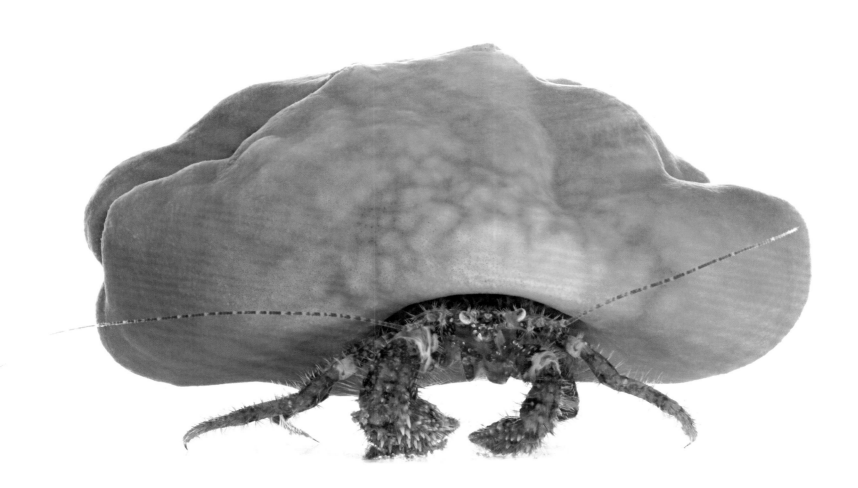

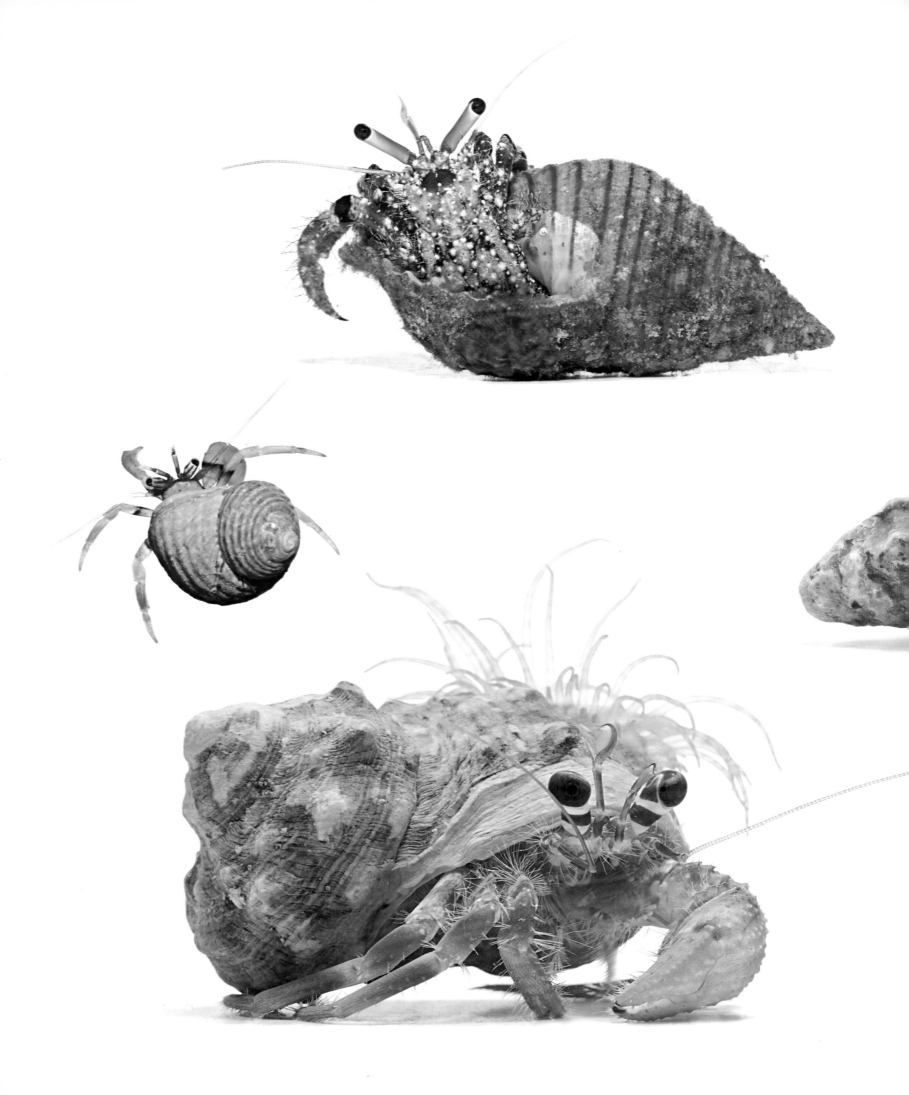

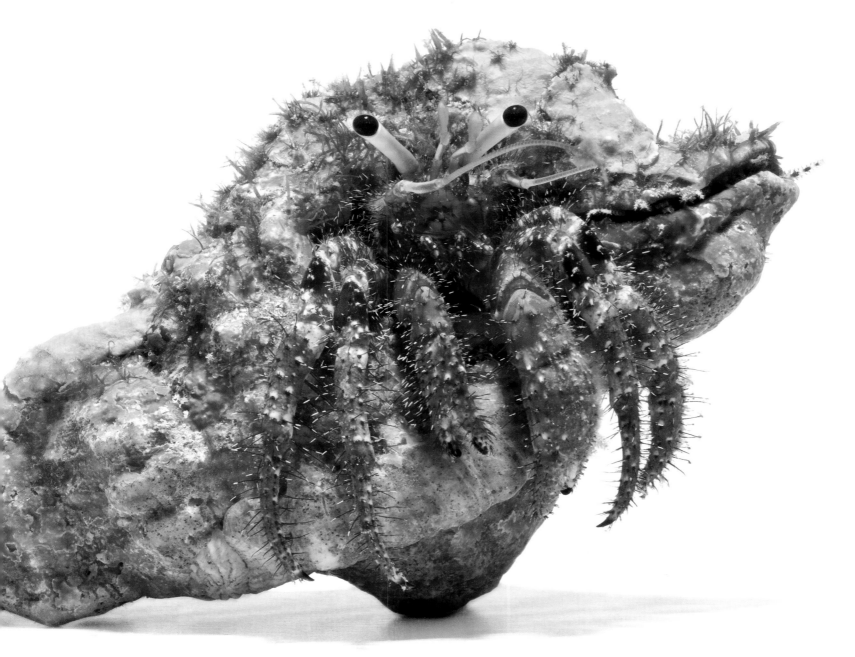

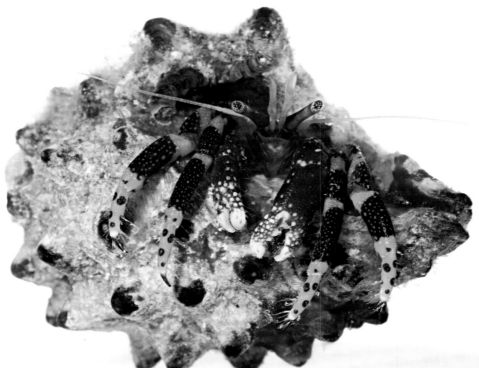

Opposite top:
Mottled Hermit
Dardanus longior

Opposite center:
Bering Hermit
Pagurus beringanus

Opposite bottom:
Jeweled Anemone Hermit and
 Hermit Crab Anemone
Dardanus gemmatus and *Calliactis polypus*

Above:
Mottled Hermit
Dardanus longior

Left:
Blue-Eyed Hermit
Calcinus sp. aff. *elegans*

Species Profiles

Text by Bernadette V. Holthuis

PACIFIC GIANT OCTOPUS, front cover

Enteroctopus dofleini

SCALE: Length without arms 1.5 cm (0.6 in)

This young octopus is probably transitioning from a life in the plankton, where it spent its earliest days, to one crawling on the bottom of the ocean, where it will live out its adulthood. Students collected the animal in surface waters off a dock at night, but its long arms, excellent crawling abilities, and well-developed coloration suggest that it's already spending considerable time on the bottom. A member of the world's largest octopus species, it may grow to weigh 45 kilograms (99 pounds) or more during its three-to-five-year life span (one individual was recorded at 272 kilograms [600 pounds]), on a diet of crustaceans, clams, fish, and even the occasional seabird captured in the intertidal. (Also pages 1, 184–185, 188–189.)

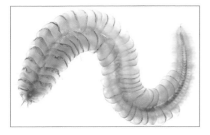

GIANT FLESHY SCALE WORM, pages 4–5

Hololepida magna

SCALE: Length 17.5 cm (6.9 in)

One of the longest scale worms known, this monster reaches lengths of 30 centimeters (12 inches) or more. And to other, smaller invertebrates, it may indeed be a monster, as many scale worms are predators (the diet of this species is uncertain). Oddly enough, the scale worm has hard jaws not at the front of its mouth but at the back of its throat, which can be turned inside out: When the throat is thus extended, its back is in front and the jaws are exposed. The jaws grasp the prey, and the throat reverts inside the body, pulling the food in with it. The giant fleshy scale worm is nocturnal and seldom seen during the day.

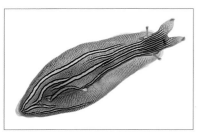

TAYLOR'S SEA HARE, page 5

Phyllaplysia taylori

SCALE: Total length 4 cm (1.6 in)

A careful examination of eelgrass (*Zostera*) leaves in shallow waters of the Northeast Pacific may reveal this sea slug, its translucent green body aligned along the length of the blades, its color and pattern blending with the color and venation of the grass. The Taylor's sea hare spends its entire life on those leaves, grazing on the film of tiny organisms (mostly diatoms) on the leaf surfaces. It even lays its eggs on the grass blades, packaging hundreds of them in a flat, transparent mass. About a month after an egg mass is laid, tiny, crawling juveniles emerge and immediately begin feeding. With two generations per year and no planktonic larval stage, these animals can occur in great abundance in some eelgrass beds.

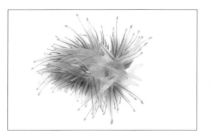

OPALESCENT NUDIBRANCH, pages 6–7

Hermissenda crassicornis

SCALE: Length 4 cm (1.6 in)

Numerous orange-tipped tentacles called cerata (singular: ceras) are scattered along the back of this nudibranch. One function of the cerata seems to be helping the animal escape predation. In a set of laboratory experiments, researchers placed the nudibranchs in a tank with northern kelp crabs (*Pugettia producta*): When a crab grasped a nudibranch's ceras in its claw, the slug immediately cast off the entire appendage, detaching it at its base. The crab was left with a squirming tentacle while the nudibranch rapidly escaped, gecko-style. Within a few days, regeneration of the lost ceras began, and within several weeks, the limb was as good as new. (Also pages 154–155.)

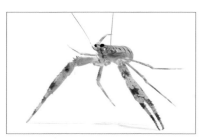

KANALOA SQUAT LOBSTER, pages 8–9

Babamunida kanaloa

SCALE: Front leg span as viewed 9.5 cm (3.7 in)

During a three-week expedition to French Frigate Shoals (northwestern Hawaiian Islands) in 2006, researchers used lobster traps (retrofitted for capturing smaller organisms) to collect marine animals. Dropped to depths unattainable via scuba diving, the traps yielded a wealth of crustaceans poorly known to science. One such animal was the squat lobster in this photograph, collected at about 240 meters (790 feet) depth. It was the first known specimen of the species: While the lobsters had been previously seen by researchers in submersibles, they'd always eluded capture by the vessels' suction devices. With this specimen, scientists could formally describe the species. They did so three years after collecting it, at which time the animal photographed here was still the only specimen known.

FRAGILE FILE CLAM, page 10

Limaria sp. aff. *fragilis*

SCALE: Shell length 2 cm (0.8 in)

Bivalves are a group of mollusks that are, for the most part, a withdrawn lot, hiding between two thick, protective shells that they clamp shut at the slightest disturbance. The file clam, however, takes a different tack: It's boldly out there, loudly proclaiming its presence with long, vermilion tentacles. In fact, the shell is too small to contain the animal and too thin to protect it. When disturbed, the clam instead relocates by clapping its light shells together, thereby jet-propelling itself away from danger. And if a potential predator has already come into contact with some of its sticky tentacles, it simply leaves those ones behind.

LION'S MANE JELLY, pages 14–15
Cyanea capillata
SCALE: Bell diameter 7 cm (2.8 in)
The lion's mane is the world's largest jellyfish species, its bell reaching a diameter of 1 meter (3 feet) or more. Like all jellyfish, it's a carnivore, feeding on planktonic animals that drift into its curtain of tentacles, which can stretch for several meters. The tentacles (relatively short in the juvenile seen here) arise from eight crescents along the bell's margin and are armed with batteries of stinging cells. When an unsuspecting animal brushes against the cells, it triggers the release of sticky or poisonous filaments that entangle and subdue the animal. On a diet of animal plankton, small fish, and other jellies, the lion's mane jelly grows quickly, reaching its adult size in less than a year.

ORNATE TUBEWORM, page 16
Diopatra ornata
SCALE: Body width 4 mm (0.2 in)
Usually when we see thin-walled, finely branched appendages on a marine animal, we can safely assume they're involved in respiration. On a worm, the location of such gills is often an indication of lifestyle: If they're concentrated around the head, the species probably lives a sedentary life hidden in a tube or burrow, with its head near the opening; if the gills run down the entire body, the animal is likely an active one that crawls about with its length exposed. The placement of the red, feathery gills on the ornate tubeworm is somewhere in between: large and numerous up front, increasingly smaller and sparser toward the back. Accordingly, its lifestyle is both sedentary and active. The worm lives in a tube but, when feeding, extends its front end out to crawl and forage on the surrounding sand flat.

SAN JUAN STALKED JELLY, page 21
Haliclystus "sanjuanensis"
SCALE: Diameter with tentacles 3 cm (1.2 in)
This remarkable jellyfish doesn't swim but lives attached by a short stalk to leaves of seaweed or grass. In one photo, the animal is secured to a blade of eelgrass whose edges are adorned with a delicate red seaweed; in another, it's attached directly to a seaweed. Eight arms radiate from a central mouth, each one bearing a terminal explosion of tentacles. Loaded with stinging cells, the pinhead tips of the tentacles capture small crustaceans on which the animal feeds. Scientists recognize about fifty stalked jelly species, and while the name of this common one has been in use since the 1920s, it has never been formally described (hence the quotation marks around the species name). (Also pages 190–191.)

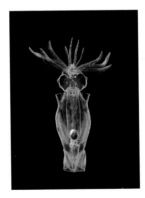

BLACK-EYED SQUID, page 22
Gonatus onyx
SCALE: Length without arms 2 cm (0.8 in)
Squids generally have a hands-off style of parenting: Mothers lay their fertilized eggs on the ocean floor or in floating masses and leave them to develop unattended. In 2000, biologists reported the first known case of a species with parental care: black-eyed squid females holding large, gelatinous masses of embryos in their arms. Adults of the species are normally found at 500 to 800 meters (1,600 to 2,600 feet) depth, but the brooding mothers were observed much deeper, at 1,500 to 2,500 meters (4,900 to 8,200 feet). Evidence suggests that a female carries the mass for up to nine months (during which time she can't feed), moving inshore to shallower waters as hatching time approaches. Young members of the deepwater species, like this one collected right off a dock, are found in surface waters.

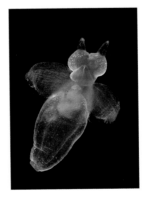

SEA ANGEL, page 23
Clione limacina
SCALE: Body length 6 mm (0.2 in)
The wing-like extensions of this sea slug's foot allow it to "fly" angelically, but this angel has a dark side: It preys voraciously (and exclusively) on a species of swimming snail, *Limacina helina*. In fact, the species name *limacina* refers to its prey animal. The sea angel's mouth sits between the two short tentacles on its head. When the predator comes into contact with a swimming snail, it everts a set of six long appendages from the mouth, capturing the snail in their grip. Holding the shell tightly, it extracts the body and swallows it whole. Tiny, young sea angels rely on larval swimming snails for food, while adult angels consume adult prey.

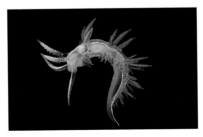

THREE-LINED NUDIBRANCH, page 24
Flabellina trilineata
SCALE: Body length 1 cm (0.4 in)
Curling its body and bristling the appendages (cerata) on its back, this nudibranch strikes a defensive pose. At the tip of each appendage is a brown sac filled with stinging cells. When disturbed, the animal discharges the cells via tiny pores. Remarkably, the stinging cells are not produced by the nudibranch itself: It appropriates them from its prey, tiny colonial animals called hydroids, which are related to sea anemones and jellyfish. After a meal, the stinging cells are transferred from the stomach to the sacs at the ceratal tips via red-colored fingers of the digestive system, plainly visible in the photograph. The cells are stored in the sacs for the nudibranch's own defense.

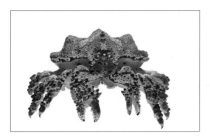

PUGET SOUND KING CRAB, page 25
Lopholithodes mandtii
SCALE: Leg span as viewed 18 cm (7.1 in)
The Puget Sound king crab is a cousin of the red, blue, and golden crabs—three species collectively known as Alaskan king crabs and the basis for a major commercial fishery. While the carapace of the Puget Sound species can reach sizes comparable to those of the Alaskan ones (30 centimeters [12 inches] across), its legs—the crab parts most valued by human predators—are relatively small and short. The colorful animal in the photograph here stands out against a white background, but in its natural habitat, the crab is surprisingly well camouflaged among the encrusting algae and invertebrates that cover the surrounding rocks. (Also pages 26–27.)

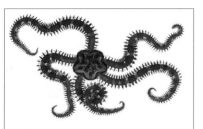

BRITTLE STARS
DAISY BRITTLE STAR, page 32
Ophiopholus aculeata
SCALE: Disc diameter 8 mm (0.3 in)
Brittle stars are highly mobile echinoderms that use their long, snake-like arms to get around. Unlike most quickly moving animals, they have no directionality, lacking not only a head but even front and back ends. So how do these brainless creatures manage to move toward or away from anything in a directed way? Recent studies have found that when a brittle star crawls, it designates one of its five arms as the front and then "rows" with the arms on either side of that one, an action that propels it forward, that is, in the direction of the assigned "front arm." The central disc holds the viscera and has a mouth on its underside. (Also pages 33, 34, 35, 118.)

CANDY CORN NUDIBRANCH AND FINGER COPEPOD, page 36
Janolus fuscus and *Ismaila belciki*
SCALE: Figure width 3.5 cm (1.4 in)
I studied this photograph for some time before realizing that I was looking at more than one animal: the nudibranch, facing the camera, and two parasitic copepods embedded in its head. The copepods themselves are buried inside the host, but their emergent white egg masses give them away. If you're familiar with copepods as tiny crustaceans swimming in the plankton, it may come as a surprise to learn that many species are parasitic on other animals. The white finger copepod, commonly found on this species of nudibranch, feeds on the blood of its host. While it doesn't generally kill the slug, it does appear to lower its fecundity: Parasitized animals lay fewer eggs than unparasitized ones do.

CANDY CORN NUDIBRANCH (EGGS), page 37
Janolus fuscus
SCALE: Frame width 1 cm (0.4 in)
Among marine invertebrates, large families are the norm, with each adult typically producing thousands of offspring. The candy-corn nudibranch—whose coiled-string egg mass is shown here—is no exception. Magnified, the egg string appears as a necklace of beads (capsules), with each capsule holding tens of closely packed embryos. One painstaking study on the species found that egg masses contained an average of 324 capsules, each with an average of 66 embryos; every (hermaphroditic) adult in the study laid several egg masses in just three weeks' time, giving birth to upward of 100,000 children. The reason we're not neck-deep in candy-corn nudibranchs is that only a minute fraction of the young survive the three and a half months from birth to adulthood.

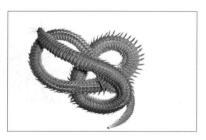

BANNER SEA NYMPH, page 38
Nereis vexillosa
SCALE: Length 20 cm (7.9 in)
The genus name for this group of worms refers to the ancient Greek sea god Nereus, who, like the worms, was a shape shifter. The animals in these photographs were found crawling on intertidal sand flats, but when it comes time to breed, they'll undergo a drastic transformation to become swimmers: Their appendages will become long and paddle-like, their eyes much larger, and their swimming muscles enhanced. Males and females swollen with gametes will then gather at the water's surface, spawn their sperm and eggs freely, and die. Until that time, however, the worms will live on the bottom, feeding on pieces of seaweed and possibly small animal prey taken with their black, pincer-like jaws. (Also page 39.)

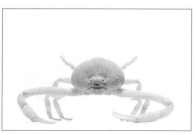

WHITE PHANTOM CRAB, page 40
Tanaoa distinctus
SCALE: Body width 5 cm (2 in)
A Polynesian myth tells of Tanaoa, the god of primeval darkness: After light came into being, he was banished to the depths of the ocean, where total darkness still reigns. The myth inspired a biologist studying the white phantom crab—an inhabitant of deep waters (up to 800 meters [2,600 feet] or more) around tropical Pacific islands—to christen the crab and its close relatives "Tanaoa," after the god. The genus is a member of the purse crab family, named for the species' very large abdomens (curled under the body as in all crabs) that form purse-like pockets in which females brood their embryos. Purse crabs live buried in sand with only their faces showing.

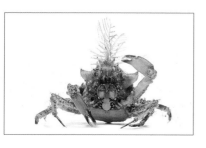

GRACEFUL KELP CRAB, page 41
Pugettia gracilis
SCALE: Leg span as viewed 4 cm (1.6 in)
This crab holds its head high, showing off its mouthparts and seemingly preening itself with one claw. The feather-like projections that it's fingering, however, are not part of the crab: They're a colonial animal called a hydroid, purposefully placed there by the crustacean. Like many members of the spider crab family, this one is a decorator, albeit a minimalist. It seldom bothers with more than a piece of seaweed or hydroid on its snout—perhaps enough to throw off anyone looking for a crab lunch. If a predator does spot the animal, the pronounced triangular teeth on either side of the crab's head may make it think twice about eating it.

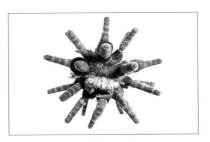

TEN-LINED SEA URCHIN AND KNOBBY LIOMERA, page 42
Eucidaris metularia and *Liomera monticulosa*
SCALE: Diameter with spines 3 cm (1.2 in)
If you look carefully at this small urchin, you'll notice that it has an even tinier crab nestled among its spines; as far as we know, the pairing represents a chance occurrence rather than a symbiotic relationship between the two animals. The ten-lined urchin belongs to the most primitive group of living sea urchins, the order Cidaroidea, which is unusual in many respects. The blunt spines are notable in that they're slightly marred with detritus and tiny organisms starting to grow on them, whereas the spines of most urchins are kept pristinely clean by a thin layer of skin that always covers them. In cidaroids like this one, the skin sloughs off as the animal gets older, allowing dirt and organisms to settle.

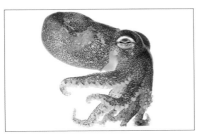

STUBBY SQUID, page 43
Rossia pacifica
SCALE: Length without arms 6 cm (2.4 in)
Susan captured this delightful animal in mid-stride as it "walked" along the aquarium floor in a movement typical of the species. Not in fact a squid, the stubby squid's lifestyle is very different from those streamlined swimmers: It's found near the ocean bottom, buried in sand during the daytime and crawling on the surface at night. Its reason for hiding in the day may be to escape the notice of both predators and prey. While it sometimes buries itself completely, at other times the stubby squid leaves its eyes and the tip of a waving tentacle exposed, suggestive of an animal luring in unsuspecting food items.

FROSTED NUDIBRANCH, page 44
Dirona albolineata
SCALE: Body length 5.5 cm (2.2 in)
Like all nudibranchs, the frosted nudibranch is a carnivore, but unlike most, it's fairly catholic in its diet—eating everything from moss animals and sea squirts to sponges and barnacles. Individuals in different places feed on different organisms according to what's available. One researcher examined the feeding habits of populations on San Juan Island, Washington: On a reef practically devoid of animal life except for three species of tiny snail, the nudibranchs subsisted on those snails; in a location where moss animals were especially abundant, the slugs fed largely on them. This dietary flexibility may allow the species to live in a broader range of habitats than is typical for nudibranchs, most of which have much more restricted diets. (Also pages 45, 139.)

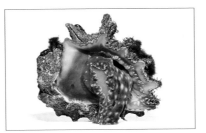

STRAWBERRY DRUPE, page 46
Drupa rubusidaeus
SCALE: Shell length 3 cm (1.2 in)
Walking along any coral reef in the Indian or Pacific Oceans, you're likely to stumble upon at least one species of drupe—intertidal snails with small, thick shells. You might not notice these common mollusks, however, as their rough shells can be covered with algae and easy to overlook. The outside of the shell in this photograph is coated with a layer of pink encrusting algae and red tufted algae. Normally, the doorway of the shell (aperture) would be facedown and the animal's daring ensemble of white-spotted green flesh on hot pink aperture hidden from view. Drupes are carnivores, feeding mostly on polychaete worms, mollusks, sponges, and other invertebrates on the reef.

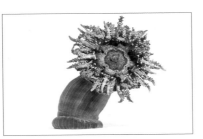

FRILLED ANEMONE, page 47
Phymanthus sp.
SCALE: Oral disc diameter with tentacles 3 cm (1.2 in)
One of the beauties of Susan's portraits is that they allow us to see the animals in exquisite detail, unobscured by their natural surroundings. If you were to come across this anemone while snorkeling, for example, much of it would be entirely hidden from view and the exposed parts difficult to distinguish. In nature, the brown stalk of the anemone is buried in sediment, its base attached to rocks below; the disc, with its central mouth and encircling tentacles, lies flat on the surface, its colorful speckles blending in with the sand. The anemone relies on not being noticed in order to capture its prey, a variety of small animals in the plankton.

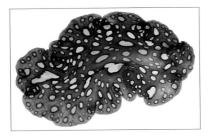

PACIFIC LEOPARD FLATWORM, page 48
Pseudobiceros sp.
SCALE: Length 3.5 cm (1.4 in)
"When you collect marine animals there are certain flatworms so delicate that they are almost impossible to capture whole, for they break and tatter under the touch. You must let them ooze and crawl of their own will onto a knife blade and then lift them gently into your bottle of sea water." So wrote John Steinbeck in *Cannery Row*, describing the fragility of polyclad flatworms like this one. Polyclad specialists have met the challenge of collecting specimens whole by devising special techniques for handling the flimsy animals, including using paintbrushes to "coax" them into collecting jars underwater.

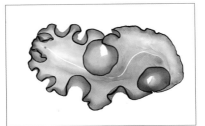

ORANGE-RIMMED FLATWORM, pages 48–49
cf. *Maiazoon orsaki*
SCALE: Length 1.5 cm (0.6 in)
Hermaphroditism, wherein an individual has both male and female systems, is not uncommon among invertebrates. As humans, we might not readily appreciate the advantages of an all-in-one arrangement, but it could be adaptive under certain circumstances. For example, if other members of your species are few and far between, it might not be a bad idea to be able to reproduce with whomever you bump into; you might not get another chance before you're eaten. Some flatworms take things even further by having more than one complete system for each gender; the animal here has two penises and three to five female openings, the benefits of which are open to speculation.

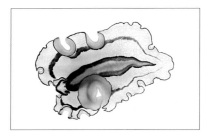

FOUR-LINED FLATWORM, page 49
Pseudobiceros gratus
SCALE: Length 2.5 cm (1 in)
Divers lucky enough to spot this diaphanous creature underwater have noted that they can see right through it to the sand grains over which it crawls. Translucent and no more than 2 millimeters thick throughout, the insubstantial worm is nonetheless complex internally: Sandwiched in the wafer-thin layer between back and belly are elaborate reproductive, digestive, and nervous systems, including a rudimentary brain. The brain is located at the leading end, and although the animal could hardly be accused of having a head, its body margin is upfolded at that end to form two pseudotentacles equipped with numerous simple eyespots.

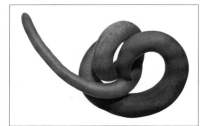

SMOOTH BROWN PEANUT WORM, page 50
Thysanocardia nigra
SCALE: Body lengths 7 and 9 cm (2.8 and 3.5 in)
Leggy creatures that we are, we probably overrate limbs as a means of locomotion: Many animals move effectively, and have been successful, without them. In fact, worms—elongate animals lacking limbs—are widespread in the animal kingdom, making up twenty of the roughly thirty-four major divisions (phyla) and having representatives in most other divisions as well. Without legs, worms move using cilia (motile cellular extensions) on the body surface or muscles beneath it. These two intertwined peanut worms each move with the help of a muscular, eversible proboscis on their front ends (in the photograph, the slimmer, lighter-colored length stretching to the left is one animal's proboscis).

SUBORBICULAR KELLY CLAM, page 51
Kellia suborbicularis
SCALE: Shell length 3 cm (1.2 in)
The kelly clam can be found nestled in hard spaces, from holes in rock to the insides of empty beer bottles. In the latter case, the young clam settles inside and then grows too large to escape—not a problem for an animal that doesn't have to search for food. To eat, the clam creates a water current that runs over its gills; from the flow, it extracts food particles in addition to oxygen. The water enters via the long siphon seen to the right in the side view and face-on in the front view. The clam pictured here was one of two found together in a bottle, both of their siphons in the bottle's neck, reaching toward the opening.

COLUMBIA DOTO, page 52
Doto columbiana
SCALE: Body length 5 mm (0.2 in)
It's easy to overlook this tiny, inconspicuous nudibranch with its muted colors, readily lost among the branches of the brown hydroid (*Aglaophenia* spp.) on which it's found. But once isolated and magnified, the animal becomes an exquisite glass figurine, minutely detailed. Its head bears a pair of antennae called rhinophores, used in smelling, and its back is decorated with club-shaped appendages whose function is poorly understood. As with many small nudibranchs that feed on colonial organisms, habitat and food are one and the same for this species: It lives, feeds, and lays its eggs on the hydroid.

HOODED NUDIBRANCH, page 53
Melibe leonina
SCALE: Total length 7.5 cm (3 in)
In the world of tiny crustaceans, the hooded nudibranch is the great white shark, its tentacle-fringed hood the equivalent of a toothy pair of jaws. Here, we're looking up into that maw, formed by a fantastically expanded face. In normal feeding position, the hooded nudibranch holds the hood up, face forward or down. To catch the small crustaceans on which it feeds, it either closes the opening, purse string–style, around an animal that has strayed inside, or it brings the hood down on top of the prey like a net trapping a butterfly. Once the prey is captured, the nudibranch squeezes the hood to force the animal into its mouth.

TWICE-BRANCHED HYDROID, page 54
Macrorhynchia phoenicea
SCALE: Frame width 9 mm (0.4 in)
An important component of the so-called fouling community, hydroids are found in abundance on rocks, docks, boat hulls, and shells, where they form brownish fuzzy or bushy growths easily dismissed as seaweeds. Under a microscope, however, a hydroid reveals itself as a colony of tiny, anemone-like animals. In this image, while we can't see the tentacles of living animals, we can see the alternating dark and light beads that represent individuals. The entire colony originated from a single larva that settled and metamorphosed, affixing itself to one spot. Through a series of successive clonings, the initial settler gave rise to others, all genetically identical and all remaining connected to one another to form this complex colony.

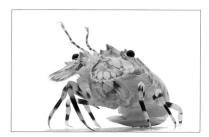

AURORA SLIPPER LOBSTER, page 55
Galearctus aurora
SCALE: Figure width 8.5 cm (3.3 in)
Slipper lobsters, like their close relatives the spiny lobsters, lack the front claws so prominent in so-called true lobsters. They're distinguished and readily recognized by the shape of their second pair of antennae, which are broadly expanded and flattened into wide plates on either side of the narrow first pair. The animal's body is also flattened, and it can press itself down against rocks and into crevices in a way other lobsters can't. Slipper lobsters are warm-water animals that typically live in reef caves and crevices during the day and come out to forage at night; they prey on a variety of invertebrates and scavenge on dead animals.

WANAWANA CRAB, pages 56–57
Sakaila wanawana
SCALE: Frame width 4 cm (1.6 in)
One night in 2006, 250 meters (820 feet) deep on a reef in French Frigate Shoals, a crab walked into a lobster trap baited with mackerel. The next morning, when the trap was raised and brought on board the *Oscar Elton Sette* (a National Oceanic and Atmospheric Administration [NOAA] research vessel), biologists couldn't identify the animal inside; as it turned out, the crab, a female, belonged to an undescribed species. In 2009, specialists formally named her "wanawana," Hawaiian for "spiny." Following standard protocol, they not only published a description of the animal but also identified a single specimen as the "holotype"—a representative of the species, deposited in a museum. We're looking here at the holotype of *Sakaila wanawana*. Two additional specimens have been found in museum collections, bringing the total to three.

FRILLED DOG WHELK, page 58
Nucella lamellosa
SCALE: Shell length 2.5 cm (1 in)
In the early 1980s, biologists noticed that populations of a British whelk were declining, especially around harbors. This decline was later observed in whelks elsewhere, including this species from the North American west coast. Researchers linked the problem to tributyltin (TBT), a component of antifouling paints used on boats. The toxin leached into the water and caused what's known as imposex: female snails developing male genitalia, often rendering them sterile. In the late 1980s, countries began restricting the use of TBT, and in 2008, an international ban on TBT-based agents went into effect. Accordingly, the occurrence of imposex in this and other species has been declining over the past twenty-five years, although it remains a problem in certain regions.

ORANGE HYDROID, page 59
Garveia annulata
SCALE: Colony height 2 cm (0.8 in)
Placed under a microscope, a small piece of hydroid will often reveal a microcosm of other tiny organisms living on it. The orange hydroid here, plucked off the dock at the Friday Harbor Marine Laboratories, provides the infrastructure for a community that includes another, much smaller, white hydroid growing up its branches on the right; toward the top, you can see the second hydroid's stems and tiny polyps. At the base of the larger hydroid is a pale yellow sponge as well as some minute moss animals entangled with the smaller hydroid. And scattered like bits of tinsel on a Christmas tree are short chains of golden, rectangular diatoms, a kind of one-celled algae.

SEA SLUGS
NEON SAPSUCKER SLUG, page 60
Thuridilla neona
SCALE: Body length 6 mm (0.2 in)
Several lineages of the snail evolutionary tree abandoned shells for a more sluggy lifestyle; all true slugs—from garden-variety lettuce nibblers to flamboyant marine nudibranchs—are simply snails without shells. Although a shell offers protection, it also comes at a price: It costs energy to build and lug around, and it can be unwieldy, increasing drag and slowing down movement. In the absence of a shell, slugs have adopted a variety of other strategies for deterring predators. Some harbor toxic compounds and/or stinging cells they've appropriated from their prey foods, making them inedible; some are capable of quick movements, even swimming, that allow for fast getaways; and some are elaborately camouflaged to avoid detection. Here, the montage of five images includes two distinct groups of non-nudibranch sea slugs. The sapsuckers spend their lives on seaweed, making a living by sucking sap: They pierce the seaweed with a single sharp tooth and sip out its juices. The swallowtails, on the other hand, are active predators, with at least some known to eat tiny worms called acoels. This feeding habit makes certain swallowtails popular among aquarists, for whom the acoels are problematic; the worms show up uninvited in aquariums and can quickly reach epidemic proportions, blanketing corals and other animals. A couple of swallowtails introduced into an infested aquarium can vacuum up the worms, bringing them under control quickly. (Also page 61.) GRACEFUL SAPSUCKER SLUG, *Thuridilla gracilis* (body length 1 cm/0.4"); WHITE-FACED SWALLOWTAIL SLUG, *Chelidonura inornata* (length 1.5 cm/0.6"); SAPSUCKER SLUG, *Elysia* sp. (length 8 mm/0.3"); ELECTRIC SWALLOWTAIL SLUG, *Chelidonura hirundinina* (length 7 mm/0.3").

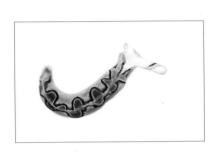

GREEN-EYED, RED-SPOTTED GUARD CRAB, page 62
Trapezia rufopunctata
SCALE: Leg span as viewed 3 cm (1.2 in)
This small crab plays a big role in the health of reefs. It and related species are found only among the branches of living corals. The crab finds safe refuge in the coral and protects its home by attacking coral predators such as fish and sea stars that threaten to destroy it. The species here is one of two that are large enough to consistently fend off that most notorious of coral predators: the crown-of-thorns starfish, infamous for outbreaks that have annihilated coral populations and devastated reefs. Studies of severe crown-of-thorns outbreaks have found that some of the few corals to survive are those housing these larger species of guard crab.

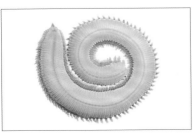

BLOODWORM, pages 62–63
Glycera sp.
SCALE: Body width 1 cm (0.4 in)
Found buried in the sediment of an intertidal sand flat, this is only the front half of the animal, the back having broken off; fortunately, it can readily regenerate a tail. The worm's front end bears a tiny pointed head of sorts, immediately behind which is the mouth (belly and mouth are facing up in the photograph). Students unversed in the ways of bloodworms are often startled when an individual in their hands suddenly extends a proboscis from its mouth: a structure up to one-third the animal's body length, bearing four striking black jaws on its squared end. The worm uses its proboscis both for burrowing into the sand and for catching its prey, such as small worms and crustaceans.

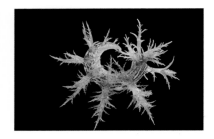

TREE-TOP NUDIBRANCH, page 64
Dendronotus venustus
SCALE: Body length 2 cm (0.8 in)
Exploration of the marine fauna of North America's Pacific shores did not begin in earnest until the twentieth century. By then, most of the common invertebrates in temperate North Atlantic waters—especially on the European side—had been christened with scientific names. When biologists began documenting Pacific animals, they often identified them as similar, already-named Atlantic species. The tree-top nudibranch is one such animal: Until recently, it went by the name of a species originally described from Norway. But in 2010, a careful analysis of the group's morphology and DNA revealed that the Pacific animals are a distinct species. The marine invertebrate fauna of the Northeast Pacific includes many other species with Atlantic names that probably deserve a closer look.

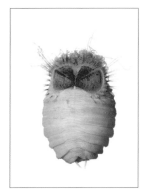

GROUND-DIGGER DUMBBELL WORM, page 65
Sternaspis fossor
SCALE: Body length as viewed 9 mm (0.4 in)
What looks like a head of tentacles on this worm is in fact a butt of filamentous gills, fooling even the biologist who christened the animal: "Sternaspis" means "breast plate," referring to the two brown plates that were thought to be on the front end. Knowing the plates are at the rear, though, the question becomes, Where's the head? On this animal, we're actually looking at the equivalent of its shoulders; the worm has its front end, including its head, withdrawn into the body, inside out. It can extend that end to burrow into sediments or eat. The dumbbell worm is normally found upside down in the mud, with only its gills extending above the surface.

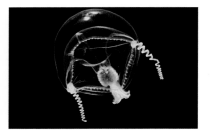

HANGING STOMACH JELLY, page 66
Stomotoca atra
SCALE: Bell diameter 8 mm (0.3 in)
Aptly named, this small jellyfish's stomach hangs well below its bell and terminates in a flower-like mouth. Covering the stomach are conspicuous white or brown folded gonads. Numerous short tentacles and two longer, opposite ones line the rim of the bell. The longer tentacles are tightly contracted in these photographs but can extend to more than ten times the length of the bell and are used to capture food. Like all jellyfish, this one is a predator: The species feeds entirely on other jellyfish. Its two long tentacles stretch behind it as it swims, entrapping and subduing its prey with the help of countless stinging cells in their tissues. (Also page 71.)

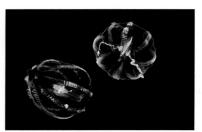

SEA GOOSEBERRY, page 67
Pleurobrachia bachei
SCALE: Widths 1 cm (0.4 in)
These glassy orbs belong to a group of animals called comb jellies, similar to jellyfish in that most are gelatinous predators living in the plankton. But unlike jellyfish, which swim by the muscular pulsing of their bells, comb jellies get around with the action of hundreds of little paddles called combs, each one made up of microscopic cilia (mobile cellular extensions) fused together. Eight rows of the iridescent combs run from one pole to the other, like seams on a beach ball. An enormous vessel propelled by so many tiny oarsmen, there are no quick getaways for the gooseberry, and its travels are largely dictated by ocean currents.

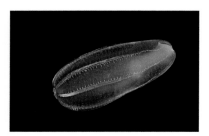

RAINBOW COMB JELLY, page 68
Beroe abyssicola
SCALE: Length 4 cm (1.6 in)
With no apparent head, brain, eyes, arms, or tentacles, the rainbow comb jelly is nonetheless a rapacious predator of the plankton. Unusual for a comb jelly, the rainbow and its relatives feed exclusively on other comb jellies, including ones near their own size. In cruising mode, the animal glides forward mouth first, lips usually sealed to form a streamlined leading edge (to the right in this photograph); its movement is powered by the paddling of hundreds of minute, hair-like cilia in eight iridescent rows running down the body. When the gliding animal encounters another comb jelly, it hardly misses a beat: The seemingly rubbery mouth opens and expands widely, and the one jelly simply engulfs the other as it continues swimming.

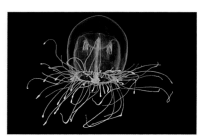

RED-EYE MEDUSA, page 69
Polyorchis penicillatus
SCALE: Bell diameter 2.5 cm (1 in)
While jellyfish are usually planktonic swimmers, this one is typically found on the bottom of the ocean during the day. Negatively buoyant, it perches on its tentacles like a spider on its legs, feeding on tiny animals that crawl on the sand. At night, it pulses its bell to rise a few meters above the bottom, where it catches small organisms that themselves emerge from the sediment to feed. The jellyfish's daily vertical migrations are probably instructed by the tiny eyespots trimming the bell margin—spots that don't seem to form images but detect light. One study found that as light levels decreased, the animal pulsed its bell more quickly, which explains why it rises into the water column when the sun sets.

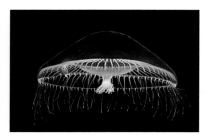

CRYSTAL JELLY, page 70
Aequorea victoria
SCALE: Bell diameter 6 cm (2.4 in)
From the 1960s through the 1980s, Princeton biologist Osamu Shimomura spent most of his summers at the Friday Harbor Marine Laboratories, studying crystal jellies. He was interested in the fact that the jellies glow and worked on isolating and purifying the molecules responsible for their bioluminescence. The work eventually led to the 2008 Nobel Prize in Chemistry, awarded to him for the discovery (and to two others for the development) of green fluorescent protein (GFP), a molecule that not only fluoresces green when exposed to UV light but also is harmless to living cells. GFP is used today in living systems to "tag" proteins and genes, allowing us to visualize their operation in different cells and tissues—ultimately relevant to everything from cancer treatments to regenerative medicine.

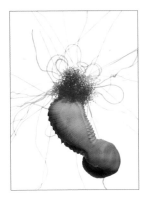

CURLY-HEAD SPAGHETTI WORM, page 72
Thelepus crispus
SCALE: Body length as viewed 2.5 cm (1 in)
Segmented marine worms (phylum Annelida) are generally soft-bodied and frequently lack the well-developed chemical and mechanical defenses seen in other soft creatures; thus many adopt a strategy of staying hidden much or all of the time. This spaghetti worm spends its life under rocks, inside a sandy tube it makes for itself. From the safety of its home, it sends out highly extensile, filamentous, white tentacles over the sand and rock to collect bits of detritus that are carried back to the mouth. And while the exposed tentacles may themselves get eaten, they're readily regenerated. Adjacent to the feeding tentacles are the bright red gills; their color comes from hemoglobin in the blood circulating through them.

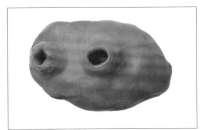

BROADBASE TUNICATE, page 73
Cnemidocarpa finmarkiensis
SCALE: Length 2.5 cm (1 in)
This is one of those surprising facts that invertebrate zoologists take delight in sharing with the uninitiated: Sea squirts like the one you see here (looking more exotic vegetable than animal) are the invertebrate group most closely related to vertebrates—that is, to salmon, lizards, hawks, and humans. The evidence for this link is apparent when we look at the squirt's fish-like larva, a swimming stage that shares key traits with primitive vertebrates: a notochord, dorsal nerve cord, and gill slits. The adult stage, however, lacks a notochord and nerve cord and lives attached to rocks. To feed, it creates a current by drawing seawater in one opening and ejecting it out the other, removing food particles from the flow.

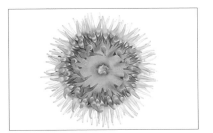

PAINTED ANEMONE, pages 74–75
Urticina crassicornis
SCALE: Oral disc diameter with tentacles 2.5 cm (1 in)
A sea anemone is effectively a hollow sac filled with seawater, which enters and exits via a single opening—its mouth. When the animal is threatened, it contracts its muscles to quickly collapse and withdraw into itself, ejecting some or most of the water out of its mouth; even its hollow tentacles deflate. Re-emerging is a less hurried process: The anemone relaxes its muscles, and microscopic hair-like processes (cilia) in the corners of its mouth get to work, driving water into the animal like tiny paddles. When fully inflated, the animal can seal its lips closed to prevent water loss.

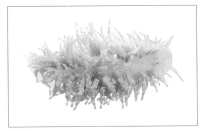

PORITES NUDIBRANCH, page 76
Phestilla lugubris
SCALE: Length 3 cm (1.2 in)
The porites nudibranch feeds only on corals in the genus *Porites*, scraping the layer of living tissue off the underlying coral skeleton. The relationship goes beyond one of predator and prey: The nudibranch lives on and looks like the coral, and lays its eggs on it. The eggs hatch as swimming larvae that drift about for two to three days before settling and metamorphosing, which raises the question: How do the young know where to land so they'll be near a porites coral at touchdown? Laboratory studies addressing this question have found that the larvae use a chemical produced by the coral as a cue for settlement and will only metamorphose in the presence of that compound.

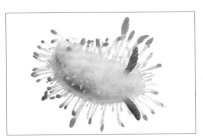

COCKERELL'S NUDIBRANCH, page 76
Limacia cockerelli
SCALE: Body length 7 mm (0.3 in)
Upon close examination, you can see fine lines crisscrossing this animal's back and extending up its long orange-tipped appendages. These are skeletal elements called spicules: minute calcareous needles embedded in the translucent tissue. Researchers have proposed that the spicules in this and other nudibranchs serve to keep predators at bay, but there's little evidence supporting that claim. Recent studies instead suggest that the elements are primarily structural, reinforcing the tissues like hay in a mud hut's walls or glass filaments in a boat's fiberglass hull. Most spicule-bearing nudibranchs studied to date harbor a vast array of noxious chemicals that probably serve as their primary defense against predators.

SEAWEED NUDIBRANCH, page 76
Melibe pilosa
SCALE: Body length 3 cm (1.2 in)
The golden brown color of this seaweed nudibranch doesn't come from the animal itself but from one-celled organisms called dinoflagellates that live in the animal's tissues. Like plants, the dinoflagellates are photosynthetic, relying on sunlight for energy to produce food. The relationship between the two organisms is probably mutually beneficial. In the nudibranch, the dinoflagellates get some protection against being eaten while still receiving plenty of light through the animal's translucent tissues; they may also be fertilized by the animal, whose waste products include nutrients like nitrogen. The tiny organisms return the favor by apparently feeding the nudibranch: One study documented that animals with dinoflagellates can go much longer without eating than can animals without them.

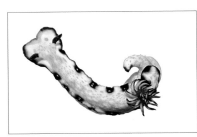

IMPERIAL NUDIBRANCH, pages 76–77
Hypselodoris imperialis
SCALE: Length 4 cm (1.6 in)
Nudibranchs, the most diverse and familiar of the sea slugs, are sometimes referred to as the butterflies of the sea for the striking color patterns that they boldly display. As in their terrestrial counterparts, the bright colors often seem to serve as red flags for visual predators, announcing that the slugs are distasteful or toxic. Nudibranchs share another similarity with butterflies: Their larval stages are unrecognizable as the adults they'll become and live a distinct lifestyle. This imperial nudibranch crawls on rocks and eats sponges, but it began life as a tiny, swimming larva that fed on microscopic particles in the plankton.

LEOPARD DORID, pages 76–77
Diaulula sandiegensis
SCALE: Length 6 cm (2.4 in)
Many animals have specialized respiratory organs, where oxygen is taken up and carbon dioxide (a waste product) is released. These structures usually take the form of inpocketings (lungs) in land animals and outpocketings (gills) in aquatic ones; in either case, they're generally finely branched, frilly, or leafy, offering as much surface area as possible for gas exchange between environment and animal. The gills in this leopard nudibranch are at the back end of the slug, to the right in the photograph. The bushy cluster encircles the animal's anus and can be retracted into a gill pocket when the animal is threatened.

LEMON DROP SLUG, page 77
Berthellina delicata
SCALE: Lengths 2 cm (0.8 in)
These slugs belong to a group called pleurobranchs, closely related to nudibranchs. Unlike nudibranchs, pleurobranchs have a small, thin, limpet-like shell under the skin—a remnant of their evolutionary history as snails, much like our tailbones are a vestige of our monkey past. With no functional shell for protection, they evolved another means of deterring predators: Their skin produces an extremely acidic secretion when they're irritated. The goo is as caustic as battery acid, so researchers studying a species closely related to the lemon drop slug were not surprised to find that its secretion makes it inedible to fish, crabs, and anemones.

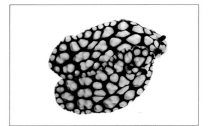

PUSTULOSE NUDIBRANCH, page 77
Phyllidiella pustulosa
SCALE: Lengths 4 cm (1.6 in)
Leave one of these nudibranchs in an aquarium overnight, and you're likely to find all the other inhabitants dead by morning and an acrid odor emanating from the tank. They and others in their family secrete a milky white, noxious substance when disturbed, presumably as a defense against predation. In the nudibranch's natural environment, the secretion sends potential predators swimming in the opposite direction, but in an enclosed space, there's no escaping it. Evidence suggests that the animal forms the toxins by accumulating and modifying compounds in the sponges it eats. Chemists analyzing the secretion for potential biomedical applications have found that one component is active against a microbe that causes a form of malaria.

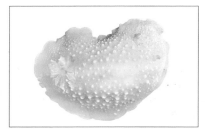

YELLOW-RIMMED NUDIBRANCH, page 77
Cadlina luteomarginata
SCALE: Length 6 cm (2.4 in)
If you had the inclination to smell this nudibranch, you might be surprised by its pleasant, fruity odor, thought to come from one of the many terpenoid compounds it harbors. Terpenoids are organic chemicals we usually associate with plants: They're largely responsible for the aromas and flavors of our kitchen herbs and spices, for the lemony smell of citrus, and for the distinct odor of eucalyptus leaves. Biochemists have extracted close to forty different terpenoids from the skin of the yellow-rimmed nudibranch, the majority of them derived from the sponges the animal eats. Terpenoids are often distasteful or noxious to animals, and in nudibranch and sponge alike, appear to discourage predators (a defense obviously ineffective for the sponge against the nudibranch).

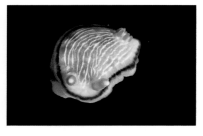

ISLAND NUDIBRANCH, page 78
Hypselodoris insulana
SCALE: Figure width 5 mm (0.2 in)
Few have been lucky enough to see this spectacular animal: It's known only from atoll lagoons in the virtually uninhabited northwestern Hawaiian Islands. The nudibranch is found on widely separated atolls in the group and on the basis of geography alone would certainly be expected to occur in the adjacent southeastern Hawaiian Islands—the familiar volcanic islands with large human populations. The limiting factor may be habitat availability: Like the iconic spotted owl that requires old-growth forests, the island nudibranch may be capable of surviving only in the lagoons of large atolls, which are absent from the southeastern Hawaiian Islands.

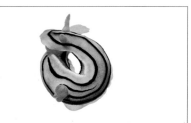

ELISABETH'S NUDIBRANCH, page 79
Chromodoris elisabethina
SCALE: Lengths 2 cm (0.8 in)
The Elisabeth's nudibranch belongs to a large family of species that feed exclusively on sponges—primitive animals that live attached to rocks and feed on tiny particles suspended in the water. Although sponges would appear to be an easy target for predators, few creatures other than nudibranchs—for example, some fish, sea stars, and the hawksbill sea turtle—can eat them, as they're loaded with an array of noxious chemical compounds as well as tiny, glass skeletal pieces. The nudibranchs not only get around the sponge's defenses but also add insult to injury by appropriating some of those defenses for their own purposes: They extract toxic chemicals from the sponges and incorporate them into their own skin to provide defense against predation.

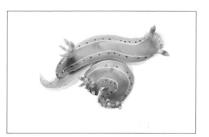

AIRSTRIP NUDIBRANCH, page 79
Thorunna australis
SCALE: Lengths 9 mm (0.4 in)
It's not hard to see why nudibranchs sometimes act as gateway invertebrates: Relatively accessible and irresistible, they're often the first marine invertebrates noticed and appreciated by underwater enthusiasts. And it can be a slippery slope from nudibranchs to flatworms or snails, and from there to increasingly esoteric groups. This charismatic pair is among the more than ten species (many unrelated) that are color variations on a common theme of pink to purple with longitudinal white lines. The members of the group, all sponge eaters and likely distasteful to predators, may benefit by mimicking one another: Once a fish tastes one individual and spits it out, it's unlikely to sample others of like color pattern.

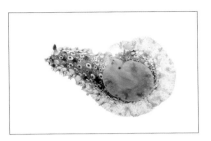

SEA CUCUMBER NUDIBRANCH, pages 80–81

Dendrodoris albopurpura

SCALE: Body length 7 mm (0.3 in)

Nudibranchs like this graceful one have a skeleton in their closet—an exoskeleton, that is: Among the branches of their family tree are ancestors who bore shells. The nudibranch's origins are especially evident during development, as it passes through a shelled larval stage. It hatches from the egg as a minute, swimming snail that spends days, weeks, or even months in the plankton, feeding on microscopic particles and growing. When the larva settles down to assume a life on the seafloor, it undergoes a drastic metamorphosis, during which it jettisons its tiny shell and crawls away a slug—in this case, a nudibranch.

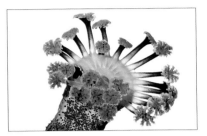

BLACK-SPOTTED SEA CUCUMBER, pages 82–83

Pearsonothuria graeffei

SCALE: Body width 3 cm (1.2 in)

Lacking brains or special sensory organs, sea cucumbers don't have heads in the conventional sense, but they do have an end with a mouth that's opposite the end with an anus. Here, looking at the first end, we see a ring of tentacles surrounding a central golden mouth. The black-spotted sea cucumber lives on the reef and feeds by using the branching ends of its tentacles to pick tiny bits of organic matter from the rock. As it eats, it continually "licks its fingers," stuffing the tentacle tips, one at a time, into its mouth and pulling them out to wipe off any adhering food particles.

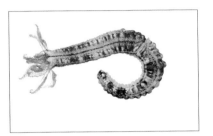

TAHITIAN GLASS SAUSAGE, page 83

Euapta tahitensis

SCALE: Total length 12 cm (4.7 in)

This sea cucumber, like many, eats detritus—minute bits of dead animals and plants—from the sea bottom, using the feathered tentacles encircling its mouth. As it gathers food particles, it also takes in sediment; in fact, every mouthful contains more sand than it does food. This means that sea cucumbers have to eat a lot in order to meet their daily energy needs, which is why we find them perpetually eating with one end and pooping with the other. Studies have found that all that eating and pooping by cucumbers is vital to marine ecosystems: It processes the sediments and associated organics, releasing nutrients and dissolved calcium into the seawater where sea grasses, corals, and other organisms can make use of them.

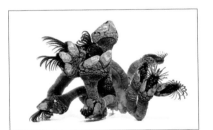

GOOSE-NECK BARNACLE, pages 84–85

Pollicipes polymerus

SCALE: Height of tallest individual 4 cm (1.6 in)

The origin of this barnacle's name involves a European bird—the barnacle goose—and a misunderstanding about its life history that persisted into the seventeenth century. Medieval scholars, unaware that geese migrated to the Arctic, puzzled over the fact that they never saw them nesting. They solved the enigma with the most egregious zoological error I know of: They deduced that young geese "hatched" out from between the shells of stalked barnacles (the word "barnacle" comes from the goose—not vice versa). As for the barnacles' true affinities, the jointed appendages seen raking the water in the photograph are a giveaway: They're crustaceans that live attached to rocks and use their legs to gather food from the plankton.

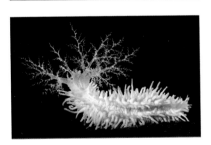

STIFF-FOOTED SEA CUCUMBER, pages 86–87

Eupentacta quinquesemita

SCALE: Body length 2.5 cm (1 in)

The mouths of almost all sea cucumbers are encircled by a ring of feeding tentacles, which they use to collect food particles either from rocks and sand or from the water column. This one eats plankton and is usually found under rocks with only the finely branched tentacles exposed. Like many cucumbers, the stiff-footed sea cucumber has a habit of periodically "eviscerating": tossing out most of its insides (and even losing its tentacles), and then spending two to four weeks regenerating them all. One study conducted in British Columbia found that this habit is seasonal in this species, with the majority of individuals eviscerating during the fall. The researchers speculated that the process functions to purge the cucumbers of chemical wastes that accumulate during the summer feeding season.

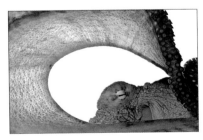

DAY OCTOPUS, page 88

Octopus cyanea

SCALE: Frame width 11.5 cm (4.5 in)

A common shallow-water species in the tropical Indian and Pacific Oceans, the day octopus lives in small dens in the reef, the doorways of which are recognizable by the scattering of crab shells typically surrounding them—remnants of the animal's meals. The octopus leaves its lair and forages for food during the day: It captures crabs with its suckered arms, quickly disables them, and drags them home to eat. The soft, squishy octopus has a few tricks for managing a hard, pinchy crab: Its central mouth is equipped with a parrot-like beak, with which it cracks the exoskeleton; it then injects poisons that kill its prey and enzymes that liquefy the animal into crab soup in a shell. (Also pages 89, 182, 183.)

GREEN SEA URCHIN, page 90

Strongylocentrotus droebachiensis

SCALE: Diameter with spines 2 cm (0.8 in)

Like the oversized paws of a puppy, this young urchin's purple tube feet are disproportionately long; as the animal grows into them, they'll become less prominent relative to the green spines. The tube feet—tentacle-like appendages with sucker-like tips—are a trait unique to echinoderms: the "star" animals (sea, brittle, and feather), plus sea urchins and cucumbers. Animals in the group use their feet for walking, sticking to rocks, transporting food to the mouth, and breathing. Adhesion by the "suckers" is not mechanical, but chemical: Each foot can secrete substances that act as glues as well as ones that dissolve the glues, allowing the animal to stick and unstick its feet at will.

BANDED SEA URCHIN, page 91

Echinothrix calamaris

SCALE: Diameter without spines 1 cm (0.4 in)

This reef urchin has two types of spines: large, hollow primary ones and shorter, finer secondary ones. Both types are very brittle, designed to break off and embed themselves in anyone foolish enough to attack, but the smaller ones have the added deterrent of being venomous. The spines are not fixed in place but can pivot on their bases like joysticks, the movement controlled by tiny muscles associated with each one. And in spite of the fact that the urchin has no discernible eyes or photoreceptor organs of any sort, it can detect the shadow of a potential predator and, in one coordinated movement, direct its spines toward that threat.

ORIENTAL SPONGE CRAB

ORIENTAL SPONGE CRAB AND SPONGE, page 92

Homola orientalis and Phylum Porifera

SCALE: Body width 4 cm (1.6 in)

A bit like a hermit crab carrying a snail shell, the sponge crab carries sponges (and in at least one instance, a sea pen) over its back. Like the hermit crab, its rearmost pair of legs is reduced to carrying the accessory and no longer functions in walking. While sponges can't provide the physical protection of shells, they may nonetheless be a defense against predation: They're loaded with compounds that are toxic to or inedible for many animals, so a sponge topping might be enough to dissuade predators from an otherwise tasty meal. A sea pen, with its stinging cells, could serve the same defensive purpose, and both sponge and sea pen may also act as camouflage. (Also page 93.) ORIENTAL SPONGE CRAB and FLAME SEA PEN, *Homola orientalis* and *Pennatula* sp. (body width 3.5 cm/1.4").

• CREEPING PEDAL SEA CUCUMBER, page 94

Psolus chitonoides

SCALE: Length with extended tentacles 6 cm (2.4 in)

Sea cucumbers are typically soft, wormy, more or less cylindrical animals, often with five rows of sticky appendages called tube feet running between mouth and anus on either end. It's no wonder that few students recognize this animal as a cucumber at first glance: It has a flat underside—a sole of sorts; a top side covered with hard, calcareous plates; and feeding tentacles (encircling a mouth) emerging more from the top than the end. These unusual features appear to be adaptations to a largely sedentary lifestyle. With its sole, this cucumber clings to rocks, hardly moving, feeding on plankton with its tentacles. If you manage to remove one, you'll find a clue to its identity: three rows of tube feet running down that sole.

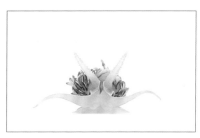

OPALESCENT NUDIBRANCH, page 95

Hermissenda crassicornis

SCALE: Span of oral tentacles 2 cm (0.8 in)

Face to the camera, this nudibranch shows off four prominent appendages: a pair of antennae (rhinophores) projecting from the top of its head and two oral tentacles extending from the sides of its mouth like a handlebar mustache. Its eyes are tiny and virtually invisible; they distinguish light and dark, but probably little else. To navigate and find food—in this case, a variety of invertebrates—the animal relies largely on its head appendages. The rhinophores (literally, "nose bearers") are smellers, detecting chemical molecules dissolved in seawater, while the oral tentacles function in touch as well as smell and taste. (Also pages 154–155.)

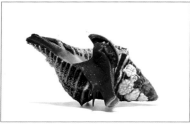

ORNATE LATIRUS, page 96

Latirus amplustre

SCALE: Shell length 3.5 cm (1.4 in)

It may look like this animal is about to bail out of its shell, but that's unlikely: Its shell is as much a part of it as our bones are of us, and separating the two would mean certain death. The firmly attached, hard shell serves as protection for the soft-bodied snail, which can withdraw completely inside when danger approaches. Here we see the scarlet, white-speckled head and foot of the animal—the parts that can extend out; its viscera always remain safely within. Attached to the back of the foot is a dark brown fingernail; it acts as a door over the shell's opening when the snail is fully withdrawn.

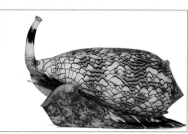

TEXTILE CONE, page 97

Conus textile

SCALE: Shell length 7 cm (2.8 in)

Imagine a painkiller that's one hundred times more potent than morphine and carries no risk of addiction. A 2013 study reported the results of preclinical trials on just such a drug, a compound whose basis is the venom of a cone snail. All cone snails are predators, and all produce powerful venoms that subdue and kill their prey; there are hundreds of cone species and thousands of different molecules (called conotoxins) making up their venoms. Since the 1990s, researchers have been studying conotoxins for potential medical applications. The textile cone feeds on other snails and has a venom so powerful that it's reported to have killed people handling the live animals.

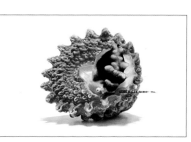

LINE STAR SNAIL, page 98

Astralium plicatospinosum

SCALE: Shell diameter 3 cm (1.2 in)

Upside down, this snail peers at us with one eye—the tiny black pinpoint on a white nubbin at the base of its left tentacle. The animal's shell is elaborately ornamented with scales and ridges that may serve to strengthen it and discourage predators; it's largely overgrown by a thin, pink layer of calcareous algae, a common occurrence on these shells. The species' common name refers to the fact that it is known only from a few northern atolls in the Line Islands, a limited distribution that's partly a reflection of the fact that its swimming larvae are very short-lived and incapable of broad dispersal.

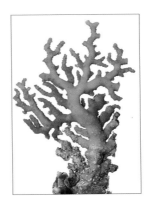

ROSE LACE CORAL, page 99
Distichopora sp.
SCALE: Height 6 cm (2.4 in)
A few times when diving, I've poked my head into a cavern and looked up to find the ceiling covered with lace corals, hanging like tiny, arborescent stalactites. Unlike reef-building "stony" corals, which require sunlight (due to the photosynthetic, symbiotic organisms living in their tissues), these ones can live in total darkness. In shallow, tropical waters, lace corals are usually small and slow-growing and never form reefs. There, they can't compete with the larger, faster-growing stony corals that would quickly overwhelm them, so they survive by living in places where stony corals can't. When they die, their bright color remains because it's part of their calcareous skeleton (in stony corals, the color is part of the living tissue and is lost when the animal decomposes).

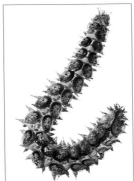

EIGHTEEN-SCALED WORM, page 100
Halosydna brevisetosa
SCALE: Length 7 cm (2.8 in)
The paired scales running down the length of this worm protect the thin skin of the back, the whole of which functions as a gill: Water flows in the narrow space between scales and skin, with gas exchange occurring across the latter. As it happens, almost any time we see a group of animals with such a well-aerated, semi-enclosed pocket on the body surface, we find that some species have evolved to make use of the pocket as a nursery. Sure enough, some scale worms brood their embryos under the scales. The worms are also known to use the scales as decoys, leaving one or two behind for a predator while the real meal flees.

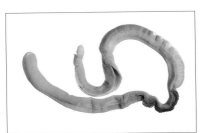

GRACEFUL DECORATOR CRAB, page 101
Oregonia gracilis
SCALE: Leg span as viewed 10 cm (3.9 in)
One of the most decorated of decorator crabs, this species accessorizes with everything from red and green seaweed to small invertebrates such as sponges, sea squirts, and hydroids. It collects the organisms using the claws on its front pair of legs, clipping off bits and affixing them to tiny, Velcro-like hooks on its shell. Not merely a fashion statement, the decor covering the crab effectively obscures the animal from the view of potential predators. The animal itself, however, maintains a clear line of sight: Its eyes are on long stalks that allow a view unobstructed by the overgrowth. Some species of decorator crab appear to select stinging or noxious organisms as cover, using them as deterrent as well as camouflage. (Also pages 116–117, 134, 151–152.)

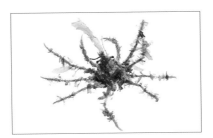

ACORN WORM, page 108
Glossobalanus berkeleyi
SCALE: Length 20 cm (8in)
Despite its raggedy appearance, this animal is in excellent shape—an acorn worm at its best. It's one of about one hundred species of the animals, all soft-bodied, extremely fragile, and slow moving. In shallow waters, the seemingly vulnerable worms are always found buried in sand or mud, with only the proboscis (if anything) extended for feeding (the proboscis of this individual is the "acorn" on one end; immediately behind it is the mouth). In the deep sea, however, acorn worms are seen crawling on the sand surface and even suspended in the water above the bottom. Recorded at depths as great as 4 kilometers (2.5 miles), these deep-sea species often have elaborate proboscises with long, tentacle-like extensions used for gathering food.

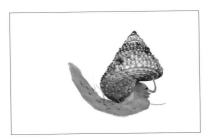

PURPLE-RINGED TOPSNAIL, page 109
Calliostoma annulatum
SCALE: Shell width 1 cm (0.4 in)
Snails have an undeserved reputation for slowness: While some on land are fairly sedentary, those in the sea are often quick and agile. Take this topsnail, which uses its long, dexterous foot not only to move forward but also to twist out of a predator's reach or quickly right itself. When crawling, the animal produces rhythmic, muscular waves that travel the length of the sole, propelling it forward at a rapid pace. In fact, the single foot acts as two, with separate, asynchronous waves running along the right and left halves. This bipedal mode of locomotion may increase efficiency and maneuverability.

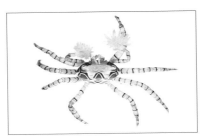

MOSAIC POM-POM CRAB AND ANEMONE, page 110
Lybia tessellata and *Triactis* or *Bunodeopsis* sp.
SCALE: Leg span as viewed 2.5 cm (1 in)
Because anemones are loaded with stinging cells to discourage predators, some other animals have made use of them for their own protection—for example, clownfish that live among their tentacles and hermit crabs that put them on their shells. Pom-pom crabs are another such creature: They're almost always carrying a pair of anemones in their claws, ready to thrust them at any potential threat. These omnivores also use the anemones for feeding, mopping up bits of food with them and removing the particles with their mouthparts. The anemones retain some of the bits and probably benefit from being moved about and brought to food sources; they're otherwise quite immobile and must wait for food to come to them. (Also page 249.)

KNOTTED LIOMERA, page 111

Liomera supernodosa

SCALE: Leg span as viewed 2.5 cm (1 in)

The protection provided by this crab's hard outer shell comes at a price: the risks associated with molting, in which the crab sheds its current shell and replaces it with a new, larger one. Molting is necessary because the armor-like shell, or cuticle, can't stretch to accommodate growth. So periodically, the crab prepares a new, soft cuticle beneath the outer one; it then crawls out of the latter and quickly fills itself with water to expand before the new cuticle hardens. It's risky: Crabs often get stuck and die while trying to extract themselves from a cuticle that covers everything from leg tip to eyeball. Immediately after extraction, they're soft and unable to move, making them especially vulnerable to predation.

BUTTERFLY CRAB, page 111

Cryptolithodes typicus

SCALE: Shield width 4 cm (1.6 in)

"Cryptolithodes" means "hidden stone," a fitting name for a crab that's usually hunkered down under its head shield (carapace) in a convincing imitation of a rock. From above, all appendages are hidden from view and the carapace can easily be mistaken for a stone, old clamshell, or patch of algae, depending on its color, which in this species is highly variable. Contributing to the illusion is the fact that the butterfly (aka Darth Vader) crab is one of the slowest moving crabs known and reacts to danger by clinging to the rock rather than racing away. Being a slow animal, it subsists on slow food: seaweeds, moss animals, and other attached organisms.

MINOR VENUS'S GIRDLE, pages 112–113

Velamen parallelum

SCALE: Lengths 4 cm (1.6 in)

It's hard to guess the affinities of these ethereal planktonic ribbons at first glance: They're comb jellies. Each one actually began life looking more or less like a typical comb jelly (see page 68), roughly spherical. As it grew, though, it became greatly flattened in one plane and stretched out in the other. Its mouth is located in the center of one edge of the ribbon, identifiable by the whitish, linear pharynx behind it. Running along the edge opposite the mouth are four rows of microscopic paddles called combs. Like most planktonic comb jellies, this one glides forward mouth first, moving with the power of the combs. However, when disturbed, it can swim rapidly with muscular, snake-like undulations of the entire ribbon.

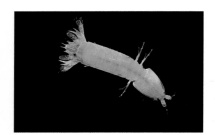

MANTIS SHRIMP

RAINBOW MANTIS SHRIMP, page 114

Pseudosquilla ciliata

SCALE: Body length 4.5 cm (1.8 in)

The rainbow of colors we're able to distinguish is based on only three types of color receptors (cones) in the retinas of our eyes. And while we might feel superior to our dog or red/green colorblind friend (both of whom have only two cone types), we can't compete with mantis shrimps: Boasting the most complex system of color vision known, they have up to sixteen types of cones. The rainbow of colors they see is unimaginable for our relatively color-limited brains. Mantis shrimp eyes are special in other ways, too: Each one sees in 3D and is perched on a rotating stalk that allows the animal to look in all directions without turning its head. (Also page 115.) URCHIN TAIL MANTIS SHRIMP, *Echinosquilla guerini* (body length 3.5 cm/1.4").

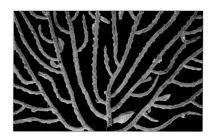

BLACK CORAL AND STALKED BARNACLE, page 119

Order Antipatharia and Family Oxynaspididae

SCALE: Frame width 3.5 cm (1.4 in)

Beneath the living tissue of this coral colony is the tough, dark skeleton for which it's named. Tiny brown spines project through the tissue, giving these animals their other common name, thorny corals. The skeleton is mostly composed of a horn-like protein that retains its deep color after the animal dies, and the skeletons of thick-branched species have been used extensively for jewelry-making. The harvesting of some deepwater species may not be sustainable, however. One study found that these corals grow extremely slowly and may take over one thousand years to become 1 centimeter (0.4 inches) thick; the study estimated the ages of single colonies to be over four thousand years.

The upper photograph shows the "front" of the fan, which is covered with the mouths and tentacles of the animals that make up the colony, presumably facing the direction of the prevailing water currents in the coral's natural environment. The center photograph shows the back of the fan, devoid of mouths. In the lower photograph, you can see magnified the anemone-like individuals on the front: Each one has a central mouth surrounded by six tentacle nubbins. Well disguised among them are larger stalked barnacles that live attached to the coral and have become largely overgrown by it; some have their feeding appendages extended, netting plankton from the water.

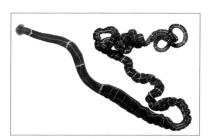

RIBBON WORMS

SIX-LINED RIBBON WORM, page 120

Tubulanus sexlineatus

SCALE: Head width (to left in photo) 3 mm (0.1 in)

The blue whale, weighing as much as 170 metric tons (375,000 pounds), certainly wins the prize for most massive animal on Earth today, but it's not the longest. That distinction goes to certain ribbon worms: One animal that washed up on a Scottish beach measured 54 meters (177 feet) (the blue whale reaches 30 meters [about 100 feet] in length). Ribbon worms comprise their own distinct phylum of worms that are typically narrow, stretchy, and fragile. One group lives inside clamshells, feeding on plankton in the circulating water, and another lives on female crustaceans, eating the developing embryos being brooded. Most ribbon worms, though, are like these three: free-living predators on animals such as polychaete worms and crustaceans. (Also page 121.) BROWN-BANDED RIBBON WORM, *Baseodiscus cingulatus* (head width 2 mm/0.1"); ORANGE RIBBON WORM, *Tubulanus polymorphus* (head width 3 mm/0.1").

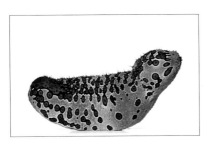

LEOPARD SEA CUCUMBER, page 122

Bohadschia argus

SCALE: Length 13.5 cm (5.3 in)

Invertebrates are animals like ourselves and face the same fundamental challenges that we do: They have to obtain food and digest it, bring in oxygen, get rid of wastes (from digestion and respiration), and reproduce. Some, however, meet those challenges with approaches wildly different from our own. Take this sea cucumber: It breathes, inhaling and exhaling water like we do air, bringing oxygen into the body. The unexpected part? It does so through its anus. Most sea cucumbers have internal respiratory trees associated with their rectums: highly branched lung equivalents where oxygen exchange takes place. It's not obvious which end is the breathing (back) end in this cucumber, whose feeding tentacles are withdrawn. It's to the left. (Also page 123.)

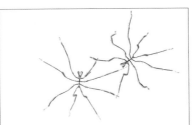

SEA SPIDER, page 124

cf. *Phoxichilidium quadradentatum*

SCALE: Leg spans 1.5 cm (0.6 in)

These living stick figures are not spiders at all, despite their name and superficial similarity. Strictly marine, they typically live and feed on sessile invertebrates such as hydroids, soft corals, and sponges, sucking tissues from their prey with tubular snouts. Like seahorses, sea spiders are one of the few animals in which the fathers are responsible for child care: The male collects and fertilizes the eggs from his mate and then carries the developing embryos on special appendages near the head. He holds as many as one thousand young in a ball-shaped mass, bonded to one another and to him by a glue he secretes. Upon hatching, the larvae may cling to their father's legs for some time before crawling away. (Also page 125.)

LARGE GREEN PHORONID, page 126

Phoronopsis harmeri

SCALE: Tube section lengths 3.5 cm (1.4 in)

These slender worms occur in great abundance in some intertidal sand flats but are easily overlooked: They live under the surface in narrow, sandy tubes that are challenging to see, even when dug up. The tubes shown here are only 2.5 millimeters (0.1 inch) wide but average 10 centimeters (4 inches) in length. The worms make the tubes by secreting a thin, transparent layer of chitin (the stuff of insect cuticles), into which they incorporate sediment particles. They stay safely tucked in their tubes when the tide is out, but when waters are high, they extend their crowns of feeding tentacles to the surface to collect tiny particles from the plankton. (Also page 127.)

ICE CREAM CONE WORM, page 128

Pectinaria sp.

SCALE: Tube length 1.5 cm (0.6 in)

This tube is no random assortment of agglutinated sediment but a carefully assembled structure: The owner selects the particles, positions them, and mortars them together with the precision of a stone mason. The tubes of live animals are found buried vertically in the sand, with the broad end facing downward and the narrow tip barely projecting above the surface. Inside the tube, the upside-down worm sorts through the sediment below it, extracting detritus to eat and selecting particles to add to the tube's growing edge. At the other end, the tube's narrow tip acts as a snorkel, with the worm creating a current that brings fresh water into the opening and over the gills.

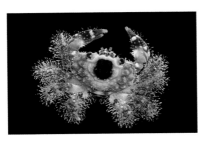

FUZZY ISLAND CRAB, page 129

Tweedieia laysani

SCALE: Leg span as viewed 13 cm (5.1 in)

All arthropods wear a whole-body coat of armor: a tough cuticle that covers every square millimeter of the animal. In crustaceans, the cuticle can be much thicker than in insects, and it is often hardened by the addition of calcium carbonate; it's especially thick and hard in many crabs. On certain parts, the cuticle typically has hair-like extensions, forming everything from filters for catching plankton and paddles for swimming to brushes for cleaning off gills and baskets for brooding embryos. The cuticular hairs of the small fuzzy island crab are remarkable for their abundance, length, and broad tips; their function is uncertain.

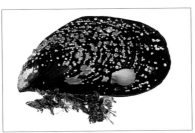

BAY MUSSEL, SCALLOP, DWARF CALCAREOUS TUBEWORM, AND MOSS ANIMAL, page 130

Mytilus trossulus, Chlamys sp., Subfamily Spirorbinae, and Phylum Bryozoa

SCALE: Shell length 6 cm (2.4 in)

Like coral reefs in the tropics, intertidal mussel beds on temperate shores harbor diverse communities. Hundreds of species have been recorded from beds along the North American west coast. The mussels in a bed can be layers thick, their shells providing vast areas of hard surface for other animals to occupy, as well as a variety of microhabitats between and beneath them. On this bay mussel, we see tiny worms that live in coiled tubes and even tinier moss animals that form encrusting colonies; both live cemented to the mussel shell and extend crowns of tentacles (pink in the worms, microscopic in the moss animals) to capture plankton. The juvenile scallop is temporarily anchored to the mussel; it can swim away. (Also page 131.)

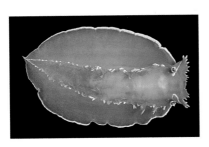

PINK TRITONIA, page 132

Tritonia diomedea

SCALE: Length 7 cm (2.8 in)

We know that different regions of the human brain drive different behaviors: Thus, one area controls speech while another dictates fine movement. Our current understanding is the product of decades of research, some of the earliest of which was on the pink tritonia—a nudibranch with a relatively simple brain that has large, colorful cells. In 1967, Dr. Dennis Willows published a groundbreaking study: Working with pink tritonia in Friday Harbor, he identified specific behaviors associated with the stimulation of specific brain cells. Today, a network of neurobiologists in the United States, the academic descendants of Willows, continue to use the nudibranch as a model for studying everything from the neural basis of hallucinations to the sensing of magnetic fields. (Also page 133.)

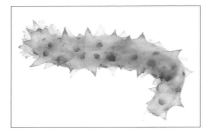

CALIFORNIA SEA CUCUMBER, pages 134–135
Apostichopus californicus
SCALE: Length 5.5 cm (2.2 in)
In 1942, classes at the Friday Harbor Marine Laboratories were suspended for World War II and converted to a Coast Guard station for training servicemen. Biologist Trevor Kincaid later described the summer prior to the transition, during which researchers at the lab turned to the sea as their wartime victory garden: "An especially extensive use was made of [California sea cucumbers] in the commisary [sic] of the laboratory, [as the animals' muscle bands provided] a very acceptable food product." Decades later, a commercial fishery for the species was established in the northeast Pacific, primarily for export to Asian markets. Careful management of this fishery will be crucial to preventing the depletion of populations, as cucumber species elsewhere have proven alarmingly susceptible to overexploitation.

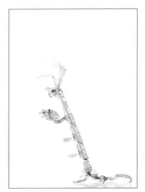

LARGE-THUMBED SKELETON SHRIMP, page 136
Caprella laeviuscula
SCALE: Body length 1.5 cm (0.6 in)
During courses in marine invertebrate zoology, students examining seaweeds, moss animals, or hydroids under the microscope are invariably delighted to discover tiny skeleton shrimp, often in abundance, clinging with their hind legs to the objects of study. Like stick insects, they have slender, elongated bodies that seem to mimic and blend in with their habitat, and, like praying mantises, they have a pair of enlarged, spiked, raptorial forelegs. While some are ambush predators like mantises, catching tiny invertebrates with those forelegs, the large-thumbed skeleton shrimp feeds by scraping algae and detritus from the eelgrass, seaweeds, and animals on which it lives.

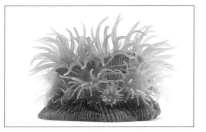

BROODING ANEMONE, page 137
Epiactis prolifera
SCALE: Base width 2 cm (0.8 in)
This anemone wears its babies like a belt around its waist, protecting them beneath an umbrella of tentacles; the young ones are dependent on that protection and can't survive on their own until they've reached a certain size. Parental care like this is highly unusual among sea anemones: Most spawn eggs and sperm into the water, where fertilization leads to a larva that settles some distance from its parent. In this species, though, eggs are fertilized in the parental stomach, and the new embryos dribble out the mouth and down the side to settle in a crease and grow. When they're large enough, the young will glide off and fend for themselves.

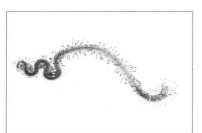

NECKLACE WORM, page 138
Trypanosyllis sp.
SCALE: Body length 6 cm (2.4 in)
With over seven hundred species worldwide, the necklace worms are one of the largest families of marine worms and live in a variety of bottom habitats. They're probably best known for the interesting ways in which they reproduce, which involve them (or at least their gonads) swarming up into the water column to spawn. Before spawning, the worm undergoes a metamorphosis to become a swimmer: Either the entire animal or a section of it develops swimming appendages and paddles itself to the surface. In the latter case, the piece usually develops its own separate head with eyes. When the time comes for the necklace worm pictured here to spawn, its back end, full of gametes, will break off and swim away.

SOFT CORAL, page 140
Family Nephtheidae
SCALE: Section height 3.5 cm (1.4 in)
Soft corals are related to hard corals and, like them, are made up of colonies of individuals called polyps. In hard corals, the polyps form a layer of living tissue on top of a hard, fused external skeleton that they secrete; it's these skeletons that form the framework for shallow tropical reefs. In soft corals, the polyps don't produce an external skeleton, but they can have an internal one. The tissues of this species contain a skeleton of white, calcareous needles called spicules, readily visible in the photograph. The spicules reinforce the soft tissue, allowing the colony to grow in its upright form. They may also act as spiny deterrents to predators, especially where they protrude.

PROLIFIC ANEMONE, page 141
Triactis producta
SCALE: Figure width 1 cm (0.4 in)
Like reef-building corals, the prolific anemone houses one-celled organisms called dinoflagellates in its tissues. The dinoflagellates are photosynthetic and have a symbiotic relationship with the anemone: They pass on some of the food they produce, and in return they obtain fertilizer and protection from their host. The anemone doesn't survive on photosynthetic contributions alone but also eats an assortment of small prey that it catches with its long feeding tentacles, which are expanded when it's dark outside. When light levels are high, the animal withdraws the long tentacles to fully expose its pseudotentacles—dark brown, branching appendages full of dinoflagellates—for photosynthesis. The pseudotentacles are protected by adjacent, bubble-like vesicles loaded with stinging cells that fend off predators.

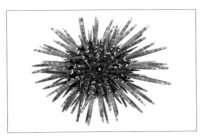

WHITE-CIRCLED URCHIN, page 142

Parasalenia poehlii

SCALE: Diameter with spines 3.5 cm (1.4 in)

Sea urchin innards are a popular delicacy in many countries, and an expensive one, partly because there are so few innards within each animal. It's striking when you look inside one: You see gut, gonads (the part humans consider edible), and plenty of watery space. There's no visible muscle—after all, what purpose would it serve inside a hard, immobile skeleton? Instead, the muscles—here, microscopic fibers that move the spines and tube feet responsible for defense and locomotion—lay mostly outside the globose shell. In this case, it's possible to have muscles outside the shell because the skeleton is actually internal, despite appearances: The shell and every spine are entirely covered by a layer of skin.

CARPENTER'S MELANELLA, page 143

Melanella micans

SCALE: Shell length 9 mm (0.4 in)

The carpenter's melanella belongs to a family of tiny white snails, all of which appear to be parasites on echinoderms: sea cucumbers, sea stars, sea urchins, and the like. Most are ectoparasitic, living on the body surfaces of their hosts. In the case of this species, though, virtually all recorded specimens have been found crawling about on sand with no apparent host association. A closely related species in Scotland is likewise typically free-living but is known to temporarily climb onto sea cucumbers to feed: It has a long proboscis that penetrates the cucumber's thick body wall, dissolving and consuming the connective tissue beneath. After a meal, the snail drops off. The carpenter's melanella likely has a similar lifestyle, but its host has yet to be identified.

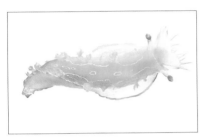

DIAMONDBACK NUDIBRANCH, page 144

Tritonia festiva

SCALE: Total length 5 cm (2 in)

The diamondback nudibranch is a finicky eater, feeding on soft corals and sea pens to the exclusion of all else. It's a surprising diet when you consider that its prey animals are cnidarians who, like their jellyfish cousins, have tentacles loaded with stinging cells that usually keep predators away. But those munitions are curiously ineffective against the diamondback and many other nudibranchs, which begs the question: How do the predators dodge their prey's stinging cells? They seem to use a mechanism similar to that employed by anemone-inhabiting clownfish, which are coated with a slime that prevents them from being stung. Nudibranchs that eat cnidarians are known to produce a mucus that inhibits the discharge of their prey's stinging cells.

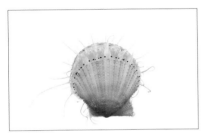

SPINY PINK SCALLOP, page 145

Chlamys hastata

SCALE: Shell width 9 mm (0.4 in)

Unlike its sedentary cousins—clams, mussels, and oysters—the scallop is a lively creature, quick to get up and go at the first sign of danger. Its long tentacles can smell and taste predators that approach or come into contact, and its numerous black eyes can detect threatening shadows. The animal responds not by clamming up and hunkering down but by clapping its shells together and lifting off into the water. It's not a speedy, directed getaway but rather a headless animal's hopeful leap off the bottom that, with any luck and a bit of current, will land it out of reach of its assailant. The strategy is effective because its predator is often a sea star, also headless.

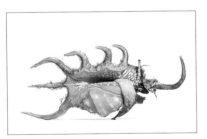

ORANGE SPIDER CONCH, pages 146–147

Lambis crocata

SCALE: Shell length with spines 12.5 cm (4.9 in)

This spider conch's shell is not only thick and spiny but also disproportionately large; the animal's head and foot, fully extended to the right in this photograph, are tiny in comparison. A shell this oversized, heavy, and ornamented is an effective means of protecting oneself from predators, but it comes at a price: It costs energy to build and lug around, slows the animal down, and precludes it from squeezing into small spaces. In the tropical waters that are home to the spider conch, predators are so abundant, diverse, and powerful that the trade-offs are presumably worth it. At higher latitudes, though, the risk of predation seems less, and for the most part, snail shells are proportionately smaller, thinner, and simpler.

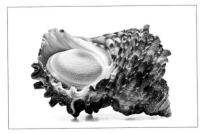

SILVER-MOUTHED TURBAN, page 148

Turbo argyrostomus

SCALE: Shell length 7 cm (2.8 in)

This snail is a bit of clam, with two shells that come together to protect the soft animal inside. When facing danger, it shuts itself inside and waits, giving the threat plenty of time to be gone before coming out to test the waters. The animal here took at least fifteen minutes to emerge (the time that elapsed between the first and second photographs; I don't know how long Susan waited before the first). Its second shell is a thick, round, calcified door that's attached to the back of the animal's foot, out of the way when it's crawling; when the snail withdraws, the door bars the main shell's opening.

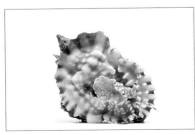

COMMON DISTORSIO, page 149

Distorsio anus

SCALE: Shell length 5.5 cm (2.2 in)

Often, the only way to get a good view of the snail living inside a seashell is to do what Susan has done here: Turn the shell so the opening faces sideways or up instead of down, and wait. With time, the head and foot will come out, extend down, and flip the shell back over. If you're quick, you might get a photograph like this one. Face-on, the animal displays two red-striped tentacles, to which are fused two shorter eyestalks with black eyes at their tips. At the base of those is a central crease—the animal's pseudomouth. When feeding, the snail everts a long proboscis from the pseudomouth, the true mouth being at the proboscis tip.

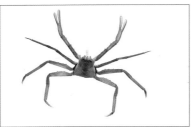

SCALED CRAB, page 150

Placetron wosnessenksii

SCALE: Leg span as viewed 4.5 cm (1.8 in)

Crabs are crustaceans with broad front ends and curled-under back ends (abdomens). While the so-called true crabs evolved from shrimp-like ancestors, king crabs like this one evolved from hermit crabs that gave up their shell habit, perhaps to be free of the size constraints it imposed. King crabs today retain a few traits from their hermit ancestors: an asymmetrical abdomen (in hermits, it's coiled to fit inside snail shells) and a highly reduced or absent fifth pair of walking legs (in hermits, those legs are also tiny and used to anchor the shell in place). The scaled crab is a king with unusual, spoon-shaped claws that may be used as forceps to reach prey in narrow spaces.

GIANT SPIDER CONCH, page 153

Lambis truncata

SCALE: Shell length 12 cm (4.7 in)

Cautiously peeking out the doorway of its overturned shell with one stalked eye (upper photograph on the page), this snail seems to be checking to see if all is clear before emerging (lower photograph); it's a young animal, less bold than adults of the species. Accordingly, it hides in sand and under rocks, seldom seen out in the open where adults are found. The young snail's reclusiveness may be because its shell is relatively simple and thin, offering much less protection than the mature shell will. In fact, the fully grown shell will look very different: The largest and heaviest of the spider conch shells, it will have long, thick, curved spines similar to those seen in the orange spider conch on pages 146–147.

GOLD-LACE NUDIBRANCH, page 155

Halgerda terramtuentis

SCALE: Length 5 cm (2 in)

Biologists document hundreds of new invertebrate species every year. The species are discovered in one of two ways: 1) researchers see a new animal they've never seen before, or 2) researchers see an old animal with new eyes, realizing that it doesn't belong to the species they'd previously assigned it to. The gold-lace nudibranch is a case of the latter: It's a fairly common shallow-water animal in the Hawaiian Islands, where for decades it was referred to by the name of a species described from Australia. But careful observation in the late 1970s revealed that it was quite different from the Australian species and in fact occurs only in the Hawaiian Islands.

COLEMAN'S NUDIBRANCH, page 155

Chromodoris colemani

SCALE: Length 1.5 cm (0.6 in)

Orange (or yellow) and black are the color duo seen in monarch butterflies, bees, many caterpillars, and even road signs; almost universally, the colors serve as a warning. In the animal kingdom, the warning is aimed at potential predators: Don't even think about eating me, because I taste bad, am toxic, or can sting you. Accordingly, the orange-and-black Coleman's nudibranch harbors in its skin poisonous compounds called terpenoids. The nudibranch's toxicity would be relatively ineffective if a predator had to taste it in order to discover that it was inedible—a bite would likely be fatal to the slug. So the nudibranch advertises its toxicity with its colors to avoid being so much as licked.

CLOWN NUDIBRANCH, page 156

Triopha catalinae

SCALE: Figure width 4 cm (1.6 in)

The clown nudibranch owes its bright spots of color to carotenoids—the pigments that also make carrots orange (carotene) and tomatoes red (lycopene). Carotenoids are widely touted for their human health benefits, and nutritionists advise eating carotenoid-rich foods because as animals, we can't synthesize the compounds ourselves; they're made only by plants, seaweeds, and other photosynthetic organisms. Similarly, the clown nudibranch must obtain the pigments from its food: the moss animals on which it feeds exclusively. The moss animals, in turn, get the compounds from the microscopic, photosynthetic organisms they eat. Another, more familiar animal that owes its spectacular color to carotenoids in its diet is the pink flamingo.

CLOWNFISH NUDIBRANCH, page 157

Thecacera pacifica

SCALE: Figure width 7 mm (0.3 in)

The clownfish nudibranch (named for its Nemo-like colors) occurs widely across the tropical Indian and Pacific Oceans and has more recently been recorded in the Caribbean—likely the result of human introduction. Atop its head are two black-tipped, chemosensory rhinophores, but the functions of several other structures are unclear: At the base of the tentacles are two expanded, white-rimmed sheaths and below those, a pair of reddish, crescent-shaped ridges. One researcher has proposed that the latter may be chemosensory in nature, like the rhinophores. Midway down the back, a central plume of small gills is flanked by two large appendages, unique to this group of nudibranchs and possibly defensive in nature.

EGG COWRY, page 158

Ovula ovum

SCALE: Foot length 9 cm (3.5 in)

Most biologists' interest in their subject matter isn't purely academic; we're also attracted by the undeniable aesthetics of living things. And just when we think we've seen it all—from psychedelic nudibranchs to ethereal jellyfish—we come across something like this egg cowry, a study in black and white, in this case jet-black flesh and chalk-white shell. The animal's head and foot are velvety black (except for white tips on its tentacles) and the egg-shaped shell on its back is solid white. The glossy shell can be entirely covered by two inky folds of skin bearing white spots and streaks; when the folds are withdrawn, the shell is revealed.

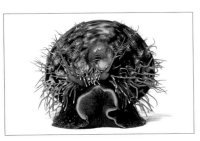

TIGER COWRY, page 159

Cypraea tigris

SCALE: Figure width 8 cm (3.1 in)

Many are familiar with the globose, shiny shells of cowries, but few are aware of the spectacular animals that construct and inhabit those shells. Like all cowries, the tiger (seen here crawling toward the camera) has folds of skin that envelop the shell and produce the glossy surface so admired by shell collectors; in this species, the skin bears numerous fine tentacles. The folds meet along the top of the shell but can be withdrawn into it when the animal is disturbed. Here, the folds are parted, revealing the brown-spotted shell beneath. The tiger cowry was once common in many parts of the tropical Indo-Pacific, but populations have suffered due to shell collecting and habitat destruction.

OPALESCENT INSHORE SQUID, page 160

Doryteuthis opalescens

SCALE: Frame width 7 mm (0.3 in)

The basis for one of the largest commercial fisheries in western North America, this species is also called the market squid. The animals' rapid growth helps sustain the fishery: They reach maturity in only four to eight months. Females deposit their embryos in spindle-shaped capsules anchored to the ocean's sandy bottom. The upper photograph on the page shows a section of capsule; the center photograph is a close-up of the embryos therein, each one attached at the mouth to a yolk mass it consumes during development. Six days after these embryos were photographed, their yolk masses were depleted and they emerged from the capsule to feed in the plankton; a hatchling is shown in the bottom photograph.

CHRISTMAS TREE HYDROID, page 161

Pennaria disticha

SCALE: "Tree" heights 3 and 4 cm (1.2 and 1.6 in)

The individuals (polyps) making up the colony of this species are larger than those of many hydroids and are instructive for understanding how the animals are put together. Arising from a basal, horizontal stolon are two tall individuals that form the trunks of the trees, their mouths like decorative stars at the top. Off each trunk, secondary polyps form side branches. Each polyp has a central mouth atop a red-and-white-striped snout. At the base of the snout is a ring of filamentous tentacles and along the snout's length are ball-tipped tentacles; the tentacles are used to capture food and defend against predation. Budding among the tentacles of some polyps are special reproductive structures: pink-red, egg-shaped individuals that will release sperm or eggs.

SPOON WORM, page 162

Anelassorhynchus or *Thalassema* sp.

SCALE: Total length 5.5 cm (2.2 in)

Spoon worms are named for the rolled organ (prostomium) at their front end, which in the specimen here is greenish yellow. Like many other soft-bodied animals that don't have obvious physical or chemical defenses, these worms usually conceal themselves in sand or under rocks, exposing only the part(s) necessary for feeding—in this case, the prostomium. With its body hidden, the worm extends the highly mobile organ, stretching it to ten or more times its contracted length. The prostomium then gathers detritus from the surrounding substrate and transports the particles back to the mouth at its base. It breaks off easily if handled but also readily regenerates.

KELP-ENCRUSTING BRYOZOAN, page 163

Membranipora villosa

SCALE: Frame width 7 mm (0.3 in)

For invertebrate classes taught at Friday Harbor Marine Laboratories, a favorite spot to find study subjects is on old tires nailed as bumpers to the lab's floating dock. The tires hang in the water, rising and falling with the tide and attracting a diversity of subtidal invertebrates. This kelp-encrusting bryozoan, a moss animal, was found forming a whitish, lichen-like plaque on kelp growing on the tires. Under a microscope, the crust is revealed to be a mandala of minute, tessellating individuals. Each animal, less than a millimeter long, sits in its own rectangular, box-like shell and extends a crown of tentacles to feed on plankton in the water.

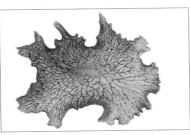

LEAF FLATWORM, page 164

Paraplanocera oligoglena

SCALE: Length 4.5 cm (1.8 in)

Flatworms like this one—headless, limbless, and thin as a leaf—challenge our ideas about what it takes to be an animal. It lacks specialized respiratory structures (gills or lungs) for gas exchange; instead, it's so flat that its skin acts as a gill, providing enough surface area for the thin body. Neither does the animal have a separate circulatory system: Oxygen and carbon dioxide simply diffuse between skin and nearby body tissues, and food and metabolic wastes are delivered directly to and from those tissues with an elaborate, highly branched digestive system. That system is beautifully depicted here as golden venation radiating and branching out from a central mouth—the only opening into (and out of) it.

BLACK DENDRODORIS, page 165

Dendrodoris nigra

SCALE: Length 2 cm (0.8 in)

Nudibranchs are hermaphroditic: Each adult is equipped with complete, functioning male and female systems, the openings of which are on the side of the animal's "neck." In this photograph, the nudibranch's head is on the right; the reproductive openings aren't visible but are positioned behind the two white-tipped head tentacles (rhinophores), on the animal's right side. Although hermaphroditic, the nudibranch can't self-fertilize but requires another individual in order to reproduce. To mate, two animals face in opposite directions with their heads alongside each other, bringing the reproductive openings in contact—necking, if you will. Both individuals play the role of male and female at the same time, giving and receiving sperm simultaneously.

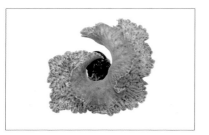

LEAF FLATWORM (EATING BLACK DENDRODORIS), page 165
Paraplanocera oligoglena (Dendrodoris nigra)
SCALE: Length 4.5 cm (1.8 in)
After Susan photographed this worm, she placed other animals in the tank with it, among them a black dendrodoris nudibranch (upper photograph on the page). Unaware that she'd done the equivalent of throwing mouse in with snake, she didn't expect what she referred to as the "predation drama" that unfolded before her camera. Like all polyclad flatworms, this one is a carnivore. It is known to eat snails with shells, as well as sea slugs like this nudibranch. Its mouth is more or less in the middle of its underside (at belly button level, from a human perspective), as seen in the photograph with the nudibranch halfway in. The flatworm typically crawls over its prey, draping itself like a blanket, and consumes it whole.

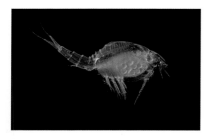

LEAF-FOOT SHRIMP, page 171
Nebalia sp.
SCALE: Total length 6 mm (0.2 in)
Tiny crustaceans—copepods, clam shrimp, and so on—are a dime a dozen in most marine systems, so it's hard to imagine why instructors of invertebrate zoology make such a point of seeking this one out. What makes the leaf-foot shrimp exceptional is that it's a living fossil, offering us a glimpse of early crustacean life: It appears in the fossil record some five hundred million years ago, and the twenty or so species living today are virtually unchanged. It's thought that shrimp, crabs, lobsters, krill, and others all evolved from an animal that was anatomically very like a leaf-foot shrimp. The one shown here is a female, carrying her yellow developing embryos in a brood basket.

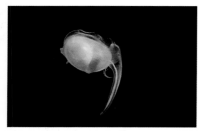

GALEO CLAM, page 172
Family Galeommatidae
SCALE: Shell length 4 mm (0.2 in)
The galeo clams are one of the most successful groups of bivalves, with over five hundred named species and probably hundreds more undescribed. They're also one of the most underappreciated and overlooked groups, largely because they're so small. Many live like this one does, nestled in crevices within or underneath rocks and moving about with a long, mobile foot. But a vast number are found living deep within sands and muds, an unlikely habitat for tiny clams with no ready access to the sediment surface for breathing and the like. Their trick? They've evolved to live commensally on larger animals (from mud shrimp to worms) that inhabit sediments, taking advantage of their burrows and associated ventilation currents.

MARBLED SHRIMP, page 173
Saron marmoratus
SCALE: Length 2 cm (0.8 in)
While insects and arachnids are the dominant arthropods in terms of sheer species numbers, crustaceans surpass them in morphological complexity and innovation. Not limited to three or four pairs of legs, they can have more than twenty; and, like the tools of a Swiss Army knife, different ones can be modified for different functions. On this common marbled shrimp, we see only the three pairs of legs used for walking; others are hidden beneath the body. In front of the walkers are smaller legs used mostly to handle food and behind them is a series of leafy appendages with several functions: respiration, forward swimming, and, in females, embryo brooding.

PLANKTON SAMPLE, pages 174–175
SCALE: Frame width 3.5 cm (1.4 in)
During an expedition to French Frigate Shoals in 2006, researchers occasionally pulled a fine-meshed plankton net behind the vessel. After a short tow, they'd bring the net on board and survey its contents to get a glimpse of life in the surface waters. This photograph shows some of the catch from one tow: Over 99 percent of the creatures are invertebrates (I see one fish larva), almost all of them crustaceans. While the handful of larger shrimp as well as the copepods and ostracods will spend their lives in the plankton, many of the individuals seen here are just passing through before they settle to the bottom: The sample is full of crab young and at least one mantis shrimp larva.

GIANT FLATWORM, page 176
Kaburakia excelsa
SCALE: Length 7 cm (2.8 in)
Typically found on the undersides of rocks in shallow water, this worm is not immediately eye-catching: drab, flat, and seemingly featureless, it blends in with the rock surface. So while I was thrilled when we found the locally rare species during a class field trip, I doubted whether the animal would be photogenic. But back at the lab, on stage in Susan's tank, the animal delighted us with a remarkable performance of contortions. Visible in some of the photographs are two sets of head tentacles and, in one back-bend pose (page 176, lower right), the animal's white, partially everted pharynx; nowhere near the front of the body, the mouth is close to the center of the worm's underside. (Also page 177.)

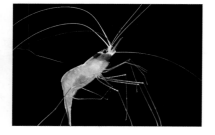

RED-WHITE-AND-BLUE SHRIMP, pages 178–179
Plesionika sp. aff. *chacei*
SCALE: Body length 5 cm (2 in)
Between about 100 and 1,000 meters (300 and 3,300 feet) below the ocean surface, depending on local water clarity, lies the so-called twilight zone: Above it, there's enough sunlight for photosynthesis to occur; below it, total darkness. In this dimly lit realm, shrimp often bear exaggerated appendages that help them feel their way about. This individual, collected from a depth of about 110 meters (360 feet), displays disproportionately long legs and off-the-page antennae. The red-and-white antennae extend in all directions and bear chemosensory as well as touch receptors; the animal uses them not only as feelers but also to smell the water and taste objects it comes into contact with.

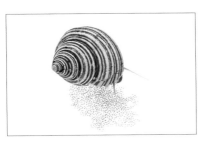

BLUE TOPSNAIL, page 180

Calliostoma ligatum

SCALE: Shell diameter 1.5 cm (0.6 in)

A female lays eggs bound loosely to one another and to the bottom of the seafloor—in this case, a tank—with a jelly that's thin enough for sperm to penetrate. Unlike most snails, these primitive ones don't mate; rather, they release eggs and sperm, and fertilization occurs externally. Only four days after the eggs are laid and fertilized, tiny larvae hatch and about ten days after that, the larvae undergo metamorphosis. Such details of development aren't known for the vast majority of the world's ocean invertebrates. However, at marine labs along the North American west coast, there's been a long history of comparative embryology; researchers at these labs have documented the development of many common species like this one. (Also page 181.)

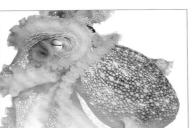

DAY OCTOPUS, pages 182–183

Octopus cyanea

SCALE: Length without arms 8 cm (3.1 in)

The scientific name "cyanea" refers to the species' blue (cyan) highlights, especially prominent around this individual's eyes. The animal's common name calls attention to the fact that it's active during the day whereas most octopus species are nocturnal. Being out in the open during daylight hours makes the animal vulnerable to visual predators, which may be why it has such an exceptional (even for a cephalopod) capacity for camouflage. The day octopus can produce an astonishing variety of color patterns and skin textures, changing from one to another almost instantaneously to adjust to its surroundings. The animal's greatest threat comes from human predators, as it's a favored food among islanders throughout the tropical Pacific.

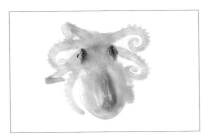

OCTOPUS, page 184

Order Octopoda

SCALE: Length without arms 2 cm (0.8 in)

This tiny juvenile has probably recently settled from the plankton and is difficult to identify at this stage: Octopus specialists have been unable to assign it with certainty to any of the species known from the Hawaiian Islands, where it was collected. Like all octopuses, squid, and cuttlefish, the animal lacks the outer shell of its ancestors. With the evolutionary loss of that protection, shell-less cephalopods became quick and dexterous, developed the ability to rapidly change skin color and texture to blend in with their immediate surroundings, evolved complex, vertebrate-like eyes, and acquired remarkably well-developed brains. When intelligence is measured according to human standards, octopuses receive the highest scores among invertebrates.

PACIFIC RED OCTOPUS (EYE), pages 186–187

Octopus rubescens

SCALE: Frame width 7 mm (0.3 in)

In this close-up photograph of an octopus eye, we see hundreds of colored spots. These are not simple, static points of pigment; rather, they're dynamic organs called chromatophores (literally, "color bearers"), which lie in the animal's deeper layers of skin. Each chromatophore has a central cell filled with golden yellow, red, or brown pigment; from the edges of the cell, muscle fibers radiate out like spokes on a wheel. When the fibers are relaxed, the pigment cell is a pinpoint. When they contract (shorten), they stretch the cell out like children holding the edges of a parachute and walking backward to pull it open. By controlling the expansion and contraction of chromatophores of different colors and in different body regions, the octopus can alter its appearance rapidly and dramatically.

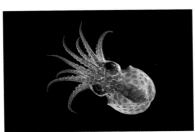

OCTOPUS YOUNG

PACIFIC RED OCTOPUS, page 188

Octopus rubescens

SCALE: Length without arms 8 mm (0.3 in)

The animals in these photographs—the young of two common Eastern Pacific octopus species—were scooped from the plankton off the dock at the Friday Harbor Marine Laboratories. While the adults crawl along the ocean floor, these cephalopods begin their lives in the water column, entering it directly upon hatching. The tiny, mostly transparent infants are carnivores from the start, feeding on small planktonic crustaceans and invertebrate larvae. As they grow, they become less transparent and begin to spend periods on the bottom; after weeks or months in the plankton, they finally settle for good, committing to a life on the seafloor. (Also page 189.)

SEA STARS

HEMPRICH'S SEA STAR, page 192

Ophidiaster hemprichii

SCALE: Diameter 3.5 cm (1.4 in)

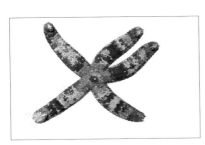

Sea stars are a diverse group of predators and scavengers that play important roles in marine ecosystems worldwide. Known to eat everything from mussels and clams to sea anemones and even other sea stars, most have the remarkable ability to turn their stomachs inside out and extrude them from their mouths. The advantage? The stomach can squeeze into spaces as narrow as one-tenth of a millimeter across (for example, between the two shells of a clam) and begin digesting tissues while it's outside the sea star's body. The sea star then brings the meat, partially broken down, into its body for further digestion and absorption. (Also pages 193–195.) SEA STAR, Class Asteroidea (p. 192 top right diameter 1 cm/0.4″, center left diameter 2 cm/0.8″, bottom right diameter 1.5 & 2.5 cm/6 & 1″); EGYPTIAN SEA STAR, *Gomophia egyptiaca* (diameter 14 cm/5.5″); MULTICOLORED LINCKIA, *Linckia multiflora* (diameter across short arms 3 cm/1.2″); DWARF MOTTLED HENRICIA, *Henricia pumilia* (p. 193 top left diameter 2 cm/0.8″); PACIFIC BLOOD STAR, *Henricia leviuscula* (diameter 5.5 cm/2.2″); ROSE SEA STAR, *Crossaster papposus* (diameter 4 cm/1.6″); DWARF MOTTLED HENRICIA and SIX-RAYED SEA STAR, *Henricia pumila* and *Leptasterias hexactis* (p. 193 center right diameters 4.5 & 2.5 cm/1.8 & 1″); RED FROMIA STAR, *Fromia milleporella* (diameter 3.5 cm/1.4″); MORNING SUN SEA STAR, *Solaster dawsoni* (diameter 6 cm/2.4″).

CHITONS

NORTHERN HAIRY CHITON, page 196

Mopalia kennerleyi

SCALE: Length 3 cm (1.2 in)

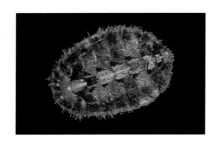

Typically found on rocks in shallow marine waters, chitons are easily recognized by the row of eight overlapping shell plates running down their backs (albeit in the gumboot chiton, the plates are covered with skin). They feed by scraping seaweed and detritus from the rocks with a rasping tongue bearing rows of teeth. To stand up to all the rock scraping, a chiton's teeth are reinforced with minerals such as magnetite, making them the hardest biological structures known—three times harder than human teeth. Nevertheless, they wear down over time, so chitons use a strategy similar to that of sharks: They replace the worn teeth up front with a continuous supply of new ones coming from the back. (Also pages 197–199.) LINED CHITON, *Tonicella lineata* (p. 197 frame height 2 cm/0.8"; p. 198 top left length 2 cm/0.8", bottom length 3.5 cm/1.4"; p. 199 top left length 3.5 cm/1.4", top right length 3 cm/1.2", center left length 3 cm/1.2"); MERTEN'S CHITON, *Lepidozona mertensii*, (p. 198 top right length 2 cm/0.8", center left length 2 cm/0.8"; p. 199 center right length 2 cm/0.8", bottom right length when flat 2 cm/0.8"); MOSSY CHITON, *Mopalia muscosa* (p. 198 center right length 2.5 cm/1"; p. 199 bottom left length 3 cm/1.2").

HERMIT CRABS

HOPPER'S HERMIT, page 2

Aniculus hopperae

SCALE: Shell length 3 cm (1.2 in)

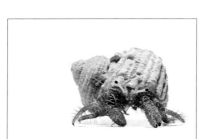

Most of us are so familiar with hermit crabs, which have been popularized as children's pets and animated characters, that we take for granted a remarkable evolutionary adaptation: They appropriate the dead skeletons of other, unrelated animals for their own use. In fact, most are completely reliant on those foreign skeletons, whose original owners were snails.

On a snail, the skeleton (its shell) is an integral, inseparable part of the animal, firmly attached to the creature and growing with it. When the snail dies and decomposes, it leaves behind the empty shell. Sturdy shells can last centuries or millennia after their owners have died, and in a community with a diversity of snails, there's also a diversity of empty shells. The shrimp-like ancestors of hermit crabs evolved to take advantage of all of those shells.

They probably began by putting their back ends (abdomens) into worm tubes, tusk shells, or coral pieces for protection, as do some hermit crabs today (including the tubeworm hermits portrayed on page 217–218). But they quickly moved to snail shells, evolving a twist in their abdomens to fit the coiled shells. Like any crustacean, they already had their own exoskeleton covering them from antenna tip to tail fan, but the mollusk shells offered protection that was more substantive.

Almost all modern hermit crabs spend their entire lives (after they've settled from the plankton) in a shell. In association with this habit, their bodies have undergone a number of changes in addition to the twist noted above: The two rearmost pairs of walking legs are tiny, being largely dedicated to anchoring the shell; the tail fan has minute hooks on it to help it grip the inside of the shell; and the abdomen, hidden inside and no longer used for locomotion, has few muscles and a very thin exoskeleton. Susan's two photographs of a gold-banded hermit out of its shell (pages 212–213) show the marked difference between the animal's armored front end and its oddly soft and contorted back end, normally concealed.

Unlike snails, hermits aren't attached to their shells, nor do the dead shells grow with them. Instead, when a crab's shell becomes too small for it, it must move to a larger one. Competition can be fierce for shells just the right shape and size, and it's not unusual for a hermit who has outgrown its shell to attack another crab whose shell it covets; if an aggressor is successful, the losing crab will abandon house, allowing the assailant to move in. One of the photographs here (page 200) shows two widehand hermits: one firmly in its shell and another—larger and shell-less—crawling on the first one's shell and approaching the opening, likely in an attempt to evict its owner. Some hermit crabs are even known to kill and eat snails in order to take over their shells.

Although hermit crabs are free to leave their shells, they're extremely vulnerable when exposed. In their natural environment, they can't survive naked for long. Their dependence on shells imposes a limit on them: They can become only as large as available shells allow. So hermit crabs never grow very large, with one notable exception: the coconut crab, the largest living arthropod on land. It has a soft abdomen and carries a shell while it's young, but it jettisons the covering when it reaches a certain size. After losing the shell, its abdomen develops a tough exoskeleton, and the animal grows to weigh as much as 4 kilograms (9 pounds). It's one of a handful of hermit crabs that live on land. The strawberry hermit (page 225) is another. It's closely related to the coconut crab but remains in a shell and stays relatively small. (Also pages 3, 200–227, 256.) BLOODY HERMIT, *Dardanus sanguinocarpus* (p. 2–3 shell length 6 cm/2.4"); WIDEHAND HERMIT, *Elassochirus tenuimanus* (p. 200 shell length 2 cm/0.8"); WIDEHAND HERMIT and HERMIT CRAB SPONGE, *Elassochirus tenuimanus* and *Suberites* sp. (p. 201 figure width 5 cm/2"); HAWAIIAN HERMIT, *Ciliopagurus hawaiiensis*, (p. 202 shell length 7 cm/2.8"; p. 203 shell length 6 cm/2.4"); CARNIVAL HERMIT, *Ciliopagurus strigatus* (p. 202–203 shell length 3.5 cm/1.4"); DWARF ZEBRA HERMIT, *Calcinus laevimanus* (p. 206 shell length 2 cm/0.8"; p. 207 shell length 2 cm/0.8"); WIDEHAND HERMIT, *Elassochirus tenuimanus* (p. 208 above figure width 1.5 cm/0.6", below shell height 1.5 cm/0.6"; p. 209 leg span as viewed 4.5 cm/1.8"); GUAM HERMIT, *Calcinus guamensis* (p. 210 figure width 7 mm/0.3"); HIDDEN HERMIT, *Calcinus latens* (p. 210 below shell length 2.5 cm/1"; p. 211 above shell length 5 cm/2", right figure width 2 cm/0.8"); GOLD-BANDED HERMIT, *Dardanus brachyops* (p. 212 above figure length 6 cm/2.4"; p. 212–213 leg span as viewed 10 cm/3.9"); ISABELLA'S HERMIT, *Calcinus isabellae* (p. 214 left shell length 2 cm/0.8"; p. 214–215 bottom shell length 3 cm/1.2"); LAURENT'S HERMIT, *Calcinus laurentae* (p. 215 top shell length 1 cm/0.4", bottom figure width 1.5 cm/0.6"); BLUESPINE HERMIT and NORTHERN SHELL BARNACLE, *Pagurus kennerlyi* and *Hesperibalanus hesperius* (p. 216 shell length 1.5 cm/0.6"); GRAINY HAND HERMIT, *Pagurus granosimanus* (p. 217 figure width 2.5 cm/1"); TUBEWORM HERMIT, *Discorsopagurus schmitti* (p. 216 –217 sand tube length 4 cm/1.6"); HIDDEN HERMIT, *Calcinus latens* (p. 218 top pair shell lengths 4 mm/0.2", bottom shell length 4 mm/0.2"; p. 219 shell diameter 3 mm/0.1"); CANDY STRIPE HERMIT, *Calcinus gouti* (p. 220 shell diameter 2.5 cm/1"); CANDY STRIPE HERMIT and BONNET LIMPET, *Calcinus gouti* and *Sabia conica* (p. 221 shell length 4 cm/1.6"); ARGUS HERMIT, *Calcinus argus* (p. 222–223 bottom shell length 10 cm/3.9"; p. 223 top figure width 2.5 cm/1"); BUMBLEBEE HERMIT, *Clibanarius humilis* (p. 224 shell length 1.5 cm/0.6"); BERING HERMIT, *Pagurus beringanus* (p. 224 figure width 3.5 cm/1.4"); HERMIT CRAB, cf. *Dardanus sp.* (p. 224 shell length 3 cm/1.2"); STRAWBERRY HERMIT, *Coenobita perlatus* (p. 225 shell length 1.5 cm/0.6"); BLUESPINE HERMIT and HERMIT CRAB SPONGE, *Pagurus kennerlyi* and *Suberites* sp. (p. 225 figure width 5 cm/2"); MOTTLED HERMIT, *Dardanus longior* (p. 226 shell length 3 cm/1.2"); BERING HERMIT, *Pagurus beringanus* (p. 226 shell diameter 5 mm/0.2"); MOTTLED HERMIT, *Dardanus longior* (p. 227 shell length 6 cm/2.4"); BLUE-EYED HERMIT, *Calcinus* sp. aff. *elegans* (p. 227 figure width 2 cm/0.8"); GOLD-BANDED HERMIT, HERMIT CRAB ANEMONE, ANEMONE (unidentified), DARWIN'S BARNACLE, CALCEREOUS TUBEWORM, *Dardanus brachyops, Calliactis polypus,* Order Actiniaria, *Chionelasmus darwini,* Family Serpulidae (p. 256 figure width 6.5 cm/2.6").

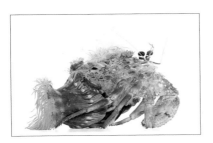

ANEMONE HERMIT CRABS
JEWELED ANEMONE HERMIT AND HERMIT CRAB ANEMONE, pages 204–205
Dardanus gemmatus and Calliactis polypus
SCALE: Figure length 10 cm (3.9 in)

It's hard not to ascribe an attitude of pride to this hermit crab, with its shell so laden with anemones. The anemones are not accidental occupants but have been placed there deliberately by the crab, who uses their stinging tentacles for its own defense. Crabs have been observed positioning the anemones with symmetrical precision, as if to protect themselves from all directions. In return, the anemone gets a place to attach (bare rock is in short supply on the reef) and access to bits of food dispersed by the crab's messy eating habits. One study of these symbiotic species found that there weren't enough anemones in their environment to go around for the crabs, who fought over them and stole them off one another's shells. (Also pages 226, 256.) JEWELED ANEMONE HERMIT CRAB, *Dardanus gemmatus* (figure width 4 cm/1.6″); GOLD-BANDED HERMIT, *Dardanus brachyops* (figure width 6.5 cm/2.6″).

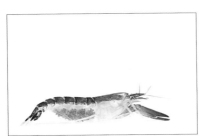

NORTHERN HOODED SHRIMP, page 253
Betaeus harrimani
SCALE: Figure length 3.5 cm (1.4 in)

The northern hooded shrimp, a member of the snapping shrimp family, is usually found in the burrows constructed and inhabited by other, much larger shrimp species: the blue mud (*Upogebia pugettensis*) and bay ghost (*Neotrypaea californiensis*) shrimp. The smaller animal presumably gets shelter and protection in the larger one's burrow, but whether the large shrimp benefits from the relationship is unclear. Other symbiotic snapping shrimp are known to clean their hosts and maintain the burrows. The animal here is a mother brooding bright green, young embryos, which she'll carry until they hatch as larvae. After spending a period of time feeding in the plankton, the young snapping shrimp will settle into another burrow.

VANCOUVER FEATHER DUSTER, page 255
Eudistylia vancouveri
SCALE: Length of tube visible 5.5 cm (2.2 in)

Common in the Northeast Pacific Ocean, the Vancouver feather duster is often found in large clusters of tubes attached to pilings and the undersides of floating docks. Each worm spends its entire settled life (after a larval stint in the plankton) in its tough, leathery tube, made from thick, solidified mucus coated with sand grains. Its body hidden within, it extends only its crown of red-banded tentacles, which function both in feeding and respiration. Each tentacle is feather-shaped, and food particles caught on the tiniest branches (pinnules) are transported in grooves to the main stem and from there down to the mouth at the crown's base.

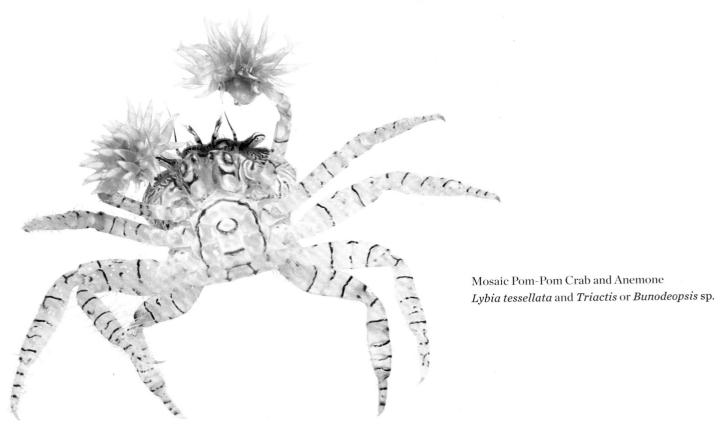

Mosaic Pom-Pom Crab and Anemone
Lybia tessellata and *Triactis* or *Bunodeopsis* sp.

About the Photography

The photographic fieldwork I undertook to produce the images in this book transpired over seven years, from 2006 to 2013, in three marine habitats: French Frigate Shoals, in the Hawaiian archipelago; the Line Islands, in the Central Pacific; and San Juan Island, in Washington State.

I conducted the first phase of my fieldwork at French Frigate Shoals, where I accompanied a Census of Marine Life CReefs expedition to the Papahānaumokuākea Marine National Monument. A team of marine biologists on the National Oceanic and Atmospheric Administration (NOAA) vessel *Oscar Elton Sette* set out to conduct a survey of "understudied, lesser known inhabitants of coral reefs." My role was to make photographic portraits of live specimens collected by the scientists in a shipboard studio I set up, which essentially consisted of modified aquariums and flat Plexiglas and glass trays for shooting from above. I employed a variety of lighting techniques, all using strobe lights, the primary light source being handheld for precise placement. I worked with one hand on the camera and the other holding the light. Although many of my subjects were tiny, none were at the microscopic level. The largest magnification I used was five times life-size. I made portraits of each subject, visually isolating it against a neutral backdrop, either white or black. My aim was to capture the detail, structural complexity, and character of each creature and to create images that would convey the beauty and wonder of this realm of life.

This first phase was extremely productive because I was essentially eavesdropping on a successful research expedition. More than a thousand distinct species were observed, or roughly 20 percent of the known invertebrate fauna from the Hawaiian archipelago, as well as many species never observed before. These findings are evidence of the rich biodiversity that thrives in the first U.S. marine national monument, the Papahānaumokuākea Marine National Monument, which encompasses the northwestern Hawaiian Islands. At 140,000 square miles (350,000 sq km), this national monument is larger than all of our national parks combined and one of the largest protected marine areas in the world.

The second phase of my fieldwork took place in the Central Pacific Ocean in the Line Islands, including Jarvis Island, Palmyra Atoll, and Kingman Reef. These areas contain some of the most pristine coral reefs in the world. I photographed invertebrates collected by marine biologists who were conducting surveys of coral reefs as part of a NOAA research expedition aboard the vessel *Hi'ialakai*. As in the first phase in the French Frigate Shoals, I set up a temporary shipboard studio where I photographed the animals, and after I had made their portraits, they were returned to their reef habitats.

The third phase of my fieldwork took place over seven summers on San Juan Island, Washington, at Friday Harbor Marine Laboratories, which is part of the University of Washington. I worked in conjunction with several expert marine-invertebrate biologists who collected live specimens from the surrounding environment as part of their research and the courses they were teaching. We were able to explore diverse habitats, which included such activities as digging down deep in vast mudflats where we discovered marvelous burrowing marine worms; rock hopping in intertidal areas in search of chitons stuck to rocks; and shining a light off the docks into the water, or nightlighting, to see what was active at night and attracted to the light. All of these habitats are wonderfully rich with life. This work also provided me with the unique opportunity to photograph at a nearshore habitat that is a different ecosystem altogether from a coral reef; it enhanced the diversity of my imagery.

These three locations, combined with the expertise of my scientific collaborators, afforded me unparalleled access to the marvelous world of marine invertebrates.

The NOAA research vessel *Hiʻialakai* in the Line Islands.

Temporary studio in the wet lab aboard the *Hiʻialakai*.

The author photographing a tiger cowry on the *Hiʻialakai*.
Photograph by Molly Timmers.

Camping on Jarvis Island, in the Line Islands, to observe and collect hermit crabs.

The dock at Friday Harbor Marine Laboratories, University of Washington, on San Juan Island.

Dr. Gustav Paulay finding invertebrates on a rubber tire bumper at Friday Harbor Marine Laboratories.

Collecting marine invertebrates from the University of Washington research vessel, *Centennial*, in the San Juan Islands.

Dr. Gustav Paulay reaching down to capture a burrowing marine worm at False Bay, San Juan Island.

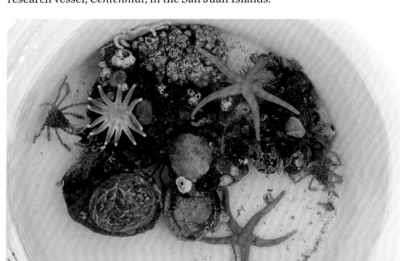

A bucket of animals, collected from the *Centennial*, awaiting their portrait sessions.

Dr. Paulay showing the delicate worm to students.

Dr. Alan Kohn examining plankton collected from the *Centennial*.

The author photographing a widehand hermit crab at Friday Harbor Marine Laboratories. Photograph by Mary Piller.

These photographs are not instant pictures, even though the act of pressing the shutter and exposing the sensor takes only a fraction of a second. Creating the setup for the animals to be photographed takes time. It must be technically perfect and hospitable to the animals, at least as hospitable as I can make it. Fresh, oxygenated seawater at the proper temperature is essential. Even more time is devoted to observing each animal to get a sense of my subject before I place it in what I call the "photarium," a modified aquarium, or glass tray, that serves as a temporary portrait studio. I consult with scientific experts, the ones who know the animals the best, for clues about what behaviors to expect. I take my cues from the scientists, but I learn mostly from patiently watching an animal in front of my camera. Sometimes I watch for a very long time—even hours—before clicking the shutter. I wait to see how an animal will respond to its new environment of smooth, slick surfaces and light. I imagine that certain realities are gradually perceived by my subject: "There is nowhere to hide! There is no way out! Is this safe, being so exposed? What are those bright flashes of light? The water feels good, it's the right temperature, there's plenty of oxygen, but there doesn't seem to be any food available . . . hummm . . . what to do, how to behave?"

There is always a period of adjustment to the new surroundings, and each animal reacts differently. Sometimes I witness a spectacular performance, as with the giant flatworm (pages 176–177). Initially this animal did not look too promising as a photographic subject—a thin, flat, brown gelatinous mass that filled the palm of my hand. I placed it in the aquarium and watched. After a while, it became a contortionist, assuming an impressive array of gestures and positions, almost like a dance. Everyone, including the scientific experts in the lab where I was working, was amazed to see what this worm could do with its body. It's possible, in fact probable, that this behavior had never been seen by humans!

Patience is the single most important aspect of my photography—waiting and watching and being ready. It took more than three hours to photograph the progression of the painted anemone opening up to its final sunflower pose (pages 74–75). My subjects do not respond well to direction, so I must wait for them to, first, feel safe enough to relax and explore, and then to assume a posture or gesture that will make a good photograph. I worked with the stiff-footed sea cucumber (pages 86–87) during multiple sessions over several days before the extraordinary branching tentacles became fully extended.

Invertebrates represent relatively unexplored territory, and at times I sensed that I might be the only person to have observed a particular kind of creature as closely and for as long a period of time as I did in the process of making a photograph. I have been continually surprised and captivated by my subjects, and there have been many revelations along the way. To a photographer, invertebrates present difficult challenges, but in equal measure to the rewards they offer in revealing their miraculous gestures and forms.

Northern Hooded Shrimp
Betaeus harrimani

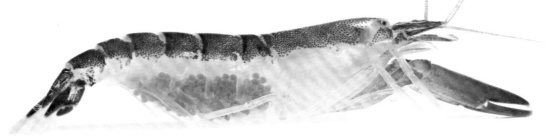

Acknowledgments

In memory of my artistic mentors and muses:

Thomas Eisner, who introduced me to the wondrous world of invertebrates; Richard Avedon, who fueled my obsession with photographic portraiture; Lydia Modi Vitale, who inspired artistic excellence and great style; Rodney Marzullo, who opened my eyes to art in unlikely places; Tokoudagba Cyprien, who exemplified the intensity of the artistic process; Nathan Oliveira, who believed in my work, because, he said, "it's about the real world."

With appreciation to Sylvia Earle for caring so deeply about the oceans and their inhabitants, for writing the Foreword, and for a memorable time together on Midway Atoll.

I am deeply grateful to Geneva Bumb Shanti, my production associate, for attending to a myriad of essential production activities over the course of seven years. She knows these photographs better than anyone and treated the subject of each portrait with extreme loving care and expertise. If only these spineless creatures could know how lucky they are to have a stylist like Geneva!

I would like to express my gratitude to:

Rusty Brainard and Gustav Paulay, for recognizing my passion for invertebrates and facilitating access to many of the animals in this book; Bernadette Holthuis, for exposing me to the wonders of marine worms and so much more, and for writing the stories; Leonard Feinstein and Mary Piller for making the films; Greg Bigelow, longtime neighbor, for sharing his culinary creations during my long days of writing and work on the book.

Sincere thanks goes to my publisher, Abrams:

Eric Himmel, Editor in Chief, for wanting to publish this book and for recognizing and appreciating that sweet spot where art and science meet; Andrea Danese, my editor, for shepherding the book through production with equanimity, wit, and a light hand; Darilyn Carnes, designer, for observing and listening, for her openness to collaboration, welcoming my ideas and contributing spectacular ideas of her own, and for her patient and sensitive execution; Emily Albarillo, for her care and attention to every detail of the production process.

With deep gratitude to these "project angels" for providing financial support:

Susan O'Connor, Charles Engelhard Foundation; Robert J. Bettencourt; Kirk Fredrick; and Mary Richardson. Additional support was provided by a 2009 Guggenheim Fellowship.

With appreciation to the following organizations and individuals for their in-kind and logistical support:

California Academy of Sciences, for serving as a fiscal sponsor for the project. Special thanks to Frank Almeda, Charlotte Pfeiffer, and Charles Delbeek; Friday Harbor Marine Laboratories, University of Washington, College of the Environment; The Helen Riaboff Whiteley Center for granting five summer fellowships; National Oceanic and Atmospheric Administration (NOAA); Papahānaumokuākea Marine National Monument; United States Fish & Wildlife Service; State of Hawai'i, Department of Land & Natural Resources.

Thanks to the following people for their friendship and support during my fieldwork on San Juan Island:

Arthur Whiteley, James Murray and family, Patricia Morse, Rachel Merz, Craig Staude, Marjorie Wonham, Chris Neufeld, Elaina Jorgensen, Gretchen Lambert, Claudia Mills, Mary Rice, Billie Swalla, Brad Buchanan, and Erika Davis.

Special thanks to:

Scott Godwin, for placing so many hermit crabs before my lens; Molly Timmers, dive buddy and collector extraordinaire; Alex Wegman, inspirational field associate and friend; Meagan Moews, Andy Collins, and the officers and crew of NOAA research vessels: *Hi'ialakai* and *Oscar Elton Sette.*

Bernadette Holthuis and I are especially grateful to the following people who served as consultants for the species profiles:

Arthur Anker, Marcela Bolanos, Dale Calder, Tin-Yam Chan, Andrea Crowther, Sammy De Grave, Richard Emlet, Daphne Fautin, Ryutaro Gato, Terry Gosliner, Leslie Harris, Erika Iyengar, Gregory Jensen, Elaina Jorgensen, Jingchun Li, Bill Lyons, Chris Mah, Seabird McKeon, Enrique McPherson, Claudia Mills, William Newman, Peter Ng, Jon Norenburg, Diana Padilla, Gustav Paulay, Cory Pittman, James Reimer, Mary Rice, Kareen Schnabel, Julia Sigwart, Craig Staude, Richard Strathmann, Megumi Stratmann, Billy Swalla, Leen Van Ofwegen, Bob Van Syoc, Gary Williams, Maya Wolf.

For their technical assistance and expertise, I would also like to thank Samuel Hoffman, John-Paul Jespersen, Stephen Shearer, and Cassandra Fecho at Light Source; and Bob Tamura.

With gratitude to the following people for their ongoing encouragement and inspiration:

William and Paula Merwin, Edward O. Wilson, Peter Raven, Jane Lubchenco, Richard Duggan and Susan Gabaree, Kathan Brown, Tom Marioni and the members of SIA, John Rampley, Demetrios Skourtis, Mark Alsterlind, Deidre Kernan, Mary Richardson, Ted Richardson, the Richardson families, the Bodner family, John Francis, the Hiner families, the Campodonico family, the Grundy family, Suzanne Fritch, Karen Ciabattoni, Pat Burke, Maureen Murphy, Betsy Gagné, Steve Perlman, Barbara Pope, Paula Kirkeby, Susan Campodonico, Mark Ludwig, Stephanie Browner, Richard Hamlin, Willie Royal, Pat Gossan, J. Miller, Sagbohan Danialou, Ives Apollinaire Pédé, Serge Omer Affognon, and Myriam Sagbohan.

And finally,

To Mami Wata, Mother Goddess of the Ocean

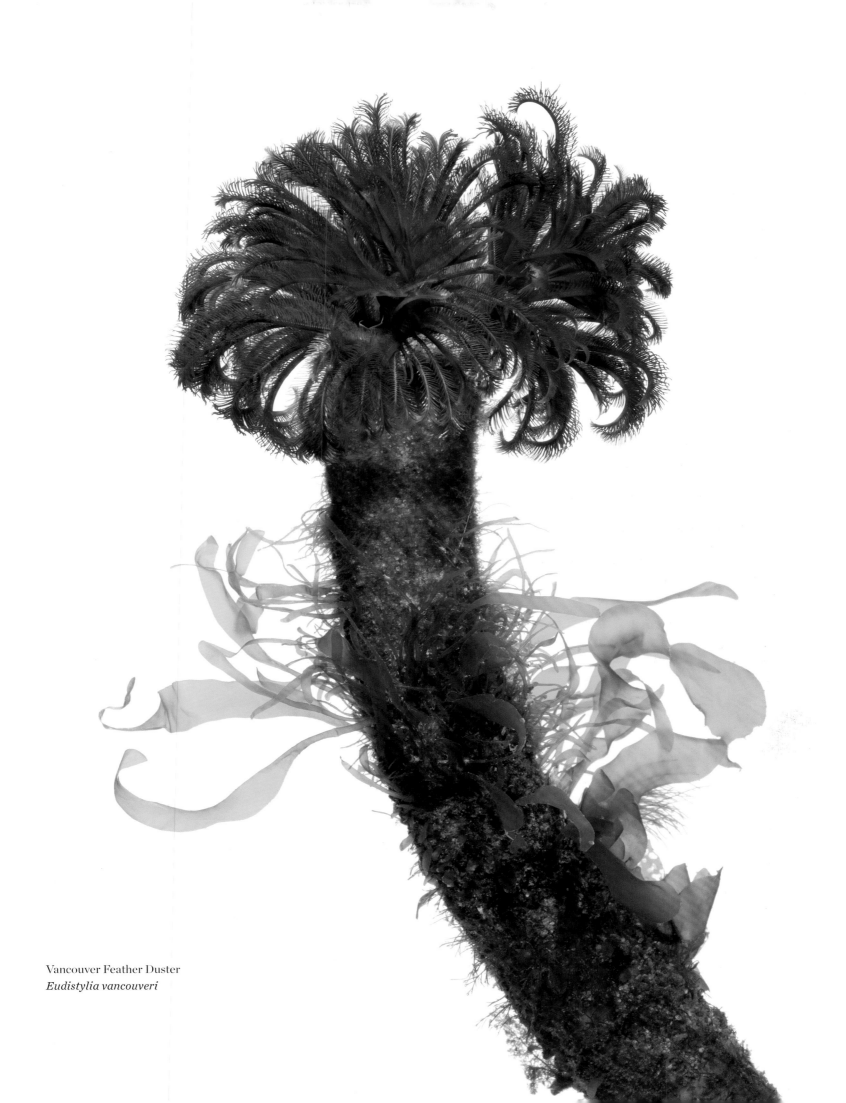

Vancouver Feather Duster
Eudistylia vancouveri

Editor: Andrea Danese
Designer: Darilyn Lowe Carnes
Production Manager: Erin Vandeveer

Library of Congress Control Number: 2014930722

ISBN: 978-1-4197-1007-0

Printed and bound in China
10 9 8 7 6 5 4 3 2 1

Abrams books are available at special discounts when purchased in quantity for premiums and promotions as well as fundraising or educational use. Special editions can also be created to specification. For details, contact specialsales@abramsbooks.com or the address below.

ABRAMS
THE ART OF BOOKS SINCE 1949
115 West 18th Street
New York, NY 10011
www.abramsbooks.com

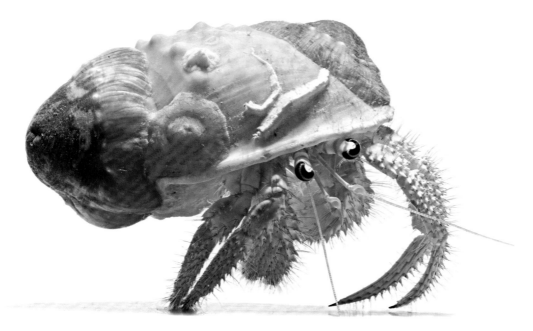

Gold-Banded Hermit, Hermit Crab Anemone, Anemone (unidentified), Darwin's Barnacle, and Calcareous Tubeworm
Dardanus brachyops, *Calliactis polypus*, Order Actiniaria, *Chionelasmus darwini*, and Family Serpulidae

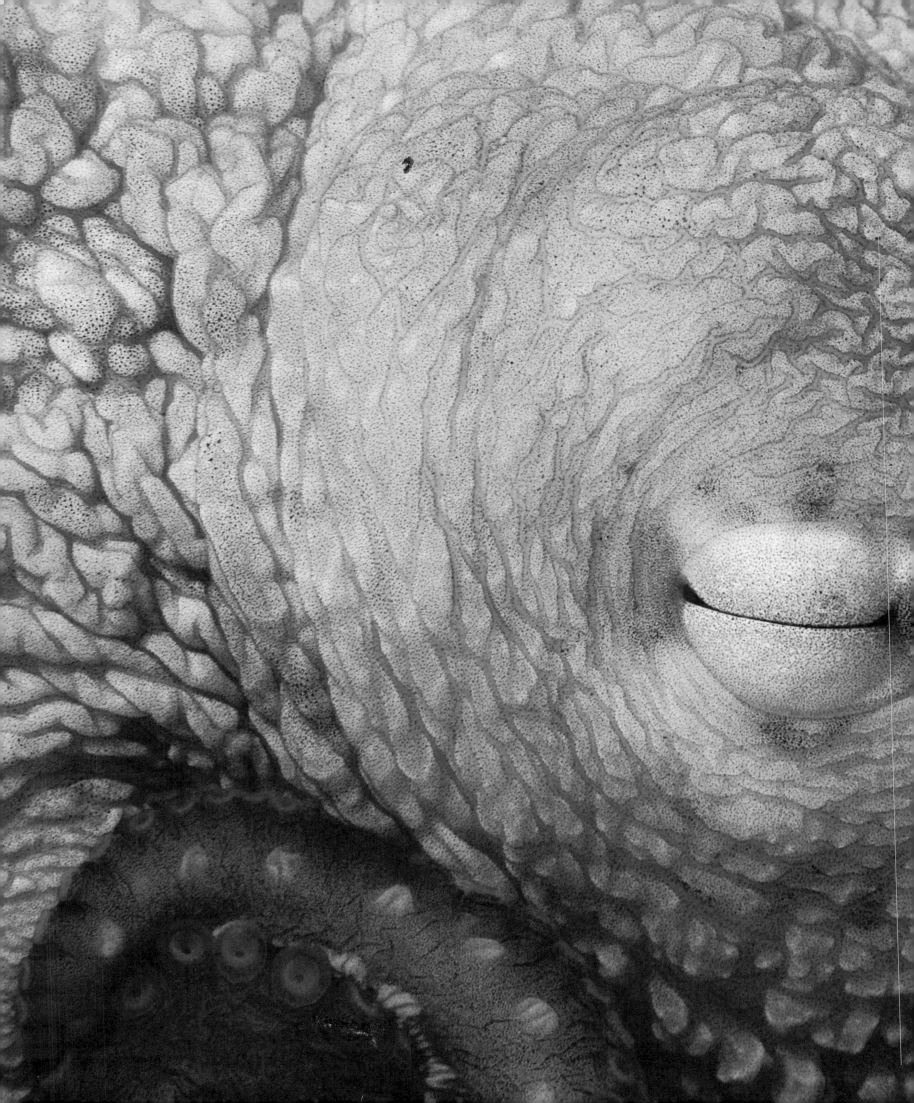